THE STRUGGLE FOR UTOPIA

THE STRUGGLE FOR UTOPIA
RODCHENKO, LISSITZKY, MOHOLY-NAGY
1917-1946

VICTOR MARGOLIN

THE UNIVERSITY OF CHICAGO PRESS
CHICAGO AND LONDON

Victor Margolin is associate professor of design history
at the University of Illinois, Chicago. He is the editor of
the journal *Design Issues*, editor of *Design Discourse*,
and coeditor of *Discovering Design* and *The Idea of Design*.

The University of Chicago Press, Chicago 60637
The University of Chicago Press, Ltd., London
© 1997 by Victor Margolin
All rights reserved. Published 1997
Printed in the United States of America

06 05 04 03 02 01 00 99 98 97 1 2 3 4 5
ISBN: 0-226-50515-4 (cloth)
ISBN: 0-226-50516-2 (paper)

Library of Congress Cataloging-in-Publication Data
Margolin, Victor, 1941–
 The struggle for utopia: Rodchenko, Lissitzky, Moholy-Nagy:
 1917–1946/by Victor Margolin.
 p. cm.
 Includes bibliographical references and index.
 ISBN: 0-226-50515-4 (cloth).—ISBN: 0-226-50516-2 (paper)
 1. Modernism. (Art) 2. Avant-garde (Aesthetics)—History—20th
century. 3. Art and society—History—20th century. 4. Rodchenko,
Aleksandr Mikhailovich, 1891–1956—Philosophy. 5. Lissitzky, El,
1890–1941—Philosophy. 6. Moholy-Nagy, László, 1895–1946—
Philosophy. I. Title.
 N6494.M64M36 1997
 709'.04'1—dc20 96-34090
 CIP

The paper used in this publication meets the minimum
requirements of the American National Standard
for Information Sciences—Permanence of Paper for
Printed Library Materials, ANSI Z39.48-1984.

This book is printed on acid-free paper.

TO SYLVIA AND MYRA

ix

The Struggle for Utopia first took shape fifteen years ago as a doctoral dissertation on the graphic design of Rodchenko, Lissitzky, and Moholy-Nagy. From there it developed into its present narrative form which has enabled me to present the three artists in a broader light while still focusing on specific critical issues in their practice.

I am grateful to the Institute for the Humanities at the University of Illinois, Chicago, and the Graham Foundation for Advanced Studies in the Fine Arts for fellowships and grants that enabled me to devote several large blocks of time to this project. I also wish to thank a number of people with whom I had fruitful discussions or who read chapters or drafts of the manuscript at different stages: Oliver Botar, John Bowlt, Richard Buchanan, John Bushnell, Ed Colker, Brad Collins, Dennis Doordan, Hanno Ehses, Alain Findeli, Peter Hales, Michael Hays, Steve Heller, Christina Lodder, Steven Mansbach, Ann Morgan, Marvin Surkin, Nancy Troy, Karl Werkmeister, and Frank Williams.

Alexander Lavrentiev, grandson of Alexander Rodchenko, and Hattula Moholy-Nagy, daughter of László Moholy-Nagy, were more than generous in providing photographic material from their respective family archives. A visit to the Rodchenko studio in Moscow in 1989 gave me a sense of the place where Rodchenko worked. The Dessau Family Trust graciously made available photographs of several Lissitzky paintings from the collection of the late Eric Estorick. Howard Garfinkel and Larry Zeman of Productive Arts provided a rare copy of *USSR in Construction.*

Russell Maylone, Special Collections librarian at the Northwestern University Library has been a great source of research materials over the years. At the University of Illinois, Chicago, Gretchen Lagana, head of Special Collections, and Mary Ann Bamberger, a member of her staff, guided me through the Institute of Design collection.

I would like to thank Kiki Wilson at the University of Chicago Press for her boundless patience and support during the lengthy gestation of this manuscript. Page Kennedy Peale, her assistant, has handled the myriad details connected with preparing the manuscript for publication, and Lila Weinberg made many helpful editorial suggestions. The Institute for the Humanities and the Campus Research Board at the University of Illinois, Chicago, generously granted funds to acquire the photographs. Sarah Peak, Roberto Buitrón, and the university's Photographic Services did a lot of the photography. Marta Huszar designed a book that can hold its own with its avant-garde predecessors.

And last, Sylvia, my wife, and Myra, my daughter, provided love and encouragement.

It is we, artists, that will serve as your avant-garde; the power of the arts is indeed the most immediate and the fastest. We have weapons of all sorts: when we want to spread new ideas among people, we carve them in marble or paint them on canvas; we popularize them by means of poetry and music; by turns, we resort to the lyre or the flute, the ode or the song, history or the novel; the theatre stage is open to us, and it is mostly from there that our influence exerts itself electrically, victoriously. We address ourselves to the imagination and feelings of people: we are therefore supposed to achieve the most vivid and decisive kind of action; and if today we seem to play no role or at best a very secondary one, that has been the result of the arts' lacking a common drive and a general idea, which are essential to their energy and success.

Olinde Rodrigues (1825)[1]

In the early 1820s, when the Comte Henri de Saint-Simon first conceived of the artist as a social visionary, allied in an elite triumvirate of leaders with the scientist and the industrialist, he defined a role for the artist that has remained an elusive ideal ever since.[2] For Saint-Simon, art denoted the broad creative exercise of the imagination. Artists would use all their techniques, including poetry, painting, and music, to produce statements that could inspire human aspirations. In Saint-Simon's triumvirate, the artist's role was to envision the future of society, while the scientist would analyze the feasibility of visionary ideas, and the industrialist would devise administrative techniques for putting them into practice. Thus the triumvirate would be responsible for the invention, analysis, and execution of all social initiatives.

1 Olinde Rodrigues, "L'artiste, le savant et l'industriel: Dialogue" (1825), quoted in Matei Calinescu, *Five Faces of Modernity: Modernism, Avant-Garde, Decadence, Kitsch, Postmodernism* (Durham: Duke University Press, 1987), 103.

2 Saint-Simon first envisioned the artist as a member of the social vanguard in the early 1820s. In a letter of 1820 he described the artist as the leader who would be followed first by the scientist and then the industrialist. Olinde Rodriques, one of Saint-Simon's disciples, elaborated this idea in his essay "L'artiste, le savant et l'industriel: Dialogue," which was published in 1825. Donald Drew Egbert first attributed this dialogue to Saint-Simon, but Matei Calinescu claims that he was incorrect. See Donald Drew Egbert, "The Idea of the 'Avant-Garde' in Art and Politics," *American Historical Review* 73, no. 2 (December 1967): 342–44; and Calinescu, *Five Faces of Modernity*, 101–4.

Matei Calinescu claims that Olinde Rodrigues, a close friend and disciple of Saint-Simon, was the first to use the term "avant-garde" to denote an artistic practice rather than a military one.[3] As a military term, "avant-garde" referred to a line of soldiers who marched ahead in battle, but Saint-Simon and his followers gave it a much broader meaning. According to them, the artist was more like the general than the foot soldier; the artist imagined the battle plan, while the soldier in the front lines marched to someone else's orders.

In a dialogue between an artist, a scientist, and an industrialist, published in 1825, Rodrigues has his artist say:

> What a most beautiful destiny for the arts, that of exercising over society a positive power, a true priestly function, and of marching forcefully in the van of all intellectual faculties, in the epoch of their greatest development! This is the duty of artists, this their mission . . . [4]

As the nineteenth century progressed, however, many avant-garde artists refused the role of social visionary, preferring instead to isolate a sphere or terrain that was separate from social life, where they could defend the integrity of art against its potential corruption by the public. Peter Bürger, the German critic, noted a correlation between the avant-garde's declining interest in broadly accessible subject matter and their retreat to the terrain of aesthetics where they began to concentrate on formal concerns.[5] According to Bürger, the avant-garde's new self-consciousness about art language led to their important recognition that a work of art need not refer to experience outside itself. Bürger characterized artists who held this belief as an aesthetic avant-garde.

Once artists perceived that the forms or languages of art were innately powerful, however, they began to focus on the problem of relating their work to the concerns that earlier artists had taken up on terrains other than the aesthetic one. It was at this point, as Bürger points out, that "the work of art entered into a new relationship to reality. Not only does reality in its concrete variety penetrate the work of art but the work no longer seals itself off from it."[6]

The aim of developing this relationship was central to a new artistic-social avant-garde. Here we can think of the Futurists' desire to express the speed, cacophony, and simultaneity of everyday life in their art as well as to extend their sensibility to typography, furniture, interiors, and even the design of cities. The Expressionists were not similarly oriented to design, but they too sought an engagement with life as did the Dadaists in Berlin. Artists who believed in the principles of De Stijl and neoplasticism, notably Theo van Doesburg and Piet Mondrian, wanted to make their geometric language manifest in the entire built envi-

3 Calinescu makes this point in "The Idea of the Avant-Garde." which appears in his book *Five Faces of Modernity*, 101. He disagrees with Egbert's claim that Saint-Simon himself was the first to use the term.

4 Although Egbert attributes this quote to Saint-Simon, I will follow Calinescu's attribution of it to Olinde Rodriques's dialogue, "L'artiste, le savant et l'industriel." It is cited by Egbert in "The Idea of 'Avant-Garde' in Art and Politics," 343.

5 Peter Bürger, *Theory of the Avant-Garde* (Minneapolis: University of Minnesota Press, 1984), 20–27.

6 Ibid., 91.

ronment. Among the Russians, Kazimir Malevich wanted Suprematism to become an all-embracing representation of the human spirit and imagined the application of Suprematist forms to all the objects of daily life. The Russian Constructivists held intense debates about art's value, and many decided to abandon art altogether and express their strong convictions about form by creating new objects of use—kiosks, posters, furniture, and theater sets, for example. At the Bauhaus, Walter Gropius initially hoped to unite all artistic activity under the wing of architecture.

But the artistic-social avant-garde was not simply interested in innovative forms. They wanted those forms to become signifiers of a new spirit. Their ambition was to create a new social role for art, one that made the artist a significant participant in the organization and building of social life.[7] This recognition returns us to Saint-Simon's image of the artist as visionary, but with a difference. Saint-Simon and his followers distinguished between two kinds of acts in their ruling triumvirate: *discursive*, which was the artist's postulations of goals, aims, and projects; and *pragmatic*, which referred to the industrialist's practical implementation of plans.[8] What is evident in the Saint-Simonian formulation is that artists had the power to envision possibilities, while they remained dependent on others to translate their ideas into practical activities. The ambition of the artistic-social avant-garde, however, was to close the gap between discursive acts, which were confined to postulation and speculation, and pragmatic ones, which involved participation in building a new society. They wanted to effect a "double revolution" by redefining revolutionary art practice so that it became revolutionary social practice as well. While we recognize that they did not achieve their goal on the grand scale they initially anticipated, one can still argue that they nonetheless opened up new directions for the artist, particularly by assuming the authority to make statements about and produce models of what social life might be like.

The particular historical moment in European history when the artistic-social avant-garde became active began around 1909 with Marinetti's Futurist Manifesto in the Parisian newspaper Le Figaro, and it continued after World War I into the early 1920s when the Bolsheviks consolidated their power in Russia. This was the first time in the twentieth century that there was a revolutionary social context which seemed to be a promising terrain for the avant-garde artist. There are numerous studies of the early twentieth-century avant-garde move-

[7] For a philosophic exploration of how art can relate to social change, see Gordon Graham, "Art and Politics," *British Journal of Aesthetics* 18, no. 3 (Summer 1978): 228–36.

[8] My distinction between *discursive* and *pragmatic* acts follows the general thinking of Jürgen Habermas and Anthony Giddens. Habermas delineates two kinds of practice: *communicative* action functions in the sphere of discourse, while instrumental action refers to social control, whether of elements, materials, or individuals. See Jürgen Habermas, "Technology and Science as 'Ideology,'" in his collection of essays, *Towards a Rational Society: Student Protest, Science, and Politics*, trans. Jeremy Shapiro (Boston: Beacon Press, 1971), 81–122. The difficulty with Habermas's distinction is that it separates communication from instrumentality, thus weakening the effect of communication in transforming social practice. It also ignores the aspect of communication in social action. For Giddens, the differentiation is between *discursive* and *practical* consciousness. See Anthony Giddens, *The Constitution of Society: Outline of the Theory of Structuration* (Cambridge: Polity Press, 1984).

ments and their leaders. At the theoretical level, Renato Poggioli, Matei Calinescu, and Peter Bürger have attempted to assess the avant-garde as a phenomenon and examine its implications for the postwar period.[9] More specifically, scholars have written on the Futurists, Expressionists, Dadaists, Suprematists, De Stijl, Constructivists, and the Bauhaus.[10] These detailed studies of specific movements and individuals have contributed a great deal to our knowledge of the avant-garde in the interwar period, but some important questions remain to be explored. We need to clarify more precisely how the initial utopian convictions of the artistic-social avant-garde functioned as an impetus for them to take the course they did, why they believed their visions could be realized, how they changed their strategies as they encountered indifference or opposition to their visions, and what partial victories they achieved along the way.

My own interest in these questions has led me to write this series of essays on three representatives of the artistic-social avant-garde: Alexander Rodchenko, El Lissitzky, and László Moholy-Nagy. I chose these artists because their own ambitions and careers in the interwar period covered a broad range of artistic practices and political situations. They all published numerous statements of their convictions about art and design and sought to put these convictions into practice. From a contemporary vantage point, we can identify a number of issues their work raises.

Each of the essays in this book focuses on a separate issue that involves one or more of the artists. By looking at how the three men operated in a set of specific circumstances, I hope to provide a better understanding of the larger questions about the relation of art and social life that frame this study. I have not produced conclusive evaluations of the artistic and political choices that Rodchenko, Lissitzky, and Moholy-Nagy made. Theirs was not an easy course. They belonged to the first generation of artists who were in a position to test the relation of a radical art language to a terrain of revolutionary social practice. When they began to clarify their visual and social values in the period of intense political and artistic upheaval preceding and during World War I, they could not foresee the climate of reception for their work, nor could they gauge the possible extent or direction of their influence. As artists, all three rejected the received traditions of representational painting for a new visual language of abstraction. They also moved from the purely discursive sphere of art to various pragmatic forms of design. Lissitzky was an active graphic and exhibition designer as well as a trained architect. Rodchenko and Moholy-Nagy were also graphic designers as well as photographers and creators of theater sets. All three were teachers. Lissitzky first taught art and then design in the interior design stu-

9 See Renato Poggioli, *The Theory of the Avant-Garde* (Cambridge, MA: Belknap Press of Harvard University Press, 1968); Calinescu, "The Idea of the Avant-Garde," in his book, *Five Faces of Modernity*, 93–148; and Bürger, *Theory of the Avant-Garde*. Donald Kuspit charts a shift from modernist to postmodernist avant-garde practices in *The Cult of the Avant-Garde Artist* (Cambridge: Cambridge University Press, 1993).

10 Literature on the European avant-garde movements is extensive. See, e.g., Enrico Crispolti, *Storia e Critica del Futurismo* (Roma: Editori Laterza, 1986); John Willett, *Expressionism* (New York: McGraw-Hill, 1970); Stephen Foster and Rudolf Kuenzli, eds., *Dada Spectrum: The Dialectics of Revolt* (Madison: Coda

dio at the VKhUTEMAS, the Soviet design school in Moscow; Rodchenko taught in the Foundation Course and directed the Metalwork Faculty there as well; and Moholy-Nagy headed the Metal Workshop at the Bauhaus. The remarkable continuity between the various forms of their work stems from their belief in a basic visual vocabulary and their conception of art as a practice that extended beyond the aesthetic sphere. With this shift of purpose, the boundaries between art and design were no longer so firm, and the artists' preoccupation with visual concerns could be stated through extremely diverse activities in graphic design, architecture, film, exhibition and stage design, and designs for products.

What gave direction to all these activities and affirmed the relation between them was an *ideology* or set of convictions about the means and ends of the modern artist. According to anthropologist Clifford Geertz, ideology is a form of "symbolic action" through which human beings consciously or purposefully create symbol-systems that establish boundaries for human behavior.[11] In traditional societies, Geertz states, inherited symbols reinforce behavior that is continuous with past values, but in times of social upheaval, such as periods of revolution, when traditional symbol-systems are no longer perceived to be operative, a need arises to create "templates for the organization of social and psychological processes."[12]

It was just such conditions of upheaval that led to the ideological formation of Rodchenko, Lissitzky, and Moholy-Nagy. All three began to develop as artists around the time of political revolutions in their countries—Rodchenko and Lissitzky in Russia and Moholy-Nagy in Hungary. They witnessed and participated in radical changes in art as well. These political and artistic events formed the context for their ideology which was based on three common beliefs:

• Artists belonged in the vanguard of social change and should strive to make the characteristics of a utopian society visible.

• Art was not an isolated discursive practice on its own aesthetic terrain.

• Forms which could be perceived as objective and precise were the most appropriate basis for visual statements.

Although Rodchenko, Lissitzky, and Moholy-Nagy put this ideology into action in very different ways, its characteristics still identify a common orientation in their practice. But given the fact that the social situations with which they were confronted changed radically in their lifetimes, their operative strategies were severely tested and underwent significant revisions. They worked in situations that were often at odds with the ideal practices they envisioned, and each lived within a dialectic of possibilities and realities.

So that the essays can best explain these changes and revisions, I have arranged them in an approximate chronological order. Each essay focuses on a specific issue

Press, 1979); Paul Overy, *De Stijl* (London: Thames and Hudson, 1991); Larissa A. Zhadova, *Malevich: Suprematism and Revolution in Modern Art, 1910–1930* (New York: Thames and Hudson, 1982); Christina Lodder, *Russian Constructivism* (New Haven: Yale University Press, 1983); and Gillian Naylor, *The Bauhaus Reassessed: Sources and Design Theory* (New York: E. P. Dutton, 1985).

11 See Clifford Geertz, "Ideology as a Cultural System," in his book *The Interpretation of Cultures: Selected Essays* (New York: Basic Books, 1973), 193–233.

12 Ibid., 218.

which relates to one or two of the artists. I begin just after the Russian Revolution with the strategies of Rodchenko and Lissitzky to use their paintings and drawings as a means of opening up a discourse about revolutionary architecture and town planning. What is at issue here is how the first euphoria of the Revolution created a context that energized many artists to expand their sphere of social influence.

In the second essay, I take up the problem of Constructivism in Germany, which differed markedly from Soviet Constructivism. Lissitzky went to Germany at the end of 1921 and first met Moholy-Nagy there. The two artists were central figures in the debate about the social potential of Constructivist art in the years 1922–23. By comparison with the Russian situation that Lissitzky had just left, there was no promise of an immanent revolution in Germany, and the political meaning of Constructivist art depended much more on a context the artists themselves sought to create.

The third essay returns the reader to the Soviet Union and the work of Rodchenko during the period of the New Economic Policy. In late 1921, Rodchenko declared an end to painting and began to work in various fields of design. His aim was to test the possibilities of Constructivist visual language against the exigencies of design projects. At issue was the way he conceived his role as a designer in order to accomplish this.

Both Rodchenko and Moholy-Nagy began to photograph in the early 1920s and continued throughout the decade and beyond. At certain points in their careers their work looked very similar, but their intentions were extremely different. In the fourth essay I investigate the relation of their photographs to the social contexts in which they were working, noting particularly how those contexts supported the differing assertions they made about their work and provided the impetus for the two men to move in extremely different directions from a similar point of departure.

With the inauguration of the first Five-Year Plan in 1929, Soviet artists and designers were called on to serve the state more directly than they had been in the past, and the avant-garde lost much of its autonomy. In the fifth essay, I address the question of how Lissitzky, who returned to the Soviet Union from the West in 1925, and Rodchenko confronted this new set of constraints which at once limited their autonomy while also providing them an opportunity to take up real design tasks in the service of the state.

In the final essay, I examine Moholy-Nagy's emigration from Europe to the United States where he became director of the New Bauhaus, School of Design, and Institute of Design. I compare his pedagogical initiatives at these schools with the expectations of the business leaders who supported his projects. In the complexities of this relationship, we can see how Moholy-Nagy attempted to introduce the social ideals of his early avant-garde days to the context of the corporate capitalism of Chicago.

At times it seemed that Rodchenko, Lissitzky, and Moholy-Nagy were fighting for the same utopian values, and yet Rodchenko and Lissitzky were eventually forced to pit their ideology against a Soviet policy that opposed the avant-garde, while Moholy-Nagy had to contend with a capitalist society that allowed a great deal of freedom but did not take political statements by artists seriously.

Even though the three artists imagined many possibilities that did not come about, their practices remain a rich mine of experience that can help us address a number of important questions. By reflecting on their lives, we can better assess the degree to which art and design can gain social influence, and we can understand more clearly the social conditions within which that influence can be exercised and be effective. It was the power of these questions that caused me to undertake this study and to sustain the belief that answering them could make a difference.

Every new experiment in the field of art has come out of technique and engineering and is headed in the direction of organization and construction. We know that taste and pleasant sensations are dead for ever.

Alexander Rodchenko (1921)[1]

[F]or us SUPREMATISM did not signify the recognition of an absolute form which was part of an already-completed universal system. [O]n the contrary here stood revealed for the first time in all its purity the clear sign and plan for a definite new world never before experienced—a world which issues forth from our inner being and which is only now in the first stage of its formation. [F]or this reason the square of suprematism became known as a beacon.

El Lissitzky (1920)[2]

It seems that art as art expresses a truth, an experience, a necessity which, although not in the domain of radical praxis, are nevertheless essential components of revolution.

Herbert Marcuse (1978)[3]

The utopian imagination—a means to envision new possibilities for human life—was particularly strong at the time of the Russian Revolution in 1917 when the opportunity arose to transform an entire nation.[4] This stimulated avant-garde artists who debated the social relevance of art during and after the Civil War to transcend previous boundaries of discursive practice and address questions of productive engagement in economic life as well. In discussing the relation between discourse and production among the avant-garde, we can mention

1 Alexander Rodchenko, comment in the debates on composition and construction at INKhUK, the Institute for Artistic Culture, Moscow, 1921. Quoted in Selim O. Khan-Magomedov, *Rodchenko: The Complete Work*, intro. and ed. Vieri Quilici (Cambridge, MA: MIT Press, 1987), 84.

2 El Lissitzky, "Suprematism in World Reconstruction," *Unovis* 1 (1920), quoted in Sophie Lissitzky-Küppers, *El Lissitzky: Life, Letters, Texts*, rev. ed. (London: Thames and Hudson 1980 [c. 1968]), 331.

3 Herbert Marcuse, *The Aesthetic Dimension: Toward a Critique of Marxist Aesthetics* (Boston: Beacon Press, 1978), 1.

4 James McClelland has posited two major trends within the postrevolutionary utopian discourse of revolutionaries who sought to locate themselves in the vanguard of change during the Civil War years between 1917 and 1920. Those whom he calls "utopians" argued for radical changes in the existing culture and economy that would lead to the rapid instillation of a proletarian consciousness in the masses. Others who occupied the second position, which McClelland characterizes as the "revolutionary heroic outlook," believed that "a massive build-up of the economy, rather than psychological transformation of the masses, was the most urgent prerequisite for the construction of socialism." This group advocated crash programs to increase worker productivity and stressed the training of technical specialists as being more important, at least in the initial phase of the Revolution, than the implementation of a new culture. See James McClelland, "Utopianism versus Revolutionary Heroism in Bolshevik Policy: The Proletarian Culture Debate," *Slavic Review* 39, no. 3 (September 1980): 403–25. The avant-garde shared some of the concerns of both groups. On the varied forms of cultural utopianism in Russia see also Richard Stites, *Revolutionary Dreams: Utopian Vision and Experimental Life in the Russian Revolution* (Oxford: Oxford University Press, 1989).

two principal positions. The first emphasized the creation of new objects as the most important goal of avant-garde practice. The Constructivists, which included Alexander Rodchenko, and Productivists in the Institute for Artistic Culture (INKhUK) within the People's Commissariat of Enlightenment, for example, urged artists and theorists to join economic councils and go into the factories to design new products.[5] By contrast, the second position, which was exemplified by Kazimir Malevich, El Lissitzky, and their students at the Popular Art Institute in Vitebsk, gave more importance to the capacity of objects to embody ideals than to perform a useful function.

Rodchenko maintained a materialist faith that new forms could be created through the analysis and combination of visual elements such as colors, lines, and planes. While these forms could become arguments for the character traits he espoused, they were nonetheless material objects that did not evoke transcendent values. Lissitzky, on the other hand, held the idealist conviction that forms could embody a new consciousness by pointing to a state or condition outside the limitations of contemporary lived experience. The contrast between Rodchenko and Lissitzky derives from two fundamentally different linguistic models of utopian thought proposed by the Polish scholar Andrzej Turowski. He equates the *reist utopia* (utopie reiste) with the work of Rodchenko, and the *phenomenological utopia* (utopie phenomenologique) with the work of Kazimir Malevich, to whom Lissitzky owed a great debt in the immediate postrevolutionary years.[6] The representation of objects that corresponded to new relations between humans was central to the *reist utopia*. As Rodchenko expressed it, "The objects receive a meaning, they become friends and comrades of humans and humans begin to learn how to laugh, to rejoice and to converse with objects."[7] For Rodchenko, a new form language could result in things that fit into the nexus of unprecedented social relations. Kiosks with advanced communications media, furniture that could be changed to satisfy multiple purposes, film titles that made an organic link between two edited film sequences; these were all aimed at people who had a strong, alert relation to the material world.

The *phenomenological utopia*, as Malevich defined it, offered a means to transcend the object, to identify it as a marker of human thought. We see this most strongly in Lissitzky's *Proun* paintings as well as in his new conception of the book, exemplified by his design of *Suprematicheskii Skaz Pro Dva Kvadrata v 6ti Postroikakh* (Suprematist Story of Two Squares in Six Constructions [henceforth referred to as *Of Two Squares*]). Both Rodchenko and Lissitzky responded as artists to the practical demands of daily life, but they did so at different stages of their careers and for different reasons. Rodchenko, more than Lissitzky, was inclined to unite problems of form and use in his projects, but ironically it was

5 This position is well documented by Christina Lodder in *Russian Constructivism* (New Haven: Yale University Press, 1983), 100–108.

6 See Andrzej Turowski, "Conceptualisation et materialisation dans l'art non-objectif," in *Les abstractions I: La diffusion des abstractions* (Saint-Etienne: Université de Saint-Etienne, 1986), 73–81.

7 Alexander Rodchenko, quoted in ibid., 80 (my translation).

Lissitzky who became the Soviet Union's leading designer during the Stalin years.

The period of war communism provided an open horizon which revolutionaries of all types used to give shape to their hopes for the future. This was a moment when visionary speculations, particularly artistic ones, were relatively unrestrained and unchallenged by the party leadership. Despite the debates on production art that took place within INKhUK, however, artists during this period were considerably removed from the sites where decisions about the future economy and political structure were taking place. Although the discourse of some artists and theorists regarding the end of easel painting and the future of production art may *appear* to have been more practical than the arguments of more traditional artists or idealistic ones, we must bear in mind that this discourse on the end of art most significantly turned inward to questions of how artists might be involved in the Revolution rather than outward to the direction that the Revolution was actually taking in the spheres of economics and political decision making. This is particularly important in light of emerging revisionist criticism of the avant-garde's ethics as they relate to new interpretations of the Revolution itself.[8]

2

Early in 1915, while a student at the School of Art in Kazan, where he had studied since 1910, Alexander Rodchenko produced a series of drawings with a compass and ruler that represented for him a sharp break with traditional subject matter and methods of art (**FIGURE 1.1**).[9] He divided the surfaces of the drawings by combining curved and straight lines and filled some of the segments in with black as well as other colors. Rodchenko was not allied with the Russian Futurists, who were part of an extremely active avant-garde before the Revolution, but his compass-and-ruler drawings shared with the Futurist sound poems and other verse experiments by Vasily Kamensky, Velimir Khlebnikov, and Aleksei Kruchonykh an emphasis on the materiality of artistic forms.[10] In Kamensky's poem "Constantinople," for example, the words are the units with which the poem is visually organized.[11] And Khlebnikov and Kruchonykh, speak-

8 Camilla Gray ends her book *The Russian Experiment in Art, 1863–1922* (London: Thames and Hudson, 1986 [c. 1962]) with the statement that artists after the Revolution "felt a great experiment was being made in which, for the first time since the Middle Ages, the artist and his art were embodied in the makeup of the common life, art was given a working job, and the artist considered a responsible member of society" (276). This optimistic view of the avant-garde's political role is challenged by Boris Groys, who claims that "the avant-garde allied itself with the new Bolshevik regime during a period of vicious mass repression," which included an attack on the liberal Russian intelligensia. See Boris Groys, "On the Ethics of the Avant-Garde," *Art in America* 81, no. 5 (May 1993): 110–13.

9 On Rodchenko's career, see German Karginov, *Rodchenko*, trans. Elizabeth Hoch (London: Thames and Hudson, 1979); David Elliott, ed. *Alexander Rodchenko*, exh. cat. (Oxford: Museum of Modern Art, 1979); and Khan-Magomedov, *Alexander Rodchenko: The Complete Work*.

10 While a student in Kazan, Rodchenko did attend a Futurist performance featuring Burliuk, Mayakovsky, and Kamensky. He is said to have called the performance "the second most soul-stirring experience of my life." Alexander Rodchenko, quoted in Karginov, *Rodchenko*, 12.

11 Gerald Janacek discusses Kamensky's poems in *The Look of Russian Literature: Avant-Garde Visual Experiments, 1900–1930* (Princeton: Princeton University Press, 1984), 125–33.

ing against interpretation in their 1913 manifesto "The Word as Such," stated that "all Talmuds are equally destructive for the word worker; he remains face to face, always and ultimately, with the word (itself) alone."[12]

Although we can fifind parallels in the materialism of Rodchenko's compass-and-ruler drawings and the Futurist theories of the word and letter, we can also see more in Rodchenko's drawings than the simple demarcation of a surface with lines and colors. Given Rodchenko's later arguments for a closer relation between art and engineering, which he made while participating in the production art debates at INKhUK in 1920–21, it is feasible to interpret his preparation of these drawings with a compass and ruler as a precursor to his later interest in engineering techniques as a paradigm for productive work.[13]

By the time Rodchenko arrived in Moscow from Kazan in the spring or summer of 1915, his rejection of traditional art had taken the polemical form of a revolt against the bourgeoisie as well as against an older generation of conservative artists.

> Yet I held the bourgeoisie in contempt and despised their favorite art as well as the aesthetes of the Association of Russian Artists and *Mir Iskusstva*. Artists like Tatlin, Malevich, Mayakovsky, Khlebnikov and others who, like me, remained unappreciated, whose work did not sell, and who were damned by all the papers, were much closer to me. We revolted against the accepted canons, values and taste.[14]

At the time, positions among the avant-garde had been polarized on the one hand by Vladimir Tatlin, who had started to make materialist counterreliefs of

FIGURE 1.1
Rodchenko *Compass Drawing,*
1915

12 V. Khlebnikov and A. Kruchonykh, "The Word as Such," in Velimir Khlebnikov, *Collected Works, Vol. 1, Letters and Theoretical Writings*, trans. Paul Schmidt, ed. Charlotte Douglas (Cambridge, MA: Harvard University Press, 1987), 257–58.

13 At an INKhUK meeting of April 13, 1922, Rodchenko proposed that the institute organize a series of talks by engineers so that its members could become better acquainted with practical production. See Lodder, *Russian Constructivism*, 100.

14 Alexander Rodchenko, quoted in Karginov, *Rodchenko*, 13.

industrial materials after his return from Paris in 1913, and Kazimir Malevich, whose idealistic Suprematist compositions had begun to garner a following. This polarity was evident at the exhibition "0.10" organized by Ivan Puni and Xana Boguslavskaya, which opened in Petrograd in December 1915.[15]

In early 1916, Tatlin created an exhibition in Moscow called "The Store" where Rodchenko showed a series of drawings. Malevich saw his work and sought to engage him, but Tatlin, who became a mentor to Rodchenko, advised him against visiting Malevich though Rodchenko was later to acknowledge an influence of Suprematism on his work.

After the Revolution, Rodchenko was among the first artists to support the Bolsheviks. He took on various functions within the newly formed Fine Art Department (IZO) of the People's Commissariat of Enlightenment, including a position as deputy head of the Art and Production Subsection.[16] Among the projects of the subsection was the establishment of relations with industry, even though the large factories had only recently been nationalized and were essentially preoccupied with questions of reorganization and management. Concurrent with his official duties, Rodchenko continued to produce his own art. He used color and form, as well as texture, in an architectonic way, combining them according to his perception of their material properties. This meant building up paintings and drawings with particular shapes, such as circles or semicircles, experimenting with overlapping planes, and combining straight and curved lines, rough and smooth textures, and positive and negative spaces. His use of color indicates an analytic interest in how different hues, intensities, and tones interacted rather than in the way they could be used to create a mood or feeling. As examples of his architectonic approach to art, we can cite the series of taut linoleum cuts he began at the end of 1918 in which he isolated line as a constructive element, using lines to create planes, textures (crosshatchings), tone (line density), volume, and the effects of spatial depth. His starkest print in that series (**FIGURE 1.2**), was a network of curved and straight lines—without tone, or volume—which formed a tense interplay between the grid that divided the flat surface, the diagonals that bisected it, and the circles that surrounded it. In this linocut and others, Rodchenko used line dynamically to express energy and constructive possibilities. In a lecture he gave at INKhUK in 1921, he characterized the place of line in his work of 1917–18 as follows:

> Both in painting and in any construction in general, line is the first and last thing. Line is the path of advancement, it is movement, collision, it is facetation, conjunction, combination.[17]

15 On the exhibition, see Charlotte Douglas, "0.10 Exhibition," in *The Avant-Garde in Russia, 1910–1930: New Perspectives*, ed. Stephanie Barron and Maurice Tuchman (Cambridge, MA: MIT Press; Los Angeles: Los Angeles County Museum of Art, 1980), 34–40. On prerevolutionary avant-garde activities in general, see Camilla Gray, *The Russian Experiment in Art, 1863–1922*.

16 On the Fine Art Department, see Patricia Railing, "Russian Avant-Garde Art and the New Society in the Context of D. Shterenberg's 'Report of the Activities of the Section of Plastic Arts of Narkompros' of 1919," *Revolutionary Russia* 7, no. 1 (June 1994): 38–77.

17 Alexander Rodchenko, "Line," in *Alexander Rodchenko*, ed. Elliott, 128.

Having isolated line as an architectonic element on the picture plane, Rodchenko extended his interest in it to three-dimensional forms. In 1918 he began to make constructions of metal strips and flat shapes that had a dominant vertical thrust with sections extending out on horizontal and diagonal axes. These were the logical extension of his interest in the tension between the flat surface and depth. They were then developed into a series of spatial constructions, which were suspended in space and achieved their virtual volume through the rotations of similar interlocking shapes—circles, hexagrams, and squares (**FIGURE 1.3**). The absence of color in Rodchenko's linocuts and constructions emphasizes their linear and planar qualities and reinforces their structural focus. Discounting inspiration and emotion as driving forces in artistic creation, Rodchenko redefined artistic practice as the rational combination of specific elements (i.e., color, texture, and line) and materials (i.e., wood and metal). While he was developing an analytic method of artistic production, others within the Fine Art Department of the People's Commissariat of Enlightenment were also trying to transform art into a more technical practice. In the pages of *Iskusstvo kommuny* (Art of the Commune), the Fine Art Department's short-lived journal published in 1918–19, the theorist Osip Brik and other critics attempted to bring the conception of the artist closer to that of an industrial worker and, in fact, build a rationale for a new kind of artist-constructor who would work in the service of industrial production.[18]

In the later debates on composition and construction held at INKhUK in 1921,

FIGURE 1.2
Rodchenko linocut, 1921

[18] Similar discussions of art and industry had occurred in Europe since Henry Cole and the British design reformers began to publish the *Journal of Design and Manufactures* in 1849. And in Russia, P. S. Strakhov argued in *The Aesthetic Tasks of Technology* (1906) that the aesthetic needs of daily life and the potential of machine production should be brought into closer harmony. Discussions on the relation of art and industry had intensified with the founding of the Deutscher Werkbund in 1907 and artists like Henry van de Velde and Otto Eckmann had stopped painting some years before to begin working in the applied arts. What distinguishes these events from Russian debates after the Revolution, however, is the latter attempt to locate applied art within the culture of a newly empowered class, the proletariat, and the desire to find a visual lan-

Rodchenko declared composition to be an anachronism because it was related to aesthetics and concepts of taste. He defifined construction as a new art form that arose from technology and engineering and was based on principles of rational organization.[19] Rodchenko reinforced this distinction by comparing construction as a process of producing form to the political events that resulted in the Bolshevik victory. "As we see in the life of the RSFSR, everything leads to organization. And so in art everything has led to organization."[20] Rodchenko's concern with impersonality, rationality, and structural toughness paralleled in visual terms Lenin's earlier description of the revolutionary discipline he admired in the Germans. After the signing of the Brest-Litovsk treaty in March 1918, Lenin urged the Russians to emulate the best qualities of the Germans, which he characterized as "the principle of discipline, organization, harmonious cooperation on the basis of modern machine industry, and strict accounting and control."[21]

Perhaps stimulated by the arguments in *Iskusstvo kommuny* for an art that more closely approached industrial practice, a number of artists and architects within the Fine Art Department began, in 1919, to explore a synthesis of sculpture and architecture with the expectation that principles of art could be extended to the terrain of practical objects. The hope that visual experimentation might result in buildings constructed with new formal vocabularies led in May 1919 to the formation of a group concerned with the relation between sculpture and architecture. Entitled Sinskul'ptarkh (Sculptural and Architectural Synthesis), its

FIGURE 1.3
Rodchenko *Spatial Construction,*
1920–21

guage that expressed the characteristics of an industrial society, a project that remained outside the 1914 Werkbund debate in Cologne where the discussion centered on artistic autonomy v. standardization.

19 For a thorough discussion of the debates on composition and construction within INKhUK, see Khan-Magomedov, *Rodchenko: The Complete Work*, 83–89; and Lodder, *Russian Constructivism*, 83–94.

20 Rodchenko, quoted in the "Protokol zasedaniya INKhUKa," January 21, 1921; cited in Lodder, *Russian Constructivism*, 88.

21 Vladimir Ilich Lenin, "The Chief Task of Our Day" (March 1918), in *The Lenin Anthology*, selected, ed., and intro. Robert C. Tucker (New York: W. W. Norton, 1975), 437.

aim was to bring together the spatial arts. Chaired by a sculptor, Boris Korolev, the group included seven architects—Dombrovsky, Istselenov, Raikh, Rukhlyadev, Fidman, Krinsky, and Ladovsky. Selim Khan-Magomedov calls Sinskul'ptarkh the "first new association of avant-garde architects." He explains its emergence within the Sculpture Subsection of the Fine Art Department rather than the Architectural Art Department of the People's Commissariat of Enlightenment as being due to the fact that the latter department was headed by a well-known classicist, Zholtovsky, whose tenets many young architects rejected.[22]

Sinskul'ptarkh represented one of three main approaches to the problem of architecture in postrevolutionary Russia. First was that of the Planning Depart-ment for Cities and Habitation, established in May 1918 by a decree of the Council of People's Commissars. The purpose of this department was to address the housing problem and to rethink the planning of cities to make them more habitable, recognizing the requirement to meet basic needs before considering the problems of new forms.[23] Second was the approach of the classical architects, such as Zholtovsky and Fomin, who wanted to create postrevolutionary buildings and cities with the classical language they had employed before the Revolution; and third was the approach of the young avant-garde architects who joined Sinskul'p-tarkh because they sought a new architectural language to set their work apart from that of the older classicists.

Sinskul'ptarkh initially concentrated on problems related to the fusion of sculpture and architecture. At the end of 1919, two painters, Rodchenko and Shevchenko joined the group, and it was expanded into a larger organization called Zhivskul'ptarkh (Painting, Sculpture, and Architecture Synthesis).[24] The new group formed at a moment when there was little building in Russia, and its intent was to prepare for the time when architects could resume a more active role in Soviet life. Hence the artists and architects in Zhivskul'ptarkh concentrated on new formal languages rather than structural or planning problems. Zhivskul'ptarkh's emphasis was on single structures rather than town plans, and its concern was with the formal design of these structures.[25]

22 Selim Khan-Magomedov, *Pioneers of Soviet Architecture: The Search for New Solutions in the 1920s and 1930s* (New York: Rizzoli, 1987), 67.

23 See Anatol Kopp, *Town and Revolution: Soviet Architecture and City Planning, 1917–1935*, trans. Thomas E. Burton (New York: George Braziller, 1970), 36–37.

24 For a discussion of Zhivskul'ptarkh, see Kestutis Paul Zygas, *Form Follows Form: Source Imagery of Constructivist Architecture, 1917–1925* (Ann Arbor: UMI Research Press, 1981), 14–23; see also Khan-Magomedov, *Pioneers of Soviet Architecture*, 67–69. Developments in architectural theory and practice that grew out of Zhivskul'ptarkh and related protoarchitectural activities are discussed in Anatole Senkevitch, Jr., "Aspects of Spatial Form and Perceptual Psychology in the Doctrine of the Rationalist Movement in Soviet Architecture in the 1920s," *Via* 6 (1983): 79–115.

25 There is a significant difference between the formal emphasis of the Zhivskul'ptarkh projects, which were nonetheless done in the context of a discourse about what might be built, and the "paper architecture" projects of the 1980s which represented a withdrawal from the limitations of contemporary Soviet architecture into fantasy as a way of exercising the architectural imagination. See *Paper Architecture: New Projects from the Soviet Union*, ed. Heinrich Klotz, with an essay by Alexander G. Rappaport (New York: Rizzoli, 1988).

26 John Milner fails to recognize the primacy of Zhivskul'ptarkh's discursive role when he writes that "Rodchenko's scheme is as much a two-dimensional linear construction as a practical design for a building.

By its own definition, the purpose of Zhivskul'ptarkh was discursive, hence our reading of its projects need not hold them accountable for a lack of structural integrity.[26] There are nonetheless issues of interpretation that do relate to practical matters. I will concentrate on two projects of Rodchenko's: his kiosk designs of 1919, and his drawings for the House of Soviet Deputies (Sovdep) of 1920.[27] His designs for public information kiosks were among the earliest examples of this new building type in Russia and, as Selim Khan-Magomedov has pointed out, they influenced a series of later designs by others for architecture on a small scale.[28] Rodchenko conceived the kiosk as a dynamic information and publicity center that combined a number of separate functions. The drawing, entitled "The Future—Our Only Goal" (FIGURE 1.4), was one of three variants that garnered him a first prize, shared with the architect Krinsky, in a kiosk competition sponsored by the Fine Art Department. The kiosk had a large clock, a huge billboard positioned above the building, a speaker's rostrum, a screen for advertisements, a place for posters, and a space for the sale of books and newspapers. Each element was separate, but all were suspended from a central mast. The structure, in fact, was simply a means to contain the separate functions of disseminating information. Khan-Magomedov provides an enthusiastic evaluation of the kiosk based on its innovative formal language. He writes that the kiosk "was one of the earliest projects in which, on top of a total rejection of eclecticism and stylization, the aesthetico-formal researches of 'left-wing' painting were applied to a new architectural model."[29]

While historians have traditionally accepted the interpretation of Rodchenko's kiosks as formal experiments, the political implications of the projects have remained unexamined. We can identify a set of political assumptions in their design that suggest a subordinate relation of the Soviet citizen to state power. The prominent display of the clock emphasizes the social importance of precision and efficiency. The clock's prominence in the formal hierarchy of the kiosk also iterates the power of regulated intervals in framing personal action.[30] At the core of the project is the centralization of information and its transmit-

The scale was to be enormous. It was designed at a moment when scarcely any buildings at all were put up, consequently it was bound to remain untroubled by the practical problems of its execution." John Milner, *Russian Revolutionary Art* (London: Oresko Books, 1979), 50–51; Milner refers here to one of Rodchenko's drawings for the House of Soviet Deputies.

27 Rodchenko's larger body of work for Zhivskul'ptarkh has been well documented by Khan-Magomedov in *Rodchenko: The Complete Work*, 39–54. See also Alexander N. Lavrentiev, "Prototypen der Architektur in den Frühen Arbeiten Rodčenkos," in *Russisch-Sowjetische Architektur* (Stuttgart: Deutsche Verlags-Anstalt, 1991), 90–95.

28 Khan-Magomedov, *Rodchenko: The Complete Work*, 41. Variations of the kiosk type were designed by Alexandra Exter, Gustav Klutsis, Anton Lavinsky, and Alexei Gan. The type was further developed in the design of the Vesnin brothers' 1924 project for the *Pravda* building with its enormous screen on the facade.

29 Ibid., 40.

30 The emphasis on efficiency in Rodchenko's kiosks recalls the ideas of the Russian poet and labor theorist Alexei Gastev who espoused the introduction of Frederick Winslow Taylor's theories of "scientific management" to the Soviet Union. The purpose of Gastev's Central Labour Institute, founded in 1920, was to develop ways to make Soviet workers more productive. See Kendall E. Bailes, "Alexei Gastev and the Soviet Controversy over Taylorism," *Soviet Studies* 29, no. 3 (July 1977): 373–94.

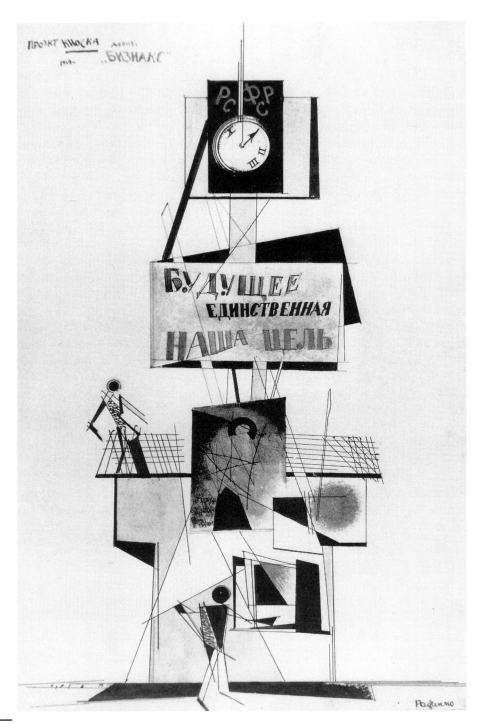

FIGURE 1.4
Rodchenko *"The Future—Our Only Goal,"* 1919

tal through public declamation. This intent is supported by the billboard with the slogan, "The Future—Our Only Goal," the speaker's rostrum, and the additional screen. The only exception is the kiosk for the sale of books or magazines at ground level where, presumably, publications that allowed for a more interactive engagement with information were to be sold.[31] The concentration of one-way information sources within the kiosk establishes a relation between the individual and the state in which decisions made by the state are primarily transmitted via impersonal media or an orator to citizens below. Rather than indicate an explicit philosophy of political power, however, the design suggests an implicit recognition within Zhivskul'ptarkh of centralized broadcasting and control as an essential mode of political communication and organization. Rodchenko's kiosk was geared to sophisticated urban masses who would assimilate information through a multitude of new media, but it lacked the accessibility for small-town folks and rural peasants that the simple stenciled wall newspapers designed by Vladimir Mayakovsky and others for the Russian Telegraph Agency (ROSTA) had.[32] We can emphasize the kiosk's distance from the actual means of communicating with the rural public at the time by comparing it with a poster by the artist Petrov encouraging the use of rural reading rooms (**FIGURE 1.5**). The poster, drawn in the style of Russian folk paintings or children's book illustrations, shows a Red Army soldier seated at a table reading aloud to a group of country people from a booklet that has most likely come from the central government. Clearly, Rodchenko's kiosk had little to do with engaging the peasantry in

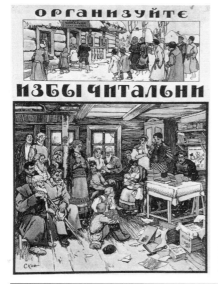

FIGURE 1.5
Petrov (Alexander Apsit)
"Fit out reading rooms," 1919

31 Variants of this kiosk had several different slogans, "Down with Imperialism" and "All Power to the Soviets." See Zygas, *Form Follows Form*, figs. 8 and 11.

32 For discussions of the ROSTA windows, see Stephen White, *The Bolshevik Poster* (New Haven: Yale University Press, 1988), 65–89, and Roberta Reeder, "The Interrelationship of Codes in Maiakovskii's ROSTA Posters," *Soviet Union* 7, parts 1–2 (1980): 28–41. Reeder addresses the question of how Mayakovsky created consistent and familiar visual devices to communicate with the populace.

terms of their own modes of communication or worldview. Whereas Petrov's poster shows information in the reading room being transmitted quietly by a man reading a book, Rodchenko's kiosk embodies much more powerful vehicles of persuasion, most of which conveyed information without a human being as intermediary. It suggests a public that would accept without question information about the goals and values of the Revolution in a form based on technology and efficiency. Even though Rodchenko's kiosk designs made no provision for radio broadcasting, they embodied various means for the one-way transmittal of information in visual and verbal forms that would characterize radio and television broadcasting in years to come.[33]

The dissemination of information was also central to Rodchenko's drawings for the House of Soviet Deputies, which included clocks and, in some variants, billboards (**FIGURE 1.6**). As Khan-Magomedov writes:

> All three variants show how the artist, evincing little interest in the spaces and facades of the lower part of the building, which he dealt with in a functional manner by laying out rooms on an orthogonal grid, concentrated all his attention on an original handling of the upper part, which rose above the whole city.[34]

For Khan-Magomedov, Rodchenko's project is a purely formal one. He reads the design as a structure of material components rather than as a narrative of power relations. Following the latter reading, we find in the drawings for the House of Soviet Deputies the preponderance of broadcasting, timekeeping, and signifying devices that tower above the places where the deputies work. Privilege is given to these devices rather than to human interaction. Although Rodchenko only made rough sketches of the building, these nonetheless describe a political relationship between the impersonality of the centralized communicative and regulating devices and the actions of people. As with the kiosk project, the drawings are more significant for their unexamined assumptions about power relations in the new regime than for any explicit argument about how political power should be used. We can compare them with the more explicit and critical assessment of centralized power and one-way communication that was made at the time by Yevgeny Zamyatin in his novel *We*, which was written in 1920 and several years later received its first publication abroad rather than in the Soviet Union. In the novel, Zamyatin was highly critical of bureaucracy and the impersonal central authority that regulated the lives of all citizens in the One State where activities were divided into modular time parcels and loudspeakers were used

33 For some members of the avant-garde, radio broadcasting was a powerful visual and poetic image. In 1919–20, Naum Gabo did an abstract design for a radio station whose lower part was adapted from the base of the Eiffel Tower while the upper part seemed to derive from diagrams of radio waves. In 1921, Velimir Khlebnikov wrote a brief prose piece called "The Radio of the Future," in which he prophesied that radio waves would be projected onto "dark pages of enormous books, higher than houses, that stand in the center of each town, slowly turning their own pages." Velomir Khlebnikov, "The Radio of the Future," in Velomir Khlebnikov, *The King of Time*, ed. Charlotte Douglas (Cambridge, MA: Harvard University Press, 1985), 155.

34 Khan-Magomedov, *Rodchenko: The Complete Work*, 49.

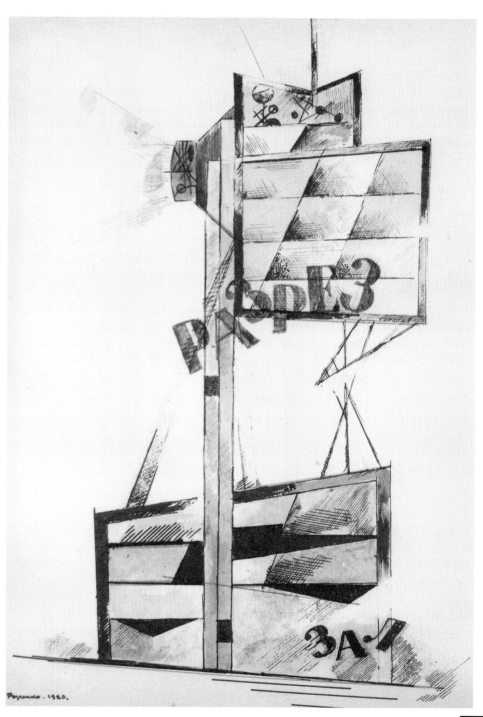

FIGURE 1.6
Rodchenko House of Soviet Deputies, 1920

to broadcast public announcements. For Zamyatin, the very model of communication that Rodchenko embodied in his kiosks and Sovdep drawings constituted a disturbing dystopia.

By contrast, Rodchenko, Ladovsky, and others in Zhivskul'ptarkh concerned themselves with the formal language of the structures they designed rather than with critical considerations of their use. Their projects were based on an unexamined faith in the political process itself as a context for the creative concern with how it should be represented in visual forms. While Rodchenko's emphasis on discipline and organization could lead at the macro level of social organization to political models of social control and one-way communication, at the level of individual objects, as we shall see in Chapter 3, the result was instead a spare design and structural toughness that spoke to individuals who would actively engage with the objects around them. This paradox of passive listeners and active users is indicative of Rodchenko's approach to the interpretation of objects. On the one hand, objects were material things with which to be engaged; on the other, they were metaphors for qualities of character. When character became a collective quality rather than a personal one, Rod-chenko's metaphoric construction could not account for the political implications of the relation between individuals and institutions which his building projects implied. When, on the other hand, the issue was how objects embodied desirable qualities of individual behavior, they functioned as powerful analogues for human identity.

3

Whereas Rodchenko believed that revolutionary consciousness could be represented in material objects such as kiosks, buildings, and furniture, El Lissitzky, whose idea of consciousness was transcendental rather than material, held the conviction that an object pointed to something beyond itself. This is to be seen particularly in his abstract paintings called *Prouns*, an acronym for the Russian words, "Proekt utverzhdeniia novogo" (Project for the Affirmation of the New), which he began to paint in 1919 while teaching at the Popular Art Institute in Vitebsk. Scholars have traditionally cited the *Prouns*, along with Lissitzky's children's tale *Of Two Squares*, as evidence of his utopianism in the early postrevolutionary years. What has not been sufficiently taken into account in the discussions of Lissitzky's utopian values, however, is the impact of his Jewish identity on his engagement with the Revolution. Attempts to address the question can only be speculative since there is scarcely any documentation on this theme, which has

35 Lissitzky-Küppers claims that Lissitzky's work on Jewish children's books in 1919 "was the end of his endeavours on behalf of his own national art. The little books were put away and later scarcely mentioned by Lissitzky." Lissitzky-Küppers, *El Lissitzky: Life, Letters, Texts*, 20. This statement, however, can be challenged by Lissitzky's subsequent involvement with a number of Jewish projects until 1923. Yve-Alain Bois accepts Lissitzky-Küppers's statement in order to support his own conviction that there is a rupture between Lissitzky's work as a Jewish artist (L1) and his *Prouns* (L2). See Bois, "El Lissitzky: Radical Reversibility," *Art in America* 76 (April 1988): 165. Counter to Bois, Judith Glatzer Wechsler makes a cogent argument for the continued influence of Lissitzky's Jewishness on selected avant-garde projects of his in the postrevolutionary

been little emphasized in recent scholarship on Lissitzky.[35] As a result, we have not had a full enough context for assessing the degree of Lissitzky's engagement with the Revolution and interpreting his art as evidence of it. Reflecting on Lissitzky's involvement with events that have not previously been brought into relation with his avant-garde production, however, may help to explain the difficulties scholars have had in construing his commitment to the Communist party as the engine of social change in Russia in the years just after the Revolution. Exploring this relation also may clarify more sharply than previously the differences between Lissitzky's and Rodchenko's situations as avant-garde artists.

Statements and actions by Lissitzky address both an engagement with and a detachment from politics in the Civil War years. He claimed to have designed a flag for the All-Union Central Executive Committee which was carried across Red Square on the first of May 1918.[36] And, while he was teaching at the Popular Art Institute in Vitebsk between 1919 and 1921, he also designed posters to support the return of workers to the factories and to urge the Red Army on to victory over the Whites. His writings of this period, however, give no indication of support for the Communists. At the end of his 1920 essay, "Suprematism in World Reconstruction," in fact, he envisions Suprematism surpassing communism as a beacon for the future. By contrast, there is the oft-cited statement of Lissitzky's about the Revolution, which is taken from an unpublished typescript of 1928:

> In Moscow in 1918 there flashed before my eyes the short-circuit which split the world in two. This single blow pushed the time we call the present like a wedge between yesterday and tomorrow. My efforts are now directed to driving the wedge deeper. One must belong to this side or that—there is no mid-way.[37]

This statement may be viewed in several ways. One way is to take it at face value and assume that Lissitzky was an unwavering supporter of the Revolution from its inception. Another is to consider the possibility that Lissitzky wrote this in 1928, after he had made a firm commitment to work for the regime, in order to consciously or unconsciously repress feelings of ambiguity about the Revolution that he may have had in the Civil War years. There is ample evidence that Jews and Jewish cultural endeavors in which Lissitzky was engaged in the years following the Revolution were harshly dealt with by the Bolsheviks, and this raises questions regarding how he might have felt about these actions. He did support the Bolshevik cause to a modest degree through the occasional production of propaganda material, but, recognizing the policy of the party to eliminate Jewish national identity, it is also feasible to consider that he may have been ambiguous about the Revolution, given its immediate impact on the Jewish community in Russia.

years. See her article "El Lissitzky's 'Interchange Stations': The Letter and the Spirit," in *The Jew in the Text: Modernity and the Construction of Identity*, ed. Linda Nochlin and Tamar Garb (London: Thames and Hudson, 1995), 187–200.

36 Peter Nisbet, *El Lissitzky 1890–1941*, exh. cat. (Cambridge, MA: Busch-Reisinger Museum, 1987), 15.

37 Lissitzky, "The Film of El's Life" (1928), in Lissitzky-Küppers, *El Lissitzky: Life, Letters, Texts*, 329.

To better understand how Lissitzky sought to negotiate his position as a Jew, a Bolshevik supporter, and an avant-garde artist at the time of the Revolution and in the years immediately following it, we must begin with some basic biographical data.[38] Lissitzky grew up in Vitebsk, which was located in the Pale of Settlement, the twenty-five provinces in the south and east of Russia to which most Russian Jews had been confined since 1791. Despite the common isolation of Jews in the Pale, there were many varieties of Jewishness, ranging from Orthodox religious convictions to a culturally and politically secular orientation. Lissitzky's father was a freethinker who knew German, English, and Yiddish, and translated European literature in his spare time. His mother was an Orthodox Jewess. Lissitzky studied art in Vitebsk with the notable Jewish artist Yehudah Pen, also a teacher of Marc Chagall.[39] He had hoped to prepare for a career in architecture at the prestigious St. Petersburg Academy of Art, but, like many other Jews who were not accepted at Russian universities and academies, he was refused admission because of the quota system maintained by the czar. He therefore followed a familiar route by going abroad to study. In Darmstadt, Germany, he obtained a degree in architectural engineering and returned to Russia at the outbreak of World War I. In the years before the Revolution he took an additional degree in architecture at the Riga Polytechnic Institute, which had evacuated to Moscow, and he worked for the Moscow architects Boris Velikovsky and Roman Klein.

Before the Revolution Lissitzky, with another Jewish artist Isaachar Ryback, undertook a mission for the Jewish Ethnographic Society to document the Jewish synagogues along the Dnieper River.[40] The two men visited approximately 200 wooden synagogues where they drew floor plans, copied wall paintings, and collected inscriptions.[41] For Lissitzky and other Jewish artists, the definition, documentation, and elaboration of specifically Jewish artifacts was a political act of some import, given the fact that the Jews in Russia were an oppressed culture struggling for self-identity. Lissitzky's and Ryback's expedition followed the czarist regime's July 1915 prohibition of all publications printed with Hebrew lettering because it viewed them as examples of Jewish disloyalty. This was also a time when numerous pogroms were conducted by Cossacks in the areas of Jewish settle-

38 The primary reference work on Lissitzky's life remains Sophie Lissitzky-Küppers, *El Lissitzky: Life, Letters, Texts*. See also Alan Birnholz, *El Lissitzky*, 2 vols. (Ph.D. dissertation, Yale University, 1973); Nisbet, *El Lissitzky 1890–1941*; and *El Lissitzky: Architect, Painter, Photographer, Typographer*, 1890–1941, exh. cat. (Eindhoven: Municipal Van Abbemuseum, 1990).

39 For a brief biography of Pen and images of his paintings, see Susan Tumarkin Goodman, ed., *Russian Jewish Artists in a Century of Change, 1890–1990* (Munich: Prestel, 1995), 210–11.

40 Scholars differ as to whether the expedition started in 1915 or 1916, due to Lissitzky's lack of specificity on this matter in an article he published about the Mohilev Synagogue in the Berlin-based Hebrew-Yiddish journal *Rimon/Milgroim* in 1923. See El Lissitzky, "The Mohilev Synagogue Reminiscences" (1923), in Nisbet, *El Lissitzky, 1890–1941*, 55–58.

41 The first expedition sponsored by the Jewish Ethnographic Society was undertaken in 1912 and collected, among other things, folk legends, songs, games, proverbs, and historical manuscripts. This material was to be housed in a Jewish museum planned by the society. The 1912 expedition and that of Lissitzky and Ryback's were part of a larger attempt to document and define a specifically Jewish culture in Russia. See Avram Kampf, *Jewish Experience in the Art of the Twentieth Century* (South Hadley, MA: Bergin and Garvey, 1984), 17–18. For an account of the Lissitzky-Ryback expedition, see Avram Kampf, "In Quest of the Jewish Style in the Era of the Russian Revolution," *Journal of Jewish Art* 5 (1978): 51–55.

ment. Pressure was mounting as well in the brief period between the outbreak of World War I and the 1917 Revolution for the Russian authorities to establish an official policy of attacking the Jews as traitors.[42] Given the official hostility to the Jews, it was critical to preserve a separate Jewish identity in order to resist either assimilation or annihilation. Yet it was also important to understand the evolution of that identity within a constantly changing world; hence the quest by many Russian Jewish artists, at least until the early 1920s, for an art that would draw on the most contemporary international trends while still maintaining a sense of Jewishness.[43]

Between his return to Russia in 1914 and the beginning of the Revolution, Lissitzky too shared this quest. Like other Jewish artists, such as Robert Falk, Nathan Altman, and Joseph Chaikov, Lissitzky took a keen interest in the avant-garde currents of Western art, which he kept distinct from his documentation of the Jewish synagogues. While Chagall made Jewish themes central to his paint-ings, artists such as Falk, who was one of the first followers of Cézanne in Russia, did not. In November 1916, Lissitzky exhibited at the fifth Jack of Diamonds exhibition as a Russian artist rather than a Jewish one. During this period, he was neither an assimilationist like the Futurist David Burliuk, for example, nor was he a Jewish nationalist. Similar to many other Jewish artists, he tried to main-tain a Jewish artistic identity while also taking an interest in the most current advances in the wider art world. As long as it was possible to incorporate elements of both there was no need to choose one over the other.

On March 20, 1917, shortly after the czar's abdication, the provisional govern-ment issued a decree establishing equality for Russians of all races and religions, thus making the Jews equal citizens.[44] It was against this hopeful background with its cause for optimism about Jewish self-determination that Lissitzky undertook his first Jewish book design, *Sikhes Kholin* (Small Talk), also called A Legend of Prague. The book was published in Moscow in the spring of 1917 in a limited edition of 110 copies; some were rolled up like Torah scrolls and placed in small wooden caskets. As Ruth Apter-Gabriel notes, Lissitzky was "creating an old-new book, fusing sources from the Jewish past with modern form."[45] With this project, which has been thoroughly discussed elsewhere,[46] Lissitzky began his work as

42 See H. H. Ben-Sasson, ed., *A History of the Jewish People* (Cambridge, MA: Harvard University Press, 1976), 888–89. The section on the modern period was written by S. Ettinger.

43 For a summary of the debate on "Jewish Art," extending back to the nineteenth century, see Avram Kampf, "In Quest of the Jewish Style in the Era of the Russian Revolution," 48–75; Seth L. Wolitz, "The Jewish National Art Renaissance in Russia," in *Tradition and Revolution: The Jewish Renaissance in Russian Avant-Garde Art*, 1912–1928, ed. Ruth Apter-Gabriel (Jerusalem: Israel Museum, 1987), 21–42; and Ziva Amishai-Maisels, "The Jewish Awakening: A Search for National Identity," in *Russian Jewish Artists in a Century of Change*, 1890–1990, ed. Goodman, 54–70.

44 Following the decree, all the organized Jewish parties in Russia began planning a Jewish Congress at which matters of national rights and self-determination would be discussed, but the Congress never met, due to the turmoil caused by the advance of the German armies and then the October Revolution.

45 Ruth Apter-Gabriel, "El Lissitzky's Jewish Works," in *Tradition and Revolution*, ed. Apter-Gabriel, 104.

46 See ibid., 104–5; and Birnholz, *El Lissitzky*, 20–25.

47 Lissitzky designated 1917–1920 as the years of his engagement with Jewish books. See "Autobiography by El Lissitzky" (June 1941) in *El Lissitzky* (Cologne: Galerie Gmurzynska, 1976), 88. The entry reads simply "1917–1920 Jewish books."

an illustrator of Jewish books which actively engaged him between 1917 and 1919 and occupied him occasionally for several years after that.[47]

Although the October Revolution promised to alleviate the harsh pogroms that were conducted against the Jews under Nicholas II, it was nonetheless greeted with a mixed response by various Jewish groups. The ultimate Bolshevik goal of folding all minority cultures into a single Communist society had been made quite clear by Lenin in a 1913 article, "Two Cultures in Every National Culture," which he wrote for the exile journal *Prosveshchenie* (Enlightenment). Designating the Jewish national culture as an obstacle to the formation of an international working-class movement, Lenin argued:

> Whoever, directly or indirectly, puts forward the slogan of Jewish "national culture" is (whatever his good intentions may be) an enemy of the proletariat, a supporter of all that is *outmoded* and connected with *caste* among the Jewish people; he is an accomplice of the rabbis and the bourgeoisie.[48]

Jews such as Trostky, Sverdlov, Zinoviev, Kamenev, and Radek were active in the higher ranks of the Bolshevik party, though most of the Jewish Bolsheviks like Trotsky considered themselves to be Russians only and many even imagined that Russian nationality would eventually give way altogether to some form of international culture.[49] After the Revolution, the Bolshevik policy was to minimize the separatist identities of the national minorities as much as possible. In January 1918, a Jewish Commissariat (Evkom) was established within the Communist Party to deal with the nationality question, and by that fall Jewish sections, generally referred to collectively as Evsektsiya, were created in many regional party organizations. A decree of June 1919 signed by Samuel Agursky, one of the leaders of the Evsektsiya, and Joseph Stalin, then commissar for nationalities, abolished all Jewish communal organizations; these were seen as enemies of the working class and the Revolution. Both the new government and the Evsektsiya were opposed to the practice of Judaism, and most synagogues were closed by decree, as was the museum founded by the Jewish Ethnographic Society. The Hebrew language was denounced by the Jewish Communists as counterrevolutionary, just as the czarist government had attacked its use during World War I. Yiddish culture had the advantage of being secular and nonthreatening on religious grounds, although it too was soon to be extinguished because of its association with a separate Jewish identity.[50]

48 Vladimir Ilich Lenin, "Two Cultures in Every National Culture," in *The Lenin Anthology*, ed. Tucker, 655.

49 Eventually the majority of Jewish party leaders were replaced by non-Jews, and most of the early Jewish leaders were killed by Stalin. Throughout the 1920s, Jewish membership in the Communist party declined from 5.2% in 1922 to 4.3% in 1927 and 3.8% in 1930. Salo Baron, *The Russian Jew under Tsars and Soviets*, 2d ed. (New York: Macmillan, 1964; and London: Collier Macmillan, 1976), 170–71.

50 The role of the Evsektsiya and the Communist attack on Jewish secular culture and religious life are described in Nora Levin, *The Jews in the Soviet Union since 1917, Volume 1, Paradox or Survival* (New York: New York University Press, 1988), 46–119. See also Baron, *The Russian Jew under Tsars and Soviets*; and Zvi Y. Gitelman, *Jewish Nationality and Soviet Politics: The Jewish Sections of the CPSU, 1917–1930* (Princeton: Princeton University Press, 1972).

Just months after the formation of the Evsektsiya, before it intensified its efforts to eradicate all traces of Jewish separatism, the Kultur Lige was founded in Kiev. Representing a range of Jewish nationalist and socialist tendencies, it supported the devlopment of a secular Jewish culture using Yiddish. According to a statement published by its central committee in November 1919, "The goal of the Kulturlige [sic] is to assist in creating a new Yiddish secular culture in the Yiddish language, in Jewish national forms, with the living forces of the broad Jewish masses, in the spirit of the working man and in harmony with their ideals of the future."[51] In 1920, however, the Kultur Lige came under attack by the Evsektsiya which took over its presses, cut off its paper supply, and disbanded its central committee. By the end of the year the Kultur Lige was officially dedicated to the Revolution and continued operation as a Communist organization.[52] Lissitzky was an active member of the Kultur Lige's art section which established studios and "art homes" for artists and their students, collected paintings and sculptures for an exhibition, and by November 1919 had published several graphic works—including *Had Gadya* (The Goat Kid), a retelling of the Passover story with ten lithographs by Lissitzky.[53] The style of the illustrations for this book (**FIGURE 1.7**), as well as other Yiddish children's books done by Lissitzky, primarily in 1918 and 1919, reveals modified aspects of Cubism, exemplifying the strategy of progressive Jewish artists in Russia to create an ethnic art that was also modern.[54] Up to 1919 the Kultur Lige's art section shared a commitment to fuse Jewish folk traditions with more contemporary concerns in order to pro-

FIGURE 1.7
Lissitzky *Had Gadya*, "One only kid," 1919

51 "*Kulturlige*, Summary Published by the Central Committee" (Kiev, November 1919), quoted in Kampf, *Jewish Experience in the Art of the Twentieth Century*, 206.

52 On the Kultur Lige, see Gitelman, *Jewish Nationality and Soviet Politics*, 274–76; and Wolitz, "The Jewish National Art Renaissance in Russia," in *Tradition and Revolution*, ed. Apter-Gabriel, 34–39.

53 In an attempt to fuse Lissitzky's involvement in Jewish projects with an enthusiasm for the Revolution, Birnholz reads *Had Gadya* as "a parable of the final, complete victory of the Revolution." Birnholz, *El Lissitzky*, 29. Such a reading ignores Lissitzky's possible negative response to concurrent Bolshevik efforts to suppress Jewish religious and cultural initiatives.

54 For an account of Lissitzky's illustrations for Jewish children's books, see Ruth Apter-Gabriel, "El Lissitzky's Jewish Works," in *Tradition and Revolution*, ed. Apter-Gabriel, 101–24.

duce a modern Jewish plastic art. There were subsequently divisions among some of the artists, particularly over the question of pure abstraction which, at least for Isaachar Ryback and Boris Aronson, could not "reveal living emotions."[55] Lissitzky, however, did not share this view.

Politically, Lissitzky's participation in the Jewish cultural movement through his involvement with the Kultur Lige and other Jewish publishers placed him in opposition to members of the Jewish Commissariat and the Evsektsiya who believed that Jews should be Communists first and nationalists second. His book illustrations were an assertion of minority cultural identity in the face of increasing Bolshevik attempts to suppress the culture of all nationalities in the Soviet Union.

4

In August 1918 Marc Chagall became the Art Commissar of Vitebsk, a position to which he was appointed by Anatoly Lunacharsky, head of the People's Commissariat of Enlightenment. Located within the Pale of Settlement, Vitebsk had a cultural milieu which consisted of many Jewish artists and intellectuals but was not composed of them exclusively. Chagall, whose position as a major Jewish artist had recently been confirmed by the publication of a book on his work, headed the Vitebsk Popular Art Institute, where he hoped to make students aware of avant-garde currents while simultaneously encouraging them to develop a modern Jewish style. Most of the teachers Chagall brought in were Jews. These included Robert Falk and Ivan Puni, as well as Lissitzky, who most likely arrived from Kiev in the spring of 1919 to direct the studios for printing, architecture, and graphic arts.[56] By July there were 600 students registered at the school.[57] Lissitzky may have had something to do with inviting Kazimir Malevich, the founder of the Suprematist movement, to come and teach there.[58]

When Malevich arrived in Vitebsk in September 1919, he already had the beginnings of a plan of activities and events to apply Suprematism in the social sphere. By early 1920, he gathered around him a group of faculty and students who established their own collective within the Popular Art Institute and called it UNOVIS, an acronym for *Utverditeli novogo iskusstva* (Affirmers of the New Art).[59] This caused a sharp split with Chagall and eventually led to Chagall's departure.

The UNOVIS group drew up new courses and started branches in several other cities. UNOVIS members applied Suprematist ideas in many variations from Nina Kogan's ballet—with its moving decors that formed a succession of

55 Isaachar Ryback and Boris Aronson, cited in Wolitz, "The Jewish National Art Renaissance in Russia," in *Tradition and Revolution*, ed. Apter-Gabriel, 35.

56 On Chagall's role at the Popular Art Institute, see Ziva Amishai-Maisels, "Chagall and the Jewish Revival: Center or Periphery?" in *Tradition and Revolution*, ed. Apter-Gabriel, 84–87. Vassily Rakitin, who, by contrast, does not emphasize the Jewish aspects of the Popular Art Institute, refers to those who gathered around Chagall as his "Talmudic Expressionist group." Vassily Rakitin, "Unovis," in *Building in the USSR 1917–1932*, ed. O. A. Shvidkovsky (New York: Praeger, 1971), 26.

57 John Bowlt, "Malevich and His Students," *Soviet Union* 5, part 2 (1978): 258.

58 According to John Bowlt, Vera Ermolaeva, then rector of the school, invited Malevich at Lissitzky's request. See John Bowlt, "Malevich and His Students," 258–59. In an earlier essay, Rakitin says simply that Ermolaeva asked Malevich to come but makes no mention of Lissitzky's participation in the decision. See Rakitin, "Unovis," *Building in the USSR, 1917–1932*, ed. Shvidkovsky, 26.

geometric shapes culminating in the square—to the decoration of trams and the creation of massive outdoor decorations to celebrate the anniversary of the Revolution. The interest in applying Suprematist forms to public walls, theater curtains, teacups and saucers, speakers' rostrums, and textiles, wallpaper, and book covers gave evidence of the UNOVIS group's concern in Vitebsk with extending Malevich's influence to the social world. Lissitzky and Malevich undertook projects for the decoration of rostrums, theater curtains, book covers, and other objects, though few of these, notably several of Lissitzky's posters, were taken beyond the maquette stage and could be considered real propaganda work.

The bearing that Lissitzky's affiliation with UNOVIS had on his self-definition as a Jewish artist is open to several interpretations. One is to consider Lissitzky's attraction to UNOVIS as a sign that his involvement with Jewish art had ended and that Suprematism offered a new and more promising path. This interpretation allows for the marginalization or suppression of Lissitzky's response to the Bolshevik actions against the Jews, which might have made him ambivalent about embracing the Revolution wholeheartedly. By not foregrounding the possibility of Lissitzky's ambivalence toward the Revolution, it also supports a reading of his *Prouns* as signs for a social utopia that the Revolution would bring about, and it suggests an interpretation of his book *Of Two Squares* as a political parable. There is, however, another way to think about Lissitzky's work while a member of UNOVIS that neither severs the ties entirely with his Jewish period nor links the work too closely to his Jewish book illustrations. As scholars of the Jewish Renaissance in Russia have shown, many Jewish artists sought to incorporate currents from Western avant-garde art practice into their work.[60] We can postulate that Lissitzky's attraction to Suprematism did not signify a rejection of his Jewish identity, and his interest in it had numerous precedents among Jewish artists who were drawn to related avant-garde movements. Lissitzky's affiliation with Malevich rather than Chagall need not be seen as a choice between Jewish and Russian art. We can also read it as a different way of being a Jewish artist. Many, if not most of the young students and faculty who joined UNOVIS— Nina Kogan, Ilya Chashnik, Lev Iudin, and Lazar Khidekel among them—were also Jewish although, unlike Lissitzky, they had not been active previously in Jewish artistic circles. By 1920, opportunities for Jewish artists to participate in publishing projects was diminishing as the government and the Party began to clamp down on the Kultur Lige and other Jewish cultural organizations. Hence

59 On UNOVIS, see Bowlt, "Malevich and His Students," 256–86; also Rakitin, "Unovis," in *Building in the USSR, 1917–1932,* ed. Shvidkovsky, 26–30; *The Suprematist Straight Line: Malevich, Suetin, Chashnik, Lissitzky,* exh. cat. (London: Annely Juda Fine Art, 1977); and Sarah Bodine, "UNOVIS: Art as Process," in *Ilya Grigorevich Chashnik* (New York: Leonard Hutton Galleries, 1979), 26–31. The most thorough documentation of Malevich's activities in Vitebsk, including photographs of many UNOVIS projects, is in Larissa Zhadowa, *Malevich: Suprematism and Revolution in Russian Art 1910–1930* (London: Thames and Hudson, 1982 [c. 1978]).

60 See Avram Kampf, "In Quest of the Jewish Style in the Era of the Russian Revolution," 48–75, Igor Golomstok, "Jews in Soviet Art," in *Jews in Soviet Culture,* ed. Jack Miller (New Brunswick, NJ: Transaction Books, 1984), 23–64; Wolitz, "The Jewish National Art Renaissance in Russia," in *Tradition and Revolution,* ed. Apter-Gabriel, 21–42; and Bowlt, "From the Pale of Settlement to the Reconstruction of the World," in *Tradition and Revolution,* 43–60.

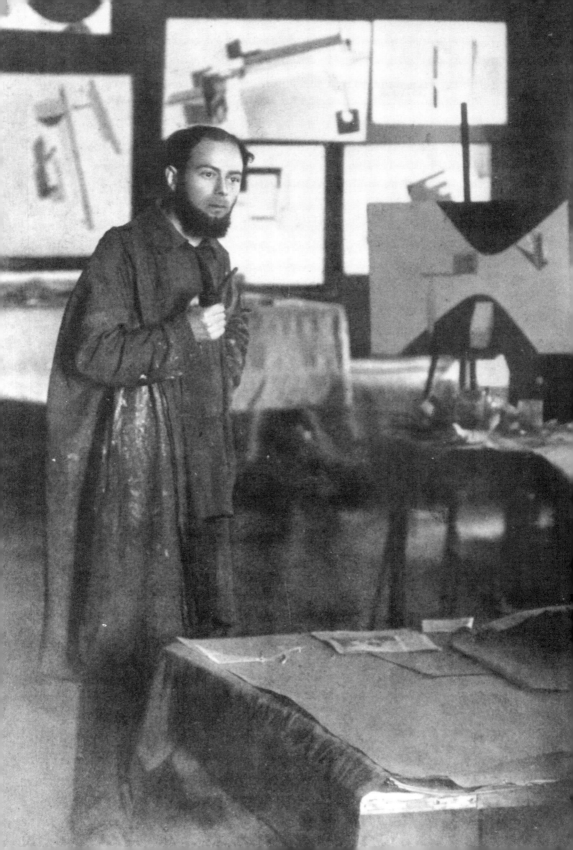

Lissitzky could not continue as actively with the book illustration projects that had engaged him in 1918 and 1919.

But he still maintained his connections to the Kultur Lige while a member of UNOVIS. He was one of eleven participants, along with Chaikov, Aronson, Tyshler, and others, in the first and last Jewish art exhibition that the Kultur Lige sponsored in Kiev between February and April 1920. Because of Kiev's isolation due to the Civil War, it is probable that his earlier work, rather than his *Prouns*, was exhibited. The point, however, is not to assert a Jewish context for the *Prouns* but to recognize that Lissitzky still defined himself as a Jewish artist during this period rather than as an assimilationist.

What is at stake in this argument is the weight we give to the effect that political acts, which were being carried out to suppress Jewish cultural autonomy, had on Lissitzky's art. When he began to work on the paintings that were eventually to be called *Prouns* in the autumn of 1919 at the time that Malevich arrived in Vitebsk, the Kultur Lige and other Jewish cultural organizations were at the peak of their activity (**FIGURE 1.8**). Malevich, however, was clearly the impetus for Lissitzky's new direction. Not only did Lissitzky print two of Malevich's books, *O Novykh Sistemakh v Iskusstve (On New Systems in Art)* in 1919 and *Suprematizm: 34 Risunke (Suprematism: 34 Drawings)* in 1920, but he also adopted some of Malevich's messianic rhetoric for his own manifestos. Yet, the spatial and formal complexity of Lissitzky's *Prouns* was a major departure from Malevich's simpler form language.[61] Lissitzky's handling of space and multiple perspectives gives evidence of his training in architecture, a formation that Malevich lacked. At the same time, Lissitzky had learned a great deal from Malevich about the visual represen-

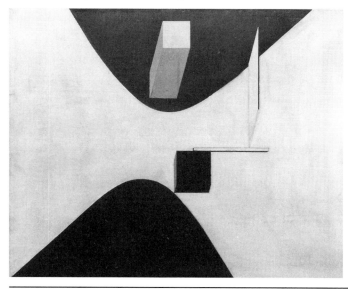

FIGURE 1.8 (p. 30)
Lissitzky in his Vitebsk studio, 1919

FIGURE 1.9
Lissitzky *Proun 23 no. 6, 1919*

61 Peter Nisbet notes that Lissitzky did not use the term *Proun* until late 1920 or early 1921. Nisbet, *El Lissitzky, 1890–1941*, 20.

tation of space and time. In Malevich's 1915 essay, "From Cubism and Futurism to Suprematism," the older artist had posed a new basis for artistic construction, "not on the interrelation of form and colour, and not on the esthetic basis of beauty in composition, *but on the basis of weight, speed and the direction of movement.*"[62] This shift of definition derived from Malevich's interest in time as the "fourth dimension" of representation and was essential to Lissitzky's move beyond the stasis of the picture surface to depict spaces that could only be experienced fully through motion.[63] The viewer has to move in and around the *Proun*, a process that reveals multiple axes. The relation of these to motion was expressed by Lissitzky in his article "PROUN: Not World Visions, But—World Reality":

> We have set the Proun in motion and so we obtain a number of axes of projection; we stand between them and push them apart.[64]

A number of the *Prouns* have neither top nor bottom, and the formal relationships change each time they are tilted. In *Proun 23 no. 6* (1919) (**FIGURE 1.9**), upward thrusts become downward ones and stable vertical forms observed from an aerial perspective appear to move horizontally in space when the viewer's position changes. In effect, such paintings are not experienced in a single moment but through changing perspectives, the "fourth dimension" of time Malevich had spoken about but did not activate as Lissitzky did.

The concept of visual economy, first articulated in the *Prouns*, was central to all of Lissitzky's work. "Proun is the creation of form (control of space) by means of the economic construction of material to which a new value is assigned," he wrote.[65] To achieve this economy he tried to reduce pictorial construction to a set of basic elements that would be universally comprehensible.[66] The stress on such elements derived from Lissitzky's intention to represent a force that went beyond personality or nationality. According to him, it was this force, "a kind of lunatic force from which all will retreat in shame," that would shape the new world.[67]

Though Lissitzky refused to link the *Prouns* to utilitarian designs, he was nonetheless more interested in Vladimir Tatlin's definition of color as an expression

62 Kazimir Malevich, "From Cubism and Futurism to Suprematism," in K. S. Malevich, *Essays on Art 1915–1928*, vol. 1, ed. Troels Andersen (Copenhagen: Borgen, 1971), 24.

63 On Lissitzky and the "fourth dimension" see Linda Dalrymple Henderson, *The Fourth Dimension and Non-Euclidean Geometry in Modern Art* (Princeton: Princeton University Press, 1983), 294–99.

64 Lissitzky, "PROUN: Not World Visions, BUT—World Reality," in Lissitzky-Küppers, *El Lissitzky: Life, Letters, Texts*, 347. This essay was published in *De Stijl* 5, no. 6 (June 1922). However, in *De Stijl* the subtitle, in bold letters, is separated from the title and begins the article in a new column.

65 Ibid.

66 At the Congress of International Progressive Artists in Düsseldorf, May 29–31, 1922, Lissitzky and other members of the International Faction of Constructivists called for a "systematization of the means of expression." Lissitzky refined this idea in "Element and Invention," an article he wrote for the Swiss architectural journal *ABC* in 1924: "In this way we possess a series of elements of design, which must be organized into a classified list, like the table of chemical elements . . . However, a mere loose combination of the elements can at best produce aesthetic stimuli . . . It depends far more on the manner of combining them." See "Element and Invention," in Lissitzky-Küppers, *El Lissitzky: Life, Letters, Texts*, 350.

67 El Lissitzky, "Proun" (1920–21), in *El Lissitzky*, 71. This text precedes the article on *Prouns* that was published in *De Stijl*. It is also lengthier. According to its translator John Bowlt, it was written in Vitebsk and Moscow in 1920–21, and was probably the basis for Lissitzky's lecture at INKhUK on September 23, 1921, before he left for Germany.

68 Lissitzky, "Proun," 68.

of material than in Malevich's equation of it with physical sensation. The colors of the planes in the *Prouns* create properties of volume, transparency, and opacity. By appearing to advance or recede, they also define a distance between the form and the viewer. About Malevich's use of color, Lissitzky wrote that it was at the point when "Suprematism cleansed itself of the individualism of green, orange, and violet tones and advanced towards black and white," that "we saw the purity of a collective force."[68]

Attributing great powers of organization to the *Proun*, Lissitzky wrote, "Emptiness, chaos, the unnatural, become space, that is: order, certainty, plastic form, when we introduce markers of a special kind in a specific relationship to each other."[69] The "balance between the tensions of the forces of the individual parts"[70] to which he referred is a metaphoric resolution of the dialectic Lissitzky later came to attribute to the flow of life in general.[71]

The *Proun* was a new kind of painting that could more actively engage the viewer because it denied a fixed perspective and embodied a strong orderly arrangement of elements. Despite his debt to Suprematism, Lissitzky critiqued Malevich's paintings for failing to achieve this engagement:

> For all its revolutionary force, the Suprematist canvas remained in the form of a picture. Like any canvas in a museum, it possessed one specific perpendicular axis (vis-à-vis the horizontal), and when it was hung any other way it looked as if it were sideways or upside down.[72]

This critique of Malevich reinforces Lissitzky's argument that the *Proun* was more than a painting; it was "the station on the road towards constructing a new form."[73] The viewer was not supposed to admire the *Proun*, or even extract information from it, but instead was to be moved by it. "Proun's power is to create aims," he wrote. "This is the artist's freedom, denied to the scientist."[74]

Whereas Rodchenko's drawings for kiosks and buildings were grounded in a concept of utility, Lissitzky's forms were not. Lissitzky disparaged the Productivist argument that "primitive utilitarianism," as he called it, was the most important aim of the artist, declaring that

> [w]e must take note of the fact that the artist nowadays is occupied with painting flags posters pots and pans textiles and things like that.

69 Lissitzky, "PROUN: Not World Visions, BUT—World Reality," 347.

70 Ibid.

71 See Lissitzky, "Ideological Superstructure," in Lissitzky-Küppers, *El Lissitzky: Life, Letters, Texts*, 375–77.

72 Lissitzky, "Proun," 65.

73 Ibid., 60. When Lissitzky and Hans Arp published *Die Kunstismen* (The Isms of Art) in 1925, they defined the *Proun* as "the transfer point from painting to architecture" (my translation). See El Lissitzky and Hans Arp, *Die Kunstismen* (Erlenbach-Zürich: München, and Leipzig: Eugen Rentsch Verlag, 1925), xi.

74 Lissitzky, "PROUN: Not World Visions, BUT—World Reality," 348.

75 Lissitzky, "Suprematism in World Reconstruction" (1920), 331. Lissitzky's disparagment of applied art is in marked contrast to the 1920 manifesto signed by Vladimir Tatlin and those who helped him build his Monument to the Third International. They called for "models which stimulate us to inventions in our work of creating a new world." These models, rather than serving as markers on the path to a future world of perfect order, were to "call upon producers to exercise control over the forms encountered in our new everyday life." See Vladimir Tatlin, T. Shapiro, I. Myerson, and Pavel Vinogradov, "The Work Ahead of Us" (1920), in *The Tradition of Constructivism*, ed. and with intro. Stephen Bann (New York: Viking Press, 1974 [The Documents of 20th-Century Art]), 11–14.

What is referred to as "artistic work" has on the vast majority of occasions nothing to do with creative effort.[75]

Instead, Lissitzky espoused a belief in the power of objects to direct human action. It was through this faith that he endowed the *Prouns*, which were abstract representations of form relations in space, with the capacity to represent utopian values. In more than one instance, Lissitzky compared the creation of forms to the natural process of evolution, suggesting thereby the attainment of a higher order of being. Making art was a way of following "the revolutionary path along which the whole of creation is striding forward and along which man must also bend his steps."[76]

The *Prouns* have more to do with the experience of perception than with the representation of a subject. Unlike the artists and architects in Zhivskul'ptarkh, Lissitzky felt that the *Prouns* could shape values about the built environment without literally depicting buildings as such. In "Suprematism in World Reconstruction," he expressed his interest in the town rather than the individual building:

> . . . because we are capable of grasping the idea of a whole town at any moment with any plan the task of architecture—the rhythmic arrangement of space and time—is perfectly and simply fulfilled for the new town will not be as chaotically laid out as the modern towns of north and south america but clearly and logically like a beehive. [T]he new element of treatment which we have brought to the fore in our painting will be applied to the whole of this still-to-be-built world

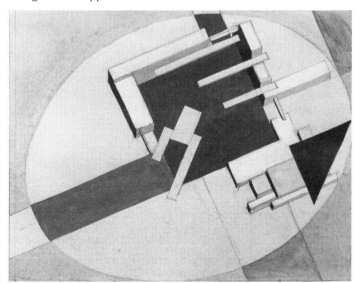

FIGURE 1.10
Lissitzky sketch for *Proun 1E, The Town*, 1919–20

76 Lissitzky, "Suprematism in World Reconstruction," 331.

77 Ibid., 332. Lissitzky's optimistic reading of metal and glass as materials to signify the new life can be compared with Zamyatin's dystopic account in *We* of the One State that is built from those same materials.

and will transform the roughness of concrete the smoothness of metal and the reflection of glass into the outer membrane of the new life.[77]

As Peter Nisbet has pointed out, Lissitzky gave some of the *Prouns* names that made specific references to architecture or building: *The Town, Bridge, Arch,* and even *Moscow*.[78] The shapes in these paintings with architectural titles, however, are part of a formal vocabulary that Lissitzky also used in other *Prouns* which made no reference to architecture. This leads us to consider the *Prouns* as highly abstract compositions anchored in a space that cannot, however, be consistently read as architectural. *Proun 1E, The Town* (1919–1921) (**FIGURE 1.10**), for example, is perhaps closest to the model of a town plan. Rectangular shapes are clustered around a black square, which is then set on a circular shape into which diagonal lines are directed. Lissitzky adopts an axonometric perspective that leads to a possible reading of the volumes as buildings, but that level of referentiality disappears as we move to other parts of the image which read more as parts of an abstract visual composition. In another example, *Proun 1A, Bridge I* (1919–1920) (**FIGURE 1.11**), Lissitzky placed the dominant bridge shape above a curved blue field which is both next to it and distant from it. The eye shifts back and forth, searching for a position to define the point of view, only to find that there is more than one. Lissitzky speaks of the *Prouns* dialectically as being neither one thing or another; first they are markers on the path toward constructing new forms, and later they become objects that occupy a position between painting and architecture. This conceptual location suggests a read-

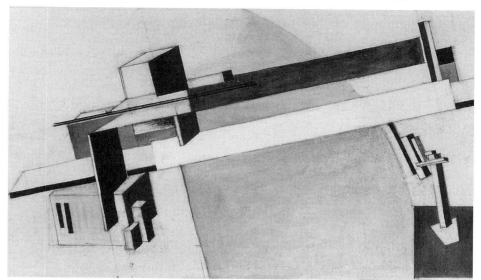

FIGURE 1.11
Lissitzky sketch for *Proun 1A, Bridge I*, 1919–20

78 Nisbet, *El Lissitzky, 1890–1941*, 20.

ing of the *Prouns* as metaphors of organization and order rather than models of specific structures that might be built.

A dialectical reading of the *Prouns* is consistent with Lissitzky's own situation at the time as a Jewish artist positioned between the particularism of a Jewish identity rooted in a specific verbal and visual culture and the universalism of a sensibility that was drawn both to advanced avant-garde art, as represented by Suprematism, and to a future world of order and harmony. Reconsidering Lissitzky's Jewish identity as a contributing factor to his thinking about the *Prouns* may help to explain why the paintings do not more clearly indicate a relation to the Revolution. They operate at a level neither purely nonobjective nor purely representational. Lissitzky makes references to architecture but does not let us interpret the *Prouns* simply as models for buildings. He does reference them to the future, but he doesn't tie that future to the Revolution. In fact, he states that Suprematism will supercede Communism just as a new testament supplanted the old.

The question then becomes how Suprematism will make the world into a "true model of perfection."[79] Lissitzky suggests that it will have a spiritualizing effect, by attracting people "away from the domination of work and from the domination of the intoxicated senses."[80] He is noncommittal about what the new world will be like except to suggest that humans will function on a higher plane than they presently do. One can only imagine Suprematism bringing this state of being about through an art that would possess a transformative power. This is consistent with Lissitzky's endowment of the *Prouns* with the power to create aims, to represent models of clarity and order that might enable a viewer to help bring about a similar condition in the world itself.

In 1919 and 1920 Lissitzky had every reason to defer the arrival of utopia to some point in the future. While he was clearly influenced by Malevich and his ideas and participated actively in promulgating them, it is also possible that the abstract philosophy and visual system of Malevich provided Lissitzky with a vehicle to project a better world for the future without having to rely on the Bolshevik revolution as the only way that this might come about. The vagueness of Lissitzky's utopian projections thus can be understood as a reluctance to define a position toward the Revolution. The moment of UNOVIS is for Lissitzky a

79 Lissitzky, "Suprematism in World Reconstruction," 334.

80 Ibid.

81 Although Lissitzky created *Of Two Squares* in 1920, it was not published until 1922 in Berlin. See the facsimile edition and the accompanying essay "More about Two Squares" by Patricia Railing (Forest Row: Artists Bookworks, 1990). See also Yves-Alain Bois, "El Lissitzky: Reading Lessons," *October* 11 (Winter 1979): 113–28.

82 For a discussion of Futurist book design, see the following: Vladimir Markov, *Russian Futurism: A History* (Berkeley and Los Angeles: University of California Press, 1968); Susan Compton, *The World Backwards: Russian Futurist Books, 1912–1916* (London: British Museum Publications, 1978); Arthur A. Cohen, "Futurism and Constructivism: Russian and Other," *Print Collector's Newsletter* 7, no. 1 (March–April 1976): 2–4; Gail Harrison Roman, "The Ins and Outs of Russian Avant-Garde Books in Russia, 1910–1932," in *The Avant-Garde in Russia, 1910–1930: New Perspectives*, ed. Barron and Tuchman, 102–9; and John Bowlt, "A Slap in the Face of Public Taste: The Art of the Book and the Russian Avant-Garde," in *Russian Samizdat Art*, ed. Charles Doria (New York: Willis Locker and Owens, 1986), 9–38.

moment to hold open options, to wait and see, and to avoid a full commitment to a process that was responsible for supppressing parts of his own identity. The *Prouns* thus became a means for Lissitzky to work through his ambivalence toward the future by creating metaphorical models of formal order that were still consistent with the possibilities for a Jewish art as some of his compatriots defined them. They also enabled him as an architect to participate productively in a metaphorical activity of construction.

5

Lissitzky's children's tale, *Of Two Squares*, which he wrote and designed in 1920, was radically different in form and purpose from the heavily decorated volumes admired by the *Mir Iskusstva* (World of Art) artists at the turn of the century, such as Alexander Benois.[81] It was equally dissimilar to the cheap handmade books published by the Russian Futurists before the Revolution.[82] Though the Futurist books were a welcome antidote to the expensive limited editions of the time, they did not radically change the relation of the reader to the book format itself as Lissitzky proposed to do with *Of Two Squares*. To understand Lissitzky's idealistic conception of the book as a vehicle for social change, we must recognize the central place of the book, particularly the Torah, in the Jewish tradition. For the Jews, the Torah is a source of wisdom and a guide to action. Certainly

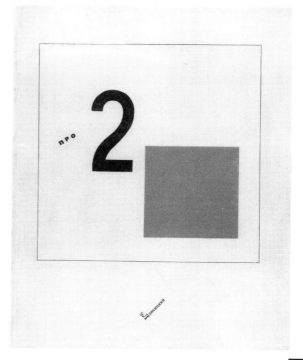

FIGURE 1.12
Lissitzky *Of Two Squares*, cover, 1920–22

Lissitzky's children's book was intended to direct the reader to act. Like the Torah, *Of Two Squares* propagated an all-encompassing ideal; in the latter case it was the construction of a new world. The book's design combined the Jewish passion for moral improvement with Lissitzky's hope that art could play a prophetic role in bringing this about.

Of Two Squares, which Lissitzky called "a Suprematist tale," is a narrative sequence of six images or "constructions," as Lissitzky called them. They tell the story of a black square and of a red square that come to earth from afar and witness a storm where everything flies apart. After the storm, a three-dimensional structure is implanted on the black square and is covered by the red square. The black square withdraws but does not disappear completely. The space in the images changes from a flat surface in the first to the polydirectional deep space of the second, the chaotic explosion of elements in the third and fourth, and the return to a surface seen from above in the last two. A 1915 painting by Malevich, *Pictorial Realism of a Boy with a Knapsack: Color Masses in the Fourth Dimension*, is a precedent for the red and black squares, but the multiple perspectives, flat and deep space, two- and three-dimensional shapes, and strong diagonal axes in the "constructions" themselves relate more closely to Lissitzky's *Prouns*.

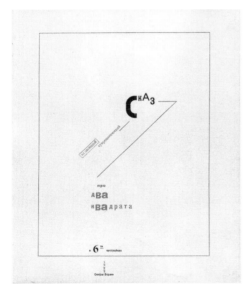

FIGURE 1.13
Lissitzky *Of Two Squares*, title page, 1920–22

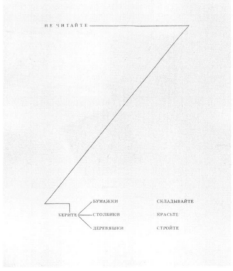

FIGURE 1.14
Lissitzky "Don't read. Take paper, rods, blocks. Set them out, color, build," *Of Two Squares*, 1920–22

Of Two Squares demonstrates a new mode of reading based on a different graphic syntax from that of the traditional book with its lines of horizontal text and ancillary illustrations. Lissitzky's bold typographic layout with its mix of type sizes and weights and its diagonal settings parallels the visual elements and moves the reader rapidly along to the end. One of his objectives was to quicken the absorption of information by eliminating visual redundancy; hence, he frequently used a common letter in several words. Another way of achieving formal unity was to mix verbal and visual signs which he did in his cover design where he formed the book title, *Of Two Squares*, from the Russian word "pro," the number "2," and a red square (**FIGURE 1.12**). With this cover, Lissitzky made clear his intention to create a text with an expanded vocabulary of signs that demanded of the reader a heightened visual literacy.

The basis for Lissitzky's new syntax was the diagram, whose elements he could combine in various gestalt relationships for efficient reading. A good example is the title page (**FIGURE 1.13**) where he changed diagonal lines into force vectors that move the eye from one cluster of words to another. In a letter of September 12, 1919, to Malevich, Lissitzky drew a parallel between the concentration of thoughts in the mind and word clusters on a page.

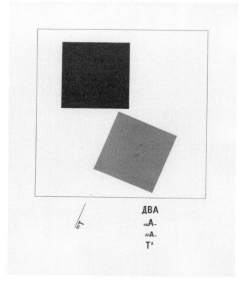

FIGURE 1.15
Lissitzky "Here are two squares,"
Of Two Squares, 1920–22

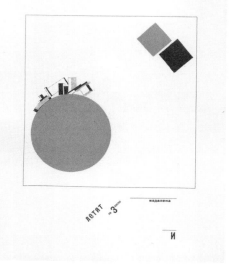

FIGURE 1.16
Lissitzky "They fly to earth from afar,"
Of Two Squares, 1920–22

> The letters and punctuation marks, which impose order on the
> thoughts, must be included in our calculations; the way the lines are
> set out can lead to particular concentrations of thought, they must
> be concentrated for the benefit of the eye too.[83]

He acted on this intention in his instructions to the reader (**FIGURE 1.14**) on the
back of the title page which were diagrammed as one would a sentence. From
the phrase "Don't read," a line extends horizontally and then angles diagonally
downward to the word "Take," from which extend three short lines that con-
nect the words "paper, rods, blocks" to the rest of the phrase. To the right of this
cluster is the phrase, "Set them out, color, build," which exhort the reader to act.
With great economy, Lissitzky presented a set of directions articulated by group-
ings and placement of words in a way that clearly indicated their importance
in the statement.

Of Two Squares was Lissitzky's first demonstration of the "simultaneous" book
of the future that would accommodate both the space and time dimensions of
the word—its image and sound—and would forge the two into a new unity. This
would lead as a next step to the film, and there is evidence that filmic ideas were
important in his thinking about a new kind of book.[84] Lissitzky's ambition to

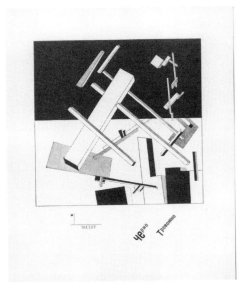

FIGURE 1.17
Lissitzky "And see black. Alarming,"
Of Two Squares, 1920–22

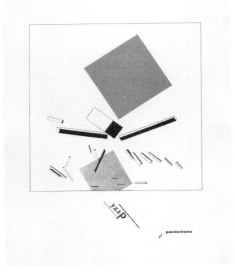

FIGURE 1.18
Lissitzky "Crash. Everything scatters,"
Of Two Squares, 1920–22

83 El Lissitzky, quoted in N. K. Khardzhiev, "El Lissitzky, Book Designer," in Lissitzky-Küppers, *El Lissitzky: Life, Letters*, Texts, 384.

84 Lissitzky heard about the Swede Viking Eggeling's experiments with abstract film in 1920 from a young German visiting Russia, and he may have had these in mind when he designed *Of Two Squares*. "While speaking to me of Einstein and Spengler, he spoke to me about Eggeling, whom he had met during the brief existence of the Bayrischen Räterepublik. Eggeling told him that he had discovered the 'absolute' film, that he was still working on it and hoped to get support for his work from the Russians." El Lissitzky, "Viking Eggeling," in El Lissitzky, *Proun und Wolkenbügel: Schriften, Briefe, Dokumente*, ed. Sophie Lissitzky-Küppers and Jen Lissitzky (Dresden: VEB Verlag der Kunst, 1977), 205 (my translation). Lissitzky met Eggeling

create a more dynamic book form was appropriate to the messianic quality with which he infused *Of Two Squares*. He provided no simple key, however, for an exegesis of the text and, in fact, even confounded the possibility of a singular interpretation through changing the shapes and scale relationships of the two squares. One certain element is the identification of the red square at the end of the story as a sign for UNOVIS. But the black square can also be identified with Malevich's group. John Bowlt writes that members of the group sewed small black squares to their clothing.[85] Given the various contexts in which the red and black squares were used by Malevich and the UNOVIS group between 1915 and 1920, we find no clear support for giving a value to either the red or black square on the basis of color alone. This difficulty is compounded by the choice of red to represent the earth before everything flies apart, black for the storm, and then black for the new ground on which the red structure is built (**FIGURES 1.15-1.20**).

The shifts in the scale of the squares also makes a simple political reading problematic. In the first "construction" (**FIGURE 1.15**) both the red and black squares are equal in scale and fill the entire image. In the second "construction" (see **FIGURE 1.16**) as they move toward earth (a movement indicated only by

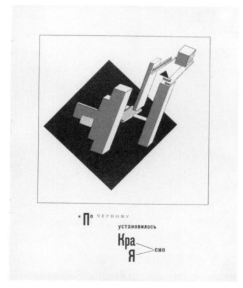

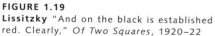

FIGURE 1.19
Lissitzky "And on the black is established red. Clearly," *Of Two Squares*, 1920–22

FIGURE 1.20
Lissitzky "Here it ends. Further," *Of Two Squares*, 1920–22

in Berlin in 1922. In "Topography of Typography," published in *Merz* 4 (July 1923), Lissitzky refers to "the continuous page sequence—the bioscopic book." N. Khardzhiev states, "Like Eggeling, Lissitzky hoped to solve the problem of the representation of movement in the visual arts with the help of the cine-camera." "El Lissitzky, Book Designer," 384–85.

85 John Bowlt, "Malevich and His Students," 259. Extracting the meaning of the red and black squares is further complicated by Malevich's statement in the introduction to his 1920 book *Suprematism: 34 Drawings:* "In its historical development Suprematism has gone through three states: black, colored and white." Cited in Milka Bliznakov, "Suprematism in Architecture," *Soviet Union* 5, part 2 (1978): 245.

Lissitzky's accompanying text), they maintain parity of scale in relation to a much larger circle which represents the earth. The red square then becomes bigger than the black as the storm continues (**FIGURE 1.17**); there is a crash (**FIGURE 1.18**), and then a small cube with one red side tops the structure which sits on a large black square (see **FIGURE 1.19**). In the final "construction" (**FIGURE 1.20**) the black square is changed to a much smaller circle, a large red square covers the three-dimensional structure, and a smaller black square hovers at the edge of the image frame in the position where we saw it flying toward the earth. Neither text nor images indicate that the black square is flying off nor is its relationship to the red made clear.

Spatially, both the black and red squares come from beyond the earth. They witness a storm that is not of their own doing, and then, following the storm, they assume their respective relationships to the remains. The black square becomes the support for a new form of construction which is red. Both colors are thus working together to bring about something new, even though the red is planted on the black. Given the complimentary relation of the red and black squares, their arrival from beyond the earth, and their removal from the storm and its causes, a political reading whereby the red square represents the Bolsheviks is highly unlikely. It is possible that both the red and black squares represent aspects of Suprematism, but Lissitzky does not say this. Perhaps he simply wants to assert that a new order is coming while leaving the reader in doubt as to the specific vehicles for bringing it about. This would be consistent with my argument that the ambiguity of the *Prouns* is intentional. What is perhaps more significant about *Of Two Squares* than its exegesis, however, is the relation to the reader that Lissitzky establishes. At the end of the story, he shifts to a form of direct address and exhorts the reader, supposedly a child, to go out and build something. As a utopian object, *Of Two Squares* is more meaningful as an intended *instrument* of change than as a political parable to be hermeneutically decoded.

6

Although Rodchenko's and Lissitzky's utopian projects can be differentiated according to Turowski's distinction as materialist or idealist, they nonetheless fulfilled a common function. To quote H. J. N. Hornsburgh:

> But there is another and still more fundamental role which the utopian is called upon to fill, namely, that of introducing new values into the life of the community . . . Only an embryonic value-conception can be at work in the minds of those who first introduce a value into society. The value-conception is then built up through analogical reflections centering on the extreme proposals.[86]

Despite their shared concern with the creation of new artistic values, what

86 H. J. N. Hornsburgh, "The Relevance of the Utopian," *Ethics* 67: 137.

becomes clear from this comparison of Rodchenko's and Lissitzky's projects is their sharp difference in degrees of engagement with the Revolution and the way that difference shaped their practices as artists. Rodchenko was an unequivocal supporter of the Bolsheviks, although he did so from the terrain of art which was removed from the formation of economic and social policy. As a result of his commitment, however, we can unequivocally read his kiosk and building projects as political objects, although close readings indicate a somewhat naive faith in a centralized authority to direct and organize life for the Soviet people. By contrast, Lissitzky as a Jew was caught between the hope that the Revolution would ameliorate the situation of Russian Jews from what it was under the czars and Lenin's intention to eradicate the autonomy of ethnic minorities and create a single national culture. Lissitzky's art, therefore, lacks the specific context of the Revolution that Rodchenko addressed; instead, Lissitzky deferred his vision of a new world to some point in the future and remained ambiguous about how that world was to be brought about.

For Rodchenko and Lissitzky, the "extreme proposals" of the 1917–21 period, when there was an openness to shape individual responses to the new political situation, were eventually relinquished for practical work. Both artists had to extract from their utopian practices those values that were more closely related to the needs of daily life. What then was the relation between their utopian formulations and their subsequent work as designers and educators? For Rodchenko, a formal continuity existed between his kiosk and building projects for Zhivskul'ptarkh and the product and furniture designs he and his students produced at the VKhUTEMAS during the 1920s. This was based on the line which continued to be a basic element of construction for him. For Lissitzky, the connection between the *Prouns* and his later work as a publications and exhibit designer was more architectural, emphasizing the placement of forms in two-dimensional or three-dimensional space.

Lissitzky's ambiguity about the Revolution compared to Rodchenko's certainty reinforces the recognition that there was no single avant-garde response to the Bolshevik victory nor did the avant-garde share a common trajectory as the drive to stabilize and reorganize Soviet society continued. It was inevitable that the openness of the Russian Civil War years would end and that the utopian imagination of the avant-garde would have to be tested in the arena of daily life. Nonetheless, it was the quest for a new society that fueled the formal experiments of both Rodchenko and Lissitzky and remained an elusive goal for the rest of their lives.

We, who today have become one with the necessity and condition of class struggle in all respects, do not think it important that a person should find enjoyment in a picture, in music, or in poetry. The primary requirement is that those who have not yet reached the contemporary standard of mankind should be enabled to do so as soon as possible through our work.

László Moholy-Nagy (1922)[1]

We stand at the outset of a great creative period. Obviously reaction and bourgeois obstinacy remain strong on all sides in Europe as well as in disoriented Russia. But all the energy of those who cling to the past can only, at the very most, delay the process of constructing new forms of existence and communal work.

El Lissitzky and Ilya Ehrenburg (1922)[2]

Unfortunately the Constructivists have a practical failing—they're falling short of their goal. In most cases they're still confined within the traditional sphere of art. They forget that, as a rule, there is only one type of constructivist: the engineer, the architect, the welder, the carpenter. In a word, the technician. They set out to be leaders—but were, it turns out, only a reflex.

George Grosz (1925)[3]

Although the major proponents of Constructivism in Germany—Theo van Doesburg, El Lissitzky, and László Moholy-Nagy—wanted to create an abstract art that would signify new objective values, they, and others who joined the Constructivist project in its peak years of 1922–23, disagreed on what those values should be.[4] It was, in fact, the differing expectations for Constructivist art and the way artists sought to articulate them that is central to an understanding of German Constructivism.[5] At issue was the question of whether Constructivism was to revolutionize social relations as a whole or operate on the terrain of art

1 László Moholy-Nagy, "On the Problem of New Content and New Form," in Krisztina Passuth, *Moholy-Nagy* (London: Thames and Hudson, 1985), 286–87.

2 El Lissitzky and Ilya Ehrenburg, "The Blockade of Russia is Coming to an End," *Veshch* (1922), in *The Tradition of Constructivism*, ed. and with intro. Stephen Bann (New York: Viking Press, 1974 [The Documents of 20th-Century Art]), 55.

3 George Grosz, "Art Is in Danger!" in George Grosz, John Heartfield, and Wieland Herzfelde, *Art Is in Danger*, trans. Paul Gorrell (Willimantic, CT: Curbstone Press, 1987 [Art on the Line 5]), 42.

4 For a comparative study of the utopian ideals of van Doesburg, Lissitzky, and Moholy-Nagy as manifested in their art and thought, see Steven A. Mansbach, *Visions of Totality: Laszlo Moholy-Nagy, Theo Van Doesburg, and El Lissitzky* (Ann Arbor: UMI Research Press, 1980 [c. 1978]). For a more recent interpretation of how Lissitzky and Moholy-Nagy theorized their Constructivist practice, see Daniel Hurwitz, "Constructivism's Utopian Game with Theory," in his book *Making Theory/Constructing Art: On the Authority of the Avant-Garde* (Chicago: University of Chicago Press, 1993), 61–92.

5 For some time scholars have recognized that "constructivism" does not denote a unified movement that

alone. Because Constructivist art consisted of abstract forms, it could not of itself represent the artists' intentions and thus depended on a context of assertions and interpretations which at times seemed to overshadow the work.

Germany was a particularly appropriate site for these debates. Although she lost World War I, Germany was nonetheless a country of advanced science and technology with a class of intellectuals and industrialists who believed strongly in modernity. Artists who championed an art for the modern age as the Constructivists did were thus in tune with a larger ambition to abandon tradition and shape a contemporary culture.

Just after the war, Germany had become fertile ground for Expressionism, Dada, and other avant-garde movements among which the Constructivists found a place. Berlin, one of Europe's most cosmopolitan art centers, was a meeting ground for artists from both Western and Eastern Europe; and Berlin dealers like Herwarth Walden were promoting a market for art from abroad. Besides the gallery scene in Berlin, active artists' organizations like the Novembergruppe and the Arbeitsrat für Kunst were organizing exhibitions and publishing manifestos to bring about a climate of spiritual and political renewal.

However, the Constructivists fought their battles in a limited milieu, despite ambitious claims that their art was a beacon for social transformation. They published their articles and manifestos in avant-garde journals which only a few artists and other interested parties read, and their debates at occasional congresses were witnessed only by colleagues. The location of the Constructivists on the periphery of the German cultural scene was partly due to the fact that most were from abroad and entered the scene as outsiders. Van Doesburg was Dutch, Moholy-Nagy was from Hungary, and Lissitzky came from Russia. All were ambitious and fought hard to gain recognition on the German cultural front.

The first of the future Constructivists to arrive in Germany was Moholy-Nagy. He left Hungary a few months after the short-lived Communist Republic of Béla Kun collapsed in August 1919.[6] Before coming to Berlin in early 1920,

occurred during the 1920s but instead covers a range of differing convictions about the signification of nonobjective forms. Early writers on Constructivism such as Stephen Bann contrasted the Russian experience with a broad movement called International Constructivism. See *The Tradition of Constructivism*, ed. Bann. This model was followed by Christina Lodder in the last chapter of *Russian Constructivism* (New Haven: Yale University Press, 1983), 225–38. In a more recent essay by Bann, "Russian Constructivism and Its European Resonance," in *Art into Life: Russian Constructivism, 1914–1932*, with intro. Richard Andrews and Milena Kalimovska (New York: Rizzoli, 1990), the author questions the degree of Russian Constructivism's influence in the West. After Bann and Lodder, Oliver Botar continued to use the term "International Constructivism," but he did so with some hesitation, since he focused specifically on Constructivism and the Hungarian avant-garde in the 1920s. See Botar, "Constructivism, International Constructivism, and the Hungarian Emigration," in *The Hungarian Avant-Garde, 1914–1933*, ed. John Kish (Storrs, CT: William Benton Museum of Art, 1987): 90–98. Complementing Botar's attention to the Hungarians and Constructivism, I have identified Germany as the site of a distinct Constructivist project which was neither an outgrowth nor an extension of Russian Constructivism or any other Constructivism but was instead a separate movement with its own issues.

6 See Krisztina Passuth, *Moholy-Nagy*, for biographical information on Moholy-Nagy. His early years are described in László Péter, "The Young Years of Moholy-Nagy," *New Hungarian Quarterly* 13, no. 46 (Summer 1972): 62–72. On the Kun regime, see Rudolf L. Tökés, *Béla Kun and the Hungarian Soviet Republic: The Origins and Role of the Communist Party of Hungary in the Revolution of 1918–1919* (New York: Praeger, 1967).

he stopped for a few weeks in Vienna where a number of other Hungarian artists had emigrated. He moved on to Berlin because, as he recalled years later, "I was less intrigued with the baroque pompousness of the Austrian capital than with the highly developed technology of industrial Germany."[7]

Moholy-Nagy did not play an active role in the Kun regime nor did he distinguish himself as an artist during that period. He was attracted to the ideas of Lajos Kassák, the leading promoter of the European avant-garde in Hungary and the founder of several important journals including *Ma* (Today), but his own work was largely derivative.[8] Moholy-Nagy's portraits, drawn with a nervous line, recall the work of Lajos Tihanyi, an established artist in the group of modernists known as "The Eight," while some of his early attempts to express a more formal structure recall the paintings of Sándor Bortnyik, one of the few Hungarian artists to take an interest in abstraction at the time. Moholy-Nagy concluded in Hungary that modern artists derived their real power from a personal visual language based on the combination of certain "fundamental" elements. With this in mind, he made an important shift from paintings suggesting a subject to works that combined lines and geometric shapes with iconographic elements.

Unlike Moholy-Nagy, van Doesburg was already a well-developed artist and critic before coming to Germany.[9] He founded the De Stijl group and its eponymous journal in 1917. The following year he and his colleagues, in their first manifesto, declared the goal of creating a pure universal art form and bringing about a unity of "life, art, and culture."[10]

Before 1921 most of the original Dutch members of De Stijl had dissociated themselves from van Doesburg, whose strong personality and dogmatic opinions fostered disagreements, and van Doesburg had decided to proselytize for the movement abroad. In Berlin, which he visited in December 1920, he met Walter Gropius, founder of the Bauhaus, decided to visit the school in Weimar, and then returned to settle there in April 1921. Van Doesburg would have liked a teaching position at the Bauhaus but wasn't offered one. Instead, he chose to combat the romantic and nostalgic tendencies he perceived there by setting up

7 László Moholy-Nagy, *The New Vision and Abstract of an Artist* (New York: George Wittenborn, Schultz, 1947), 72. The emigration of Hungarian avant-garde artists to Vienna and Berlin is discussed by Steven Mansbach in "Revolutionary Engagements: The Hungarian Avant-Garde" in S. A. Mansbach, *Standing in the Tempest: Painters of the Hungarian Avant-Garde, 1908–1930*, exh. cat., with contributions by Richard V. West et al. (Santa Barbara: Santa Barbara Museum of Art; and Cambridge, MA: MIT Press, 1991), 46–91. See also Lee Congdon, *Exile and Social Thought: Hungarian Intellectuals in Germany and Austria, 1919–1933* (Princeton: Princeton University Press, 1991), 139–76.

8 On Kassák, see Tomás Straus, *Kassák: Ein Ungarischer Beitrag zum Konstruktivismus* (Köln: Galerie Gmurzynska, 1975); and Esther Levinger, "Lajos Kassák, MA and the New Artist, 1916–1925," *The Structurist* 25/26 (1985/1986): 78–86.

9 On van Doesburg's life see Joost Baljeu, *Theo van Doesburg* (New York: Macmillan, 1974); and Allan Doig, *Theo van Doesburg: Painting into Architecture, Theory into Practice* (Cambridge: Cambridge University Press, 1987). For a discussion of van Doesburg's early De Stijl period see Carel Blotkamp, "Theo van Doesburg," in *De Stijl: The Formative Years, 1917–1922*, ed. Carel Blotkamp (Cambridge, MA: MIT Press, 1986), 3–37. Detailed readings of van Doesburg's projects can be found in Evert van Straaten, *Theo van Doesburg: Painter and Architect* (The Hague: SDU Publishers, 1988). See also Serge Lemoine, ed., *Theo van Doesburg: Peinture, Architecture, Theorie* (Paris: Sers, 1990).

10 "'De Stijl': Manifesto I," in *Programs and Manifestoes on 20th-Century Architecture*, ed. Ulrich Conrads (Cambridge, MA: MIT Press, 1975 [c. 1970]), 39.

a studio and offering a course in De Stijl principles, which he ran from March to July 1922. He also continued to edit his journal and gave public lectures in which he propounded his definition of a new elemental art language and its relation to the contemporary world.[11]

Lissitzky arrived in Berlin from Russia in December 1921, a year later than van Doesburg. After leaving the Popular Art Institute in Vitebsk at the beginning of 1921, he appears to have remained primarily in Moscow for the rest of the year before leaving for Europe. He taught a course in "Monumental Painting and Architecture," at the VKhUTEMAS (Higher State Art-Technical Workshops), the state art and design school Lenin established in 1920; he also gave a series of lectures, including one on the *Proun*, at INKhUK, and most likely did some work for the publishing division of the Comintern. On his way to Berlin at the end of the year he stopped briefly in Warsaw where he met the Jewish artist Henrik Berlewi. Lissitzky's diverse activities in Germany coincided with the end of war communism at home and Lenin's inauguration of the New Economic Policy (NEP), whereby the state temporarily abandoned the drive for total nationalization of the economy and allowed the private sector a greater role. The liberalized climate for trade resulting from the NEP created a spirit of conciliation between Germany and Russia despite the fact that Zinoviev of the Comintern, as well as other Soviet officials, still envisioned Germany as the next site for the spread of the international proletarian revolution. The conciliatory mood of the two countries, however, was conducive to Lissitzky's own lack of clear and consistent support for the Revolution at the time.

Before Lissitzky and van Doesburg arrived in Germany, they had developed their thinking about a new art far more than Moholy-Nagy. In advancing a new Constructivist movement, their initial strategy was to promote what they had previously done and thought in a new context. Lissitzky repositioned his Russian work within the emerging scientific and technological values of Weimar Germany, while van Doesburg drew a larger group of artists into his discourse about an elemental art, arguing points that he had stated with certainty before leaving the Netherlands.

Van Doesburg was the first propagandist for Constructivism in Germany. He began to articulate the premises for a Constructivist ideology in the pages of *De Stijl*, which he edited in Weimar between 1921 and 1923. Publishing some of the articles in trilingual versions that included German and French as well as Dutch, he presented his own arguments for a new objective and universal art, along with related theoretical essays by other artists who were to be associated with Constructivism in Germany—Hans Richter, Werner Graeff, Lissitzky, and Moholy-Nagy.

11 For an account of van Doesburg's German years, see Sjarel Ex, "'De Stijl' und Deutschland 1918–1922: die Ersten Kontakte," in *Konstruktivistische Internationale Schöpferische Arbeitsgemeinschaft, 1922–1927: Utopien für eine Europäische Kultur*, eds. Bernd Finkeldey, Kai-Uwe Henken, Maria Müller, and Rainer Stommer, exh. cat. (Ostfilden-Ruit: Verlag Gerd Hatje, 1992), 73–80. On the De Stijl course in Weimar, see Kai-Uwe Hemken and Rainer Stommer, "Der 'De Stijl'-Kurs von Theo van Doesburg in Weimar (1922)" in the same volume, 169–77.

Calling for a form of expression that was objective, universal, and representative of machine age values, van Doesburg defined art as an expression of the spirit rather than the realization of a political program. In the manifesto, "Towards a Newly Shaped World," which he published in the August 1921 issue of *De Stijl*, he stated:

> We know just one thing; only the exponents of the new spirit are sincere. Their wish is solely to give. Gratuitously. They arise among all nations, among all countries. They do not boast in deceiving phrases. They do not call each other "brother," "maestro" or "partisan." Theirs is the language of the mind, and in this manner they understand each other. . . . The International of the Mind is an inner experience which cannot be translated into words. It does not consist of a torrent of vocables but of plastic creative acts and inner or intellectual force, which thus creates a newly shaped world.[12]

Rejecting both capitalists and socialists as exploiters, van Doesburg placed his hopes for a new and better world in a fraternity of artists who would exercise their power through the creation of formal objects.

In a lecture entitled "The Will to Style," which he gave in Weimar, as well as at the Kunstverein in Jena and in Berlin during 1921, van Doesburg outlined his criteria for a contemporary art: certainty instead of uncertainty, openness instead of closedness, clarity instead of vagueness, religious energy instead of faith and religious authority, truth instead of beauty, simplicity instead of complexity, relation instead of form, synthesis instead of analysis, logical construction instead of lyrical representation, machine production instead of crafts, creative design instead of imitation and decorative ornamentation, collectivism instead of individualism.[13] Van Doesburg was interested in developing these qualities in all artistic forms, including architecture, literature, film, and music as well as the plastic arts.[14]

However, it was artists other than him—principally Lissitzky and Moholy-Nagy, who actually produced the work that embodied the arguments for Constructivism. We therefore need to examine the way that work developed and how the artists transmuted or set aside their social ideals as they adapted themselves to their new situation. It is this interplay between their strong convictions and strategic maneuvering that is central to understanding Constructivism in Germany.

2

Sometime in 1919 Moholy-Nagy made the important shift from figurative painting to works that combined lines and geometric shapes with iconic elements,

12 Theo van Doesburg, "Towards a Newly Shaped World," in Baljeu, *Theo van Doesburg*, 113–14.

13 Theo van Doesburg, "The Will to Style," in Baljeu, *Theo van Doesburg*, 115–26. The lecture was published in 1922 in the February and March issues of *De Stijl*.

14 In the early issues of *De Stijl*, e.g., van Doesburg published articles on the abstract films of Hans Richter and Viking Eggeling and the linear and planar furniture of Gerrit Rietveld. He was also quick to devote a double issue of the journal to a Dutch version of Lissitzky's innovative visual book, *Of Two Squares*.

letters, and numbers. In his paintings and drawings of late 1919 and 1920, technology was the primary subject. *Perpe* (**FIGURE 2.1**), a gouache sometimes dated 1919, was one of the first pictures to manifest the simplicity and geometric construction that would characterize his nonobjective works. Here Moholy-Nagy began to construct machine-like objects rather than derive abstractions from known technological symbols. He combined gear forms with images of the modern industrial environment—bridge shapes and lines resembling a road or railroad tracks disappearing into the distance. *Perpe* was actually a montage of images—the machine, the bridge, and the tracks or road—that connote motion.

Moholy-Nagy continued to develop these ideas in *Bridges* (**FIGURE 2.2**), an oil painting of 1920 that had the density of some of his earlier drawings, but he replaced the thickets of lines in those drawings with shapes—partial circles, triangles, and trapezoids—which he painted in strong expressive colors. Moholy-Nagy did not achieve an orderly arrangement in *Bridges*, but he began to explore the placement of three-dimensional shapes in space.

In 1920 and 1921 he made machine-like objects central to works, such as *Collage R, Movement, The Big Wheel,* and *The Peace Machine Devouring Itself.* Moholy-Nagy's treatment of the machine in these pictures is witty and has something of a Dada flavor. In *Dada-Collage* (1920) he incorporated word fragments composed of carefully drawn serif letters as in *Perpe*, but he related the letter shapes more closely to the formal composition of curved and straight lines.

Letters were also central to Moholy-Nagy's constructions with objects such as *h Construction* (**FIGURE 2.3**). These "were not projections of reality rendered with photographic eyes, but rather new structures, built up as my own version

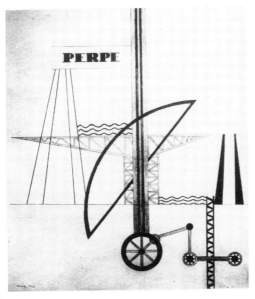

FIGURE 2.1
Moholy-Nagy *Perpe, 1919*

FIGURE 2.2
Moholy-Nagy *Bridges, 1920*

of machine technology, reassembled from the dismantled parts."[15] For these constructions, Moholy-Nagy glued and nailed screws, bolts, sections of T-squares, and machine pieces to wooden boards on which he also drew and painted. Though these works strongly recall Kurt Schwitters's collages of found objects, they also sparked Moholy's interest in the properties of light and color which became central to his nonobjective paintings. Reflecting on these works years later, he wrote:

> It seemed to me that in this way I could produce real spatial articu-
> lation, frontally and in profile, as well as more intense color effects.
> Light falling on the actual objects in the constructions made the col-

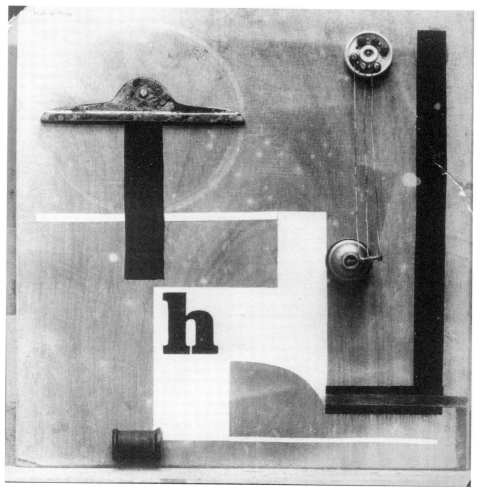

FIGURE 2.3
Moholy-Nagy *h Construction,* c. 1921

15 Moholy-Nagy *The New Vision and Abstract of an Artist,* 72.

51

ors appear more alive than any painted combination. I planned three-dimensional assemblages, constructions, executed in glass and metal. Flooded with light, I thought they would bring to the fore the most powerful color harmonies. In trying to sketch this type of "glass architecture," I hit upon the idea of transparency.[16]

Moholy-Nagy's awareness of spatial articulation led him to examine forms in deep space, first in his paintings and shortly thereafter in his metal constructions. *Glass Architecture III* (1921–22) (**FIGURE 2.4**) shows his early interest in the definition of space through light and color. Subsequently he said of this and similar pictures:

> The liberation from the necessity to record was their genesis. I wanted to eliminate all factors which might disturb their clarity—in contrast, for example, with Kandinsky's paintings, which reminded me sometimes of an undersea world.[17]

The year 1921 was one of transition for Moholy-Nagy. He continued to develop technological themes with referential icons such as trestles and wheels, and to use letters and numbers as well; at the same time, he produced paintings like *Red Collage* and *Red Cross with White Spheres*, which were stripped of references to the cyclists, fields, and industrial objects that populated his earlier works of that year. These new works represented his commitment to the active investigation of color, space, illumination, and transparency.

Moholy-Nagy first contributed to the emerging German discourse about a new nonobjective art when he and three other artists—the German Raoul Hausmann, the Swiss Hans Arp, and the Russian Ivan Puni—wrote a manifesto, "Aufruf zur Elementaren Kunst" (A Call to Elementarist Art), which Theo van

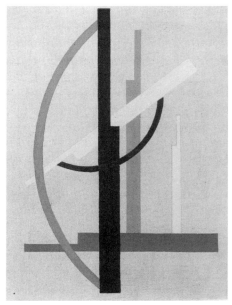

FIGURE 2.4
Moholy-Nagy *Glass Architecture III*, 1921–22

Doesburg published in *De Stijl* in late 1921. The authors echoed van Doesburg's views with their demand that art be something unprecedented that expressed the spirit of the time. Moholy-Nagy and his colleagues used the term "elementarist art" which they defined as "something pure, liberated from usefulness and beauty, something elemental which can arise in each person."[18] They called for an art that expressed an inner universal, spiritual feeling. At the same time, the work of art was to be stripped down to formal elements which represented that feeling. The manifesto separated art from any alliance with a political program, defining it instead as an expression of inner values shaped by the forces of contemporary life. The manifesto's appearance in *De Stijl* took the appeal for a new art beyond a specifically German context and framed it within van Doesburg's ambitious aim of building an international cadre of artists who would promulgate a new form language that was independent of political objectives.

Whereas "A Call for Elementarist Art" clearly separated art from the demands of a political program for *De Stijl*'s readers, Ernö Kállai, a Hungarian critic who came to Germany around the same time as Moholy-Nagy, had presented Moholy-Nagy's work to the readers of the Hungarian language exile journal *Ma* a month earlier, according to a different argument.[19] Kállai's essay, which reveals his attempt to fit Moholy-Nagy's paintings into his own criterion for a contemporary art form, also contains ideas that were to contribute to his later writings on Constructivism in German publications.[20]

Although Kállai opposed reductive art that was used as "a murderous weapon of moral and social criticism," he nonetheless expressed strong anticapitalist sentiments when he spoke of "the all-destroying selfish instinct of the bourgeois free-enterprise."[21] He claimed that Moholy-Nagy's art neither rejected nor supported this instinct, and he referred to the work as "anarchistic." Kállai ended his essay by saying, "Over problematical features of the present, Moholy-Nagy proclaims law and liberty which throw light on the perspectives of the infinite future."[22]

According to Kállai, Moholy-Nagy's art reflected allegorically the qualities of freedom and order that belonged to an ideal future rather than the problematic present. "Colours develop themselves into form through their strong

16 Ibid.

17 Ibid., 75. Lissitzky also criticized the amorphous forms in Kandinsky's paintings. Reviewing a 1922 Kandinsky exhibition in Berlin for the journal *Veshch*, he wrote: "Clear geometric forms are in fact worked into the vegetation which proliferates over the edges of the square canvas. But they are so swamped with colour that they are unable to establish order in the confusion." El Lissitzky, "Exhibitions in Berlin," in Lissitzky-Küppers, *El Lissitzky: Life, Letters, Texts*, rev. ed. (London: Thames and Hudson, 1980 [c. 1968]), 346.

18 R. Hausmann, Hans Arp, Iwan Puni, and Maholy-Nagy [sic], "Aufruf zur Elementaren Kunst," *De Stijl* 4, no. 10 (1921), 156 (my translation).

19 Ernö Kállai, "Moholy-Nagy," in Passuth, *Moholy-Nagy*, 412–13.

20 For the development of Kállai's theory of Constructivism, see Eva Forgács, "Der Konstruktivismus von Ernö Kállai," in *Wechselwirkungen: Ungarische Avantgarde in der Weimarer Republik*, ed. Hubertus Gassner (Marburg: Jonas Verlag, 1986), 158–63.

21 Kállai, "Moholy-Nagy," 412.

22 Ibid., 413.

contrasts, through their brutal clashing with each other; the articulations of form are of the most simple kind possible," he wrote, "and that space, which was left empty for a tabula rasa, constitutes a single, wide abstract wall behind the form, on which the artist's credo concerning the future-shaping power of man's civilizing activity is written up with lapidary laconicism."[23]

Kállai placed great faith in the power of visual metaphors to bring about changes in human life. Therefore he refused to make art accountable to a political program. Although he stated a preference for a social system other than bourgeois capitalism, he proposed no alternative, thus claiming a visionary quality for Moholy-Nagy's work without linking it to a specific process of social transformation. In his essay we can see Kállai beginning to develop his view of art as a metaphor that would awaken public consciousness with its powerful imagery. He would continue this line in later reviews of work by Moholy-Nagy and Lissitzky.

Although Kállai located Moholy-Nagy at the borders of Cubism and Dada, Moholy-Nagy himself continued to move away from the playful manipulation of iconic elements toward the organization of more abstract forms in space. The works he showed in his first major German exhibition, shared with fellow Hungarian László Péri at Herwarth Walden's *Der Sturm* gallery in February 1922, represented a transitional phase of his development. A number of the paintings and drawings such as *E Picture*, *Large Railway Painting*, *The Great Wheel*, and *Large Field with Construction*, all done in 1920–21, incorporated letterforms or referred to known objects. Some pictures, however, such as *White on White* or *White, Black, Gray* were without such references, as were the sculptures constructed of wood and metal.[24] *Nickel Construction* (1921) (**FIGURE 2.5**) was similar in many ways to sculpture being done in Russia at the time, but Moholy-Nagy was not specifically concerned with the manipulation of industrial materials as the basis for his work.[25] For him, art was a means of representing the

23 Ibid.

24 See the catalog, *Moholy-Nagy, Peri: Gesamtschau des Sturm* (Berlin: Der Sturm, 1922), n.p. In a review of Moholy's exhibition for the journal *Veshch*, Lissitzky noted that "Moholy-Nagy has prevailed over German expressionism and is striving to achieve an organized approach. Against the background of jellyfish-like German non-objective painting, the clear geometry of Moholy and Peris [sic] stands out in relief. They are changing over from compositions on canvas to constructions in space and in material." Lissitzky, "Exhibitions in Berlin," in Lissitzky-Küppers, *El Lissitzky: Life, Letters, Texts*, 345.

25 Soviet artists such as Konstantin Medunetsky, whose metal sculptures were similar to Moholy-Nagy's and were done around the same time, concerned themselves with the exploration of formal problems on the material plane. In the context of debates held in late 1921 at Moscow's INKhUK, where questions about the usefulness of art were raised, the solution of such problems prepared the way for the design of functional objects. Moholy-Nagy, however, did not intend his work to be read as the organization of materials. He was informed of the new tendencies in Russian art by the artist Béla Uitz, who had been sent to Moscow by the Hungarian Communist party in early 1921 to attend the III International of the Comintern and then visited Berlin that fall. Oliver Botar makes the point that Uitz brought news of Russian Constructivism to Moholy-Nagy and other Hungarians in Berlin before El Lissitzky and Naum Gabo, who arrived in December 1921 and the summer of 1922, respectively. See Botar, "Constructivism, International Constructivism, and the Hungarian Emigration," 95. Moholy-Nagy also would have heard about Russian artistic developments, including the INKhUK debates on construction and composition, from his friend Alfréd Kemény who was sent to Moscow from Budapest as a delegate of the Communist Youth International to attend the same Comintern Congress as Uitz. While in Moscow, Kemény gave several talks at INKhUK in late 1921. See Alfréd Kemény, "Vorträge und Diskussionen am 'Institut für Künstlerische Kultur'(INChUK), Moskau 1921," in *Wechselwirkungen*, ed. Gassner, 226–30.

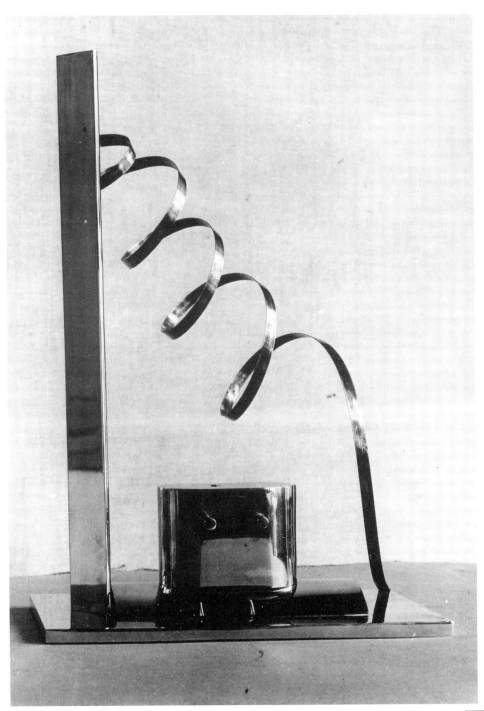

FIGURE 2.5
Moholy-Nagy *Nickel Construction,*
1921

qualities of contemporary industrial culture. Its function was to signify values rather than provide models for utilitarian objects. His art therefore remained open to an idealistic reading as exemplified in Kállai's essay.[26]

3

Whether and how Lissitzky was representing the interests of the Soviet government while in Germany still remains unclear. He had a connection to the Fine Art Department in the People's Commissariat of Enlightenment whose interest it was to develop contacts with progressive artists abroad, but there is no evidence that he came to Germany with the intent of attracting artists to the Russian cause or spreading the Revolution.[27]

On the contrary, he maintained close contacts with artists like van Doesburg, who eschewed partisan politics, and he was a frequent visitor to Moholy-Nagy's studio where he argued with him and other artists about Constructivism.[28] He also worked for émigré publishers who had left Russia because of the Revolution, designed covers for the American "little magazine" *Broom*, and was involved in the Berlin community of Jewish artists.[29]

In April 1922, the month that the Germans and Russians signed the Treaty of Rapallo, which ushered in a period of *rapprochement* between the two countries, Lissitzky and the Russian émigré novelist Ilya Ehrenburg edited the first issue of *Veshch* (Object), a cultural magazine intended to create a bridge between Western Europe and Russia but not to espouse a political line.[30] *Veshch* was published by the Scythians, a group of Russian émigré intellectuals who saw in the

26 The distinction between idealist and materialist readings points out the significance of differing critical interpretations in asserting the meanings of the new nonobjective art that was emerging in Russia and Germany.

27 Peter Nisbet believes that Lissitzky, while in Berlin, acted as "an unofficial representative of advanced Russian culture in the West." See Nisbet, *El Lissitzky, 1890–1941*, exh. cat. (Cambridge, MA: Busch-Reisinger Museum, 1987), 25. This argument is echoed by Henk Puts, "El Lissitzky (1890–1941): His Life and Work," in *El Lissitzky, 1890–1941: Architect, Painter, Photographer, Typographer* (Eindhoven: Municipal Van Abbemuseum, 1990), 18. Puts notes, however, that whether or not Lissitzky left for the West on an official government assignment is not known.

28 See Hans Richter, "Begegnungen in Berlin," in *Avantgarde Osteuropa*, exh. cat. (Berlin: Kunstverein und Akademie der Künste, 1967), 13–21. Richter credits Lissitzky with bringing information about Russian avant-garde art to Germany and states that "Lissitzky was naturally a member of our Constructivists' club and belonged with Doesburg, Mies van der Rohe, Hilberseimer, van Eesteren, Haussmann [sic], Eggeling, me and my Adlatus Graeff to our inner circle so to speak" (15; my translation). See also Erich Buchholz, "Begegnung mit Osteuropäischen Künstlern," in the same volume, 26–27. Buchholz notes that Lissitzky called himself a pupil of Malevich.

29 While in Warsaw on his way to Moscow, Lissitzky designed a title page for a new edition of Mani Leib's Jewish children's book *Yingl Tsingl Khvat*. It was published by the Kultur Lige whose leaders had moved to Warsaw after the organization in Kiev was taken over by the Evsektsiya. This activity, his illustrations for several other Jewish children's books while he was in Berlin, and his involvement with the Berlin-based Hebrew-Yiddish journal *Rimon/Milgroim*, where he published an important article on the synagogue of Mohilev in 1923, is clear evidence that he remained connected to the Jewish community after leaving Vitebsk.

30 See Kestutis Paul Zygas, "'Veshch/Gegenstand/Objet': Commentary, Bibliography, Translations," *Oppositions* 5 (Summer 1976): 113–28.

31 On the Scythians, see Robert C. Williams, *Culture in Exile: Russian Emigrés in Germany, 1881–1941* (Ithaca: Cornell University Press, 1972), 252–58.

32 El Lissitzky and Ilya Ehrenburg, "The Blockade of Russia Moves Towards Its End," in Lissitzky-Küppers, *El Lissitzky: Life, Letters, Texts*, 345.

Revolution the beginning of a messianic new order, although they did not embrace the Bolshevik line and preferred to write and publish their views outside Russia.[31]

Lissitzky and Ehrenburg declared a position that was "aloof from all political parties."[32] Objects—whether poems, houses, or industrial products—could bear the qualities of a new order that would conform to "the eternal laws of clarity, economy, and legality."[33] The editors used the term "constructive art" and said its mission was "not, after all, to embellish life but to organize it."[34] However, despite their claim that "we cannot imagine a creation of new forms in art unrelated to the change in social form," they did not explain how artists were to alter these social forms if not through a political process.

Primarily, *Veshch* informed Russian-speaking readers about new artistic developments in France and Germany.[35] Although three outlets handled the magazine in Moscow, many of the readers were probably Russian émigrés in Germany, of whom there were nearly half a million at the time.[36] *Veshch*'s contents were eclectic and included the work of Russian writers, mostly émigrés, whose contributions were supplemented by Ehrenburg's contacts with writers and artists in Paris and Lissitzky's friends in Germany.

As it happened, little information about Russian art was published in *Veshch*, the most notable article being a truncated version in translation of Nikolai Punin's "Tatlin's Tower." There were, however, Russian translations of articles by Le Corbusier, Ludwig Hilberseimer, Gino Severini, and van Doesburg. These were among the first appearances in Russian of writings by the Western European avant-garde.

At the same time, Lissitzky's and Ehrenburg's catholic definition of constructive objects and their lack of specifics about how these objects would relate to social transformation were severely attacked by several Russian critics. Boris Arvatov, a leader of the Productivist faction within INKhUK, supported the rhetoric of *Veshch*'s opening editorial which claimed that the aim of art was to organize life rather than embellish it, but he argued that the editors were too opportunist and didn't go far enough toward renouncing painting for industrial production. Arvatov wrote that for *Veshch* technology was an end not a means, and he urged the editors to change their view as quickly as possible.[37]

Another Russian, Alexei Gan, a cofounder of the First Working Group of Constructivists within INKhUK, leveled a similar charge at *Veshch* in his mani-

33 Ibid., 344.

34 Ibid.

35 Three-quarters of *Veshch*'s contents were in Russian while two-thirds of the rest were in German, and the remainder was in French. See Zygas, "Veshch/Gegenstand/Object," 116.

36 Ibid.

37 Boris Arvatov, "Critica a Vešč," in *L'Architettura del Costruttivismo*, ed. Vieri Quilici (Bari: Laterza, 1978), 113–16. Arvatov's review of *Veshch* appeared in the journal *Pečat i Revoljucija*, no. 7 (1922).

38 Alexei Gan, "Il Costruttivismo," in *L'Architettura del Costruttivismo*, ed. Quilici, 122–59. English excerpts from Gan's manifesto appear in *Russian Art of the Avant-Garde: Theory and Criticism, 1902–1934*, rev. and enlarged ed., ed. John Bowlt (New York: Viking, 1988 [c. 1976]), 214–25; and *The Tradition of Constructivism*, ed. Bann, 32–48. Gan's manifesto is discussed in Lodder, *Russian Constructivism*, 98–99. Lodder also considers *Veshch*'s program in relation to *Russian Constructivism*. See 227–29.

festo, *Constructivism*, which he published in late 1922.[38] Gan, like Arvatov, stated that the fundamental error of Lissitzky and Ehrenburg was not knowing how to separate themselves from art. Therefore, what they were calling Constructivism was simply new art. It was natural, he said, that Constructivism would not be the same in different countries. Russian Constructivism had declared war on art and was fighting for "the intellectual-material production of communist culture."[39] In the West, Gan asserted, Constructivism fraternized with art, practicing conciliatory politics that were the West's chronic malady. Gan had directly confronted Lissitzky's and Ehrenburg's lack of a specific political context, but his distinction between Russian and Western Constructivists was defined more by rhetoric than by actual programs. Nonetheless, *Veshch*'s differences with Gan and Arvatov were not surprising, given Lissitzky's and Ehrenburg's lack of firm commitment to the Revolution and their unwillingness to subordinate art to utilitarian ends.

4

Veshch failed to establish a fraternity of Russian and Western European artists as its sponsors had hoped, but it did become part of a movement in Germany to found a Constructivist International. The idea for such a movement was first presented at the International Congress of Progressive Artists, which was organized by the artists' group known as the Junge Rheinland (Young Rhineland) in conjunction with other associations including the Novembergruppe, the Darmstadt Secession, and the Dresden Secession.[40] Held in Düsseldorf from May 29–31, 1922, the congress included, in addition to artists representing many German groups, a number of individual artists from Germany and abroad. Among the better-known artists attending were Theodore Däubler, Else Lasker-Schüler, Oskar Kokoshka, and Wassily Kandinsky. The aim of the congress was to forge an international organization of artists who could cooperate in exchanging information, holding exhibitions, and generally supporting each other.

Although Lissitzky and Ehrenburg had edited only two issues of *Veshch*, and in fact the publishers did not bring out any others, Lissitzky presented himself at the congress as the representative of a new tendency within the German art world. Amidst heated debates, he spoke both as an editor of *Veshch* and as a member of the International Faction of Constructivists, an alliance consisting of himself, van Doesburg, and van Doesburg's friend Hans Richter, the painter and abstract filmmaker. This alliance was consolidated after a meeting earlier in the year in the Berlin studio of the painter Gert Caden, where a much larg-

39 Gan, "Il Costruttivismo," 159.

40 For a discussion of the congress, see Stephan von Wiese, "Ein Meilenstein auf dem Weg in den Internationalismus," along with the collection of original documents in *Am Anfang, Das Junge Rheinland: Zur Kunst und Zeitgeschichte einer Region 1918–1945*, ed. Ulrich Krempel (Düsseldorf: Claessen, 1985), 50–63. See also Maria Müller, "Der Kongress der 'Union Internationaler Fortschrittlicher Künstler' in Düsseldorf," in *Konstruktivistische Internationale Schöpferische Arbeitsgemeinschaft, 1922–1927*, ed. Finkeldey et al., 17–22.

41 See Kai-Uwe Hemken, "'Muss die Neue Kunst den massen Dienen?' Zur Utopie und Wirklichkeit der 'Konstruktivistischen Internationale,'" in *Konstruktivistische Internationale Schöpferische Arbeitsgemeinschaft,*

er group of artists met to discuss the founding of a Constructivist organization. The meeting included artists from Russia, Hungary, and Germany, some of whom were shortly thereafter to become protagonists.[41]

As a spokesman for *Veshch*, Lissitzky made a nine-point statement about the objective nature of art. "The new art," he declared, "is founded not on the subjective, but on an objective basis. This, like science, can be described with precision and is by nature constructive."[42] Employing the collective "we," Lissitzky claimed that he and other artists in Russia had struggled to give the new art a broad social and political significance. He used the Russian experience to suggest the working of a unified avant-garde artistic will, which was hardly the case but conformed to the image of what he hoped to bring about at the congress. He concluded his speech by calling for the founding of an International of Progressive Artists which would fight for a new, though unspecified, culture.[43]

Hans Richter, who succeeded Lissitzky as a speaker, echoed Lissitzky's views when he spoke for the Constructivist groups of Rumania, Switzerland, Scandinavia, and Germany. Richter gave no indication of who comprised these groups, and he was most likely speaking for only a few individuals such as Viking Eggeling, the Swedish filmmaker who was working with him in Berlin. Richter exhorted the gathering to "no longer tack between a society that does not need us and a society that does not yet exist, let us rather change the world of today."[44]

Following Richter, van Doesburg, representing De Stijl, echoed Lissitzky's call for a universal creative language but referred to it as an "aesthetic theory," leaving open to question its relation to a change of social forms.[45] As a Constructivist presence at the congress, Lissitzky, Richter, and van Doesburg were neither unified among themselves nor did they have a following at the time. However, they used the gathering as a platform to assert their views which they claimed were more coherent and directed to social transformation than those of the others who spoke.[46]

After the congress, van Doesburg wrote a selective account of the proceedings for the April 1922 issue of *De Stijl*.[47] He joined to this account the statements Lissitzky, Richter, and he had read on behalf of their respective groups. Van Doesburg also printed the statement of the International Faction of

1922–1927, ed. Finkeldey et al., 58. Those present at the meeting, as noted by Caden and Hans Richter, were Lissitzky, Naum Gabo, Nathan Altman, Antoine Pevsner, Alfréd Kemény, Moholy-Nagy, Lászlo Péri, Kállai, Hans Richter, Hans Arp, Willi Baumeister, Viking Eggeling, Knud Lönberg-Holm, van Doesburg, Cornelis van Eesteren, Ludwig Mies van der Rohe and Werner Graeff, and the wives of Kemény and Péri.

42 "Statement by the Editors of *Veshch*," in *The Tradition of Constructivism*, ed. Bann, 56.

43 Several years earlier, while still in Russia, Lissitzky had called for something similar but proclaimed Suprematism to be the force that would bring it about. See El Lissitzky, "Suprematism in World Revolution," in Lissitzky-Küppers, *El Lissitzky: Life, Letters, Texts*, 331–34.

44 "Statement by the Constructivist Groups of Rumania, Switzerland, Scandinavia, and Germany," in *The Tradition of Constructivism*, ed. Bann.

45 "Statement by the Stijl Group," in *The Tradition of Constructivism*, ed. Bann, 64.

46 Several days before the Congress, there was a meeting in Weimar to develop a strategy for it. Those involved were van Doesburg, Lissitzky, Richter, Werner Graeff, Karl Peter Röhl, and Cornelis van Eesteren.

47 *Theo van Doesburg*, "A Short Review of the Proceedings," in *The Tradition of Constructivism*, ed. Bann, 58–62.

Constructivists and clarified its position toward the other delegates. He indicated in a note that the term "Constructivist" was used only in contrast to those at the congress whom he called "Impulsivists;" most likely he was applying the latter term to artists who did not share his will to create a geometric art.

Thus he did not define a specific program, but what the International Faction of Constructivists demanded was a recognition of art as a means to organize material in a way that was similar to science and technology, as well as the acknowledgement of art as a universal expression of creative energy. The triumvirate also called for an organization to create art in the way they advocated. Lissitzky, van Doesburg, and Richter rejected the congress proposal for an international exhibition, which they sarcastically characterized as "a warehouse stuffed with unrelated objects, all for sale,"[48] and they proposed instead that "the only purpose of exhibitions is to demonstrate what we wish to achieve (illustrated with plans, sketches, and models) or what we have already achieved."[49]

While the arguments of the three artists were in a distinct minority at the congress, they nonetheless managed to prevent the signing of a proclamation in support of individual artists and, indeed, helped to polarize the congress so that it ended without any conclusive resolutions. The results were something of a pyrrhic victory, however, since the International Faction of Constructivists gained no new followers and managed to alienate themselves from numerous artists who could have been allies had the group been less doctrinaire about its goals and strategies.

Rather than using their experience at the congress to begin a process of organization to expand their ranks, the International Faction of Constructivists moved cautiously, preferring instead to issue a call for collaboration in a new manifesto they published several months later in a special issue of De Stijl dedicated to the Constructivist International (K.I.).[50] The manifesto, which was printed in German, Dutch, and French, appeared on the front page. The group's name was now changed to the Konstruktivistische Internationale Schöpferische Arbeitsgemeinschaft (Constructivist International Creative Working Group), and the membership was enlarged by two to include Karl Maes of Belgium and Max Burchartz of Germany, both friends of van Doesburg.

The five signatories of the new manifesto called for an objective method of work using a universal means of expression. Their aim was to employ modern techniques in a collective way, and they invited artists from around the world to send their expressions of interest to a Berlin address. Since the number of

48 "Statement by the International Faction of Constructivists," in The Tradition of Constructivism, ed. Bann, 69.

49 Ibid.

50 "K.I. Konstruktivistische Internationale Schöpferische Arbeitsgemeinschaft," De Stijl 5/8 (August 1922): 113–19.

51 Carel Blotkamp cites these circulation figures in his introduction to De Stijl: The Formative Years, 1917–1922, ed. Blotkamp, ix.

52 "Stellungnahme der Gruppe 'MA' in Wien zum Ersten Kongress der Fortschrittlichen Künstler in

subscribers to *De Stijl* at this time probably varied between 100 and 200, most of whom were connected to van Doesburg in some way, the Constructivists were unlikely to generate a truly international dialogue with such an appeal.[51]

In the same special issue of *De Stijl*, van Doesburg published a response from the Hungarian *Ma* group in Vienna to the statement of the International Faction of Constructivists, which he had printed four months earlier.[52] Krisztina Passuth suggests that at least some members of the Hungarian group then residing in Vienna would have liked to attend the Düsseldorf congress but were constrained from doing so by problems of finances and visas. Passuth also believes that the Hungarian response was most likely drafted by Lajos Kassák, the founder of the group, and then signed by the others, including Moholy-Nagy, who was the Berlin correspondent for *Ma*. She notes as well that most of those who signed were writers, theorists, and actors rather than visual artists.[53]

In the way van Doesburg dealt with the Hungarian response, we can see additional evidence of the newly formed Constructivist International Creative Working Group's inability or reluctance to widen the discussion of Constructivism. The Hungarians had supported van Doesburg, Lissitzky, and Richter in their repudiation of a forum for exchanges by individual artists and their rejection of subjective expression in favor of a systematized objective visual language. There was one important difference in the *Ma* statement, however, which hinged on the interpretation of the word "collective," a factor that may have led van Doesburg to ignore the statement later.

Lissitzky and Ehrenburg spoke in their initial *Veshch* editorial of a "collective, international style," and the Constructivist International Creative Working Group referred to "collective collaboration" in their manifesto. Neither document, however, was intended to refer to a collective social order, whereas the *Ma* response called for a "future collective society as the only possible basis for the full development of our creative life."[54] This pushed the commitment for a Constructivist International to a more political level than the International Faction of Constructivists had originally proposed. Van Doesburg was no political revolutionary and had consistently argued for the separation of art from politics. Lissitzky avoided the issue while speaking broadly about new forms and collective work, and Richter's position was unclear. The Hungarian response was also vague in stating how artists were to establish a relationship to life and

Düsseldorf," *De Stijl* 5/8 (August 1922): 125–28. Those who signed this response, using German versions of their Hungarian names, were Ludwig Kassák, Alexander Barta, Andreas Gaspar, Ernst Kállai, Ludwig Kudlák, Johan Mácza, Ladislaus Moholy-Nagy, Jolan Simon, and Elisabeth Ujvari. Despite the appearance of a united front, however, the Hungarians had many differences among themselves. These were soon to be evident in the emergence of new factions and journals that departed from the views Kassák promoted in *Ma*. For a discussion of the Hungarians' involvement with Constructivism, see Botar, "Constructivism, International Constructivism, and the Hungarian Emigration," 90–98; Hubertus Gassner, "'Ersehnte Einheit' oder 'erpresste Versöhnung': Zur Kontinuität und Diskontinuität ungarischer Konstruktivismus-Konzeption," in *Wechselwirkungen*, ed. Gassner, 183–220; and Esther Levinger, "The Theory of Hungarian Constructivism," *Art Bulletin* 69, no. 3 (September 1987): 455–65.

53 Krisztina Passuth, "Ungarische Künstler und die 'Konstruktivistische Internationale,'" in *Konstruktivistische Internationale Schöpferische Arbeitsgemeinschaft, 1922–1927*, ed. Finkeldey et al., 239.

54 Ibid., 125 (my translation).

solve contemporary problems, but it nonetheless expressed the intention to strive toward a new social order in which everyone would work together.

This was not to be a Soviet-oriented order, however. The revolution called for in the Hungarian document was a universal one that could not be compared to any previous national revolution. The collective society envisioned by the Hungarians would not be controlled by the state but would instead be a "permanent revolution" of creative expression. Kassák vehemently believed in art's independence and had earlier come into conflict with Béla Kun in Hungary over the issue of artistic freedom.[55]

The *Ma* position statement called for collaboration on a "collective, nonrestrictive basis," whereby people would work together without intruding on each other's individuality. The collective society which the signatories of the statement strove for was based on a form of social cohesion that went well beyond the goals of the International Faction of Constructivists.

The broad response of the Hungarians was followed by their detailed proposal of how to organize the International. Each participating group was to designate at least two members who would oversee the larger body's projects. The responsibility of these members was to locate places for work, support projects generally, and organize congresses, publications, and demonstration exhibitions. The objective of each participating group was to work in its own way toward the larger goals. The journals *De Stijl*, *Veshch*, and *Ma* were to agree on a common position that would reflect the revolutionary aims of the International, although, probably unbeknownst to the Hungarians, *Veshch* had already ceased publication by then. The *Ma* manifesto called for a program of lectures in many countries and urged that the International's initiative be directed from Holland, which was politically neutral. The organizing body was to publish an anthology of work by like-minded artists and arrange an international congress within a year.

The ambitious program of the Hungarians not withstanding, van Doesburg had no intention of sharing control of the International with them, nor of adopting their goal of a collective society. He established a central office as they had suggested, but he did not include any Hungarians on the provisional organizing committee of the International, even though Moholy-Nagy was in Berlin where the office was located.[56] Van Doesburg's exclusion of the Hungarians indicated his will to keep the proposed organization separate from all political action. By avoiding an alliance with them, he could avert any possible disagreement on this subject. We should also note here that by the time the Hungarian

55 Shortly after Kun came to power, Kassák expressed the need for the artist to be free of state control in his "Letter to Béla Kun in the Name of Art," which was published in *Ma*.

56 In a letter to van Doesburg written in October 1922, Richter suggested his studio in Berlin as the International's central headquarters. He also expressed his pessimism about working with Moholy-Nagy who he said did not see things as clearly as he and van Doesburg did. Hans Richter, letter to Theo van Doesburg, in *Konstruktivistische Internationale Schöpferische Arbeitsgemeinschaft, 1922–1927*, ed. Finkeldey et al., 317. Moholy-Nagy and Kemény were the Hungarian representatives at the Dada-Constructivist Congress which van Doesburg organized in Weimar on September 25, 1922. Also attending were members of the Constructivist International Creative Working Group—Richter, Lissitzky, and Burchartz—and initial supporters of the International Faction of Constructivists, Graeff and Röhl. However, no rapprochment between the Hungarians and the Working Group was reached at the congress. According to Richter's letter to van

manifesto was published in the August issue of *De Stijl*, the *Ma* group had split apart. Moholy-Nagy had broken with Kassák, ceasing to be the Berlin correspondent for *Ma*. The first issue of a rival journal *Egység* (Unity) had appeared in May, while another journal, *Akasztott Ember* (The Hanged Man), would begin publication in November. *Egység*, edited by the Communist writer Aladár Komját and the painter Béla Uitz, had ties to the Austrian Communists and the Party of Hungarian Communists (KMP) which maintained connections with the Soviet Union, while *Akasztott Ember*, though not identified explicitly as a Communist publication, was clearly intended as a vehicle to ruthlessly attack bourgeois culture.[57]

In the context of advancing Constructivism as a movement in Germany, the differences between the manifestos of the International Faction of Constructivists and the *Ma* group were of epic proportions. While both groups espoused a visual language of elemental forms, they were sharply divided as to the social implications of those forms. Van Doesburg, Lissitzky, Richter, and their colleagues wanted to demonstrate methods of collaboration that would transform the practice of art while the Hungarians envisioned a radical new society the artist would help to bring about.

5

As a signatory of the *Ma* response to the International Faction of Constructivists, Moholy-Nagy was in the camp that called for a collective society. Yet, unlike his Hungarian colleagues László Péri and Alfréd Kemény who joined the German Communist Party (KPD) in 1923 and 1924, respectively, he formed no official political alliances in Germany and tempered his revolutionary rhetoric according to whether his audience was Hungarian or German.[58]

Moholy-Nagy's Hungarian-language articles and manifestos, which he published alone or with others, were strident in their call for an art that would help to bring about a proletarian revolution, but his manifestos in German muted this advocacy of collective change and tended to emphasize the relation of art to individual human development. "A Call for Elementarist Art," for example, attacked reactionary art, not reactionary politics, even though the authors stated that "the individual does not exist in seclusion."[59] In "Produktion-Reproduktion" (Production-Reproduction), a brief essay published under Moholy-Nagy's name in the July 1922 issue of *De Stijl* and which will be discussed at greater length in Chapter 4, he focused on man's senses, which, he said, it was art's task to refine to the limits of their capacity.[60] Artists would accomplish this

Doesburg, the meeting helped to confirm his and van Doesburg's differences with Moholy-Nagy.

57 The breakup of *Ma* and the emergence of the two journals is chronicled by Oliver Botar in "From the Avant-Garde to 'Proletarian Art': The Emigré Hungarian Journals *Egység* and *Akasztott Ember*, 1922–23," *Art Journal* 52, no. 1 (Spring 1993): 34–45. See also Passuth, "Contacts between the Hungarian and Russian Avant-Garde in the 1920s," in *The 1st Russian Show* (London: Annely Juda, 1983), 48–66.

58 Both Péri and Kemény were members of the "Rote Gruppe," the KPD artists' organization led by George Grosz and John Heartfield. Kemény became the art critic of the KPD cultural magazine *Rote Fahne* (Red Flag) in the fall of 1924.

59 Hausmann et al., "Aufruf zur Elementaren Kunst" (my translation).

60 László Moholy-Nagy, "Produktion-Reproduktion," *De Stijl* 5, no. 7 (July 1922): 98–100. An English trans-

through experiments that challenged conventional uses of different media. Moholy-Nagy distinguished between *production*, the creative use of a medium itself, and *reproduction*, which was simply the transmission of content through a medium. As examples of *productive* art, he cited photograms, sounds made by scratching on plastic disks, and abstract films of which he recognized works by Viking Eggeling and Richter as outstanding examples.

Moholy-Nagy also made new forms central to the brief manifesto "Dynamic-Constructive System of Forces," which he published with Kemény in the journal *Der Sturm* at the end of 1922, after he had broken with Kassák.[61] By then, Naum Gabo, the Russian artist, had been in Berlin for some time, and Moholy-Nagy was most likely familiar with the ideas that he and his brother Antoine Pevsner had put forth in their "Realist Manifesto" two years earlier.[62] Kemény had met Gabo during a visit to Moscow the year before.

Gabo and Pevsner were exploring the possibilities of a kinetic art by incorporating time, along with space, as a dimension of the artwork. They renounced mass as the primary spatial element and proposed to convey the perception of time through kinetic rhythms. Moholy-Nagy and Kemény echoed the Russians' rejection of static forces, demanding the replacement of "the *static* principle of *classical art* with the *dynamic principle of universal life.*"[63] To exemplify static art, they referred to "the over-simplification of form limited to the horizontal, the vertical and the diagonal."[64] This was surely a reference to De Stijl and signified Moholy-Nagy's differences with van Doesburg.

He and Kemény addressed the topic of dynamic art by posing the prospect of freely floating sculpture as well as film that could convey abstract motion. Like Gabo and Pevsner, they were excited by the idea of new forms they termed "experimental demonstration devices for testing the connections between man, material forces and space."[65] The two authors avoided any references to class struggle or the building of a collective society in their manifesto although the dynamic-constructive system of forces was to take on a more political cast in a document that Moholy-Nagy coauthored for *Egység* the following year.

lation was published in *Studio International* 190, no. 976 (July 1975): 17. Although the essay was signed "L. Moholy-Nagy," it is not clear that he was the sole author since we have his wife Lucia Moholy's statement that she was responsible for the wording and editing of a number of Moholy-Nagy's articles in German during the 1920s.

61 László Moholy-Nagy and Alfréd Kemény, "Dynamic-Constructive System of Forces," in Passuth, *Moholy-Nagy*, 290. The original document, "Dynamish-konstruktives kraftsystem," can be found in *Wechselwirkungen*, ed. Gassner, 230–31.

62 See Naum Gabo and Antoine Pevsner, "The Realistic Manifesto," in *The Tradition of Constructivism*, exd. Bann, 3–11.

63 Moholy-Nagy and Kemény, "Dynamic-Constructive System of Forces," 290. We can better understand Kemény's interest in abstract dynamic forms by considering his critique of Tatlin's work as naturalism with an aesthetic conception and Rodchenko's wood constructions as "nothing other than the reproduction of industrial objects." He stated these opinions during his meetings with Russian artists at INKhUK in Moscow. See Alfréd Kemény, "Vorträge und Diskussionen am 'Institut für Künstlerische Kultur,' (INChUK), Moskau 1921," in *Wechselwirkungen*, ed. Gassner, 227.

64 Ibid.

65 Ibid.

66 László Moholy-Nagy, "On the Problem of New Content and New Form," in Passuth, *Moholy-Nagy*, 286.

In his German language manifestos of 1921 and 1922, Moholy-Nagy presented himself as an artistic rather than political revolutionary who was challenging visual conventions with proposals for new abstract art forms. The journals in which he published—*De Stijl* and *Der Sturm*—did not take a doctrinaire political line, and his writings were consistent with the views of their respective editors. In his Hungarian writings of late 1922 and 1923, however, he adopted the position of an artistic *and* political revolutionary. We can explain this in part by the fact that he shared with his Hungarian colleagues the experience of a failed revolution in their homeland. The Hungarian exile journals were not widely circulated, and Moholy-Nagy would not have jeopardized any potential opportunities in Germany by expressing himself militantly in the Hungarian language.

He stated his political views in a Hungarian article, "On the Problem of New Content and New Form," published in nos. 3–4 of *Akasztott Ember* (December 1922). The context for his defense of Constructivism was an article in the previous issue by the editor, Sándor Barta, who espoused agitprop art and painting integrated with architecture as being the most politically relevant forms of art in capitalist society. In his response to Barta, Moholy-Nagy declared that the task of Constructivism was to broaden the proletariat's horizon. He reasserted the avant-garde's role in helping the proletariat reach "the contemporary standard of mankind," which he equated with the artist's standard. He spoke militantly about class struggle and the need to discover "the very laws of our humanity," which were distinct from existing social dogmas.

> We seek for that simplest solution which will provide maximum possibility for the treatment and for spatial tension so that, on one hand, man may learn to handle his materials, while on the other he may participate with his own tensions in his environment, thereby increasing its vitality.[66]

Here again, Moholy-Nagy, arguing vehemently for the indissoluble unity of content and form, asserted that Constructivist art would be effective not by simply illustrating new values but by actually incorporating them into its production. Although he recognized the need for "militant propaganda" in raising proletarian consciousness, it is clear to see why he refuted the political efficacy of traditional paintings and posters, which could only illustrate ideals rather than embody them in their forms.

He therefore claimed that film, as well as posters that incorporated photography, would be more effective than conventional propaganda in influencing the masses.[67] In a direct response to Barta he noted that some of his own Hungarian colleagues, who may well have interpreted his views as formalist or

[67] In his essay for the catalog of the Bauhaus exhibition in 1923, written after he joined the school's faculty, Moholy-Nagy continued to call for posters that used photography, but he made no reference to a political function for them; rather he called photography "The new storytelling device of civilization." See László Moholy-Nagy, "Die Neue Typographie," *Staatliches Bauhaus in Weimar 1919–1923* (Weimar-München: Bauhausverlag, 1923), 141.

idealist, disagreed with his conception of the artist's role in changing society. He sought to alleviate this by calling for a concentration of energies among all those fighting to realize a communist way of life and asserting, "We too are at work, work that is no child's play."[68] This assertion reinforced Moholy-Nagy's claim for art's revolutionary role in changing mass consciousness. The argument in *Akasztott Ember* over the most politically effective forms of art, however, was conducted in a small Hungarian journal with limited circulation and no political base. Thus, it was not accessible to others of the avant-garde in Germany besides Moholy-Nagy's fellow Hungarians, and it therefore did not contribute to a wider and more public debate about the social potential of Constructivism.

6

The militant rhetoric employed by Moholy-Nagy in *Akasztott Ember* and the visionary statements in Lissitzky's Russian writings were in sharp contrast to the opportunities the two artists found and took advantage of in Germany. While both espoused a role of social leadership for the artist, the channels through which they introduced their work in Germany were mainly the private galleries, even if these were avant-garde ones like Herwarth Walden's *Der Sturm* gallery as well as the small progressive art societies and occasional museums. All of these institutions were supported primarily by enlightened middle-class patrons.

Moholy-Nagy's ambition to make paintings without traces of individual expression in no way conflicted with these opportunities.[69] He was producing avant-garde abstract art which did not represent a view that was socially oppositional. To achieve the impersonal effect he wanted, he applied the paint in a precise, smooth way that eliminated texture. He also adopted a vocabulary of geometric forms—using circles, crosses, and crescents most frequently—and replaced his earlier descriptive titles with those comprised of letters and numbers.

In many paintings of 1922, such as *Yellow Cross* and *Composition Q VIII*, Moholy-Nagy used the space of the canvas as a flat negative field for a composition of overlapping shapes. In *K XVII* (**FIGURE 2.6**) which he most likely painted that year, he began, with his complex relations of shapes in space, to achieve the

68 Moholy-Nagy, "On the Problem of New Content and New Form," 286.

69 Moholy-Nagy even carried his quest for impersonality to the extent of having someone else complete a series of pictures for him based on a grid he designed. These were the so-called telephone pictures (*EM1*, *EM2*, and *EM3*)in which he examined the effects of scale on perception by commissioning an enamel factory to have the same painting made in five different sizes, all done on an identical grid. These paintings received the name "telephone pictures" because they were once thought to have been ordered by telephone, which would have added to their aura of impersonality. Lucia Moholy, the artist's first wife, states that Moholy was so elated with the results he said, "I might even have done it over the telephone!" Lucia Moholy, *Marginalien zu Moholy-Nagy/Moholy-Nagy: Marginal Notes* (Krefeld: Scherpe Verlag, 1972), 75–76. The recounting of this incident is mistakenly attributed to Moholy's second wife Sibyl in Passuth, *Moholy-Nagy*, 392.

70 Richard Kostelanetz, in his anthology of Moholy-Nagy's writings, *Moholy-Nagy* (New York: Praeger, 1970), mistakenly attributed an article entitled "Constructivism and the Proletariat," to Moholy-Nagy. This article, which was published in a Hungarian version entitled "Constructivism and the Proletariat," in *Ma* (May 1923), was actually by Egon Engelein, a Bauhaus student who participated in van Doesburg's De Stijl course.

71 Lissitzky and Ehrenburg, "The Blockade of Russia is Coming to an End," in *The Tradition of Constructivism*, ed. Bann, 55.

dynamic tension that he believed characterized the way humans related to their surroundings. Eventually he pushed the shapes into the space to create depth, which we can see in pictures like *Q XXV* or *Composition A VII*, both from 1923.

Moholy-Nagy's paintings and sculptures were the result of his *personal* attempt, rather than that of a group, to express the values of contemporary life in art. Therefore, he used the term "constructivism" in an individual way rather than as the description of a developed collective program.[70] Because his work was not anchored in a context of debate and discussion that was framed by shared social aspirations, as was the case of the Russian Constructivists, it was thus open to multiple interpretations, not only by fellow artists, critics, and the general public but by Moholy-Nagy himself.

The situation was similar for Lissitzky. He envisaged his *Prouns* as utopian statements that represented, however abstractly, new social values and aims. In Russia he presented his work within the context of Suprematism and made considerable claims for it. But the *Prouns* were abstract works, and the credibility of Lissitzky's claims to their significance depended heavily on the discourse and events that surrounded them. When he came to Germany, he created a new discourse to contextualize his work. For example, he declared in the editorial he and Ilya Ehrenburg wrote for the first issue of *Veshch* that art and politics should be separated. They advocated "the constructive method," which could be found "in the new economics and the development of industry as in the psychology of our contemporaries in the world of art."[71] But, unlike some of their colleagues at home who believed that the Revolution gave everything new meaning, they made no reference to the economics or industry of a particular social order, while referring to the psychology of artists rather than that of a new social class.

This separation from politics was reinforced in Lissitzky's *Proun* manifesto

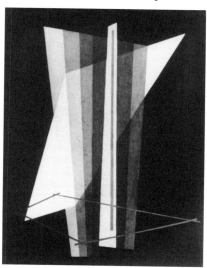

FIGURE 2.6
Moholy-Nagy *K XVII*, c. 1922

for *De Stijl*.[72] By publishing the manifesto right after the Düsseldorf Congress, van Doesburg may have intended it to support the as yet undefined program of the International Faction of Constructivists. Just as van Doesburg had opposed the Constructivists to more expressive Impulsivists in his report on the congress, Lissitzky differentiated *Prouns* from the negative consequences of imitative expressionist art, claiming that the *Proun* was an articulation of space, energy, and forces rather than aesthetics. This definition made it easy for him to link the *Prouns* to the new values of science and technology as well as to the general rhetoric of the Constructivist International Creative Working Group that was published in *De Stijl* several months later. It also separated Lissitzky's work from any taint of Communism and made it acceptable to show in galleries and art societies, such as J. B. Neumann's gallery in Berlin and the Kestner Gesellschaft in Hanover.

The Hungarian critic Ernö Kállai reinforced the separation of *Prouns* from Soviet politics in the first major article on Lissitzky's work to appear in Germany. Published in *Das Kunstblatt*, an art journal of fairly wide circulation, in July 1922, Kállai's article introduced Lissitzky's *Prouns* to a much wider public than would have learned about them from the avant-garde publications *Veshch* or *De Stijl*.[73] After asserting that science and technology had replaced supernatural religion and nature as the dominant belief systems of the time, Kállai argued that art had to demonstrate the same objective clarity and discipline as those new systems in order to claim a relevant position in society. Deriving most of his *Proun* descriptions from Lissitzky's *De Stijl* manifesto, Kállai described Lissitzky's paintings as models of technological qualities, though he declared that they had an identity that was more than utilitarian.[74] In fact, he said, they mirrored aspects of the universe itself.

> A technical planetary system keeps its balance, describes elliptical paths or sends elongated constructions with fixed wings out into the distance, aeroplanes of infinity. Their colouring moves between black and white in shades of intellectual, realistic grey, in which suddenly a single, intense red explodes. The living, *artistic* kernel of the construction opens. What are mere utilitarian purposes beside this overflowing energy and dynamism? . . . Lissitzky says himself, in his introduction to Proun, that this is not an attempt to compete with engineers. Proun should be more than a purely technical sensation.[75]

Kállai, an idealist, read the *Prouns* as analogs for his own vision of the cosmos, just as he had earlier found related qualities in Moholy-Nagy's paintings. In the

72 Lissitzky, "Proun," *De Stijl* 5/6 (June 1922): 81–85.

73 Ernö Kállai, "El Lissitzky," in Lissitzky-Küppers, *El Lissitzky: Life, Letters, Texts*, 379–380. The article appears under Kállai's Germanicized name Ernst.

74 Even though Kállai sought to imbue Lissitzky's paintings with a technological aura, such an argument was still contrary to the views of materialists, like Arvatov and Gan in Russia, who espoused industrial production rather than making art as the work of the artist.

75 Lissitzky-Küppers, *El Lissitzky: Life, Letters, Texts*, 380.

work of both artists, he recognized a concern for order that for him permeated every aspect of life from the technological to the cosmic.

7

The public that first learned of Lissitzky's *Prouns* from Kállai's article would have had to make a considerable shift of context to see them in lithographic form in the large exhibition of Russian art that opened at Berlin's Galerie van Diemen three months later in October 1922.[76] Since 1918, German and Russian officials had talked of exchanging exhibitions between progressive artists of their respective countries, but nothing significant took place until the signing of the Treaty of Rapallo in April 1922, after which an organizing committee in Moscow quickly put the Galerie van Diemen show together. Despite the fact that works by some artists in the exhibition were done before 1917, its thrust was to emphasize those tendencies that followed the Revolution and led up to the current situation.[77] Lissitzky showed work done both in Russia and in Germany. Amidst almost 600 items, his contribution included a suite of lithographs from his first *Proun* portfolio of 1921, as well as sketches for a portfolio of puppet figures from the avant-garde Russian opera *Victory over the Sun*. These were to appear as lithographs the following year.[78]

Although the wide array of artworks in the exhibition were extremely varied in their aims, as a result of negotiations with a cautious German government, Arthur Hollitscher, a left-wing German journalist, claimed in an introductory statement to the catalog that the work in the "1st Russian Art Exhibition" conveyed a strong political force.

> It is no longer the prophetic vision of a single man that carries art forward; now it is the gigantic choice of the people's triumphant spirit, the natural urge of the spirit to rise upward from the primeval depths toward the light of delivered humanity. Theory, born and fostered in the studio, the theory of schools of art, theory that the passage of time has disclosed to be unclear and barely decipherable, is now banished from the purified atmosphere of the victorious Revolution.[79]

Hollitscher's enthusiastic introduction would seem to have been precisely what

76 Scholars believed for some time that Lissitzky had a central function in bringing this exhibition to Germany, but it was subsequently clarified that his role in that enterprise was a modest one. See the statement by Naum Gabo in *Studio International* 182, no. 938 (November 1971): 171; see also Peter Nisbet, "Some Facts on the Organizational History of the van Diemen Exhibition," *The 1st Russian Show*, 67–72. Nisbet rightly points out that Gabo does not mention Lissitzky's design of the catalog cover.

77 This was done by hanging the postrevolutionary modern works on the upper floor which was better lit, so the viewer came away with a stronger sense of them than the works in the darker galleries on the lower floor. See Steven Mansbach, The 'First Russian Art Exhibition' or the Politics and Presentation of Propaganda, *Künstler Austausch/Artistic Exchange: Akten des XXVIII Internationalen Kongresses für Kunstgeschichte, Berlin 15–20 Juli 1992*, ed. Thomas W. Gaehtgens (Berlin: Akademie Verlag, 1993), 1:307–20. Mansbach gives a thorough account of the planning, display, and aftermath of the exhibition.

78 Lissitzky's contributions to the exhibition are listed in the catalog, *1st Russische Kunstausstellung Berlin 1922* (Berlin: Galerie van Diemen, 1922), 25.

79 Arthur Hollitscher, "Statement," in *The Tradition of Constructivism*, ed. Bann, 74.

Soviet cultural administrators wanted from the German Left as part of their strategy to win Western intellectuals to their cause.[80]

In a lecture Lissitzky delivered during the exhibition, he spoke chauvinistically about the exhibited work; he gave no sign of the ambivalence toward the Revolution that characterized his years in Vitebsk and might also be inferred from the variety of exile types and bourgeois Germans with whom he associated in Berlin.[81] The thrust of his argument was that the Russian avant-garde, because of its involvement with large historic forces, could provide guidance for artists in the West.

> Only now do we realize that in Europe the same problems were arising at the same time as in our country. I refer to *De Stijl* in Holland, the new Hungarian movement, Germany, and so on. . . . After the period of great impetus the world is now moving into a stagnant rut. Yet we are sure that our vitality and our instinct for self-preservation will again set all our forces in motion. Then not only our achievements but also our unsuccessful experiments will bear fruit for those masters in every country who are consciously creating.[82]

However, Lissitzky ignored the important distinctions between the aims of the Russian artists and those from other countries who were unlikely to support the Revolution or had refused to do so. Van Doesburg, for example, had clearly separated his expectations for art from any program of political change, while Lajos Kassák and many of the Hungarian *Ma* group were strongly opposed to any state interference with artistic practice. In this lecture, Lissitzky was walking a rather thin tightrope. Although he represented himself as a man who had participated actively in creating new art forms in Russia, he was also attempting to champion an art that transcended political differences, thus taking a stance in opposition to the Russian Constructivists, such as Alexander Rodchenko and Alexei Gan who promulgated an art that signified a specifically communist way of life.

While Lissitzky was abroad he did not consistently state his support for the Revolution and his hopes for Russian artists. As a result, his work remained free of a red taint, and he thus gained a following among German collectors. In early 1923 he had an exhibition at the Kestner Gesellschaft in Hanover where Kurt Schwitters

80 The complex cultural politics of the First Russian Art Exhibition are addressed by Karl Werkmeister in "The 'International' of Modern Art: From Moscow to Berlin, 1918–1922," *Künstler Austausch/Artistic Exchange*, ed. Gaehtgens, 3:553–71.

81 El Lissitzky, "New Russian Art: A Lecture," in Lissitzky-Küppers, *El Lissitzky: Life, Letters, Texts*, 334–44. Lissitzky later gave the lecture in Amsterdam when a version of the exhibition traveled there.

82 Ibid., 344. The statement that avant-garde artists in Russia and the West were addressing similar problems was made earlier by Lissitzky at the Düsseldorf Congress.

83 Lissitzky-Küppers, *El Lissitzky: Life, Letters, Texts*, 34.

84 El Lissitzky, "Prounen Raum: Grosse Berliner Ausstellung 1923," *G: Material zur elementaren Gestaltung* 1/1 (July 1923). English translation in Lissitzky-Küppers, *El Lissitzky: Life, Letters, Texts*, 365. The name G, Lissitzky's idea, was short for "Gestaltung" which connoted the construction or shaping of form. On G's history, see Werner Graeff, "Concerning the So-Called G Group," *Art Journal* 23, no. 4 (Summer 1964): 279–82. Graeff mentions Moholy-Nagy, Kémeny, Kállai, and Péri as participants in the initial meetings that led to G's founding, but he doesn't discuss the significance for German Constructivism of the Hungarians' later split with the journal's editors on political grounds.

initially championed him. According to Sophie Küppers, who arranged the show:

> The members of the Kestner bought a number of works. They need-
> ed no encouragement to be convinced by the new spaces which were
> opening up before their eyes and the dynamic effect of the geomet-
> ric forms floating within those spaces.[83]

This reception of Lissitzky's work was not conditioned by revolutionary rhetoric but by his and Kállai's arguments that the *Prouns* invited new perceptual relationships and embodied cosmic values.

Besides undertaking special projects such as the two lithographic portfolios commissioned by the Kestner Gesellschaft, Lissitzky continued to create and exhibit his *Prouns*. Although the ones he produced in Germany did not differ markedly from those he did in Russia, he made a major breakthrough by extending the *Proun* into real space in the *Proun Space* he designed for the Grosse Berliner Kunstausstellung in 1923 (**FIGURE 2.7**). The lines of force on each wall, expressed by rods and planar shapes, were seemingly presented with the expectation that the room's inhabitant would experience the walls sequentially, but the reliefs also pulled the walls together as the boundaries of a single volumetric space, with the cube on the left wall connecting to the sphere on the center wall and the bars on the right one.

Lissitzky wrote a brief article about the *Proun Space* for a new Constructivist journal, *G*, which was founded by Hans Richter and Werner Graeff and whose first issue appeared in July 1923.[84] There he argued for a space that engaged the human being rather than served as a passive receptacle for paintings and objects. He did not explore the social meaning of this engagement, however, nor did he

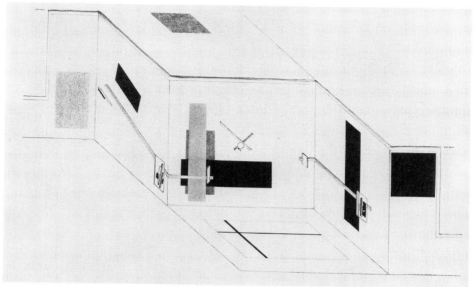

FIGURE 2.7
Lissitzky sketch for *Proun Space*, 1923

discuss any particular function for the room or its potential architectural implications. Instead, he chose to concentrate on the organization of "elementary forms and materials." By this decision, he deferred yet further Constructivism's confrontation with the social life that its proponents spoke of transforming.

8

Lissitzky's separation of his *Proun Space* from the actual situation of daily living was symptomatic of his reluctance at the time to forge links between his revolutionary formal concerns and the utilitarian objects of daily life.[85] As a collaborator on *G*, he did nothing to urge such a connection. *G* defined form broadly, echoing Lissitzky's and Ehrenburg's declaration in *Veshch* the year before that anything could be an object. With a circulation that approximated those of the other small avant-garde journals, *G* reported on the new architectural projects of Mies van der Rohe, the abstract films of Richter and Viking Eggeling, the tone poems of Kurt Schwitters, and Man Ray's photography. At the Düsseldorf congress both Lissitzky and Richter had spoken of the need for artists to change society, yet *G*, which published the work of many progressive artists and architects, focused more on the functional applications of elemental forms than on their potential relation to a social program.[86]

Van Doesburg set this tone in the first issue with his article "Elemental Formation" which focused on the relations between painting, sculpture, and architecture and the definition of each medium's elemental qualities. In the third issue, which did not appear until June 1924, after the initial Constructivist polemics had subsided, Richter stated *G*'s purpose as follows:

> In this sense, *G* is a specialized organ, but one that gathers material that is indeed not specialized but universal for requirements which are both of the time and outside it. How great this need is depends on the extent to which it already appears necessary in all fields, to set out general not merely specialized guidelines.[87]

Richter regarded the strength of the journal as its ability to provide a new outlook to working professionals in various fields, whether physics, engineering, economics, retailing, or manufacturing. He defined *G*'s collaborators:

> All for whom these are matters of necessity, who find utility and pleasure in having something to express in a definite way, are unequivocally able to think in elementarist terms and . . . to create form.[88]

This promotion of a functionalist aesthetic, however, was not to be developed.

85 We can compare Lissitzky's emphasis on the abstract characteristics of the *Proun Space* with the more concrete social statement that Rodchenko made with his interior for a Worker's Club at the Exposition des Arts Décoratifs et Industriels Moderne in Paris in 1925.

86 To judge from a letter Lissitzky wrote to the Dutch architect J. J. P. Oud in 1924, he was dissatisfied with *G*. He agreed with Oud that *G* had nothing new to say and referred to it as "a snobby studio affair" (my translation). El Lissitzky, "Letter to J. J. P. Oud," in El Lissitzky, *Proun und Wolkenbügel: Schriften, Briefe, Dokumente*, ed. Sophie Lissitzky-Küppers and Jen Lissitzky (Dresden: VEB Verlag der Kunst, 1977), 126.

87 Hans Richter, *G*, in *The Tradition of Constructivism*, ed. Bann, 95.

88 Ibid., 96.

With few subscribers and little money, Richter ceased publishing *G* after the third issue, although, in later years, he brought out two more issues that dealt mainly with film problems.

Many informal meetings among artists and architects who sought a new, objective means of expression had preceded the publication of *G*. Out of such discussions—which included van Doesburg, Lissitzky, Gabo, Pevsner, Richter, Hausmann, Graeff, Mies van der Rohe, Moholy-Nagy, Kemény, and Kállai—several different Constructivist factions formed. The group that initially supported *G* included Richter, Lissitzky, and van Doesburg, who were members of the original International Faction of Constructivists and its slightly enlarged version, the Constructivist International Creative Working Group. Others like Graeff, Mies van der Rohe, and Hilberseimer were subsequently attracted to the journal and collaborated as editors and authors.[89]

Opposed to *G* were the Hungarians—Kállai, Kemény, Moholy-Nagy, and the sculptor Péri—who withdrew at an early stage from the deliberations that preceded the first issue. Their decision was no doubt a continuation of the differing views on social engagement that had surfaced in the earlier exchange between the International Faction of Constructivists and members of the *Ma* group. Rather than participate in a publication that was not committed to a revolutionary aim, Kállai, Kemény, Moholy-Nagy, and Péri drew up a manifesto for *Egység*, the revival of which Aladár Komját had spearheaded in Berlin after its demise in Vienna.[90] The authors used this new forum to argue against the "bourgeois traits" of Constructivism which they identified with the "constructive (mechanized) aestheticism of the Dutch Stijl group" as well as with the "technical Naturalism achieved by the Russian Constructivists (the Obmohu group) [sic] with their constructions depicting technical devices."[91] Criticizing what they saw as bourgeois Constructivism, the group propounded a constructive art that emanated from their own communist ideology.[92]

This art would take two forms: unified town plans to meet collective needs, including buildings with forms that expressed the potentialities of new materials, and an architecture that was based on Moholy-Nagy's and Kemény's dynamic-constructive system of forces. The latter proposal was an attempt to generate dynamic buildings from the powerful images of new art forms, replete with formal tensions that the two men had envisioned in their earlier manifesto. The *Egység* manifesto,

89 The editors for the first issue were Graeff, Lissitzky, and Richter. Beginning with the next issue, Mies van der Rohe replaced Lissitzky, thus helping to confirm aesthetic functionalism as a focus for the journal.

90 Ernö Kállai, Alfréd Kemény, László Moholy-Nagy, and László Péri, "Manifesto," in *The Hungarian Avant-Garde: The Eight and the Activists* (London: Arts Council of Great Britain, 1980), 120. Three issues of *Egység* were published in Vienna, after which Béla Uitz no longer particiated; the fourth and fifth were published in Berlin. The manifesto of Kállai, Kemény, Moholy-Nagy, and Péri appeared in the fourth issue, which was devoted to the Proletkult. For an account of *Egység*'s resurrection in Berlin, see Aurél Bernáth, "A Letter from Berlin," in Passuth, *Moholy-Nagy*, 392.

91 Bernáth, "A Letter from Berlin," 392.

92 Despite the manifesto's criticism of De Stijl, Moholy-Nagy nonetheless published Piet Mondrian's *Neue Gestaltung* and van Doesburg's *Grundbegriffe der Neuen Gestaltenden Kunst* as vols. 5 and 6 in the series of Bauhaus Books that he and Walter Gropius began to edit in 1924.

however, was not simply a critique of other Constructivist projects or a plan for new ones. It was actually a response to *Egység*'s proposal for a new proletarian cultural organization. The authors urged artists to fight alongside the proletariat who were active communists. They declared that the new organization should "liberate the proletariat from the oppression of bourgeois culture and must arouse in it a desire for the most developed organization of life, instead of the hunger of the bourgeois intellectuals for culture."[93] There was little in the manifesto that Hungarian artists and writers had not said before in the exile press, but the separation of these goals from the *Ma* group and their presentation in a journal that was oriented toward communist concerns represented a significant change.

Moholy-Nagy was no longer trying to build an international coalition of Constructivist artists as the signatories of the *Ma* manifesto in *De Stijl* had urged. The group of Hungarians who signed the *Egység* manifesto, none of whom any longer supported Kassák, and all of whom were beginning to gain recognition in the German art world as artists and critics, were promulgating a more doctrinaire communist culture, though not specifically a Soviet one, as the inspiration for the new order they envisioned.[94]

The differences between the two Constructivist factions—the group that founded and wrote for *G* and the Hungarians who published in *Egység*—had become extreme. A year earlier it had seemed possible that existing distinctions between the Hungarians and the group around van Doesburg might be accommodated within a cooperative organization. But Richter had translated the idealistic statements of the International Faction of Constructivists into the functionalist focus of *G*, couching his aims within an unexpressed framework of capitalist production, while the Hungarians who initially supported Kassák and *Ma* had splintered into a congeries of radical groups that took various antibourgeois or procommunist positions.

Neither the *G* nor the *Egység* faction could develop the drive to become a major movement. Both journals appeared only a few times and reached limited audiences. The opportunity of Kállai, Kemény, Moholy-Nagy, and Péri to promulgate their position in Germany was severely constrained by the fact that they wrote their manifesto in Hungarian. This restricted it to a small circle of Hungarian émigrés in Germany and a few elsewhere. At the same time, neither van Doesburg nor Richter ever developed significant audiences for their respective journals, *De Stijl* and *G*.

93 Ernö Kallai et al., "Manifesto," in *The Hungarian Avant-Garde*, 120.

94 Ironically, Kállai and Kemény were banned from publishing further in *Egység* because they wrote criticism for the German bourgeois press. In his previously cited article, "From the Avant-Garde to 'Proletarian Art': The Emigré Hungarian Journals *Egység* and *Akasztott Ember*, 1922–1923," Oliver Botar unravels the intricate cultural arguments with Komját that surrounded the publication of this manifesto. See Botar, 43.

95 In Paris, van Doesburg initially devoted himself to the construction of a series of architectural models for the house and gallery of the art dealer, Léonce Rosenberg. Van Doesburg lived in Paris, more or less isolated from the German scene, until his death in 1931. During his Paris years he continued to publish *De Stijl*, which was probably the longest lasting avant-garde journal of the 1920s.

96 Gropius saw Moholy-Nagy's exhibition at the *Der Sturm* gallery in February 1922 and also was well aware

9

The difficulty of publishing these journals was only a symptom of what led to the disintegration of Constructivism's ideological thrust in Germany by the end of 1923. The primary reason was that the nascent movement's principal proponents shifted their energies elsewhere. Before the first issue of *G* appeared, van Doesburg had moved to Paris, perhaps frustrated because he was not invited to teach at the Bauhaus when Johannes Itten resigned.[95] Some months after van Doesburg's departure, Lissitzky discovered that he had pulmonary tuberculosis and had to make plans to recuperate in a Swiss sanitorium. He left for Switzerland in January 1924 and never returned to live in Germany, although he came back periodically to install exhibitions and to visit friends.

In early 1923, Walter Gropius, director of the Bauhaus, invited Moholy-Nagy to replace Itten at the school, and Moholy-Nagy accepted. In the spring of that year he took over the Foundation Course and became Form Master in the Metal Workshop.[96] According to Eva Bajkay-Rosch, a group of Hungarian students at the Bauhaus who had formed a Constructivist group called KURI, influenced Gropius's decision to hire Moholy-Nagy.[97]

Gropius derived his understanding of Constructivism from the discourse in Germany, which was largely shaped by the arguments and proposals put forth in *De Stijl*. Moholy-Nagy gave no evidence in his German writings, particularly those which appeared in *De Stijl*, that he was publishing radical manifestos in Hungarian calling for Constructivists to lead a proletarian revolution.[98] In any case, he ceased to publish such documents after his appointment to the Bauhaus, where he concentrated on design and photography as well as painting.

By the end of 1923, other artists in Germany were also painting abstract geometric compositions, but none made the same social claims for their work as van Doesburg, Moholy-Nagy, and Lissitzky had.[99] Despite such claims, however, the initial Constructivists could not anchor their art in fixed ideological frames unless they controlled the discourse that surrounded it, a function that the avant-garde journals served. When the work was produced or exhibited outside the orbit of these journals, others could easily fit it into different critical frameworks, particularly since the reductive geometric language the artists used lent itself easily to multiple interpretations.

Two articles of 1924 by critics who attempted to sum up Constructivism and

of van Doesburg's work in Weimar. He might have considered van Doesburg for the Bauhaus when Itten left, but, like the school's Council of Masters, who had to approve new faculty, he was concerned that van Doesburg's personality would be too dominant.

97 Eva Bajkay-Rosch, "Hungarians at the Bauhaus," *ICSAC—Cahier* 6/7 (1987): 100–101; and "Die KURI-Gruppe" in *Wechselwirkungen*, ed. Gassner, 260–266. According to Lothar Schreyer, a member of the Council of Masters at the time, Gropius proposed Moholy-Nagy to the council as a candidate, and they supported him. See Schreyer's memoir *Errinerungen an Sturm und Bauhaus: Was ist des Menschen Bild?* (München: Albert Langen, Georg Müller, 1956), 237.

98 The Hungarian members of the KURI Group at the Bauhaus may have known these, however.

99 For an account of the various forms of painterly Constructivism in Germany during the 1920s, see Brigitte Lohkamp, "Malerei," in *Deutsche Kunst der 20er und 30er Jahre*, ed. Erich Steingräber (München: Bruckmann, 1979), 164–82.

the tendencies that led to it can enhance our understanding of these ideological shifts. Writing in the March 1924 issue of *Das Kunstblatt*, Paul Schmidt defined Constructivism as a phenomenon common to many countries just after the war. Its impulse, he said, sprang from a reaction against "the formlessness and anarchy of subjectivism" and from "the necessity to put an end to all romantic feeling and vagueness of expression."[100] It was the art form, he said, whose style corresponded to all the matter-of-fact technological products of the time—bridges, ships, cars, and other artifacts made without artistic pretension. In the future, Schmidt predicted, paintings would take their forms much more from the machine. Constructivist art was in advance of an epoch that was not yet ready to provide tasks for it. More than a style, Constructivism was a presence that would provide a form for all of life.

Schmidt paid little attention to what the artists themselves had said about their work; nor was he able to trace a clear lineage of artistic tendencies related to Constructivism. He named Moholy-Nagy as a leading exemplar of Suprematism, for example, and defined that movement as a play of colored light on white surfaces.[101] Schmidt's article was less a discussion of the issues that van Doesburg, Lissitzky, and Moholy-Nagy had defined than a polemic in which he projected his hopes and expectations for the machine age onto this new art.

Ernö Kállai gave a more articulate and comprehensive summary of Constructivism in an article he wrote the same year for the *Jahrbuch der Jungen Kunst*.[102] Unlike Alfréd Kemény who had begun to look critically at the work of Moholy-Nagy, Lissitzky, and other abstract artists through the doctrinaire lens of the German Communist party,[103] Kállai hailed Constructivism as one of the two radical paths, along with Expressionism whose opposite it was, that led beyond the narrowness of individual feelings about life.

Where Expressionism tried to develop "with the boundlessness of individual

100 Paul Schmidt, "Konstruktivismus," *Der Kunstblatt* 8 (March 1924): 83 (my translation).

101 Kemény corrected Schmidt's mistake in a short observation he published in a subsequent issue of *Das Kunstblatt*. He also used the same occasion to criticize Moholy-Nagy sharply, thus making public the split that occurred between them after Moholy-Nagy joined the Bauhaus and he the KPD. "It is noteworthy," he wrote, "that Moholy, who up to now has converted Constructivism into objective unauthorized self-propaganda, should in 1924 be called a Suprematist, since the real Suprematism was finished in Russia in 1919. Moholy, as an eclectic and a follower, has had as little part in the essential results of the new constructive art as of Suprematism." Alfréd Kemény, "Bemerkungen," *Das Kunstblatt* 8, no. 6 (1924), in *Wechselwirkungen*, ed. Gassner, 239 (my translation). Moholy responded in a letter to Paul Westheim, editor of Das Kunstblatt: "My work at the Bauhaus is concerned with translating my concept of contemporaneousness into form and word. This is so big a task that it leaves me no time to worry about its interpretation from without. Whatever the quality of my oil paintings and my sculptures might be, I am satisfied that I am given the privilege—rare to anyone—to translate revolution into material reality. Compared to this task, the fiddling of Kemeny and others about priorities is quite irrelevant." László Moholy-Nagy quoted in Sibyl Moholy-Nagy, *Moholy-Nagy: Experiment in Totality* (Cambridge, MA: MIT Press, 1969 [c. 1950]), 43. Hans Richter also made reference to Schmidt's mistaken characterization of Moholy-Nagy as a Suprematist, but he did so as a prelude to his own criticism of Moholy-Nagy as an opportunist, suggesting that Moholy might have more luck as a Suprematist than as a Constructivist. Hans Richter, "An den Konstruktivismus," *G: Zeitschrift für Elementare Gestaltung* (June 1924), cited in *Konstruktivistische Internationale Schöpferische Arbeitsgemeinschaft, 1922–1927*, ed. Finkeldey et al., 308.

102 Ernö Kallai, "Konstruktivismus," *Jahrbuch der Jungen Kunst* (1924), in *Wechselwirkungen*, ed. Gassner, 163–67 (my translation).

moments of feeling and visions," Constructivism was imbued "with the will to the most outward objectivity, economy, and conscious precision."[104] Kállai restated a critique of the Dutch and Russian Constructivists that had appeared in the *Egység* manifesto of 1923, which he signed with Moholy-Nagy, Kemény, and Péri, but he did so without the call for a new art based on communism that he and his colleagues had made the year before.

A major point of Kállai's article was that Constructivism had developed obstacles in its attempt to establish a connection to daily life. A choice had to be made. Opposing the *artistic* construction of everyday objects, which was the aim of the Russian Productivists, he argued that if one were to make objects of use, then one should take a utilitarian approach and leave aesthetic concerns behind.[105] As examples, he cited architectural designs by Oud, Mies van der Rohe, Hilberseimer and others as well as the work of engineers. Surprisingly, this point of view was not so far from the functional aesthetics that *G* was promoting, despite the fact that Kállai had earlier refused to follow that direction.

Kállai did not agree with the Russian Productivists that art was no longer valid in itself. He envisioned a distinct sphere for art but stated that the artist had to know where the boundaries of artistic purpose were. He wanted art to be significant and not simply made for its own sake, a point of view that was clearly evident in his earlier articles on Moholy-Nagy and Lissitzky. Like Moholy-Nagy, Kállai believed that experimentation with new materials such as glass, plastic, concrete, and iron was one way to achieve this significance.

In essence, Kállai was now representing Constructivism as a sensibility of rationality, economy, and precision. It could be manifested in art as well as applied in various media such as film, photography, typography, and stage design.[106] This was a considerable shift from his prior support for a communist art that could liberate the proletariat. It did, however, accord with the wide appropriation of Constructivism in Germany as an aesthetic of functionalism in architecture and design.

Constructivism was the basis for the "new typography," which the typographer and advertising artist Jan Tschichold promoted to the German printing industry beginning in 1925.[107] It also shaped the international architectural style that dominated the Weissenhof Siedlung in Stuttgart which Mies van der

103 See Alfréd Kemény, "Die abstrakte Gestaltung vom Suprematismus bis heute," *Das Kunstblatt* (1924), in *Wechselwirkingen*, ed. Gassner, 234–38.

104 Kallai, "Konstruktivismus," 163.

105 Here Kállai echoed an argument of Naum Gabo which Gabo may have made to him in Berlin. Before leaving Russia, Gabo told a group of his colleagues who were praising Tatlin's Monument to the Third International, "Either build functional houses and bridges or create pure art or both. Don't confuse one with the other. Such art is not pure constructive art but merely an imitation of the machine." Naum Gabo, quoted in Kenneth Frampton, *Modern Architecture: A Critical History*, rev. ed. (London: Thames and Hudson, 1985 [c. 1980]), 169.

106 In several concurrent articles, Kállai continued to champion Moholy-Nagy and Lissitzky who both embodied his call for an art that represented the contemporary spirit. See Ernö Kallai, "Ladislaus Moholy-Nagy," *Jahrbuch der Jungen Kunst* (1924): 181–87; and "El Lissitzky," in ibid., 304–9.

107 See Tschichold's special issue of the German printing journal *Typographische Mitteilungen* (October 1925) entitled "Elementare Typographie."

Rohe organized for the Deutscher Werkbund in 1927, and it influenced as well the functionalist aesthetic in industrial design that Moholy-Nagy and Marcel Breuer promulgated at the Bauhaus.[108]

After joining the Bauhaus faculty, Moholy-Nagy, like Kállai, began to promote clarity and objectivity as qualities that the art and design of technological society should possess. Lissitzky, too, ceased to argue for a socially transforming Constructivism after he left Germany at the beginning of 1924. That year, while in Switzerland recuperating from tuberculosis, he and Hans Arp edited *Die Kunstismen* (The Isms of Art), a book in which they established categories for the major art movements of the prior decade and assigned specific artists to each category. They classified neither van Doesburg, Moholy-Nagy, nor Lissitzky himself under Constructivism.[109] In short, Moholy-Nagy and Lissitzky defined and redefined their work, grouped and regrouped it, according to shifting strategies which could be as different from each other as van Doesburg's call for a new apolitical plastic art and the radical Hungarian definition of Constructivism in *Egység* as a force to transform communist culture.

What is evident from these shifts of definition and classification is that Constructivism in Germany had no fixed center or process of debate to facilitate a confrontation of conflicting views. Yet, for those who called themselves Constructivists during this time, the rubric still represented their hopes for a new society, whether the emphasis was on the spirit, science and technology, or political transformation. Because Constructivist forms were radically different from the art that preceded them and neutral enough to allow multiple interpretations, they provoked an extensive discourse about aesthetics, politics, and modernity. But this discourse was short-lived because it was not anchored closely enough in concrete formulations of the issues. In an article on abstract art, which he wrote for *Das Kunstblatt* in 1924, Alfréd Kemény, who had championed a dynamic abstract art with Moholy-Nagy but then split with him to espouse a socially engaged figurative art, said:

> The most revolutionary abstract works of west european artists are conservative when measured against the Russian results. We have to look for the revolutionary character of west european art on another

108 John Willett discusses these developments and related ones within a larger social context in *Art and Politics in the Weimar Period: The New Sobriety 1917–1933* (New York: Pantheon, 1978).

109 Lissitzky and Arp only identified Russians as Constructivists: Gabo, Tatlin, the Russian OBMOKhU group, and the architect Nikolai Ladovsky. Lissitzky placed himself under the heading Proun, van Doesburg was classified under neoplasticism, and Moholy-Nagy was identified as an Abstractivist, along with Kandinsky, Péri, Rodchenko, Peter Miturich, Nathan Altman, Liubov Popova, Hans Arp, Arthur Segal, and Johannes Molzahn. See El Lissitzky and Hans Arp, *Die Kunstismen* (Erlenbach-Zürich: Eugen Rentsch Verlag, 1925).

110 Alfréd Kemény, "Die abstrakte Gestaltung von Suprematismus bis heute," in *Wechselwirkungen*, ed. Gassner, 235 (my translation). As examples of relevant artists, Kemény cited members of the KPD's "Rote Gruppe" (Red Group): John Heartfield, George Grosz, Rudolf Schlichter, and Otto Dix. He criticized Lissitzky's *Prouns* as being "laboratory work." They were, he said, only for a small circle of interested specialists and were hardly preparations for life. Moholy-Nagy was not even mentioned in the article

111 As early as May 1923, Gustav Hartlaub, director of the Mannheim art gallery, announced his plan to stage an exhibition of realist art entitled "Neue Sachlichkeit," which took place in the summer of 1925.

level. The artists on this level do not flee from the decaying reality of social life into abstraction.[110]

Whether from the artists and critics on the Left or those of the middle-of-the-road Neue Sachlichkeit tendency, the desire for a new art of social reality began to spread.[111] Abstraction did not disappear, but it became a more formal practice as the decade advanced. Constructivism had crystallized utopian aspirations for a new world order, but it could not generate a compelling discourse on what that order should be like. And thus its moment passed.

The creation of a new type of artist-constructor who had no precedent in Tsarist Russia was an extremely difficult objective.
Alexander Rodchenko (n.d.)[1]

For me and all the group, Professor Rodchenko was the man who taught us to understand the contemporary situation in a creative and concrete way. He indicated and revealed anew our place in production art. As a man with advanced ideas and creative ability in many fields, he taught us a lot.
Zakhar Nikolaevich Bykov (n.d.)[2]

Let the man in the street spit with disgust at the iron constructive power of Rodchenko's construction.
Osip Brik (1923)[3]

In an exhibition entitled "5 x 5 = 25," organized within Moscow's Institute for Artistic Culture (INKhUK) in September 1921, Alexander Rodchenko showed, among other works, three monochromatic canvases, whose surfaces were each solidly covered with a different primary color—red, yellow, or blue. The exhibition, which included four other artists—Alexandra Exter, Liubov Popova, Rodchenko's wife Varvara Stepanova, and Alexander Vesnin—was mounted amidst fervent debates at INKhUK about the relevance of art in postrevolutionary Russia. Rodchenko's stark canvases marked an end to his formal research. They were his declaration that pure art could go no further as a revolutionary practice.

1 Alexander Rodchenko, "Autobiography," quoted in Selim O. Khan-Magomedov, *Rodchenko: The Complete Work*, intro. and ed. Vieri Quilici (Cambridge, MA: MIT Press, 1987), 171.

2 Zakhar Nikolaevich Bykov (VKhUTEMAS student), "Working with Rodchenko," in *Alexander Rodchenko*, exh. cat., ed. David Elliott (Oxford: Museum of Modern Art, 1979), 107.

3 Osip Brik, "Into Production," in *Alexander Rodchenko*, ed. Elliott, 131.

Two months after the exhibition, twenty-five artists affiliated with INKhUK, of whom Rodchenko was most probably one, accepted the proposition of Osip Brik, a leading INKhUK theorist, to abandon the terrain of pure art and commit themselves to working in industry.[4] They took "production art," defined as the formation of useful objects, to be the purpose of artistic activity and declared that Constructivism was its sole form of expression.

Shortly afterward Rodchenko became the deputy head of the Metfak (Metalwork Faculty) at the VKhUTEMAS, where he had been teaching since its inception.[5] There he sought to develop a pedagogy that would train students to produce the kinds of new objects that he believed a revolutionary society required. He also began to work on designs himself. Within a few short years his own work had broadened to include advertising posters and logotypes, book and magazine covers, film titles, furniture, workers' club interiors, and film and theater sets.

But, despite this activity, Rodchenko and other Constructivists who entered the sphere of production in the years of the New Economic Policy (NEP) between 1922 and 1927 found few opportunities for practical work with industry.[6] New methods of industrial production and distribution remained underdeveloped. Therefore the Constructivists were rarely hampered by marketing demands as they sought other opportunities—theater and film sets, film titles, commercial and cultural posters, magazines, and books. Their clients ranged from avant-garde theater directors to publishing houses, film companies, and state factories and trusts. Due to the party's decision to allow a wide range of artistic initiatives during the NEP period, the artists encountered few restrictions of style, a situation that gave them the space to invent new applied forms according to their own values.[7]

Because most of the design projects that the Constructivists undertook were in the arts rather than industry, we need to rethink their own claim that social utility was the purpose of this work. Although much of their work was artistic

4 The likelihood that Rodchenko was a signatory is strongly suggested by Christina Lodder, *Russian Constructivism* (New Haven: Yale University Press, 1983), 90.

5 The major work on the VKhUTEMAS is Selim O. Kahn-Magomedov, *Vhutemas: Moscou 1920–1930*, 2 vols. (Paris: Editions du Regard, 1990). See also Vahan D. Barooshian, "Vkhutemas and Constructivism," *Soviet Union* 3, part 2 (1976): 197–207; Szymon Bojko, "Vkhutemas," in *The Avant-Garde in Russia, 1910–1930: New Perspectives*, ed. Stephanie Barron and Maurice Tuchman (Los Angeles: Los Angeles County Museum of Art, 1980), 78–83, and Christina Lodder, "The Vkhutemas and the Bauhaus," in *The Avant-Garde Frontier: Russia Meets the West, 1910–1930*, ed. Gail Harrison Roman and Virginia Hagelstein Marquardt (Gainsville: University Press of Florida, 1992): 196–240.

6 Among the rare projects done by avant-garde artists for factories were the textile designs by Liubov Popova and Varvara Stepanova for the First State Textile Print Factory and the Suprematist decorations and designs for ceramics by Kazimir Malevich, Ilya Chashnik, and Nikolai Suetin for the Lomonosov Factory. A few avant-garde artists besides Rodchenko, Tatlin, and Lissitzky, e.g., taught at the VKhUTEMAS, but little work done at the school was put into production by the time it closed in 1930, even though faculty and students had generated a number of prototypes.

7 On Soviet cultural policy during the NEP years, see A. Kemp-Welch, "'New Economic Policy in Culture' and Its Enemies," *Journal of Contemporary History* 13 (July 1978): 449–465; and Sheila Fitzpatrick, "The Soft Line on Culture and Its Enemies," in Fitzpatrick, *The Cultural Front: Power and Culture in Revolutionary Russia* (Ithaca: Cornell University Press, 1992), 91–114. Fitzpatrick argues that "the line was neither liberal nor non-Communist, as its opponents believed, but the product of a policy of expedient accommodation with the intelligentsia, on non-negotiable terms laid down by the party leadership and without institutional guarantees" (91).

collaboration rather than design for the marketplace, it was nonetheless important for the Constructivists because it helped them develop an understanding of how to apply their artistic knowledge to practical purposes. Unlike designers in Germany, for example, they had no models of industrial design or advertising art that could rival the tradition of Russian engineering design that extended from Krasnapolsky's suspension bridge over the Great River at Ostrov (1851–53) to Shukhov's Briansk railroad station in Moscow (1912–1917).[8]

The Constructivists were thus inventing a new profession, the artist-constructor. Along with the theorists of production art, they advanced this model without any accountability or reference to prior forms of design practice.[9] What had preceded them in the name of applied arts reform were the late nineteenth-century attempts at a craft revival promoted by the merchant Sasha Mamontov and by Princess Tenisheva at their respective estates Abramtsevo and Talashkino, and, around the turn of the century, the *Mir Iskusstva* group's use of folk art for theater decor and their application of eighteenth-century decorative ornamentation for book designs.[10]

The Constructivists could reject these initiatives on numerous political, economic, technical, and aesthetic grounds. They were not undertaken *by* the proletariat nor were they *for* the proletariat; they were based on individual craft techniques rather than machine production; and they looked nostalgically backward to the tastes of the peasants and the aristocracy rather than forward to the culture of a new social class.

Had the Constructivists and theorists who forged the ideology of production art known more about the attempts abroad to unite art and industry, such as the formation in Germany of the Deutscher Werkbund in 1907, they might have gained a better perspective on their efforts.[11] But they believed that the postrevolutionary situation in Russia was entirely new and called for a completely different strategy of design from any employed before.

As the Constructivists and production art theorists saw it, the Revolution had created a new proletarian class who badly needed functional objects. But these

8 See John Bowlt, "One Engineer Is Worth More Than a Thousand Esthetes: Some Thoughts on the Origins of Soviet Constructivism," *The Structurist* 21/22 (1981/82): 57–65. Bowlt's claim for a continuity between Russian engineering and Constructivism does not pay sufficient attention to the distinct ideological formation of the Constructivists. He suggests links between engineering projects and Constructivist art based on formal similarities between objects rather than congruities of political intention.

9 In his book *Soviet Science, Technology, Design: Interaction and Convergence* (London: Oxford University Press, 1976), Raymond Hutchings cites only one noteworthy example of Russian design before the Revolution—the first icebreaker, a technology-driven vessel built in England after an idea of Admiral Makarov.

10 These developments are discussed in Camilla Gray, *The Russian Experiment in Art, 1863–1922*, rev. and enlarged ed., ed. Marian Burleigh-Motley (London: Thames and Hudson, 1986 [c. 1962]), 11–27, 37–57.

11 The role of the artist in industry was heatedly debated at the Werkbund's Cologne exhibition in 1914. The debate was polarized by the *Propositions* of Hermann Muthesius, who argued for the standardization of industrial forms, and the *Counter-Propositions* of Henry van de Velde, who defended the need for continued artistic invention. The debate is discussed in Joan Campbell, *The German Werkbund: The Politics of Reform in the Applied Arts* (Princeton: Princeton University Press, 1978), 57–81; and the key documents are reproduced in *Documents: A Collection of Source Material on the Modern Movement*, ed. Charlotte Benton (Milton Keynes: Open University Press, 1975), 5–11.

objects also required an innovative formal language to distinguish them from those that had belonged to other classes such as the peasants or the aristocracy. When Nikolai Tarabukin or Boris Kushner, both theorists at INKhUK, described the artist-constructor as someone who would combine the tough formal values of Constructivism with an understanding of technology to produce a new kind of industrial product, they were inventing an argument for a type of designer who was untested in practical situations.[12]

Within the narrative they proposed, and here I use the term narrative to signify the course of action they envisioned for this new type of designer, the artist-constructor was to transmit his or her values through mass-produced objects.[13] What made this narrative a revolutionary one was the emphasis on the proletariat as the consumer class and the conviction that the objects themselves would embody values consistent with the goals of the Revolution. When the Constructivist artists began to enact this narrative in the NEP years through their teaching at the VKhUTEMAS, their advertising work for the state trusts, their attempts to work with industry, and their collaborations with filmmakers, theater directors, and publishers, they saw themselves as the inventors of a new culture whose values they wanted others to share. This was a distinctly rhetorical objective. We can therefore interpret Rodchenko's work as a designer during the NEP years most effectively as an attempt to create a new narrative of design for a revolutionary society.

The progression of this narrative as it is usually understood is that the Constructivists considered their experiments with form, materials, and color to be a transition or laboratory phase between easel art—painting and sculpture associated with the middle and upper classes—and production art—a practical activity intended to further the aims of the Revolution. As the historian Selim Khan-Magomedov said of Rodchenko's three monochromatic paintings in the "5 x 5 = 25" exhibition, "Only with these works did he [Rodchenko] reach the end of his researches in the field of pictorial representation and shift his interest towards the construction of *real objects* (italics mine)."[14]

This line of reasoning suggests that Rodchenko's abandonment of formal art was an act which led him to make objects that represented a greater engagement with social life. What requires elucidation, however, is the degree to which production art as the Constructivists engaged in it addressed social needs or remained an experimental activity whose aim was more rhetorical than practical.[15] The

12 For a discussion of production art theories, see Lodder, *Russian Constructivism*, 100–108. The role of Osip Brik, a key figure who promoted these theories within INKhUK, is elaborated in Vahan D. Barooshian, *Brik and Mayakovsky* (The Hague: [Noordeinde 41]; New York: Mouton, 1978), 43–72.

13 Though much of the literature on the theory of narrative pertains to literary texts, we can find a related concept of social narrative in performance theory, which conceptualizes social behavior as a type of drama. Performance theory provides a useful framework for interpreting rhetorical action, which is the aim of this essay. An excellent book that lays the groundwork for later developments in performance theory is Kenneth Burke's *A Rhetoric of Motives* (Berkeley: University of California Press, 1969 [c. 1950]).

14 Khan-Magomedov, *Rodchenko: The Complete Work*, 106.

15 Even if we conclude that this was the case for Rodchenko's work as an artist-constructor, it would still fall within the project of the avant-garde to integrate art and life. Peter Bürger in *Theory of the Avant-Garde* (Minneapolis: University of Minnesota Press, 1984) sees the avant-garde distinguishing itself from estheti-

importance of this distinction is paramount, particularly for assessing the way Rodchenko defined and sought to advance the aims of the Revolution through the narrative of the artist-constructor.

What remains unclear in the INKhUK theorists' binary opposition of utilitarian and nonutilitarian objects is their definition of "utility," which was never discussed in terms of specific user needs. To distinguish between pure art and production art according to the criterion of utility was also to privilege a production model of design that limited the interpretation of objects either to their *exchange value*—their role in the process of economic exchange—or their *use value*—the practical purposes to which they were put.[16] Pure art was useless because it didn't have a practical purpose, and production art or design was useful because it did.

The INKhUK theorists believed production art to be utilitarian and therefore more meaningful. But their reductive definition of "utility" closed out the ground on which a broader definition of rhetoric could be argued. The articulation of such a demonstrative rhetoric was certainly inherent within the project of Constructivist art.[17] By rethinking the opposition between nonutilitarian and utilitarian art which the INKhUK theorists posed, we can discern a new rhetorical continuity between Rodchenko's Constructivist paintings, drawings, and sculpture and the work he did as a production artist. We can then give Rodchenko's work as an artist-constructor in the NEP years a fuller rhetorical dimension, holding it less accountable for the satisfaction of current needs and recognizing it instead as an argument for new values.[18]

Implicit in the Constructivists' urge to move from nonutilitarian to utilitarian

cism by attempting to merge art and life. I would argue that Rodchenko brought the rhetorical function of art closer to lived experience but never intended to drown it in utilitarianism.

[16] Jean Baudrillard has added a third term to the theory of value—*sign* value. Baudrillard argues that signification is a function with a life of its own in a society where signs are unfettered from a connection to actual objects. See Baudrillard's essay "Design and Environment," in his book *For a Critique of the Political Economy of the Sign* (St. Louis: Telos Press, 1981), 185–203. His theory of sign value is useful in understanding the rhetorical operation of Rod-chenko's designs.

[17] Richard McKeon provides an excellent discussion of demonstrative rhetoric and its potential in his essay "The Uses of Rhetoric in a Technological Age: Architectonic Productive Art," in Richard McKeon, *Rhetoric: Essays in Invention and Discovery*, ed. Mark Backman (Woodbridge, CT: Ox Bow Press, 1987), 1–24. McKeon states, "The field of demonstrative rhetoric should provide the grounds for discovery and invention, going beyond the bounds of what is already known and the fields of that knowledge." One can think of no better description to characterize Rodchenko's goal as an artist-constructor. McKeon's concept of demonstrative rhetoric is a thematic development of epideictic rhetoric, one of Aristotle's three rhetorical categories. We can contrast this rhetorical reading of Constructivist objects with the psychoanalytic one employed by Christina Kiaer in her article, "Rodchenko in Paris," *October 75* (Winter 1996): 3–36. Kiaer presents provocative, though as she notes "fragile," claims that Rodchenko's Worker's Club, as well as other projects, reflect a tension between overt political argument and repressed personal fantasy. There is much to consider in Kiaer's reading although its value to an understanding of Rodchenko would be enhanced by bringing it into closer relation with his rhetorical intentions.

[18] Richard Buchanan has discussed the rhetorical function of objects in "Declaration by Design: Rhetoric, Argument, and Demonstration in Design Practice," which is included in *Design Discourse: History Theory Criticism*, ed. and with introductory and closing essays by Victor Margolin (Chicago: University of Chicago Press, 1989), 91–109. As Buchanan states, "Most important, however, is the idea of argument, which connects all of the elements of design and becomes an active engagement between designer and user or potential user" (95). He defines the three elements of a design argument as technological reasoning, character, and emotion. For Rodchenko, character was the most important element, next was technological reasoning, and then emotion. **85**

art was their ambition to make forms which would empower people to change according to a model of revolutionary behavior. While production artists like Rodchenko were concerned with function, they also paid great attention to the way objects embodied arguments for particular types of actions.[19] The objects of Rodchenko and his students embodied rhetorical arguments for a new kind of individual who was to possess the qualities of discipline, directness, and clarity as well as the ability to interact creatively with the things of the material world. It was for this hypothetical individual that Rodchenko developed his design program instead of gearing his projects to the prevailing public taste.[20] This does not mean that he was not interested in mass production; it was a consideration that informed a number of his and his students' designs. But he was also concerned with embodying in designed objects a rhetorical emphasis that would convey the qualities of character he valued in the ideal Soviet citizen. Rodchenko developed a new kind of pedagogy to produce designers who could deal with the issues of rhetoric as well as function. He also conceived a strategy of presenting new prototypes to the public to promote their acceptance. This was done through rhetorical occasions, moments of presentation, which were either exhibitions, films, or plays. Where production was possible, particularly in book design and advertising art, Rodchenko introduced a new formal language to give a strong rhetorical argument to the statements of his clients.

His applied projects fall into several distinct spheres of activity—publications, film titles, advertising posters, furniture, film and theater sets—while the projects he gave his students include a wide array of useful objects from teakettles to folding beds. In each sphere of design activity, Rodchenko joined with fellow artists to fight against objects he perceived to be outmoded or socially irrelevant. His collaborators were filmmakers, poets, theater and film directors, and architects— filmmaker Dziga Vertov and his *kinoki*, the film director Lev Kuleshov, the poet Vladimir Mayakovsky and the *Lef* group, and the Rationalist architect Konstantin Melnikov. Rodchenko wanted to inscribe the values of a new culture in the forms he and his compatriots produced. Our concern here is to assess his design strategies and their results to better understand whether he marginalized the functional purpose of utilitarian objects or expanded the rhetorical terrain of art.

19 This actually worked in the theater where the sets by Liubov Popova for *The Magnanimous Cuckold* or Varvara Stepanova for *The Death of Tarelkin* defined the spaces in which Meyerhold's actors moved according to his theory of "bio-mechanics." We can consider these movements as a new form of action that was facilitated by the sets. The ambition to make objects into instruments of change might have been achieved in the theater where the director could control the movement of the actors, but trying to create the same effect in real life was another issue.

20 This approach can be contrasted with the more market-oriented one of Peter Behrens, who was the design director of the AEG, the large electrical conglomerate in Berlin, between 1907 and 1914. As one example of this difference, Behrens redesigned AEG's line of electric teapots in a wide variety of shapes and finishes to allow the customer a latitude of choice. A thorough discussion of Behrens at the AEG can be found in Tilmann Buddensieg and Henning Rogge, *Industriekultur: Peter Behrens and the AEG*, trans. Iain Boyd White (Cambridge, MA: MIT Press, 1984).

21 G. D. Chichagova, "Vkhutemas," in *Alexander Rodchenko*, ed. Elliott, 106.

22 Ibid.

23 For discussions of Rodchenko's role at the VKhUTEMAS, see Lodder, *Russian Constructivism*, 109–40; and Khan-Magomedov, *Rodchenko: The Complete Work*, 102–5 and 168–78.

2

"A man walked into the studio, he looked from his appearance like a combination of pilot and motorist. He was wearing a beige jacket of military cut, Gallifet-breeches of a grey-green color, on his feet were black boots with grey leggings. On his head was a black cap with a huge shiny, leather peak . . . I immediately saw that this was a new type of man, a special one."[21] Thus did Galina Chichagova, a young art student at the VKhHUTEMAS, recall Alexander Rodchenko, her teacher in the school's Basic Course. Through his potent sartorial statement, Rodchenko represented himself as an artist fully engaged with the modern world. The straight cut of his jacket, the firm leather of his boots with their glistening sheen, the tightness of his leggings, all signified the precise disciplined way he produced his art.

Chichagova had an analogous impression of Rodchenko's paintings which she and other students viewed at the Nineteenth State Exhibition in 1920:

> Nobody who has not seen Rodchenko's paintings of that period can imagine how strong the impression they create is. There was something thrilling, staggering in them.[22]

Rodchenko wanted the strength and toughness of his paintings to characterize every object, whether a still life he set for his students or his project for the design of a proletarian teakettle. Initially he collaborated at the VKhHUTEMAS in the development of the Basic Course and headed one of the course's divisions. In 1922 he became deputy head of the Metfak and later taught artistic design in the Dermetfak, a studio formed in 1926 through an amalgamation of the Metfak and the Derfak (Woodwork Faculty) (FIGURE 3.1). Until the VKhHUTEMAS closed in 1930, it provided Rodchenko with a basic salary that enabled him to undertake numerous experimental projects.[23] Being there also afforded him the opportunity to develop methods for training a new generation of Soviet designers.

The VKhHUTEMAS inherited its metalworking facilities as well as some of its faculty from the Stroganov School of Applied Arts which followed a very traditional craft approach. Rodchenko's first task in the Metfak was to revamp this old style of decorative metalworking. He tried to persuade the Stroganov faculty and students to exchange their interest in handcrafted jewelry and decorative objects for a new way of working with metal, seeking a technique that stressed the material's structural and surface qualities and would result in stronger simpler forms.

Rodchenko's aim was twofold: to change the methods of metalwork and to devise design projects for new objects. Initially he maintained the concept of the craftsman in his program, intending that artist-constructors should be able to make metal objects themselves. There were two reasons for his emphasis on techniques of construction. First, the artist-craftsman as a protodesigner who made objects provided the only model of design practice, aside from engineering, that existed prior to the VKhHUTEMAS; and second, Soviet industrial managers, either

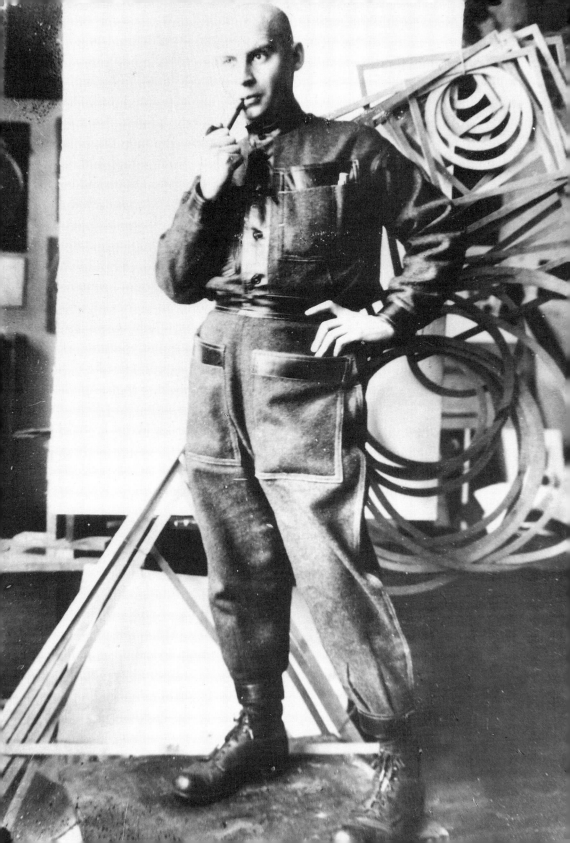

those specialists from the old system or the party members who were beginning to take over the factories, had no experience with other kinds of practice, particularly those where the designer would propose drawings and models for the factory staff to put into production.

Among the skills Rodchenko sought to develop in the Metfak students were drawing objects from different perspectives, constructing scale models and full-scale prototypes, and finishing surfaces.[24] The kinds of objects the students began to design varied significantly from those created through the Stroganov approach, which were mainly decorative in style. The initial assignments in the Metfak derived primarily from the range of projects that previously fell within the purview of craftsmen in wood and metal. These were essentially objects for domestic use, although later Rodchenko broadened the students' briefs to include objects for public buildings such as workers' clubs.

The sharpest difference between Rodchenko's design strategy and that of the Stroganov teachers, however, centered on methodology rather than end products. For Rodchenko, design was not a matter of aesthetics; instead, it was a synthesis of ideological, theoretical, and practical factors. The combination of purpose, technique, and material formed the political process of object production. Through this process, Rodchenko put a value on particular aims he believed were truly proletarian while he identified others that were not. For him, the construction of objects was not an expressive process but one based on a universal method or system. He presumed that certain materials would signify communist values by their reference either to communist purpose or methodical construction; that is, carved wooden furniture would not be appropriate, but machined mass-produced pieces would. In his formulation, the design problem itself and the way of solving it were both demonstrations of communist character.

Rodchenko's belief in an ideal user who was alert, purposeful, and precise led to his interest in objects with multiple functions which required a creative intelligence to manipulate. Besides the traditional projects for spoons, pots, and door handles, he assigned his students in the Metfak projects for flexible beds, chairs, and storage cases.[25] Multifunctional furniture had a rhetorical meaning for Rodchenko through its demonstration of a potential for action. Users would realize this potential by interacting meaningfully with the objects rather than relating passively to them.[26]

24 See "Professor A. M. Rodchenko's Programme for Metal Object Design at the Faculty of Wood- and Metalwork," in German Karginov, *Rodchenko*, trans. Elisabeth Hoch (London: Thames and Hudson, 1979), 171.

25 These projects can be related to Rodchenko's earlier hanging sculptures with moving parts (see figure 1.3). The movement changed the sculptures from flat shapes to volumetric ones as the parts shifted positions in relation to each other. It was through these sculptures that Rodchenko first articulated the concept of flexible form which was central to the furniture projects of many of his students.

26 Rodchenko's emphasis on interactivity between objects and users marked a shift from the earlier speculative objects he designed as a member of Zhivskul'ptarkh. The central function of those objects—primarily information kiosks and government buildings—was to broadcast information. The user was primarily a listener, albeit one who might eventually act but at the moment of relation to the kiosk or building was in a passive stage prior to action.

FIGURE 3.1
Mikhail Kaufman *Portrait of Rodchenko*, c. 1922

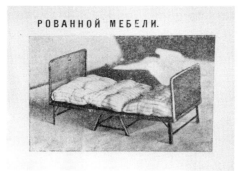
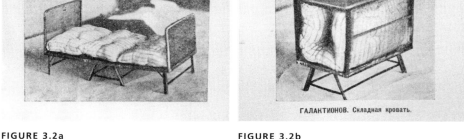

FIGURE 3.2a
Galaktionov folding bed (open), c. 1923

FIGURE 3.2b
Galaktionov folding bed (closed), c. 1923

The argument for a new kind of interactive object was demonstrated in the Metfak's initial exhibition in 1923. Among the first projects to emerge under Rodchenko's direction were N. Sobolev's armchair that could be turned into a bed, Zakhar Bykov's book stand that could be disassembled and packed up in a box, and Peter Galaktionov's folding bed. (**FIGURE 3.2a**) The latter had flat vertical surfaces at the head and foot. The horizontal sleeping surface had joints in two places so it could be folded up (**FIGURE 3.2b**). Sobolev's armchair-bed (**FIGURES 3.3a** and **3b**) was conceived so the chair back could be unhinged and the chair sides pulled out to extend the seating surface to bed length. But the user had the problem of unnecessary vertical pieces, higher than those on Galaktionov's bed, that enclosed the sleeping space in an unnecessary way. When the object was in the chair position, it looks to have been equally confining and, with its high sides and short legs, not terribly comfortable or practical for the sitter. The most successful objects in the exhibition were the bookshelves by Vladimir Pylinsky, Alexander Galaktionov, and Zakhar Bykov. Bykov's kiosk (**FIGURES 3.4a** and **4b**) was perhaps the most important of these projects, not only for its convenience of use but also for its employment of modular parts. This suggested the possibility of relatively simple mass production, unlike the chair or the bed. The kiosk utilized the concept of virtual volume which meant that it could become a rather small physical object if that volume were reduced. It also had a linear frame with selected planar surfaces. This resulted in structural strength, sufficient surface space, and portability. The latter quality was an appropriate one for a kiosk that might be moved from place to place for meetings and exhibitions.

The objects in the first Metfak exhibition were the initial manifestations of Rodchenko's belief in the unity of purpose, construction, and material which was the basis for his theory of design. As such, their success varied. The rationale for Sobolev's armchair-bed seems questionable, since it posed problems for the user. Its construction was not specifically geared to industrial production nor

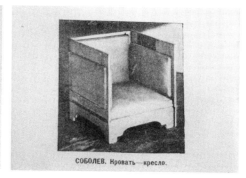

FIGURE 3.3a
Sobolev armchair-bed (open), c. 1923

FIGURE 3.3b
Sobolev armchair-bed (closed), c. 1923

was it particularly appropriate to the material used. But Bykov's modular kiosk did relate purpose, construction, and material in a unified way. Its portability was entirely suited to its use for temporary gatherings of all kinds. Its modular construction was also highly appropriate to industrial production. Most of the support pieces, probably wood, were straight and could be cut to varying lengths. They then could be attached to the planar surfaces, which might also be cut relatively easily.

In Bykov's project, we see a confluence of rhetorical argument and pragmatic construction, both in form and production. Rodchenko stated the metaphorical significance of the kiosk's straight lines and planes in his INKhUK lecture of 1921, "Line":

> Line has revealed a new world-view—to construct essence, and not to depict, to objectivise or to non-objectivise; to build new, expedient, constructive structures in life, and not from life or outside life.[27]

As a structural support, line connoted for Rodchenko an emphasis on essentials—structure rather than decoration, economy rather than excess, strength and direction rather than weakness. Besides the rhetorical meaning of its linear form, the kiosk's modular construction had a meaning as well. It allowed for maximum interactivity with a strong active user who could alter its form according to different needs. More than other projects in the exhibition, Bykov's kiosk exemplified an object whose rhetorical statement was synonymous with its efficacy of use.

To theorists of production art such as Osip Brik, the Metfak exhibition supported the argument for the artist-constructor as a new exemplar of design practice. In the exhibition Brik identified examples of Constructivist principles embodied in objects for use:

> Naturally the works by students are not yet concrete objects, ready for use; they are just trials, important texts that demonstrate how art has emerged from the narrow confines of the easel, and that little by

27 Alexander Rodchenko, "Line" in *Alexander Rodchenko*, ed. Elliott, 128.

little, but decisively, the way towards production is opening up. From it will be born the material culture of the future.[28]

Varvara Stepanova saw in the Metfak projects the working out of a Constructivist theory of form. She identified in the objects the representation of two Constructivist principles: the derivation of form from the combination of function, material, and construction and a new principle of organization that fostered student initiative.[29] For Stepanova and others who believed in production art as a new paradigm of design practice, the exhibition demonstrated that form was not an expression of preconceived aesthetic quality but was instead the response to a problem.

Opposition to nonutilitarian aesthetics was first evident in Rodchenko's rejection of the Stroganov faculty's decorative approach to objects. Brik, in his review of the exhibition, also emphasized construction or the act of making as a higher value than appearance. "The Constructivists wish the value of an object to depend not on how it is decorated," he argued, "but on how it is made."[30] By the time of the Metfak exhibition, however, it had become evident to production art theorists and to Rodchenko himself that the artist-constructor's step into production would not be an immediate one. This was reinforced by a number of factors—the disarray of Soviet industry just after the Civil War, the lack of developed methods for training designers for industry, and the reluctance of students to enter the Metfak as well as similiar faculties, since the relation of these faculties to art was unclear as were the potential opportunities for their graduates.

Two years after the exhibition, in November 1925, only twelve students were

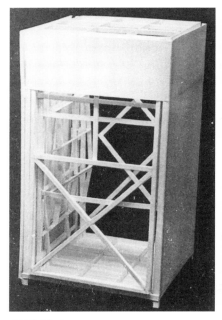

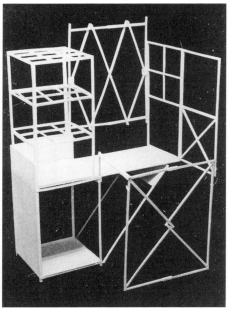

FIGURE 3.4a
Bykov kiosk (folded), c. 1923

FIGURE 3.4b
Bykov kiosk (assembled), c. 1923

studying in the Metfak.[31] That was less than 1 percent of the 1,300 or so attending the VKhHUTEMAS. In fact, only about 10 percent of the school's students were studying in all the production-oriented faculties which, besides metalworking, included woodworking, textiles, and ceramics. This is an extremely low number, given that Lenin had supported the establishment of the VKhHUTEMAS with the expectation that it would train artist-craftsmen for Soviet industry.

While the types of objects Rodchenko asked his students to design were justified to some degree by user needs, they were still marginal to the development of Soviet industrial policy as it was being debated in the 1920s. This was particularly true of the great industrialization debate of 1924–28. The Rightists in this debate wanted the government to continue the liberal trading policies of the NEP by producing a flow of goods that could be exchanged with the peasantry for more agricultural produce. Such policies, they expected, would provide raw materials for industry and food for the urban proletariat. The Leftists claimed instead that the Soviet Union would have to put its primary emphasis on heavy industry in order to create an advanced level of modernization. This would mean reducing the emphasis on consumer goods and small-scale industry for which the students at the VKhHUTEMAS were being trained.[32] In neither case, however, was the urban proletariat considered the primary market for the designed goods that would be produced by the newly developing industry.

Nonetheless, a need for new objects existed. Particularly in the later 1920s, new types of furniture were required for the reduced dwelling spaces of the apartments that Moisei Ginzburg and other architects were designing. Since the VKhHUTEMAS was the principle Soviet school for architectural training and the site where much of the debate about contemporary architecture took place in the 1920s, Rodchenko could relate his proposals for furniture closely to this activity.[33] There was thus a practical aspect to the Metfak furniture, stemming from its relation to the reduced scale of living spaces that architects such as Ginzburg were considering for future housing.

28 Osip Brik, "The School of the Constructivists," *Lef* 3 (1923), quoted in Khan-Magomedov, *Rodchenko: The Complete Work*, 175.

29 Varvara Stepanova, "On the Works of the Young Constructivists," *Lef* 3 (1923), quoted in Khan-Magomedov, *Rodchenko: The Complete Work*, 173–74.

30 Brik, "The School of the Constructivists," quoted in Khan-Magomedov, *Rodchenko: The Complete Work*, 174.

31 Khan-Magomedov, *Rodchenko: The Complete Work*, 172–73.

32 Soviet industrial policy of the 1920s is discussed in Alexander Erlich, *The Soviet Industrialization Debate, 1924–1928* (Cambridge, MA: Harvard University Press, 1967). Additional material on this topic and the general development of Soviet economics and technology in the 1920s can be found in Kendall E. Bailes, *Technology and Society under Lenin and Stalin: Origins of the Soviet Technical Intelligensia, 1917–1941* (Princeton: Princeton University Press, 1978); William Blackwell, *The Industrialization of Russia: An Historical Perspective* (New York: Crowell, 1970); Robert W. Campbell, *Soviet Economic Power: Its Organization, Growth, and Challenge* (Cambridge, MA: Riverside Press, 1960); Alec Nove, *An Economic History of the U.S.S.R.* (London: Allen Lane/The Penguin Press, 1969); and Maurice Dobb, *Soviet Economic Development since 1917* (New York: International Publishers, 1948).

33 On the architecture faculty at the VKhUTEMAS and its attendant politics, see Hugh D. Hudson, Jr., *Blueprints and Blood: The Stalinization of Soviet Architecture, 1917–1937* (Princeton: Princeton University Press, 1994), 84–117.

Prior to the expansion of the architecture program at the VKhHUTEMAS, where many of the proposals for new forms of mass housing were developed, Rodchenko treated the Metfak as an experimental laboratory where he and a few students invented new types of objects and attempted to conceive them according to production specifications that might be suitable to industry. However, until the VKhHUTEMAS closed, the objects invented in the Metfak, and later in the Dermetfak, under Rodchenko's direction would achieve their greatest success as rhetorical signs of a new way of living rather than as prototypes for production. This did not mean, however, that they bore no relation to production. A number of claims were made for them as examples of production art. First, as Brik and Stepanova had maintained in their reviews of the 1923 Metfak exhibition, the Metfak objects confirmed the difference between the Constructivist way of creating form—through a combination of purpose, construction, and material—and the aesthetic decorative approach of earlier artist-craftsmen. Second, at least some of the objects could be produced efficiently by industrial means. Third, the objects exemplified a proletarian style of simple living. And finally, they possessed a quality of character which can be seen as Rodchenko's agitation for a new way of life based on intelligence, inventiveness, and flexibility.

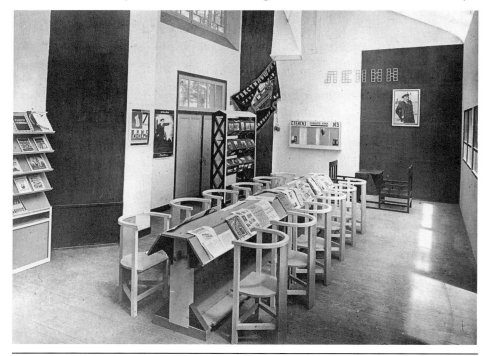

34 On the Nepmen see Alan M. Ball, *Russia's Last Capitalists: The Nepmen, 1921–1929* (Berkeley: University of California Press, 1987).

35 For a description of Melnikov's pavilion and the design process that led to it, see S. Frederick Starr, *Melnikov: Solo Architect in a Mass Society* (Princeton: Princeton University Press, 1978), 85–102. Starr notes that the pavilion received the highest award from the French commission established to judge the entries. For Melnikov, the project led to greater contact with Western colleagues, while Rodchenko's stay in Paris con-

3

Within the context of the NEP, the promotion of simplicity as a value took on additional meaning by its opposition to the more ornate and excessive taste of the Nepmen, those Russians who saw the economic interlude of competitive enterprise as a way to build their own fortunes and secure the comforts that were identified with the prerevolutionary bourgeoisie.[34] However, outside the Soviet Union, the argument of Constructivist objects was pitched to a different audience. This was evident in the interior for a Workers' Club that Rodchenko designed for Konstantin Melnikov's Soviet pavilion at the 1925 Exposition Internationale des Arts Décoratifs et Industriel Moderne in Paris (**FIGURE 3.5**).[35] Melnikov's building was located amidst a spate of pavilions that promoted the refined tastes and luxurious styles of the Western haute bourgeoisie. Jacques-Emile Ruhlmann's *grand salon* within Pierre Patout's *Residence of a Collector* was a good example (**FIGURE 3.6**). In this room Ruhlmann featured hand-crafted furniture of rare woods and expensive fabrics, a collection of art objects including a large mural by Jean Dupas, a heavy rug, and ornate wallpaper. Hanging from the ceiling was an enormous chandelier of cut glass. In contrast to the indulgent individualism of Ruhlmann's interior and those of other pavilions, the Soviet government

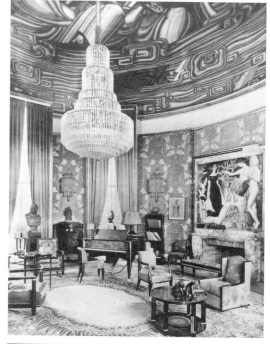

FIGURE 3.5 (p. 94)
Rodchenko Workers' Club interior, 1925

FIGURE 3.6
Ruhlmann *Residence of a Collector,* 1925

firmed his will to have no truck with the decadent West. See the extracts from his Paris letters in Khan-Magomedov, *Rodchenko: The Complete Work*, 181–84. Myroslava M. Mudrak and Virginia Hagelstein Marquardt place Melnikov's pavilion and Rodchenko's Worker's Club in a context of Soviet participation at other Western exhibitions in their article "Environments of Propaganda: Russian and Soviet Expositions and Pavilions in the West," in *The Avant-Garde Frontier: Russia Meets the West, 1910–1930*, ed. Roman and Marquardt, 75–83.

wanted the Worker's Club to make a strong statement about hard work, dedication, simplicity, and collective self-improvement.[36]

Rodchenko's club interior was a public space intended as a place where workers could relax and study. It had areas for games, reading, viewing films, and listening to talks. Juxtaposed with the French interior by Ruhlmann, which celebrated an upper-class gentleman's individual taste for expensive furniture and decor, or even compared with Le Corbusier's Pavilion de l'Esprit Nouveau, which focused on modern middle-class furnishings rather than nostalgic luxury items, Rodchenko's Workers' Club interior assumed a political meaning. It was a model of a proletarian lifestyle which opposed the bourgeois ones represented in most of the other pavilions. The intent of using a spare design style in the exhibition to represent Soviet revolutionary values was reinforced by P. Kogan in his preface to the Soviet catalog:

> Our section [of the exposition] has no luxury furniture or precious fabrics. At the Grand Palace visitors won't find furs or diamonds. But those who can feel the rising tide of the creative classes will be able to appreciate the studied simplicity and severe style of the workers' club and rural reading room . . . We are convinced that our new constructors have much to say to the world and that everything most vibrant in humanity will not delay us from knowing and seizing through art the true meaning of our struggle. With this conviction we resolutely enter the lists of the new artistic competition among nations.[37]

Rodchenko devised a formal harmony for the various objects in the Workers' Club through the manipulation of line and plane as elements of construction. He achieved further unity by painting the objects with a restricted palette of red, black, white, and gray. The material he used—primarily wood—was hard and resistant. There were no soft and pliant fabrics like those in the French pavilions. The overpainting of the wood deemphasized its natural quality in favor of its more symbolic structural value. The clarity of the forms also related to the firmness of the material. The chairs at the reading table had curved back supports which paralleled the rounded seats. The supports were held in place by strong linear strips on the backs and sides and three braces in the shape of a triangle at the bottom. The chairs themselves, like Rodchenko's earlier hanging constructions, suggested enclosed volumes although they were constructed, like Bykov's kiosk, with minimal materials.

Rodchenko played the curved backs of the chairs against the linearity of the reading table with its planar surfaces on top for the publications and on the bottom for a footrest. The angular planes of the table were also paralleled by those of the publication shelves behind them. In addition, Rodchenko reiterated the

36 Although the Workers' Club room that Rodchenko designed was an early example of an integrated Soviet design for interior furnishings, it was never shown in the Soviet Union. After the Paris exhibition, it was dismantled and given to the French Communist party.

37 P. Kogan, "Préface," *L'art décoratif et industriel de l'U.R.S.S. Moscou-Paris* (Moscow: Edition du Comité de la Section de l'U.R.S.S. a l'Exposition Internationale des Arts Décoratifs Paris, 1925), 7 (my translation).

strong linearity of the reading table, chairs, and publication shelves in the chess table and chairs with their planar surfaces and rectilinear supports. He balanced these elements against the faceted planes of the lamp that hung over the reading table. Formally the room conveyed directness, clarity, sparseness, economy, and organization. One could easily contrast these qualities in political terms with those of the more eclectic, excessive, or variegated interiors of the other pavilions.

The majority of the objects in the Workers' Club interior had single functions rather than multiple ones, although some objects had movable parts that indicated efficiency of storage or function. Chess players, for example, could move the chessboard to a vertical position so they could get into their seats (**FIGURE 3.7**). There was also a speaker's platform which could be pulled out from behind a frame as well as a movable screen for film and slide projections. The tight organization that Rodchenko exercised over the interior recalls the Constructivist sets that Popova and Stepanova designed for *The Magnanimous Cuckold*, and *The Death of Tarelkin* in 1922. This analogy to the theater also supports the interior's rhetorical aim. The objects did not exemplify advances in Soviet industry (they were, in fact, handcrafted from wood) nor did they serve as examples of products available for consumption. Instead, they demonstrated to the exposition's visitors the idealized qualities of revolutionary action through which the government wanted to characterize Soviet life.

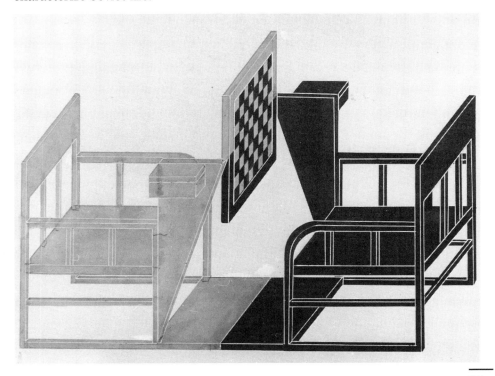

FIGURE 3.7
Rodchenko chess board and seats, 1925

Back in Moscow after the exposition, Rodchenko promoted simple convertible objects as the most appropriate for new workers' clubs and mass housing. In 1925 he began to direct a laboratory for the Moscow Proletcult, sponsored by the Fine Art Department of the People's Commissariat of Enlightenment. Here he helped students develop designs for an urban club according to his guidelines. But this activity remained speculative for the most part, and the pieces the students in the Proletkult laboratory produced were handcrafted items rather than prototypes for mass production.

4

Rodchenko continued to disseminate his concepts for new furnishings primarily through models and prototypes rather than production. Initially, he had presented his ideas through exhibitions, first in the Metfak and then in Paris. In 1926 the film director Lev Kuleshov invited him to design the sets for his film *Zhurnalistka* (The Lady Journalist), which satirized the petite bourgeoisie and its modern way of life, a popular theme in the NEP years. The film was an excellent vehicle through which Rodchenko could advance his arguments for furnishings that would represent a new way of living.

The sets he designed included the office of a newspaper as well as the study of a reporter who worked for the Scientific Organization of Labor, a bureau that was promoting more efficient methods of work, following the ideas of the American management theorist Frederick Winslow Taylor (**FIGURE 3.8**). Rodchenko was not only involved in building the sets but also in framing the shots that would determine how they looked on the screen. The reporter's room was constructed according to current building standards. N. Lukhmanov described it in an article on the film as "a rationalization (however primitive to start with) of working conditions."[38] All the furniture pieces in the room were convertible from one function to another. The bed, for example, folded up into the cupboard, something that would later be standard in many American apartments after World War II. The journalist's desk contained a set of components that could be dismantled, extended, and moved. The room was also furnished with the latest communications media similar to Rodchenko's utopian kiosks of 1919. On one side of the desk was a built-in radio and on the other a light table for viewing slides. Adjacent to the work surface was a section of small drawers for storing different kinds of supplies.

Rodchenko did not construct the sets for *Zhurnalistka* as fantasies. Instead, he tried to depict a new way of life. Short of having his furniture produced by industry, he believed the demonstration of its use in the cinema would open people's

38 N. Lukhmanov, "Life as It Should Be," *Soviet Screen* 15 (1928), quoted in Khan-Magomedov, *Rodchenko: The Complete Work*, 191.

39 Ibid., 190.

40 Ibid., 191.

41 Boris Arvatov, "From Theatrical Production to the Construction of a Lifestyle," *Ermitazh* 11 (1922), quoted in Khan-Magomedov, *Rodchenko: The Complete Work*, 195.

minds to new possibilities of living. This intention was noted by Lukhmanov in his article:

> Only when art is completely bound up with (technical and scientific) industry will it become possible to launch a planned attack on trivial taste and fight for the interests of future socialization. In the cinema this contact is becoming a de facto reality, and we can record some concrete achievements.[39]

It was through Rodchenko's sets and props, built to realistic specifications, Lukhmanov continued, that "the viewer learns to recognize a series of absolutely new ways of life which the script or direction alone could not possibly have conveyed against the setting of an old type of house."[40] Given the fact that production artists had made little headway in collaborating with industry by the late 1920s, theorists of production art such as Osip Brik and Boris Arvatov rationalized this in several ways. On the one hand, they noted the experimental nature of the applied art projects which embodied their values; on the other, they projected to the future the moment when the public would be ready to adopt such experimental objects.

Production art theorists began to talk less of the artist-engineer who would direct the forces of industry and more of "engineers and builders of a new lifestyle," as Boris Arvatov had referred to theater workers in the early 1920s.[41]

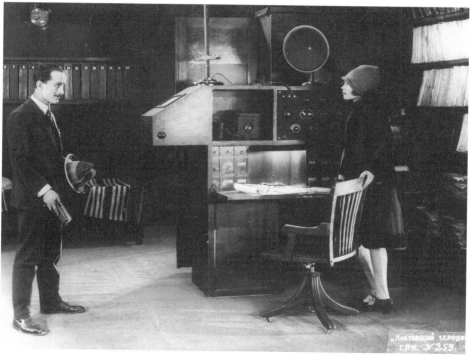

FIGURE 3.8
Rodchenko film set for *Zhurnalistka*, 1926

Arvatov saw the theater as a conduit through which artistic conceptions of new ways of life would become increasingly integrated with actual daily routines. This argument by one of the first theorists of production art was at least tacit recognition that time would be needed to prepare the public for the new kinds of furniture and interiors that Rodchenko championed. It is therefore not surprising that his experimental furniture designs found much greater receptivity among other artists—film and theater directors particularly—than they did among factory managers and those concerned with the development of Soviet industry.

In 1929, Rodchenko designed the sets for two plays: *Inga* by Anatoly Glebov, and *The Bedbug* by Mayakovsky, with whom Rodchenko had been collaborating as part of the *Lef* group since the early 1920s. For *The Bedbug*, Rodchenko's task was to create sets for part of the play that was located in the future. But for *Inga*, whose theme was the contrast between the older model of bourgeois life and the new lifestyle of the working class, the setting was the present. For this project Rodchenko once again had the opportunity to promote a group of objects that embodied the values of a new way of life.[42]

As with the Workers' Club in Paris, which the public viewed in the context of the bourgeois interiors that surrounded it, the models of new furniture that Rodchenko designed for *Inga* were contrasted on stage with the objects of the older bourgeoisie, thus continuing a polemic that began before the Revolution with the Russian Futurists' call to reject the art of the bourgeoisie in favor of revolutionary new forms. Initially, Rodchenko proposed a single two-level structure for *Inga* that would allow an almost seamless conversion from one interior to another—an apartment, a Workers' Club, a factory director's office. But the director Maxim Tereshkovich rejected this proposal as too futuristic and, instead, requested Rodchenko to design a series of full-scale furniture pieces that would be used in a more conventional way. Similar to other projects, Rodchenko stressed the use of modular components with which the furniture could be easily assembled and taken apart. As revealed in various sketches, the forms are extremely simple and the pieces consisted mainly of planar surfaces which combine rectilinearity with curves (**FIGURE 3.9**). Such pieces would have been relatively easily to put into production since they had no complex ornamentation, complicated joinery, or expensive materials. All were of wood, quite spare, and could have probably been produced at a relatively low cost. Had there been more receptivity in Soviet industry, a factory that made wood products might easily have produced them. That this did not happen is more a factor of marketing than production capability. The furniture pieces for *Inga* were clearly aimed at those who defined themselves as creators of lifestyles, just as Marcel Breuer's

42 See Roann Barris, "Inga: a Constructivist Enigma," *Journal of Design History* 6, no. 4 (1993): 263–81. Barris considers Rodchenko's sets and furniture for the play to be "a visual manifesto of constructivism" (271).

43 N. Lukhmanov, "Without Words," *Life of Art* 22 (1929), quoted in Khan-Magomedov, *Rodchenko: The Complete Work*, 196.

44 Alexander Lavrentiev compares Rodchenko's furniture with other proposals for new furniture types in his article "Experimental Furniture Design in the 1920s," *Journal of Decorative and Propaganda Arts* 11 (Winter 1989): 142–67.

tubular steel Bauhaus chairs were in Germany.

Like Rodchenko's previous designs, his spartan furniture for *Inga* contrasted sharply with the domestic objects of earlier bourgeois taste; in particular it also questioned their amenities—the soft cushions and the comfortable curves of chair arms and backs, for example. Rodchenko's furniture embodied strength of character but also demanded comparable qualities from the user. As the critic Lukhmanov wrote of the sets:

> The display of these articles on the stage has a great educational significance. In the immediate future it is objects like these that will have to be supported on the economic plane so that they can establish themselves in our market. Their rationality and the hygiene that such objects presuppose favour their success.[43]

Between the time Rodchenko began teaching in the Metfak and his later work for the film and theater, he envisioned a class of objects that would serve two purposes: to demonstrate the feasibility of mass production, and to call forth creative yet disciplined responses from their users. We can find evidence of both purposes in the drawings, models, and prototypes that he and his students produced, but ultimately the social validity of the objects was untested. Rodchenko's interest in modularity, standardized components, and the general nature of mass production was highly appropriate and valuable for his students, but his emphasis on convertible objects, on sternness of form, and on unified decors that demanded an active response rather than provide comfortable repose was based on a hypothetical user for whom a market never materialized.[44] Hence, it was through artistic form rather than industrial production that Rodchenko's ideas about objects reached the public.

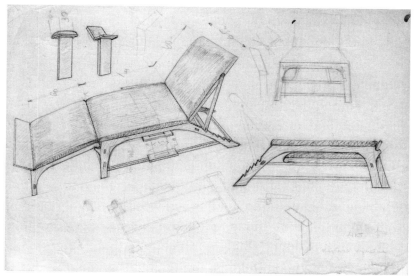

FIGURE 3.9
Rodchenko furniture for *Inga*, 1929

5

Rodchenko's intent as an artist-constructor was to create and disseminate objects that would help bring about a new way of life. In the sphere of industrial design, he was constrained by the unwillingness and inability of Soviet factories to transform his projects and those of his students into mass products. But as a book and periodical designer and advertising artist he was more successful in getting his work into production and sometimes reaching large audiences.[45] As an artist-constructor, Rodchenko was broadly concerned with the transformation of all objects, ranging from furniture to posters, into demonstrations of rhetorical arguments. In his nascent methodology of design, Rodchenko employed a strategy of organizing materials that was similar to his work on paintings and three-dimensional constructions, thus maintaining a continuity between his design work and his earlier Constructivist art. We must emphasize here that this methodology differed drastically from the theory of functionalism which grew out of the Constructivist movement in Germany and which was discussed in the previous chapter. Rodchenko's aim, by contrast, was not simply to be objective and economical in the use of materials and formal organization but, instead, to advance an argument about human action through objects. The number of people who saw his publication designs and advertising work varied widely from the small group of colleagues who read the avant-garde periodicals he worked on to the citizenry of Moscow who encountered his gigantic painted advertising signs in the streets.

We can look at his film titles, advertising art, and publication designs from two standpoints—the way they addressed the audience through their rhetorical style, and the way they contributed to the renewal or transformation of existing media in order to make them more dynamic instruments of change.[46] In 1922, shortly after Rodchenko had declared an end to painting, he accepted an invitation from Alexei Gan to design and art direct a new Constructivist film and photography periodical, *Kino-fot.* The magazine, of which Gan was the publisher and editor, was important to Rodchenko for several reasons. First, it enabled him to introduce a new style of publication design based on Constructivist principles of form as well as the concept of serial production. Equally significant was the fact that it involved him with film and photography which were to be central to his development as an artist and designer.

To fully appreciate Rodchenko's contribution to postrevolutionary publica-

45 On Rodchenko as an advertising artist and publication designer, see Gail Harrison, "Graphic Commitment," in *Alexander Rodchenko*, ed. Elliott, 82–89; John Milner and Kirill Sokolov, "Constructivist Graphic Design in the U.S.S.R. between 1917 and the Present," *Leonardo* 12, no. 4 (Fall 1979): 275–82; and Alexander Lavrentiev, "The Facture of Graphics and Words," in *Von der Malerei zum Design/From Painting to Design* (Köln: Galerie Gmurzynska, 1981), 72–91. Rodchenko's graphic design work is also discussed in Lodder, *Russian Constructivism;* Szymon Bojko, *New Graphic Design in Revolutionary Russia* (New York: Praeger, 1972); Claude Leclanche-Boulé, *Typographies et Photomontages Constructivistes en U.R.S.S.* (Paris: Papyrus, 1984); and *Soviet Commercial Design of the Twenties*, ed. Mikhael Anikst, intro. and texts by Elena Chernevich (New York: Abbeville Press, 1987).

46 For a discussion of graphic design as a rhetorical practice, see Ann C. Tyler, "Shaping Belief: The Role of Audience in Visual Communication," *Design Issues* 9, no. 1 (Fall 1992): 21–29.

tion design in the Soviet Union, let us compare *Kino-fot* with earlier designs for prerevolutionary journals. The most influential modern art journal before the Revolution was *Mir Iskusstva*, which appeared between 1898 and 1904 and whose covers showcased the work of the artists who did them. The method of printing made it clear that the covers were originally works of art which had been reproduced for mass circulation.[47] Similar in form to the *Mir Iskusstva* covers, but closer politically to Rodchenko's values, were the covers of some of the political journals that appeared for a brief period after the February Revolution of 1905.[48] As with *Mir Iskusstva*, they also featured illustrations along with lettering styles that were mostly copied from nineteenth-century European decorative typefaces.

Similar to his furniture designs and those of his students, the straight line became an essential element in much of Rodchenko's publication design. Whether it functioned as a rule that divided sections of a book or magazine cover or as a string of letters that were accented by their height, weight, or color, the line was the structural element that underlay Rodchenko's later use of exclamation marks, arrows, and other devices he employed for rhetorical emphasis. In his 1921 essay "Line," he had stated,

> At last the meaning of LINE has been elucidated in full: on the one hand its facetal and lateral relationship, and on the other as a factor of principal construction in any organism in life as a whole—so to say, the skeleton or the basis, the framework or system. Both in painting and in any construction in general, line is the first and last thing.[49]

Besides functioning as a structural element for Rodchenko, line demonstrated the character traits of economy, directness, and strength. The *Kino-fot* covers provide initial evidence of Rodchenko's reliance on it as both a formal and rhetorical element. The lack of a visual format to establish continuity from issue to issue was a central concern for Rodchenko, who envisioned *Kino-fot* as a continuing forum for the discussion of Constructivist film and photo theories. To give the publication a consistent identity, he devised a cover format that emphasized the title in bold letters and included the enlarged issue number as an important design element. Instead of considering the letters on the covers as decorative forms the way earlier journal designers had, Rodchenko regarded the lines of letters as constructive elements that could organize the page. Within this format, he varied the visual material for each cover. For *Kino-fot* 2 (FIGURE 3.10) he used a photomontage by his wife Varvara Stepanova which juxtaposed a photo of Charlie Chaplin with photos of industrial objects.[50]

Rodchenko further developed the double function of line in his film titles for

47 On the design of *Mir Iskusstva*, see Mikhail Kiselev, "Graphic Design and Russian Art Journals of the Early Twentieth Century," *Journal of Decorative and Propaganda Arts* 11 (Winter 1989): 50–67.

48 A number of these covers are reproduced in David King and Kathy Porter, *Images of Revolution: Graphic Art from 1905 Russia* (New York: Pantheon, 1983).

49 Rodchenko, "Line," in *Alexander Rodchenko*, ed. Elliott, 128.

50 *Kino-fot* 2 celebrated Chaplin for his constructive movements rather than decorative gestures. The combination of photographs on the cover resulted in a composite image of modernity that served as a visual argument for a new style of film acting.

Dziga Vertov's newsreel series *Kino-Pravda* (Kino-Truth).[51] Here he found a brief opportunity to explore line's visual power as a moving element in relation to a sequence of images. Alexei Gan, who published Vertov's manifesto "We" in the first issue of *Kino-fot*, may have been the one to establish a relation between Vertov's film theories and the Constructivist manifestos of Rodchenko and others. Like the Constructivist artists who built their drawings, paintings, and three-dimensional constructions from separate elements, Vertov argued that "the newsreel is organized from bits of life into a theme and not the reverse."[52]

Vertov, who had worked as a newsreel cameraman during the Civil War, began, with a small group of collaborators, to produce his series of short *Kino-Pravda* documentaries in May 1922. Starting with the thirteenth one, Rodchenko designed the titles which were conceived as a dynamic, integral part of each film, unlike the titles of the period's theatrical films. Vertov, who considered animation to be "an essential arm in the struggle against the artistic film,"[53] introduced the technique to Rodchenko, suggesting it as a means to create titles whose movement could be integrated with the photographed images. Rodchenko enhanced the rhetorical power of the titles by controlling the arrangement, size, and weight of the letters as well as by combining them with graphic elements (**FIGURE 3.11**). He slanted letters to add the dynamism of the diagonal and used graphic devices such as arrows to direct the eye. He also employed objects such as gear wheels to connote movement. Aware that the titles would be on the screen for only a brief moment, Rodchenko designed them for quick apprehension, using simple shapes and large letters to which he gave a sense of motion that was continuous

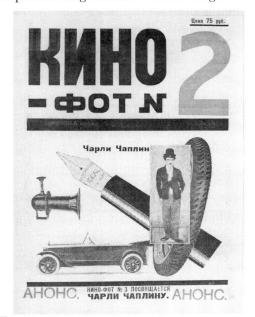

FIGURE 3.10
Rodchenko *Kino-fot 2*, cover, 1922

FIGURE 3.11
Rodchenko film titles for *Kino-Pravda*, 1922

with the moving image. Through his art direction for *Kino-fot* and his titles for *Kino-Pravda*, Rodchenko participated in the searing attack on prerevolutionary theatrical film technique and acting style that characterized Vertov's and Gan's struggle for a new Soviet cinema. Struggle, in fact, was the context within which he developed his demonstrative style of visual rhetoric—bold, largely rectilinear letterforms, symmetrical poster-like formats, pronounced graphic elements such as rules and blocks, and strong colors. With these elements he was able to forcefully represent the combative character of the contents he interpreted as a designer.

The relation of Rodchenko's declamatory forms to the content they conveyed was nowhere more evident than in the series of covers he designed for *Lef*, a journal which staked out a particularly militant literary position during the NEP years.[54] Even though it was an avant-garde journal, *Lef*, short for "Left Front for the Arts," was supported by the party and was brought out by the party publishing house Gosizdat. Besides literature that eschewed both realism and a doctrinaire proletarian line, *Lef*, which was edited by the poet Mayakovsky, supported the new documentary cinema of Dziga Vertov, Sergei Eisenstein's radical theories of theater directing, and the production art of Rodchenko, Stepanova, and Popova. What united all its concerns, however, was its strong opposition to art as individual creative expression and its promotion of the artist as a cultural worker with technical mastery of a particular medium.

Of all the literary groups during the NEP, *Lef* was the most insistent on the correspondence between artistic and social change. In the first issue, Sergei Tretiakov, one of the journal's leading theoreticians, argued that the purpose of art was to create a new man by "exerting emotionally organizing influence on the psyche in connection with the objective of the class struggle."[55] Despite its vociferous declamations and arguments for new prose forms, however, *Lef* made few inroads into the mass psyche. Initially published in an edition of 5,000, it dwindled to 3,000 by the third issue and 2,000 by the sixth.[56] The journal never became self-supporting and was dropped by Gosizdat after the seventh issue. *Lef*'s inability to attract large numbers of readers or to earn the support of party functionaries like Trotsky does not, however, mitigate the militancy of its stance or the force of Rodchenko's covers which represent the journal's combativeness.[57]

51 Alexander Lavrentiev discusses the film titles in "The Facture of Graphics and Words," *Von der Malerei zum Design/From Painting to Design*, 72–81.

52 Dziga Vertov, "On Kinopravda," in *Kino-Eye: The Writings of Dziga Vertov*, ed. and with intro. Annette Michelson, trans. Kevin O'Brien (Berkeley: University of California Press, 1984), 45.

53 Dziga Vertov, "Instructions Provisoires aux Cercles 'Ciné-Oeil,'" *Cahiers du Cinéma* 228 (March–April 1971): 16 (my translation).

54 For a history of *Lef* and its successor *Novyi lef*, see Halina Stephan, *"Lef" and the Left Front of the Arts* (München: Verlag Otto Sagner, 1981 [Slavistische Beiträge vol. 142]).

55 Sergei Tretiakov, "From Where and to Where (Futurist Perspectives)," *Lef* 1 (1923), quoted in Stephan, *"Lef" and the Left Front of the Arts*, 62.

56 Stephan, *"Lef" and the Left Front of the Arts*, 35.

57 In *Literature and Revolution*, published in 1924, Trotsky praised *Lef*'s ability to identify significant social problems for the artist, but he was critical of the *Lef* group's ability to address them. "Unfortunately the 'Lef'

As with *Kino-fot*, Rodchenko established a format for the *Lef* covers, using large drawn squared letters in two colors for the title.[58] The colors of all the covers were strong and declamatory with contrasting tones—black and red, black and orange, blue and red, juxtaposed on a light ground. Rodchenko's use of pure colors was a continuation of his monochrome red, blue, and yellow canvases of 1921. It also echoed other paintings of his from that period whose colors he selected for their intensity rather than symbolic emotional value. The *Lef* covers echoed the grammar and syntax of the poster. This was a move to amplify the visual impact of the periodical with the devices of a more dynamic medium. The poster was a vehicle for public display and group reading while the periodical was a small-scale object for individual perusal. Rodchenko achieved the poster-like effect through balancing the bold forms of the title lettering and rules against additional text and images (**FIGURE 3.12**). What he accomplished in graphic terms was to promote a new declamatory visual rhetoric that other Soviet artists picked up and employed frequently during the 1920s, particularly for book covers. Although this style was never *officially* adopted by the Communist party's publishing enterprises, it was, nonetheless, found suitable for a number of state-sponsored publications.

Rodchenko's involvement with *Lef*, however, was not limited to the design of the covers and layouts. During the initial negotiations between Mayakovsky and Gosizdat, the poet proposed to publish a series of books under *Lef*'s imprint, and two appeared immediately. One was Mayakovsky's long poem *Pro eto* (About It), with a cover and eight photomontages by Rodchenko.[59] *About It*, which came out in 1923, was a frank statement of the tensions in Mayakovsky's love affair with Lili Brik, the wife of his colleague Osip.[60] The poem's emphasis on the poet's emotional upheaval invited a number of critiques for its stress on individual emotion rather than larger social issues. In response, Mayakovsky claimed that the subject of *About It* was really the complacent way of life fostered by the NEP. The poem remains today a controversial text in that it foregrounds what some critics of the time considered to be a bourgeois theme—the breakup with a lover.

Nonetheless, its publication became a rhetorical occasion for Rodchenko to

colors these problems by a Utopian sectarianism," he wrote. "Even when they mark out correctly the general trend of development in the field of art or life, the theorists of 'Lef' anticipate history and contrast their scheme or their prescription with that which is. They thus have no bridge to the future" (134). Leon Trotsky, *Literature and Revolution* (Ann Arbor: University of Michigan Press, 1960).

58 Rodchenko drew all the letters for his covers by hand and could make them as strident as he wished. By contrast, the page typography and layouts of *Lef* are very conventional. This must have been due in part to the limited range of typefaces available in the government printing plant.

59 See the trilingual (Russian/English/German) *Pro eto/It/Das Bewusste Thema* (Berlin: Ars Nicolai, 1994).

60 For an account of the affair, see Ann and Samuel Charters, *I Love: The Story of Vladimir Mayakovsky and Lili Brik* (New York: Farrar Straus Giroux, 1979). See also *Love is the Heart of Everything: Correspondence between Vladimir Mayakovsky and Lili Brik, 1915–1930*, ed. Bengt Jangfeldt (New York: Grove Press, 1986).

61 The portrait photographer Abram Petrovich Shterenberg took the photos.

62 Sergei Eisenstein, "Montage of Attractions," in his collection of papers *The Film Sense* (New York: Harcourt, Brace and World, 1947), 231.

63 Ibid., 232.

64 Ibid.

heighten the impact of a printed text by designing it in the form of a more dynamic medium—theater. He approached Mayakovsky's poem as a theatrical script and assumed the role of director. Mayakovsky and Lili were the actors whom Rodchenko actually had photographed in various positions and with numerous expressions.[61] By combining the new photographs with those he took from published sources, Rodchenko brought an element of realism or facticity to the photomontages in order to relate the poem to the poet's life.

Rodchenko's theatrical treatment of the poem was paralleled by the work of another *Lef* contributor and member of the avant-garde, Sergei Eisenstein. Around the time *About It* appeared in June 1923, Eisenstein published an essay on the theater, "Montage of Attractions," in *Lef.* Acknowledging a debt to the photomontages of George Grosz and Rodchenko, Eisenstein noted how the "leftover apparatus of the theater," that is, the sounds, musical effects, visual paraphernalia, etc., could be used to "produce certain emotional shocks in a proper order within the totality—the only means by which it is possible to make the final ideological conclusion perceptible."[62] Analogous to the idea of photomontage was Eisenstein's concept of a theatrical production as an "action construction" made up of discrete effects combined together rather than as a "static reflection" of an event.[63] We can relate Eisenstein's separation of the elements of construction, that is, "free montage of arbitrarily selected, independent (within the given composition and the subject links that hold the influencing actions together) attractions,"[64] to the photomontages of *About It* which Rodchenko built up of separate photographic fragments. Neither Rodchenko nor Eisenstein intended the sequence of attractions (i.e., the photomontages that visualize *About It* or the

FIGURE 3.12
Rodchenko *Lef* 1, cover, 1923

effects a director uses to visualize a play) to pull the reader or viewer further into the work but rather to serve as a parallel set of elements. The "attractions," in effect, were to keep the audience alert to the tensions and directions of the poem or play rather than to submerge them in it.

Rodchenko used the photographs of Mayakovsky and Lili to intensify the dramatic effect of *About It* and link the text to contemporary social life. As psychological images, Rodchenko's photomontages, like the poem itself, were open to criticism by those who felt that Mayakovsky's focus on the lovers' emotions was an avoidance of revolutionary aims. Lili haunts the poem like Dante's Beatrice. In her stark frontal portrait on the cover (**FIGURE 3.13**) she looms larger than life as she must have seemed to Mayakovsky in his moments of despair. Her dark-rimmed eyes stare intensely forward, oblivious even to the presence of the photographer. Mayakovsky recounts in the poem how he sequestered himself in his room, a short distance from the Brik household, and communicated with them by telephone. He presents the phone as the modern version of the messenger in classical drama—the means by which the lovers' messages are transmitted; but not just messages, feelings too. Mayakovsky uses the hyperbole of his love burning up the telephone wires. He describes a word which crawls out of the phone wires as "a monster of those troglodyte days," and Rodchenko made the image concrete by placing a photograph of a dinosaur next to Mayakovsky who sits by the telephone and talks to Lili's housekeeper (**FIGURE 3.14**).

Images such as the dinosaur and the telephone, which appear outsized in relation to the housekeeper and the poet who are having the telephone conversation, become the equivalents of the "attractions" in Eisenstein's essay. By their scale and, in the case of the dinosaur, incongruous presence, they distance the viewer just as Eisenstein intended. The photomontage sequence is not only theatrical, it is also distinctly cinematic and gives strong evidence of Rodchenko's interest in the documentary film techniques of Vertov. The visual pacing of events and the images of the lovers, the variance of close-ups and distance shots, the shifts from individual gazes to long shots of entire bodies, the movement from interior to exterior, from ice flow to bourgeois parlor to Mayakovsky about to leap from a building, recall the shifting perspectives and the compression of time and space that Vertov advocated in his manifestos. The strong influence of film technique in this sequence is evidence of Rodchenko's intention to make the book form more dynamic by incorporating the grammar and syntax of theater and film in its design, just as he incorporated that of the poster in some of his periodical covers. The publication of the photomontages for *About It* with their links to the revolutionary theater and film of Eisenstein and Vertov gave an impetus to photomontage as an artistically and politically progressive means to represent social reality in the Soviet Union. Implicit in its use was a faith in the factual nature of photographs, and an awareness that a broad vision of reality

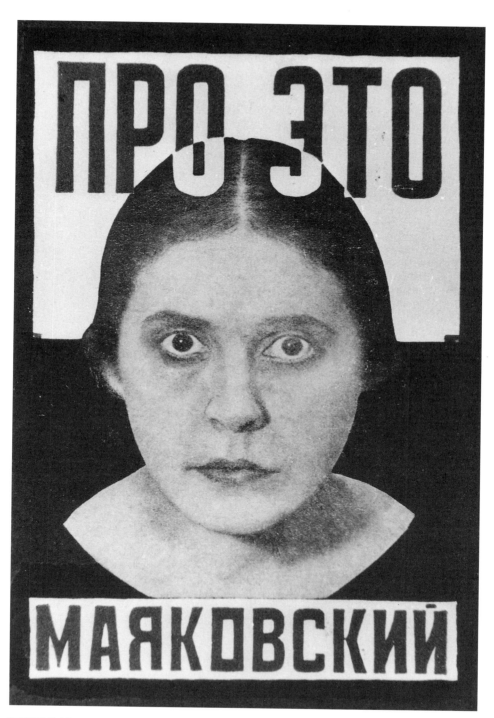

FIGURE 3.13
Rodchenko *About It*, cover, 1923

could be synthesized through the combination of photographic fragments just as artists like Vertov were doing with film shots.

Rodchenko's interest in photomontage as a progressive technique of representation corresponded to the attention that many of the *Lef* staff showed to forms of documentary literature such as travel accounts and diaries. These came to be known as the "literature of fact," a genre that became central to the journal's successor *Novyi lef* (New Lef), which first appeared in 1927 with party support despite the prior failure of *Lef*.[65] Rodchenko became the art director for *Novyi lef* and designed all the covers as well as the layouts. The look of the new journal, however, was markedly different from that of its predecessor. Rodchenko featured photographs on many of the covers in place of *Lef*'s declamatory typography. By 1924 he had begun to photograph in earnest, and when *Novyi lef* started publication in 1927 he had a sizable body of work. The covers included close-ups of industrial objects, buildings, figures photographed from unusual angles, or isolated details of objects (**FIGURE 3.15**). Some of these images were distinctly propagandistic— naval cannons, power lines, a Soviet youth, a portrait of Lenin—while others—a movie camera, a close-up of a screw, the balconies of a building (**FIGURE 3.14**)— were not. The point for Rodchenko was to promulgate a new way of looking at Soviet life rather than convey propagandistic imagery in a conventional way. By 1927 he had made photographs the primary design elements in his work. A principal reason for this was his belief that photographs had a greater capacity to

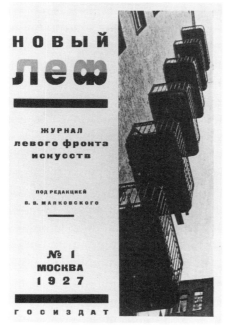

FIGURE 3.14 (p.110)
Rodchenko *About It*, photomontage, 1923

FIGURE 3.15
Rodchenko *Novyi lef* 1, cover, 1927

65 Gosizdat only provided funds for 1500 copies of each issue, an indication that the party found something worthwhile in *Novyi lef* but still considered it to be a marginal venture.

engage the viewer than abstract graphic elements. Typographic book covers still counted among Rodchenko's projects, but his later covers, for the most part, are less declamatory than those done before he shifted his interest to the photograph.

Among his strongest photographic book covers of the NEP years are those for collections of Mayakovsky's poems such as *Razgovor s fininspektorom o poezii* (A Conversation with a Tax Inspector about Poetry) (**FIGURE 3.16**). For this cover, Rodchenko used staged photographs of Mayakovsky as he did for *About It*. On the front cover of the book is a three-quarter portrait of Mayakovsky holding a page of verse. He is next to a tax collector who wants payment from him. Rodchenko placed the enlarged portrait of the poet above the tax collector's profile, in order to reveal the hugeness of the poet's vision compared to the pettiness of the bureaucrat. On the back cover, he placed a globe above the poet's forehead as if it were part of his skull. The disembodied head floats in space, dwarfing even the technological achievements represented by the airplanes circling the globe. The hyperbole of this image recalls the exaggerated scale of lettering that characterizes his *Lef* covers, only now the outsized forms have become photographs instead of letters.

In the poem, Mayakovsky emphasized his conviction that writing poetry was a form of production like any other labor. This view of art, which surely derived from Osip Brik, had been first promulgated in *Lef* where it was linked to another of Brik's concepts, the "social command," which legitimated a work of art in terms of its satisfaction of a social need. The social command not only justified the subject matter of a work that responded to it; it also shaped the work's form.

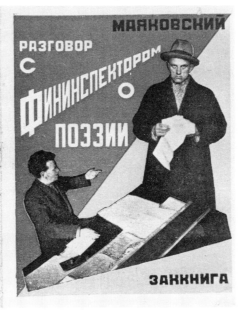

FIGURE 3.16
Rodchenko *A Conversation with a Tax Inspector* about Poetry, cover, 1927

Brik's definition of art as a type of production, along with his contention that the social command determined artistic content and form, helped support both Mayakovsky's and Rodchenko's activities as producers of advertising posters and logos for the state trusts and distribution outlets. For these projects, done between 1923 and 1925, Rodchenko worked more extensively for a mass audience than he had earlier. He not only had to consider his own rhetorical interests, he also had to mesh them with the demands and needs of his clients.[66] In 1923 Dobrolet, the state agency that was promoting investment in Soviet aviation, gave him a commission which initiated his collaboration with Mayakovsky on advertising placards. Struggling with a piece of poorly written copy for a Dobrolet poster, Rodchenko showed it to Mayakovsky and managed to persuade the poet to work with him on future projects. Rodchenko called their collaborative efforts "the first true Soviet advertisements which turned against the little heads, flowers, and other petty bourgeois tawdriness in vogue in the NEP period."[67] Their clients were various state enterprises and organizations such as Rezinotrest, a state trust that marketed light industrial products; GUM, the large Moscow department store; Gosizdat, the state publishing house; and Mosselprom, a large state distribution agency for agricultural products. The goods that Mayakovsky and Rodchenko promoted included cigarettes, candy, biscuits, rubbers, baby pacifiers, light bulbs, macaroni, galoshes, books, and butter.

The two began their work following a reorganization of the state economy that abolished the centralized control of industry by Vesenkha (Supreme Council of the National Economy). Such control had proven to be extremely inefficient, and the reorganization forced autonomous production units to make their own way in competition with the private entrepreneurs. The government units, in most instances, were known as trusts and controlled a number of enterprises in a given field. Rodchenko and Mayakovsky, for example, produced posters for Rezinotrest, which was trying to unload rubbers and baby pacifiers, among other products, on the market. Mayakovsky described their work as a form of political agitation. In a manifesto, "Agitation and Advertising," he wrote:

> The bourgeoisie knows the power of advertising. Advertising is industrial, commercial agitation. Not a single business, especially not the steadiest, runs without advertising. It is the weapon that mows down the competition . . . But face to face with the NEP, in order to popularize the state and proletarian organizations, offices, and products, we have to put into action all the weapons, which the enemy also uses, including advertising.[68]

The two artists, who called themselves "advertisement constructors," worked close-

66 Rodchenko initially introduced the design of emblems or logos into the Metfak course at the VKhUTEMAS. He undertook one of his earliest logotype designs in 1922 for Vertov's *Kino-Pravda* newsreel.

67 Rodchenko, quoted in Karginov, *Rodchenko*, 120.

68 Vladimir Mayakovsky, "Agitation und Reklame," (1923), in *Majakowski Werk, Band 5 Publizistik:* ——— *Aufsätze und Rede*, ed. Leonhard Kossuth, trans. Hugo Huppert (Frankfurt am Main: Insel Verlag, 1973), 131 (my translation).

ly to fit jingles and pictures together. Rodchenko, assisted by some of his students from the VKhHUTEMAS, made the sketches, supervised their realization, and drew crucial parts himself.[69] Many of these posters were used as single painted signs in store windows while others were reproduced by lithography or offset printing. The posters and signs were often completed within a day or so of getting the order. Thus they represent Rodchenko's quick interpretations of the commissions rather than extended negotiations with his clients.

For his advertising posters Rodchenko adopted a simple illustrative style that featured an image of the object for sale, sometimes in a rudimentary form and occasionally in a whimsical or hyperbolic one. One poster for rubbers, which captured both qualities of whimsy and hyperbole, depicted a single rubber heroically fending off the rain from the earth (**FIGURE 3.17**). The image was complemented by Mayakovsky's slogan, "Protector in rain and slush. Without galoshes, Europe can only sit down and cry." Other posters for Rezinotrest promoted the sale of rubbers in outlying Moslem regions of the country. For these Rodchenko linked the rubbers to oriental figures, one seated inside a rubber on a camel's back, as if the object were a flying carpet. Rodchenko's humor was evident as well in a painted sign promoting rubber baby pacifiers, in which he showed a dummy holding an array of rubber teats in its mouth. Mayakovsky later justified the jingle he wrote to promote these pacifiers with the statement "that if in the country to this very day they pacify infants with a dirty rag, agitation for dummies is a healthy change for culture."[70] Unlike many of the other artists who produced advertising posters in the 1920s, Rodchenko was concerned with simple presentations which he achieved by clearly separating the text from the images to give the

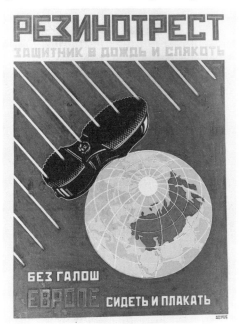

FIGURE 3.17
Rodchenko Rubber Trust poster, c. 1923

posters a stronger visual impact. To enhance this impact he used strong flat colors instead of subtle shadings, avoided extraneous details or overly complicated depictions of the products, and incorporated a number of rhetorical devices such as exclamation points and arrows for emphasis. For some of his clients, Rodchenko tried to establish a sense of visual identity that would continue from one project to another.

By the early 1920s, the concept of corporate identity was already established in parts of Europe, particularly in Germany. There Peter Behrens, as corporate design director for the big electric company AEG, had sought to unify the company's graphics, products, and architecture. Other German firms had commissioned logotypes from freelance advertising artists like Lucian Bernhard and applied them to packaging, advertising, and even company delivery trucks. But this work was little known in the Soviet Union when Rodchenko and other artists first confronted the problems of designing advertising and identity symbols for state enterprises. The graphics for Mosselprom, to cite an example, demon-strate this lack of awareness. The agency had several logotypes, varying styles of lettering, no sense of unity through format or presentational style, and inconsistencies in packaging design; in short, no design strategy which could unify the image of an organization that distributed a broad range of agricultural products. The initial emblem, which depicted an agricultural worker with a cornucopia of produce, was used on some of Mosselprom's posters and print materials. A frontal view of the Moscow headquarters building, which was an early example of concrete-frame modern architecture, was also used inconsistently as an identity mark on packaging and posters.

Rodchenko not only designed posters and newspaper ads for Mosselprom but also an advertising sign, more than six stories high, that was painted on the side of the Mosselprom headquarters in Moscow (**FIGURE 3.18**). Perhaps his strongest project for the agency was a powerful logo that unified Mayakovsky's slogan, "Nowhere but in Mosselprom," with a stark photograph of the headquarters building (**FIGURE 3.19**). It established the urban structure as the primary identity image for the organization rather than the harvester in the field with a cornucopia, but it was not adopted to replace the original. Although Rodchenko and Mayakovsky executed only a modest number of projects for Mosselprom, their work showed promise of developing into a coherent identity program which never materialized after they ceased to work for the organization.

Reviewing a sampling of Soviet advertising art from the 1920s, we can see influences ranging from nineteenth-century French lithographic posters to that of the German *sachplakat* artists—Bernhard, Hohlwein, and Erdt—as well as the American advertising artist J. C. Leyendecker and the Munich *Simplicissimus* illustrators.[71] What particularly differentiates the designs of Rodchenko and Maya-

69 Rodchenko, "Working with Mayakovsky," in *Alexander Rodchenko*, ed. Elliott, 102–4.

70 Mayakovsky, "Address to the Krasnaya Presnya Komsomol-Club," March 25, 1930, in Alexander Ushakov, ed., *Vladimir Mayakovsky: Plays, Articles, Essays* (n.p.: Raduga Publishers, 1987), 239.

71 Examples can be found in *Soviet Commercial Design of the Twenties*, ed. Anikst.

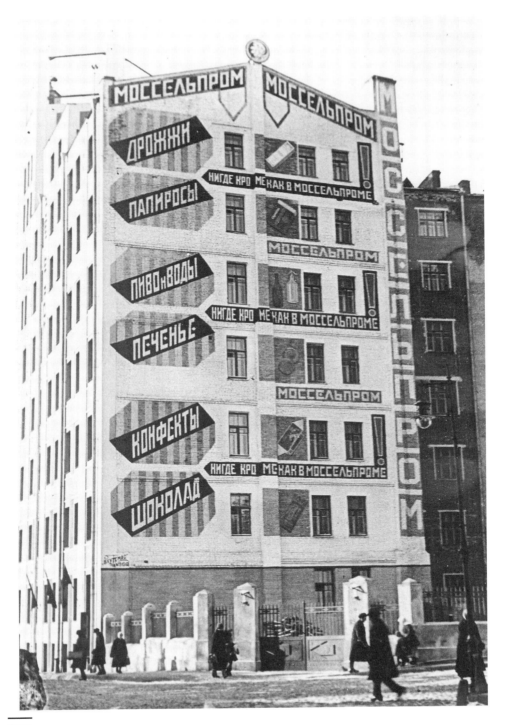

kovsky from this work, however, is their concern with creating a Soviet form of advertising rather than looking abroad for their models. Advertising projects offered Rodchenko yet another opportunity to promote the rhetorical objectives of production art. In the short time he worked in the advertising field, he developed a distinct style of visual rhetoric that featured a representation of products in active situations rather than as objects of contemplation. His "rhetoric of action" is evident in a number of the posters and advertisements he designed. In some instances he showed the product itself as an active object. The rubber in the Rezinotrest poster, for example, protects the earth from rain. Arrows emanating from a bottle of Three-Way Mountain Beer, distributed by Mosselprom, shatter the opposition (**FIGURE 3.20**), while periodicals stream independently off the presses of a government printing house in another poster.

As with all his other design projects from furniture to book covers, Rodchenko sought forms for his advertisements that suited contemporary conditions. At the same time, advertising gave him a chance to reach a large audience and thus widen the application of declamatory rhetoric he had begun to develop in his covers for avant-garde publications. He succeeded in demarcating a distinct visual style of advertising rhetoric, one that eschewed both the American technique of

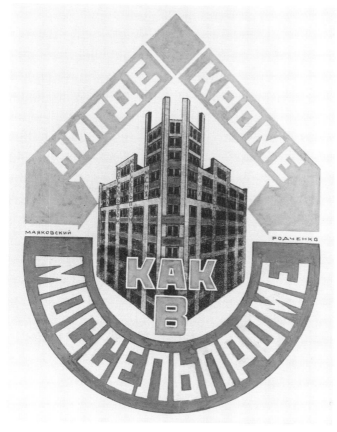

FIGURE 3.18 (p.116) **Rodchenko** advertising sign for Mosselprom, c. 1923

FIGURE 3.19 Rodchenko Mosselprom logo, c. 1923

117

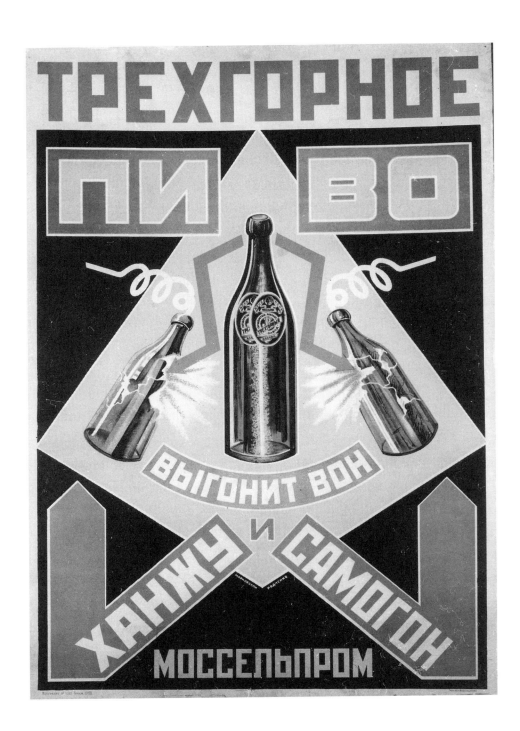

FIGURE 3.20
Three-Way Mountain Beer poster, c. 1923

playing on the consumer's desires through glamorized fantasy images as well as the avant-garde German style that treated the product as a formal element in a composition.[72] For Rodchenko, the product was an object that had a purpose and an effect. He conceived all objects, whether he designed them or promoted their sale, in the context of use. They were instruments of action, and even when he couldn't insure their use he could represent it visually.

6

In 1930 the VKhHUTEMAS, which was renamed the VKhUTEIN (Higher State Art-Technical Institute) in 1927, was closed. Although some of its programs were relocated elsewhere, the metal and woodworking facilities did not continue. Thus, after a decade, Rodchenko ended his career as a design teacher, having produced only a handful of specialists compared to the several thousand students who passed through the VKhHUTEMAS-VKhUTEIN during its existence.

Was the concept of the artist-constructor simply a myth fabricated by intellectuals who had little or no contact with industry? To some degree it was, for indeed its validity could scarcely be measured by successful collaboration with production organizations. There was barely any. Nor was there any fusion of art and engineering as some of the INKhUK theorists had envisioned. But the idea of production art motivated a few Constructivist artists, Rodchenko in particular, to invent a narrative of design for which there had been no precedent in the Soviet Union. While a better knowledge of modern design practice in the West would have helped Soviet artists and factory managers to establish new models of practice, the Soviet economy was nonetheless considerably less developed than those of England or Germany, for example, and posed different problems for designers to address. Aside from the discussions of production art in INKhUK, there was little concern elsewhere in the Soviet Union for training a new cadre of professional Soviet designers. This is understandable, given the economic and social emergencies the new government faced, particularly at the end of the Civil War. Thus, we can consider Rodchenko as one of the few people during the NEP who was grappling with the question of what kinds of designers and design practice were appropriate for the Soviet Union.

To some degree Constructivism, with its rigorous approach to organizing material, was a valuable grounding for a methodology of design. Rodchenko's fusion of purpose, material, and construction was also a powerful conceptual tool to forge a training course for designers. It prepared him as well to confront design problems. At the VKhHUTEMAS, Rodchenko succeeded in developing a set of exercises and projects to inculcate in his students a capacity for analyzing a problem, working with materials, and creating prototypes. Although his students were few, they were thus well prepared to solve the kinds of problems Rodchenko had set for them even though these problems did not correspond

72 For a distinction between the active depiction of objects in Russian Constructivist posters and their more static formal presentation in posters influenced by German Constructivism, see my article, "Constructivism and the Modern Poster," *Art Journal* 44, no. 1 (Spring 1984): 28–32.

to the new demands of Soviet industry at the end of the 1920s.

The emphasis of Constructivism and production art on form as an instrument of psychic change led Rodchenko to stress design as a means of demonstrating new possibilities for action rather than as a practice that took its cues from existing needs and tastes. Rodchenko's was neither a planning nor a marketing approach. He had strong beliefs about the qualities of character a Soviet citizen should possess. As a designer, he wanted to bring these qualities into being through the persuasive power of material objects. The challenge he set himself as a production artist and which he transmitted to his students was to invent objects that could embody revolutionary values. A chair that converted into a bed, a cover of *Lef* with its declamatory letter forms, or a logo for Mosselprom were all instruments to bring about the new culture for which he fought.

Rodchenko made his greatest impact with objects that people experienced through sight. His book covers and advertisements were widely seen and helped to promote a new graphic style. But his furniture designs and environments were also most powerfully received as images in exhibitions, films, and plays. Were we to value these achievements by the criteria for utilitarian art which were discussed in INKhUK, we would have to regard Rodchenko's lack of success with industry as a failure. But if we reject the bifurcation between pure and utilitarian art as the basis for our judgment of his work as an artist-constructor, we can find a strong connection between what Rodchenko hoped to accomplish as a Constructivist artist and what he put into practice under the name of production art. It then seems less strange that he should have made his most salient contributions in the NEP years through objects that were visually apprehended rather than physically used.

Though most of what he designed failed to reach a mass public, Rodchenko was a fighter for communist values as he defined them during a period when many in Soviet society preferred to return to a system of private enterprise and personal gain. In the long run, however, the avant-garde's vision of communist culture was never accepted by large numbers of people nor was it one which the party chose to adopt. Had the Soviet economy been more developed in the NEP years, some of Rodchenko's designs and those of his students could have been put into production. They would, however, most likely have been positioned as specialty items rather than products that satisfied mass needs. Rodchenko might have been regarded as an avant-garde designer similar to Marcel Breuer at the Bauhaus in Germany. As with Breuer and other Bauhaus designers, his idea of the artist-constructor originated from earlier examples of craftsmanship rather than engineering. Hence, he concentrated mainly on small-scale products rather than on automobiles, tractors, or various kinds of heavy equipment.[73]

Rodchenko's vision of a design practice for the emerging industrial mass econ-

73 A good example of the heavy equipment designed in the Soviet Union is the Fordson tractor, which was copied from the American model. Its production was stepped up in 1928, the year Ford shut down its plant for Fordson production in the United States.

omy of the Soviet Union was far ahead of its time. This was due not only due to the range of projects he embraced but also to his interest in methodology and formal principles. His vision, despite its rhetorical emphasis, was eminently pragmatic and could have developed into a widely applicable approach to design in the Soviet Union even though it originated within an avant-garde milieu. Unfortunately, it did not coincide with the priorities of the first Five-Year Plan which focused on heavy industry and had a marginal concern with consumer products. Hence, the potential of Rodchenko's work went unrecognized, and the Soviet Union remained in the backwaters of design for years to come.

A photograph of a newly built factory is, for us, not simply the snapshot of a building. The new factory in the photograph is not simply a fact, it is a fact of the pride and joy felt in the industrialization of the country of the Soviets. And we have to find "how to take it."
 Alexander Rodchenko(1928)[1]

Photography does not want to simulate anything, it records, but this recording method—we must emphasize this again and again—has its own, still unfathomed laws with respect to technique and design.
 László Moholy-Nagy [1927] (1989)[2]

Photography makes aware for the first time the optical unconscious, just as psychoanalysis discloses the instinctual unconscious.
 Walter Benjamin [1931] (1976)[3]

We are looking at two photographs from 1928 by Rodchenko and Moholy-Nagy, one of young people gathering for what appears to be an athletic demonstration in the courtyard behind the VKhUTEMAS, which Rodchenko photographed from his studio balcony, and the other of a man trimming a tree on a Berlin street, captured by Moholy-Nagy from his apartment window (**FIGURES 4.1** and **4.2**).

 The photographs have much in common. Both possess an imposing formal order. Each scene is photographed from a bird's-eye view. Seen from above, the figures in the two photographs are embedded in powerful arrangements of lines, shapes, and planes. Rodchenko and Moholy-Nagy shot the scenes from angles that reveal the courtyard and street as dynamic diagonals, and they emphasized the contrasts between light and dark elements. The highly structured images, with their sharply etched distinctions between shapes and space and their incorporation of the diagonal as a dynamic element, recall the earlier Constructivist paintings of both artists.

1 Alexander Rodchenko, "A Caution," *Novyi lef* 11 (1928). This document and subsequent ones are from a collection of unpublished translations by John Bowlt.

2 László Moholy-Nagy, "Photography in Advertising," in *Photography in the Modern Era: European Documents and Critical Writings*, 1913–1940, ed. and with intro. Christopher Phillips (New York: Aperture/Metropolitan Museum of Art, 1989), 89.

3 Walter Benjamin, "A Short History of Photography" *Creative Camera International Yearbook 1977* (London: Coo Press, 1976), 163.

The formal, thematic, and technical aspects of the two photographs are distinctly modernist, as modernism was articulated in photographic representations during the 1920s. The images are sharp, the scenes urban, and the bird's-eye views call attention to the new lightweight cameras both photographers were then using. Yet, despite common elements, the photographs also have their differences. Rod-chenko makes us aware that someone is viewing the demonstration by including in the picture part of the apartment building from which he was photographing and by showing us other people observing the activity below. His acknowledgment of a viewing position affirms that the event photographed is part of a social experience rather than an abstract formal exercise. In this instance, we can see the gathering of young people for what appears to be an athletic demonstration as a characteristic event in the daily life of the Soviet Union.

Moholy-Nagy, on the other hand, conceals his viewing position. We see a view, but no viewer, and are less concerned with the depiction of social activities than with the formal configuration of the picture. Moholy-Nagy's image, like Rodchenko's, is an index or trace of a novel vantage point—the bird's-eye view—but the photographer disengages us from the street as a site of social activity and directs us to the properties of the photograph itself—the flattening of space, the compositional force of the diagonal, and the contrast of textures and tones. Photographs for Moholy-Nagy always called attention to how things are seen through the mediation of the camera, but they did not necessarily emphasize the meaning of *what* is seen.

FIGURE 4.1
Rodchenko *Gathering for a Demonstration in the VKhUTEMAS Courtyard,* 1928

FIGURE 4.2
Moholy-Nagy *Spring, Berlin,* 1928

For Rodchenko, it was otherwise. Unlike Moholy-Nagy, who strove to conceal the personal relation of photographer to subject, Rodchenko forged a dialectic between the subjects he photographed and a new way of viewing them. The camera made innovative vantage points possible, thus enabling him to find a new relation to a place, person, or object and to affirm that relation through the photograph itself. In his writings on photography in the 1920s, Rodchenko did not express a particular indebtedness to Moholy-Nagy nor did Moholy-Nagy to Rodchenko.[4] But even if one man had influenced the other, neither attributed the same meaning to the results. Even though we can note the formal similarities in some of their photographs, it is more fruitful to focus on how the intended and received meanings of each photographer's work differed within his own milieu. Both photographers were recognized as the leading practitioners of modern photography in their respective countries—the Soviet Union and Weimar Germany. By comparing their work, we can identify distinct ways that modernist photographic practice was received in two different cultural contexts. I have limited the comparison to the 1920s because it was during those years that Rodchenko and Moholy-Nagy developed their identities as photographers within newly emerging discourses about the techniques, aesthetics, and social meaning of modern photography.

Though Rodchenko and Moholy-Nagy intended photography to be an instrument of personal transformation, neither found an unobstructed path for the alignment of photographic modernism with a process of social change. Rodchenko's argument for formal innovation as a new and revolutionary way of engaging with social life was ultimately seen by his opponents as a manifestation of Western bourgeois aesthetics. This brought him into conflict with powerful cultural groups that were striving for dominance at a moment when tolerance for a plurality of photographic practices was waning.

Conversely, Moholy-Nagy was acclaimed as a cultural innovator in Germany at the end of the 1920s, but his photographs were incorporated within a discourse grounded in formalism rather than the use of photography as an expansion of human vision as he intended. Both Rodchenko and Moholy-Nagy encountered reductive readings of their photographs which were consequently defined socially in ways that separated the work from their intentions.

4 Moholy-Nagy included one of Rodchenko's metal sculptures in the *Book of New Artists* which he edited with Lajos Kassák in 1922. He most likely saw several works by Rodchenko in the First Russian Art Exhibition at Berlin's Galerie Van Diemen the same year. His familiarity with Rodchenko's early Constructivist art is clearly evidenced in the letter he sent Rodchenko in December 1923, inviting him to write a short volume on Constructivism as the first in a new series of Bauhaus books. But the volume did not materialize. In a 1928 essay, "Downright Ignorance or a Mean Trick?" Rodchenko wrote that "Moholy-Nagy, once a leftist, nonfigurative painter, has asked me several times to send him my photographs. He knows them very well and he values my work." Alexander Rodchenko, "Downright Ignorance or a Mean Trick?" *Novyi lef* 6 (1928), (Bowlt translation). Rodchenko does not refer to Moholy-Nagy's work in his writings before 1928, but he knew Moholy-Nagy's book *Malerei, Photographie, Film*, which was first published in 1925, and in a second edition with the title *Malerei, Fotografie, Film* in 1927. An inscribed copy, probably of the later edition, was found in Rodchenko's library.

125

2

By the end of the nineteenth century in Russia, the prominent Academy of Fine Arts in St. Petersburg had recognized photography as a legitimate form of figurative art and allowed photographers to participate in its exhibitions. Around the same time, a group of young photojournalists emerged to parallel the developments in social photography, on the one hand, and landscape and portrait photography, on the other. It was this group, exemplified by such photographers as Karl Bulla, Jakob Steinberg, and Piotr Otsup, who started to work for the illustrated magazines that sprang up shortly after the Revolution.[5] Within this context, Rodchenko began to stake out a position of his own. On the one hand, he set himself against the photographers who operated the portrait studios and those who entered their photographs in the academy exhibitions, opposing this work on the grounds that it tried to imitate art even when the subjects were leaders or events of the Revolution. On the other hand, he criticized the way many of the photojournalists posed their subjects for the camera to achieve an emotional effect.

Rodchenko began to photograph on his own in 1924, a year after he incorporated photographs of Mayakovsky and Lily Brik, specially shot by Abram Shterenberg, into his photomontages for Mayakovsky's poem *About It*.[6] It was Dziga Vertov's *Kino-Pravda* newsreels that served as Rodchenko's own point of departure as a photographer rather than the photographs of his predecessors and peers. Working on film titles for *Kino-Pravda* in 1922, he became interested in narrative sequences. From Vertov, he learned how a new kind of narrative could be constructed from separate pieces of film, each comprising a different visual relation to a subject.

For Rodchenko, the sequence was the photographic equivalent of Vertov's new film grammar based on motion.[7] The individual photograph, he believed, could provide more information about a subject through its incorporation in series or groups. Rodchenko's commitment to a sequential structure of representation was instrumental in his rejection of the traditional conventions of

5 See the short history by Grigory Shudakov, Olga Suslova, and Lilya Ukhtomskaya, *Pioneers of Soviet Photography* (London: Thames and Hudson, 1983). For several accounts of Soviet photography up to World War II, see *Camera* 6 (June 1981), a special issue on Soviet photography between the world wars edited by Daniella Mrázková and Vladimir Remes; the catalog by the same editors for an exhibition at the Museum of Modern Art, Oxford, *Early Soviet Photographers*, ed. John Hoole (Oxford: Council of the Museum of Modern Art, 1982); and Allen Porter, *Sowjet Photographie, 1919–1939*, trans. Dieter W. Portmann (Zürich: U. Bär Verlag, 1986 [photothek 4]).

6 The most thorough book on Rodchenko's photography is Hubertus Gassner, *Rodçenko Fotografien* (München: Schirmer/Mosel Verlag, 1982). See also Evelyn Weiss, ed., *Alexander Rodtschenko Fotografien 1920–1938* (Köln: Wienand Verlag, 1978); *Alexander Rodtschenko: Möglichkeiten der Photographie* (Köln: Galerie Gmurzynska, 1982); and Alexander Lavrentiev, *Rodchenko Photography* (New York: Rizzoli, 1982). There is a chapter on Rodchenko's photographs in the context of his larger body of work in Selim O. Khan-Magomedov, *Rodchenko: The Complete Work*, ed. and intro. Vieri Quilici (Cambridge, MA: MIT Press, 1987), 214–75. Useful articles on Rodchenko's photographs include Andrei Nakov, "Alexander Rodchenko: Beyond the Problematic of the Pictorial," *Artforum* 16 (October 1977): 38–43; and John Bowlt, "Alexander Rodchenko as Photographer," in *The Avant-Garde in Russia, 1910–1930: New Perspectives*, ed. Stephanie Barron and Maurice Tuchman (Los Angeles: Los Angeles County Museum of Art, 1980), 52–59.

7 On the sequence as central to Rodchenko's photography, see Gassner, "Analytic Sequences," in *Alexander Rodchenko*, ed. David Elliott, (Oxford: Museum of Modern Art, 1979), 108–11.

painting as well as photographs that imitated those conventions. He opposed the idea of synthetic representation, where a single image was intended to convey a generalized truth.

In the early stage of his photographic career, Rodchenko did not consider the camera as an instrument to depict social narratives in a voyeuristic way as the photojournalists intended. Nor was it his idea to create mythic images of individuals as the portrait photographers did. More than any Soviet photographer in the early 1920s, Rodchenko wanted to empower viewers by engaging them with his subjects through the camera lens, rather than reducing them to spectators in a larger than life drama where the photographer and his apparatus disappeared.

Rodchenko started photographing after the initial wave of commemorative mass demonstrations and festivals that followed the Revolution and provided visual material for his predecessors.[8] The decline in these spectacles was abetted by the NEP with its emphasis on practical matters of reorganizing the government and the production system. The NEP, which allowed private entrepreneurs to participate in the economy, did not provide the same opportunities for the documentation of politically heroic acts as did the years just after the Revolution. Nor was life during the NEP as dramatic as the subsequent period that began with the first Five-Year Plan in 1929, when Stalin undertook a program of heavy industrialization and collective agriculture.

Most of Rodchenko's photographs in 1924–25 were portraits of his family and friends.[9] This was partly due to the fact that he was working with a heavy 9-inch x 12-inch box camera which he could not move around easily. Those whom he photographed in the 1920s were predominantly from the artistic milieu. They included the writers Mayakovsky, Nikolai Aseyev, Valentin Katayev, Sergei Tretiakov, and Alexander Shevchenko; artists and designers Alexei Gan, Anton Lavinsky, Liubov Popova, and Rodchenko's wife Varvara Stepanova; filmmakers Lev Kuleshov and Esfir Shub; architects Alexander Vesnin and Nikolai Ladovsky; and the critic Osip Brik.

Rodchenko's compatibility with his subjects and his respect for their characters are clearly exemplified in the series of photographs he took of Mayakovsky in 1924.[10] We can divide these pictures into two main groups: the poet standing in a hat and overcoat (**FIGURE 4.3**) and sitting in a suit and vest (**FIGURE 4.4**).[11]

8 For a discussion of these events, see Catherine Cooke, Vladimir Tolstoy, and Irina Bibikova, *Street Art of the Revolution: Festivals and Celebrations in Russia, 1918–1933* (London: Thames and Hudson, 1990).

9 John Bowlt notes that Rodchenko's first photographs, published in the journal *Tekhnika i zhizn*, were of the Soviet Mint and its operation. These, however, have not been published in the albums of his better known works. See John Bowlt, "Alexander Rodchenko as Photographer," 54.

10 It is difficult to know which of these photographs Rodchenko considered to be part of the original series and which were later printings, since several of them have been published with different croppings. At least two different frontal images of Mayakovsky in an overcoat and hat exist. In one he appears in full figure, and in another he is shown from waist to head only. An image of Mayakovsky seated with a cigarette in his mouth exists in at least two versions—the poet from the waist up and an enlargement from the shoulders up. There are also at least two versions of a frontal head shot of Mayakovsky, one from the chest up and the other similar but slightly enlarged. Since all these pictures were published in books that appeared well after Rodchenko's death, it is very likely that some of the pictures were not printed and cropped by him.

11 An exception is the poet in the country, smiling and holding a dog.

In both groups, a large sheet of paper with a grid of horizontal and vertical lines painted on it serves as a backdrop. To photograph Mayakovsky against this grid was to connect him to a Constructivist metaphor of artistic production, signified by the rectilinear structure, rather than to locate him in a natural setting. The artistic toughness of the grid metaphor becomes a context for the viewer's reading of Mayakovsky the artist. The poet's challenging image is consistent with his role at the time as leader of the *Lef* group which was fighting for a politically engaged avant-garde art. Standing in his overcoat and hat (**FIGURE 4.3**), Mayakovsky assumes a defiant stance, confronting the photographer directly instead of looking off into a space beyond the camera or gazing in another direction. His lips are pursed, his knit brow shows a sharp crevice between the eyes, and his body is taut.

What strikes one in this photograph is its directness. Mayakovsky stands, legs apart, in the middle of the frame. The frontal view brings out all the strength of his pose and establishes a powerful relation to the photographer. It inserts Rodchenko into the picture and marks his presence in the shooting situation, reminding the viewer that photographing itself is an engaged act. It also allows one to view the subject in a social relation to someone else, the photographer. Given that Mayakovsky was the most prominent voice in the *Lef* group and Rodchenko was also a member of the group, anyone viewing the pictures who was aware of their relationship might have inferred that Mayakovsky's defiant position also represented Rodchenko's to some degree.

The photographs of Mayakovsky seated (**FIGURE 4.4**) show the poet in a more

relaxed pose but confronting Rodchenko nonetheless. Mayakovsky's body does not face the camera directly, but his head is turned toward it, and he stares intently at it. He holds a cigarette, but this doesn't suggest relaxation. On the contrary, Mayakovsky has arranged his body as a series of angular lines that mesh with those of the backdrop and the floor. In his breast pocket are a pencil and several pens which, from their position, following a military metaphor, we might read as arrows in a quiver.

The lines in the picture—the straight line of Mayakovsky's body, the diagonal movement of his slightly parted legs, the edge of his hat brim, the horizontal and vertical lines of the backdrop—all contribute to the picture's tautness as they do in Rodchenko's earlier linoleum cuts and three-dimensional constructions. Rodchenko, however, does not submerge Mayakovsky in this formal order. On the contrary, the formal tension of the photograph expresses the toughness of his character that Rodchenko reveals in the portrait.

Given the radical cultural stance of Mayakovsky and the other artists Rodchenko photographed, they become revolutionary subjects for him. While the settings for some of these photographs are obscured, details suggest that Rodchenko took a number of the pictures in the artists' studios. For example, we see Alexei Gan bent over his drawing board working on a new journal cover. Likewise, Rodchenko photographed his wife Varvara Stepanova seated on a drawing board, wearing a dress made from her own Constructivist fabric. In other photos he portrayed Stepanova as a more liberated woman of the 1920s, as he did the

FIGURE 4.3 (p. 128)
Rodchenko *Portrait of Mayakovsky,* 1924

FIGURE 4.4 (p. 128)
Rodchenko *Portrait of Mayakovsky,* 1924

FIGURE 4.5
Rodchenko *Portrait of Mother,* 1924

film editor Esfir Shub, by depicting both women with variants of the proletarian worker's cap or with cigarettes dangling from their lips.

From Rodchenko's earliest images, as we see in a portrait of his mother taken in 1924 (**FIGURE 4.5**), we can note his concern with establishing a balance between their formal characteristics and their narrative possibilities. I want to argue that Rodchenko did not attempt to construct a new technique of photographic representation by diminishing or suppressing the narrative qualities of his subjects as Moholy-Nagy did. This is evident in the Mayakovsky photographs where we see the poet, eyes wide open, staring directly at the camera. While the themes of most of Rodchenko's pictures up to 1928 were not overtly propagandistic, they nonetheless bear a political meaning as his own representation of postrevolutionary life.[12] Many of the pictures are autobiographical in varying degrees. Their political value rests on the credibility of Rodchenko himself as a social activist, which is reinforced by all his concurrent activities in graphics, furniture design, theater, and education. Embedded in the full constellation of his activities during the 1920s, the photographs are signs of Rodchenko's own strong character as an artist and designer. In this sense, it is not fruitful to read them as formal exercises. Even those few pictures of isolated objects—the stemware photographs of 1927, for example, serve as particular examples of Rodchenko's struggle to define a distinct technology and rhetoric for photography. They form part of a body of work in progress through which Rodchenko as a visual artist was working out his relation to the postrevolutionary social world of the Soviet Union.

The subjects of Rodchenko's photographs in the 1920s vary in their degree of political iconicity. They range from the portrayal of his colleagues or scenes of urban life in Moscow, including his own apartment building, to trees in the Pushkino Forest near Moscow and scenes of the Red Army on maneuvers. In none of these photographs, however, are the subjects isolated from their specific social or natural setting as pure formal objects. Even the Pushkino trees, which are photographed from a stark worm's-eye view, are still identified as part of a specific geographical terrain.

Rodchenko differed from the portrait photographers and photojournalists who were his contemporaries in that he did not isolate and heighten particular themes as epiphanies of postrevolutionary life, whether these were heroically portrayed leaders or views of factory workers. At the same time, he, unlike his colleagues, did not conceal the photographer's role as the one documenting the scene. The photograph for Rodchenko was not an object that disappeared

12 When Rodchenko wrote in 1927 in support of the sequence of snapshots rather than the synthetic portrait, which was an issue of technique rather than content, he used as his example of the sequence a political subject—V. I. Lenin—claiming that the representation of Lenin in a series of pictures was more true to his identity than a single idealized portrait. See Alexander Rodchenko, "Against the Snapshot, for the Portrait," in *Russian Art of the Avant-Garde: Theory and Criticism*, 1902–1934, rev. and enlarged ed., ed. John Bowlt (New York: Viking Press, 1988 [c. 1976]), 250–54.

13 The photographs of Melnikov's pavilion are among the very few that Rodchenko took outside the Soviet Union. The pavilion already possessed rhetorical power as an example of current Soviet architectural thought, and Rodchenko enhanced this power by photographing the building from dramatic angles. At the same time, he claimed that no single view, no matter how dramatic, could encapsulate a subject's meaning.

behind its didactic message. Instead, he included himself as a revolutionary subject in his pictures by documenting his own experience from a distinct viewing position, which was not primarily a means to reveal a subject in a new way as it was for many of the "new photographers" in Germany; rather it was the representation of a revolutionary stance, an argument that individuals who participated in a revolution had to alter their perceptual habits and see the world anew as part of their involvement in a changing political practice and social structure.

We also see evidence of Rodchenko's engagement with contemporary life as a political act in the considerable widening of the social spaces where he photographed between 1924 and 1928. He began with his immediate family and close associates whom he documented in interior spaces. Then he moved out of the studio to photograph specific buildings and broadened his view to include urban settings such as courtyards, parks, and streets as well as natural sites surrounding Moscow. It was these exterior views, along with his portraits, that dominated his oeuvre before he began to work in earnest as a photojournalist for the Soviet illustrated magazines around 1928.

My intent here is to emphasize the importance of Rodchenko's themes *as well as* his viewing positions for a full reading of his photographs. Rather than suppressing the narratives of his subjects, Rodchenko entwined them with his own interpretive strategies. This was certainly the case for his portraits of Mayakovsky and other artist colleagues. It also held for objects—whether new ones such as Melnikov's Soviet pavilion at the 1925 Exposition Internationale des Arts Décoratifs et Industriels Moderne in Paris (**FIGURE 4.6**), or old ones with new formal possibilities such as the Moscow apartment building that housed his studio on Myasnicka Street.[13]

FIGURE 4.6
Rodchenko Melnikov pavilion, 1925

FIGURE 4.7
Rodchenko *Red Army on Maneuvers*, 1925

14 The Pushkino images were published in *Novyi lef* 7 (1927).

15 Alexander Rodchenko, "Downright Ignorance or a Mean Trick?" *Novyi lef* 6 (1928). The document forms part of an exchange between Rodchenko and his colleagues that was published in *Novyi lef* in 1928. Throughout this essay, quotes from these documents are taken from an unpublished set of English translations done by John Bowlt.

16 Three of these images were published in *Novyi lef* 3 (1928).

The political iconicity is self-evident in some of Rodchenko's building photographs. We can see it in his images of Melnikov's Rusakov Worker's Club, the Briansk railroad station, and the headquarters building of Mosselprom. All these buildings had revolutionary connotations implicit in their forms, whether these referred to technological accomplishment (the Briansk station), cultural policy (Melnikov's Paris pavilion), or social achievement (Melnikov's Worker's Club and the Mosselprom headquarters). Political iconicity is perhaps most clearly evident in Rodchenko's photographs of Red Army soldiers practicing in huge air balloons (**FIGURE 4.7**).

In the Red Army photographs, the political denotations are uncontestable. This is not the case in other photographs such as the series Rodchenko made of his apartment building on Myasnicka Street, but these images too had a political significance within Rodchenko's oeuvre. We can divide the most widely published pictures of this series, which are variously dated 1924 and 1925, into three groupings: the worm's-eye shots of the building from below (**FIGURE 4.8**), the bird's-eye shots from above (**FIGURE 4.9**), and the shots from below that include a ladder with or without a person on it. With his images of balconies, ladders, windows, drainpipes, and walls, Rodchenko in fact reinvented the building, making of it a series of novel views. Attending to the autobiographical aspect of this series—it was based on the building where he lived and had his studio—we can read it as a demonstration of Rodchenko's capacity to visually transform his own surroundings through a creative act. It was this quality that he believed should characterize an active citizen of the postrevolutionary culture. We can also see this act of transformation in a somewhat different series—the photographs of trees in the Pushkino Forest near Moscow.[14] Here Rodchenko tilted the camera up to photograph a single tree as a receding elongated diagonal and, shooting from below, drew a group of trees toward each other as converging clumps of leaves and branches (**FIGURE 4.10**). As he stated himself in 1928:

> When I present a tree taken from below like an industrial object such as a chimney, this is a revolution in the eyes of the philistine and the old connoisseur of landscapes. In this manner I am expanding our conception of the ordinary, everyday object.[15]

However, it was not just the object taken out of context that interested Rodchenko. It was the tree as part of a landscape that would be seen differently by a new kind of viewer.

The group of photographs most difficult to account for within the reading of Rodchenko's work that I am proposing is the series in which he photographed a piece of elegant stemware (**FIGURE 4.11**) and a glass pitcher from different angles and distances.[16] Acknowledging that Rodchenko's project as an artist was to integrate artistic practice and social life, we can interpret these photographs in several ways. First, we can consider them in relation to his aim of

defining photography as a new medium. The selection of angles, choice of lighting, and crispness of outline focus the viewer's attention on the objects rather than on a mood or atmosphere.

We also can locate them within the emerging materialist theory of "factography" that several of the *Novyi lef* writers were developing in the late 1920s. Like his colleagues, Rodchenko was opposed to abstract psychological interpretations of the self. As a materialist, he wanted to define human identity through an exchange with the surrounding world; on the one hand, the subjects photographed reflected the photographer's strong vision; on the other, that vision exposed the strength of character in objects, places, and events.

In an article entitled "The Photo-Frame versus Painting," published in the second issue of the journal *Sovetskoe foto* (Soviet Photo) in 1926, Osip Brik emphasized the social significance of seeing objects anew. He argued first of all that photography was superior to painting as a way of representing life. The point of this superiority was not simply to improve on what painters had been doing but to do a different job instead.

> The photographer must show that it is not just life ordered according to aesthetic laws which is impressive, but also vivid everyday life itself as it is transfixed in a technically perfect photograph.[17]

FIGURE 4.8
Rodchenko *Apartment on Myasnicka St.* (worm's-eye view), 1925

17 Osip Brik, "The Photo-Frame versus the Painting," *Sovetskoe foto* 2 (1926) (Bowlt translation).

18 The avant-garde's critique of the bourgeoisie took on a more powerful rhetorical value after the Revolution when its prior repudiation of this class on the basis of aesthetic values was reinforced by a rejection of the bourgeoisie's political values as well.

Brik claimed that photographers needed to battle against the painter's "aesthetic distortion of nature" by repudiating painterly conventions as a model of representation and substituting new ones that were inherent in the photographic medium. The strong connotations of revolutionary life which these new conventions had for Rodchenko derived both from the *Novyi lef* discourse about the social value of new artistic forms and the longer-term avant-garde project of transforming the representation of social life.[18] By early 1928, however, Rodchenko was drawn into a debate about the merits of his position with the editors of *Sovetskoe foto* as well as with some of his colleagues from *Novyi lef*. This debate would make clear to him that no artistic discourse could operate on its own terms alone but instead had to promote and defend itself in relation to competing discourses. The closer these discourses were allied with political power, the more severely they could reduce or close out altogether the space of exploration for the artist.

3

The development of photography in the Soviet Union during the 1920s can be characterized broadly by its intention to represent a new postrevolutionary culture to the population at large, taking into account different views of how this

FIGURE 4.9
Rodchenko *Apartment on Myasnicka St.* (bird's-eye view), 1925

was to be done. By contrast, no comparable aim existed in Weimar Germany, which was replete with competing political visions as extreme as those of the Communist party on the left and the National Socialists on the right.[19]

Among the tendencies that influenced photographic practice was the development of the illustrated news magazines in the bourgeois press. These magazines, such as the *Berliner Illustrirte Zeitung* and the *Münchner Illustrierte Presse*, created a demand for photographic investigations into many previously undocumented aspects of German life. They spawned a new breed of photojournalists, such as Erich Salomon, Felix Man, and Tim Gidal.[20] There was also a vogue for photo albums, which took the most diverse forms from collections of hazy landscapes and cultural monuments by Kurt Hielscher to the magnified views of plants by Karl Blossfeldt and the more hard-edged images of both natural and industrial scenes by Albert Renger-Patzsch. As a portraitist, August Sander set himself the task of documenting all the various social types in Germany.

While the photojournalists produced images of Weimar social life to feed the curiosity of a hungry public, and the album photographers cultivated their sensibilities as individual artists, the worker-photographers, associated with the left-wing culture in and around the Communist party, saw photography as an instrument of the working class to oppose the economic and cultural dominance of the bourgeoisie. To this end, they functioned as photojournalists for the left-wing illustrated magazine, the *Arbeiter Illustrierte Zeitung* (AIZ), and they also had their own journal, *Der Arbeiter-Fotograf* (The Worker-Photographer). They also organized classes and workshops to train photographers to work within the tenets of the movement.[21]

FIGURE 4.10
Rodchenko *Pushkino Forest*, 1927

FIGURE 4.11
Rodchenko *Stemware*, 1928

Mike Crowley

Richmond VA

804 747-4857

800 851 6832

888 851 6832

Clarinbridge Co
Richmond

Given the range of situations within which Weimar photographers functioned, we can still find no community of discourse where the question of photography's social purpose was debated. Instead of the social revolution, which became the frame of reference for all artistic production in the Soviet Union, it was the diverse and energetic movement of capital in Germany that created the dominant conditions for photographic practice there. This was true for the photojournalists whose pictures increased the circulations of the illustrated weeklies, the commercial photographers working in advertising, and also for the experimentalists such as Moholy-Nagy, whose photographs gradually achieved the status of art and thus belonged to the economy of buying and selling artworks.

Because of the formal and technological novelty in Moholy-Nagy's pictures, they fell easily within the discursive boundaries of modern art as acknowledged by curators, dealers, and collectors. They could be easily related to contemporary tendencies, whether Constructivism or Neue Sachlichkeit, and ideologically managed within the system of selling and buying art. By the late 1920s they had been incorporated within the movement known as the "neue fotografie" (new photography), and Moholy-Nagy was considered to be one of the movement's leading exemplars.

But he was not simply an innovator of new photographic forms as his adherents portrayed him. He was a utopian socialist, though not a programatic one, who believed that artists could help to bring about a collective society. As a means to this end, he envisioned photography's task as the liberation of human beings from the constraints of narrow perception and consciousness.

Moholy-Nagy thus wrote critically of photographers who sought to depict the world as it was. He declared that the purpose of photography was to make visible a new reality rather than reproduce an existing one. His idealism, however, placed him in a complex relation to the institutions of Weimar Germany and abroad— the museums, journals, and galleries, which distributed and consumed the work

19 For surveys of Weimar photography, see David Mellor, ed., *Germany: The New Photography: 1927–1933* (London: Arts Council of Great Britain, 1978); *La Photographie sous la République de Weimar* (Stuttgart: Institut für Auslandsbeziehungen, 1979); and the exh. cat. by Van Deren Coke, *Avant-Garde Photography in Germany, 1919–1939* (New York: Pantheon, 1982), which appeared first as a smaller catalog of an exhibition by that name at the San Francisco Museum of Art (San Francisco: San Francisco Museum of Art, 1980). In her critical review of this exhibition, Rosalind Krauss argues that "what unites the various techniques and formal tropes of The New Vision's camera-seeing is the constant experience of the camera-seen." See Krauss, "Jump over the Bauhaus," *October* 15 (Winter 1980): 103–10. See also Krauss's review of a colloquium on Weimar photography, "When Words Fail," *October* 22 (Fall 1982): 91–103; and Maria Morris Hambourg, "Photography between the Wars," *Metropolitan Museum of Art Bulletin* 45 (Spring 1988): 3–56.

20 Further information on German photojournalism can be found in Tim Gidal, *Modern Photojournalism: Origin and Evolution, 1910–1933* (New York: Macmillan, 1973); and the chapter entitled "The Birth of Photojournalism in Germany," in Gisele Freund, *Photography and Society* (Boston: David Godine, 1980).

21 There is little published in English on the worker-photographers. For an introduction to this topic, see Hanno Hardt and Karin B. Ohrn, "The Eyes of the Proletariat: The Worker-Photography Movement in Germany," *Studies in Visual Communication* 7, no. 3 (Summer 1981): 46–57. In German, see Johan Sauer, "Arbeiterfotografen schliessen sich ein," in *Wem Gehört die Welt: Kunst und Gesellschaft in der Weimarer Republik* (Berlin: Neue Gesellschaft für Bildende Kunst, 1977), 467–79; Joachim Büthe, Thomas Kuchenbuch, et al., *Der Arbeiter-Fotograf: Dokumente und Beiträge zur Arbeiterfotografie 1926–1932* (Köln: Prometh Verlag, 1977); and Heinz Willmann, *Geschichte der Arbeiter-Illustrierten Zeitung 1921–1938* (Berlin: Dietz Verlag, 1975).

of independent photographers produced outside the contexts of journalism or advertising. These institutions were interested in photographs as artifacts which could circulate within a given system of exchange rather than as traces of a new consciousness. Moholy-Nagy had no easy task to negotiate his own idealistic conception of photography's use-value within a milieu intent on replacing that value with a different conception more closely akin to its own need to aestheticize and commodify objects.

Even though Moholy-Nagy had an institutional base between 1923 and 1928 at the Bauhaus (**FIGURE 4.12**), where he could experiment with new techniques and theories within a pedagogical framework, there were nonetheless various agendas for photographic experimentation at the school, and his own concerns by no means dominated the work there.[22]

Moholy-Nagy's first engagement with photography was the creation of photograms or cameraless photographs he made together with his first wife Lucia in 1922.[23] She has recounted how their interest in working directly with light on photographic paper arose from a discussion of the distinctions between the productive and reproductive uses of new media.[24] These were described in "Produktion-Reproduktion" ("Production-Reproduction"), the essay which appeared in *De Stijl* (July 1922).[25] Moholy-Nagy distinguished *production*—"the representation of the most expansive new connections between known and still unknown optical, acoustical and other functional phenomena"—from *reproduction*—"the reiteration of already existing relations."[26]

In making this distinction Moholy-Nagy, as the authorial voice, claimed that photography was a medium to produce new sensory experiences rather than represent the world as already processed by the senses. Hence, the photogram was a pattern of light that had not existed before as compared to the photograph which registered a view that had already been grasped by direct perception. Extending his argument to other media, Moholy-Nagy stated that the productive use of the gramophone should bypass the mechanical recording process which registered musical performances. Instead, an artist could incise grooves

22 The first photography workshop was established at the Bauhaus in 1929, after Moholy-Nagy left. Its head was Walter Peterhans who specialized in imaginative still lifes and advertising photography. For overviews of photographic practice at the school, see *Bauhaus Photography* (Cambridge, MA: MIT Press, 1985); and Jeannine Fiedler, ed., *Photography at the Bauhaus* (Cambridge, MA: MIT Press, 1990).

23 Christian Schad and Man Ray also made cameraless photographs around the same time. Schad's images, called "Schadographs," date from 1918, and Man Ray produced his first "Rayographs" in 1921. See Aaron Scharf, *Creative Photography* (London: Studio Vista; and New York: Reinhold, 1965), 56.

24 Lucia Moholy-Nagy, *Marginalien zu Moholy-Nagy/Moholy-Nagy: Marginal Notes* (Krefeld: Scherpe, 1972), 59. Lissitzky claimed that he, not Moholy-Nagy, was the one who first made the distinction between *productive* and *reproductive*. "1921–2. When I went to Berlin and met Hausmann in Moholy's studio, it was decided to publish a periodical. I made out its programme dealing with *productive*, not reproductive achievements. At that time, Moholy still had no *special subject*, I drew his attention to *photography*." El Lissitzky quoted in Sophie Lissitzky-Küppers, *El Lissitzky: Life, Letters, Texts*, rev. ed. (London: Thames and Hudson, 1980 [c. 1968]), 66.

25 See László Moholy-Nagy, "Produktion-Reproduktion," *De Stijl* 5, no. 7 (July 1922): 98–100.

26 Ibid., 98 (my translation).

FIGURE 4.12
Lucia Moholy *Portrait of Moholy-Nagy*, c. 1925

in the wax plate on which sound was recorded and thus generate "new, not yet existing sounds and sound connections."[27] He also called for similar results in film where "dramatic performance" would be replaced by "the configuration of movement in space without reference to a direct development of forms."[28]

Moholy-Nagy thus singularly rejected the representation of social narratives as a *productive* use of photography or film. Instead, he believed that the artist should produce sensory phenomena that had not existed before. In this early essay he did not yet espouse the invention of new reproduction technologies, but he did demand a more inventive use of media that already existed. He said of photography that, "we need to use the light-sensitivity of the silver-bromide plate to capture and fix shaped light phenomena (moments of light play) produced by manipulating mirrors or lenses, etc."[29] In essence, he argued for an art of pure sensory experience as opposed to an interpretive engagement with the imagery of the lifeworld.

It is crucial to understand the reading that Moholy-Nagy gave to the representation of sensory phenomena at this stage of his development. In the manifesto, "Aufruf zur Elementaren Kunst" (A Call to Elementarist Art) which he had jointly drawn up the year before with Raoul Hausmann, Hans Arp, and Ivan Puni, he and his colleagues propounded "an art that is eternally new and does not come to a stop because of the results of the past."[30] It was to be "built up of its own elements alone" and would distinguish itself from the art that came before. The new art was to help bring about a collective culture. The elements of form did "not arise from [the artist's] individual whim; the individual is not isolated, and the artist is only an exponent of forces that give form to the elements of our world."[31]

Photography was thus to be a means of drawing people together within a common vision of the world. But this vision had to be something new rather than an outgrowth of the past. Hence, in the "Produktion-Reproduktion" essay, Moholy-Nagy argued for a photographic practice that would break cleanly with the past by exploiting photography's own technical means. The larger issue here, whose complexity Moholy-Nagy did not address at the time, was how an artist positioned against traditional conventions of representation could invent a new subject matter, that is, the manipulation of light, which would have the same binding power for the polity that more mimetic images of the world formerly had.

In an essay of the following year, "Light—a Medium of Plastic Expression," which he published in the American literary magazine, *Broom*, Moholy-Nagy devel-

27 Ibid., 99.

28 Ibid., 100.

29 Ibid.

30 Raoul Hausmann, Hans Arp, Iwan Puni, Maholy-Nagy [sic], "Aufruf zur Elementaren Kunst," *De Stijl* 4, no. 10 (1921): 156 (my translation).

31 Ibid.

32 László Moholy-Nagy, "Light—a Medium of Plastic Expression," in *Moholy-Nagy*, ed. Richard Kostelanetz (New York: Praeger, 1970), 117.

33 Ibid. Moholy-Nagy's research on this project eventually resulted in his *Licht-Requisit* or light modulator which he completed in 1930. The product of this device was initially a sequence of moving shadows projected on a wall. For purposes of distribution, however, Moholy-Nagy documented a particular sequence in

oped the position he had dramatically stated in "Produktion-Reproduktion."[32] He repeated his conviction that "copying nature by means of the photographic camera" was a sensory experience made obsolete by the nonobjective paintings of modern art. This led him to propose an apparatus that could manipulate light "as a new plastic medium, just as color in painting and tone in music."[33]

Despite the strong argument Moholy-Nagy made in these two essays for a *productive* manipulation of light through the photogram and yet-to-be-invented apparatus for kinetic light compositions, he espoused elsewhere the *reproductive* value of the photograph for advertising purposes.[34] He argued these two positions within separate discourses, one of modern art and the other of advertising design. While abstract light compositions could function quite legitimately as artistic objects, advertising depended on recognizable images.

In *Malerei, Photographie, Film* (Painting, Photography, Film), a book he completed in the summer of 1924 and published in 1925, Moholy-Nagy attempted to bring these discourses together in a comprehensive theory of visual representation.[35] The book began with a theoretical section divided into chapters. This was followed by an extensive collection of photographs, mostly taken from newspapers and magazines, to illustrate points made in the text. In the section entitled "On the Objective and the Non-Objective," Moholy-Nagy noted that the ultimate problematic of "optical figuration" (Gestaltung) would require a conciliation of the absolute and the figurative. However, "mechanical processes of representation" would have to replace painterly representation methods of the past which carried with them outmoded ideologies.[36] Although he still maintained the dialectic of production/reproduction, he now based the distinction more broadly on whether a new relation between "optical, acoustical, and other functional phenomena" was created. Widening the problematic of representation thus enabled him to attend to a number of new representational forms that included the photogram, the photoplastic (a term he ascribed to his photocollages), typofoto (the combination of photographs and typography in book and advertising layouts), and reality photographs taken from novel vantage points.

Moholy-Nagy was careful to insure his readers that by representation he did not mean mimesis but instead a creative act. He stated in a note: "Representation can't be compared with nature or a slice of nature. When, for example, a person

a film entitled, *Lichtspiel, schwarz, weiss, grau* (Lightplay, black, white, gray). The synopsis was published in *Moholy-Nagy*, ed. Kostelanetz, 148–50. Malcom Le Grice makes reference to the film within a history of avant-garde cinema in his book *Abstract Film and Beyond* (Cambridge, MA: MIT Press, 1977), 50.

34 In an essay on typography published in the catalog of the 1923 Bauhaus exhibition, Moholy-Nagy praised the photograph's objectivity and precision. As a replacement for the subjectivity of drawing, he called photography "the new storytelling device of civilization," which would be combined with new typographic effects in a form he referred to as "typofoto." See László Moholy-Nagy, "Die Neue Typographie," *Staatliches Bauhaus in Weimar, 1919–1923* (Weimar-München: Bauhaus Verlag, 1923), n.p., English translation in *Moholy-Nagy*, ed. Kostelanetz, 75–76.

35 László Moholy-Nagy, *Malerei, Photographie, Film* (München: Albert Langen Verlag, 1925). The book was the eighth in the series of Bauhaus titles that he edited with Walter Gropius.

36 Ibid., 11 (my translation).

37 Ibid., 5.

undertakes to represent a fantasy or a dream, this can also be considered a result of representation."[37] Given this distinction, Moholy-Nagy criticized most photographs for being mimetic.

> Photography as an art of representation is not simply a copy of nature. That explains why there are so few "good" photographs. Among the millions of photographs one finds in illustrated magazines and books one finds only here and there a few good examples.[38]

What made a photograph good was its capacity to kindle a new sensory experience in the viewer. Moholy-Nagy spoke of a "new feeling for the quality of chiaroscuro, radiating whites, black-gray transitions filled with flowing light" and found value in "the precise magic of the finest web . . . in the ribs of a steel building as well as in the sea's foam—and all fixed in the hundredth or thousandth part of a second."[39] But these results could only be achieved when photography fulfilled its own special task. "The unity of life cannot be attained," he wrote, "if artistic formative acts have their boundaries and components artistically rubbed together. Instead the unity must be attained when each formative act will be conceived and carried out on the basis of its own complete effective and life forming propensity and aptitude."[40]

We can see in Moholy-Nagy's insistence on exploiting photography's unique properties the outline of a social vision. This vision, he argued, was to be objective and could best be produced by the camera. In the revised and expanded edition of his book, published in 1927, Moholy-Nagy described the consequences of this objectivity.

> Everyone will be compelled to see objectively the optically true, which is explicable in its own terms, before he can generally arrive at a subjective position.[41]

This optical truth would thus draw people together in a community based on a shared apprehension of the world. There was therefore much at stake for Moholy-Nagy in advancing photography as a new creative medium. He saw the camera as an extension of human sight, a physiologically enhancing prosthesis to present the world in ways that people had not seen before, through X-ray photographs and photos of animal locomotion, for example. Photography was a way to validate those revelations as universally true. It would disclose "the inexhaustible wonder of life"[42] rather than expose its social conflicts as the worker-photographers intended.

There is a paradox in Moholy-Nagy's position, however, which exposes a tension

38 Ibid., 26.

39 Ibid.

40 Ibid., 13.

41 László Moholy-Nagy, *Malerei, Fotografie, Film*, 2d ed. rev. (München: Albert Langen Verlag,1927), 26 (my translation). In this edition, the spelling of "photographie" was changed to "fotografie" to accord with progressive thought about making German orthography more efficient.

42 László Moholy-Nagy, *Malerei, Fotografie, Film*, 27.

43 Ibid., 42. In *Malerei, Fotografie, Film*, this phrase was elaborated to read, "A fine organization of light and shade, effective in itself, apart from the picture motif" (my translation).

between the inherent visual narrativity of his photographs and the readings he imposed on them. This is most apparent when we consider images for which he provided a textual interpretation, especially those in *Malerei, Photographie, Film* and its revised edition, although we can also recognize the paradox in the photographic techniques he used to transform his subjects into formal shapes or patterns.

Moholy-Nagy took very few photographs before 1925. He worked primarily with photograms, photocollage, and typographic layouts that incorporated photographs. A number of these were included in *Malerei, Photographie, Film* but the book had only two of his own images, a section of a phonograph record seen from above and a shot of mirrors, set up at the Bauhaus as an experimental exercise. These formed part of the book's photo sequence which Moholy-Nagy intended to function both as a set of illustrations for the text and a narrative in its own right. As the latter, it exemplified the expanded conception of *productive* photography that he now espoused. Within the book's photo sequence were images of natural phenomena close up and at a distance—a stork's eye and a spiral nebula, for example. The sequence also included trick photos and photomontages, along with Renger-Patzsch's worm's-eye view of a factory chimney. Although *Malerei, Photographie, Film* might be compared to the previously mentioned photo albums published in Germany during the Weimar years, it embodied no visual thematic as those books did. Instead, Moholy-Nagy produced a collage book, subsuming the series of disparate images into a narrative about the potential of photography.

The images became part of this narrative either because he planned them to fit that purpose as he did his photograms or because he imposed a reading on them that superceded the conditioned response a viewer might have. A scene of birds in flight became, in Moholy-Nagy's words, "the wonder of light and dark,"[43] while other photographs, such as a herd of zebras and gnus in East Africa, were simply interpreted as examples of the camera's various technical capabilities. He even played down his own photoplastics, which are extremely rich in psychological themes, presenting them simply as examples of a new visual genre.

The meaning he imposed on the images suppressed their individual readings as depictions of people, places, or events. Instead, Moholy-Nagy wanted these pictures to promote the camera as a superior instrument of vision. He thus reduced the significance of images to sensory phenomena through two strategies—interpretive captions and compositional techniques that altered the conventional viewing position. These strategies determined the interpretations of his own photographs which he included in the revised edition of *Malerei, Photographie, Film*. The photographs ranged from a worm's-eye view of the Dessau Bauhaus building and two dolls with a grid pattern from an adjacent fence imposed on them to a woman at the beach, a man on a terrace, and a negative print of a woman walking.

Let us look closely at several of these photographs to examine how the reductive process worked. Take, for example, the picture of a terrace Moholy-Nagy shot

143

from the window of his hotel in Belle-Ile-en-Mer, France (**FIGURE 4.13**). We see a man seated at a small table with some papers spread out on it. But Moholy-Nagy presented this scene as something other than a social narrative. He photographed the man from the back, so his face isn't visible. There is also little to establish a sense of place. Moholy-Nagy tells us nothing about the photograph—where it was taken, or who the figure might have been. He simply created a composition. The caption states: "The attraction of the photograph lies not in the object but in the view from above and in the balanced (carefully considered) relationships."[44] The picture is a study in formal contrasts—round against linear, dark against light, rough texture against smooth, thin slats against thicker steps, objects against space. It is rich in optical phenomena, and Moholy-Nagy made it more powerful by adopting a viewing angle that featured the railings, steps, and chair as strong diagonal lines.

Concerning this picture, or possibly a related one, Siegfried Giedion, the architectural historian who traveled with Moholy-Nagy to Belle-Ile-en-Mer, recalled "Moholy taking a photograph of the terrace from a window high above it which annulled the perspective as it forced objects and proportions into the two-dimensional plane. No interesting motif—this concrete slab, a railing, a few chairs, a round table. But it was a completely new beginning. The camera had never been used like that before."[45]

We see a similar process at work in the photograph titled *In the Sand*, which

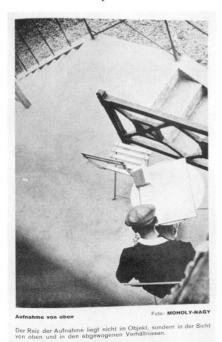

Aufnahme von oben Foto: MOHOLY-NAGY

Der Reiz der Aufnahme liegt nicht im Objekt, sondern in der Sicht von oben und in den abgewogenen Verhältnissen.

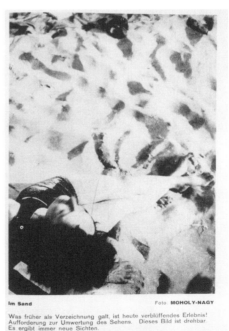

Im Sand Foto: MOHOLY-NAGY

Was früher als Verzeichnung galt, ist heute verblüffendes Erlebnis! Aufforderung zur Umwertung des Sehens. Dieses Bild ist drehbar. Es ergibt immer neue Sichten.

FIGURE 4.13
Moholy-Nagy *Man on a Terrace*, 1925

FIGURE 4.14
Moholy-Nagy *In the Sand*, n.d.

portrays a woman, perhaps Lucia, photographed from above (**FIGURE 4.14**). Moholy-Nagy contrasted the curve of her smooth body with the ridges in the sand. He also played her dark hair and bathing suit against her light legs and the grayish sand. The caption stated,

> What was earlier intended as a distortion, is today a startling experience! A challenge to re-evaluate the way we see. This picture can be turned around. It always yields new views.[46]

As one rotates the picture, the figure of the woman, seen from several of the viewing positions, becomes grossly distorted. This results from the way these positions exaggerate the contrast between the scale of her head and that of her legs. But Moholy-Nagy preferred to explain these multiple views as an expansion of the way we see rather than a selection of more or less favorable depictions of the woman.

Just as he refused the subjectivity of the woman in his own photograph, so did he read a picture of a woman taken by Lucia Moholy (**FIGURE 4.15**) as "an attempt at an objective portrait." Despite the fact that the woman gazes directly at the photographer, providing many clues to her character through her facial expression, body posture, and clothing, Moholy-Nagy believed that Lucia had attempted to photograph her "as an object so as not to burden the photographic outcome with subjective will."[47]

He stated in the revised edition of *Malerei, Photographie, Film* that it was essential for the photographer to create new visual connections so that people could see the world in a different way. And certainly the strong reading he imposed on the images in both editions of his book intended them to be demonstrations of this argument. Nonetheless, this still leaves questions of whether he envisioned the depiction of these connections as substitutes for all the other kinds of photographs that made the world visible in its full range of forms. Was "the inexhaustible wonder of life," which he referred to in his book, to be known through the actual array of visual themes that could be assembled, or was it to be made evident through a mode of sight that privileged a subjective self-reflexivity over an engagement with what was seen?

This is not an easy question to answer and obliges us to confront the full range of photographs that Moholy-Nagy took during the 1920s.[48] Many, in fact, resist the

44 Ibid., 91 (my translation).

45 Siegfried Giedion, quoted in Andreas Haus, *Moholy-Nagy: Photographs and Photograms*, trans. from the German by Fredric Samson (New York: Pantheon, 1980), 64.

46 Moholy-Nagy, *Malerei, Fotografie, Film*, 59 (my translation). Moholy-Nagy's ideas on multiple viewing positions recall Lissitzky's thoughts about his *Proun* paintings as stated in his manifesto, "PROUN: Not World Visions, BUT—World Reality." Moholy-Nagy would most likely have seen this manifesto in *De Stijl*.

47 Moholy-Nagy, *Malerei, Fotografie, Film*, 94 (my translation).

48 For collections of Moholy-Nagy's photographs, see Franz Roh, *Moholy-Nagy: 60 Fotos* (Berlin: Klinkhardt and Biermann, 1930); Leland R. Rice and David W. Steadman, eds., *Photographs of Moholy-Nagy from the Collection of William Larson* (Claremont, CA: Galleries of the Claremont Colleges, 1975), Andreas Haus, *Moholy-Nagy: Photographs and Photograms*, and Eleanor Hight's exh. cat., *Moholy-Nagy: Photography and Film in Weimar Germany* (Wellesley, MA: Wellesley College Museum, 1985). This catalog preceded a subsequent book by the same author, *Picturing Modernism: Moholy-Nagy and Photography in Weimar Germany* (Berkeley: University of California Press, 1995).

reading he proposed in both editions of *Malerei, Photographie, Film* and argued for in subsequent articles.[49] This resistance points to a tension within Moholy-Nagy himself between a theoretical model of vision that privileged a quality of sight over the identity of what was seen and a full sensuous and emotional engagement with what he photographed.

Moholy-Nagy did not systematically document a place, event, or situation. Instead, he chose his subjects more casually. Only a few of his photographs portray life in Germany. He took many of his pictures while traveling abroad in places that included Belle-Ile-en-Mer and Paris, France (1925), Ascona, Switzerland (1926) and La Sarraz, Switzerland (1928). Subsequently he photographed in other places, notably Marseille and Stockholm. He also produced a series of pictures in Dessau using the new Bauhaus building and also as a group taken from the Berlin Radio Tower. In addition, he made a variety of other photographs that are not easily categorized by subject or place.

Among the vacation pictures are a number of portraits, particularly of Lucia, which Moholy-Nagy took in unspecified locations. In fact, he was often drawn to photographing women, sometimes in sensuous poses. We have, for example, several photographs of Lucia, seen as a passive subject sleeping instead of relating to the photographer (**FIGURE 4.16**). There are additional pictures of unidentified nude women, several more close-ups of Lucia, and a series of the actress Ellen Frank, who was Moholy-Nagy's companion for a time after his first marriage broke up. We thus have a widely varying collection of images with which to account for Moholy-Nagy's approach to photography in the 1920s. Many of

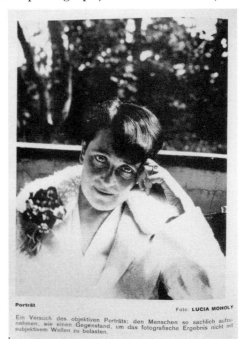

Porträt Foto: **LUCIA MOHOLY**

Ein Versuch des objektiven Porträts: den Menschen so sachlich aufzunehmen, wie einen Gegenstand, um das fotografische Ergebnis nicht mit subjektivem Wollen zu belasten.

FIGURE 4.15
Lucia Moholy *Portrait of a Woman,* n.d.
FIGURE 4.16 (p.147)
Moholy-Nagy *Lucia Sleeping,* 1925

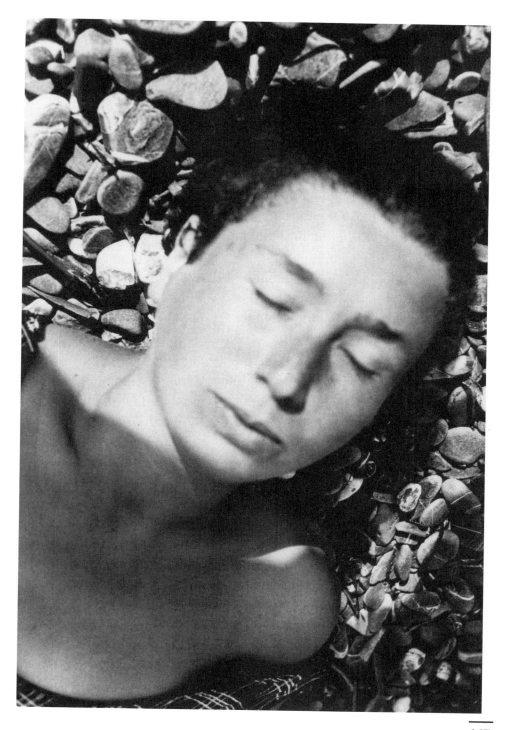

49 See, e.g., László Moholy-Nagy, "Fotografie ist Lichtgestaltung," *Bauhaus* 1 (1928): 2–9.

his pictures have a formal structure which he imposed on what he saw, often with the result of severely diminishing the narrative content. At the same time, he frequently chose themes with a sensuous quality, or he included a human presence, even as a miniscule figure, in an otherwise empty landscape or cityscape.[50] Since Moholy-Nagy did not incorporate many of these pictures into narratives that are guided by interpretive captions, it is difficult to impose a reading on them. At the same time, the strong sensuality of some of these images offers a powerful resistance to the interpretive strategy of Moholy-Nagy that we have been discussing. His photograph of two nude women sleeping outdoors, for example (**FIGURE 4.17**), emphasizes the fullness of their bodies and, in the case of the woman in the foreground (perhaps Lucia), her sense of freedom at lying outdoors nude.[51] The sensuousness of this image makes Moholy-Nagy's belief in the liberating effect of reading his photographs as abstract images somewhat problematic. Although he tried to control the meaning of his pictures by referring to them as abstract images, his own sensuous and humanitarian qualities intruded. Nonetheless, visual control remained an issue.

As a humanist, with all the hopefulness and avoidance of specifics that the term can denote, Moholy-Nagy believed in the natural inclination of everyone to share a social vision if it could be made manifest. But this vision was not to be a programatic one, as the worker-photographers believed. It was to be one that, by its novelty and demonstration of the camera's technological capabilities, represented the human potential for transformation through a new way of appre-

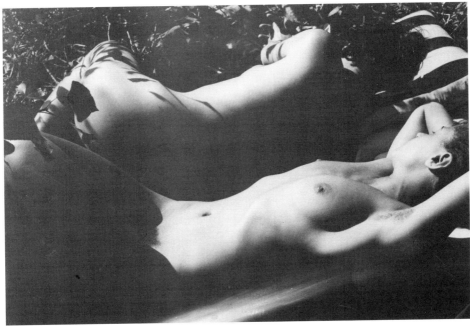

FIGURE 4.17
Moholy-Nagy, *Two Sleeping Nudes,* 1927–29

hending the world. Implicit in Moholy-Nagy's photographic strategy, whether he wanted to reduce an image to optical data or photograph a sleeping woman who could not return his gaze, was an attempt to manage the world by controlling its representation. He suppressed or strongly diminished the identity of his subjects, particularly when they were sensuously photographed women. Reading Moholy-Nagy's photographs of the 1920s in this way may also help to explain his interest in advertising, a medium that controls meaning, and his photoplastics which are clearly subjective statements of his political views and emotional states represented within a tightly constructed symbolic and formal order.[52]

How then does a definition of photography as visual control help us to understand the social import Moholy-Nagy promulgated for the medium in the 1920s? He justified this control by regarding it as evidence of a developing consciousness. It was the new photographic images, he claimed, that would enable human beings to arrive at a deeper understanding of the world. This understanding, based on formative acts of photographic representation, also would unite people within a common experience. But just as Moholy-Nagy wished to exclude resistant meanings from his pictures, so did he want to acknowledge a world that was unified in its image, one whose representation would ignore all evidence of conflict between individuals or groups.

Hence, we can understand the distance he kept from the photojournalists of the illustrated weeklies, such as Eric Salomon whose surreptitious photographs of leading politicians and portrayals of bourgeois life-styles were surely calculated to offend leftists, on the one hand, and modernists, on the other. Likewise, the worker-photographers who militantly sought to represent the potential of the working class as an agent of change also made pictures that testified to the world's conflict rather than to its potential harmony.

For Moholy-Nagy, the visual control inherent in his photographic ideology of the 1920s diminished the negotiation between perceiver and perceived that acknowledges the complexity of any encounter with the world. Hence, as a photographer, he did not confront the division of the world, and particularly the Weimar Republic, into classes of workers and capitalists as the worker-photographers recognized, or into distinct social groups as August Sander portrayed it. His reluctance or refusal to recognize these social distinctions and divisions as essential knowledge for a strategy of social change and to fix his photographs in a specific social context therefore made them vulnerable to cooption by the proponents of the "new photography," a construct espoused by Walter Dexel, Franz Roh, Jan Tschichold, and others. The "new photography" promoted innovative photographic techniques that were conflated with an ideology of modernity so

50 This tendency can be distinguished from the work of Albert Renger-Patzsch who isolated natural or industrial objects rather than photograph them in contexts that involved a human relation.

51 Andreas Haus dates this picture between 1927 and 1929. See Haus, *Moholy-Nagy: Photographs and Photograms*, plate 68, n.p.

52 On Moholy-Nagy's photoplastics, see Irene-Charlotte Lusk, *Montagen ins Blaue: Laszlo Moholy-Nagy, Fotomontagen und collagen, 1922–1943* (Giessen: Anabas, 1980 [Werkbund-Archiv 5]). This book also includes considerable information on Moholy's advertising photography.

as to be easily appropriated and assimilated by the Weimar establishment. As a result of his recognition as a proponent of the "new photography," Moholy-Nagy was retained as a principle advisor for the Deutscher Werkbund's Film und Fotografie exhibition (Fifo) in 1929 where he organized an important retrospective exhibition of his own work for the show. It was in this act of being lionized for the very reasons that created the tension in his work that we can recognize Moholy-Nagy's dilemma. He was acknowledged for the narrative strategy he attempted to impose on his photographs, but not for the reasons he believed this strategy to be significant. At the same time the proponents of the "new photography," were complicit in evading the complex relation between the viewer and the viewed which Moholy-Nagy himself refused to address.

4

In the late 1920s, both the Weimar Republic and the Soviet Union saw the rise of proletarian culture movements that sought to become the voice of the working class in their respective countries. In Germany this movement opposed capitalism and its institutions but did not have sufficient force to gain significant influence over the the nation's cultural life. In the Soviet Union, however, promoters of proletarian culture, such as Leopold Averbakh, head of the powerful writers organization RAPP, began to gain power as the Communist party sought to increase its control of the nation's economic and cultural life under Stalin's leadership, particularly after the end of the Fifteenth Party Congress in December 1927.

With the Congress mandate to begin a centralized planning process, the cultural climate in the Soviet Union began to change in several ways. While not explicitly providing a social mandate for Soviet artists, the Congress resolutions established a situation in which individual expression, whether in the arts or other sectors of life, was less acceptable than it had been during the NEP. As part of Stalin's promulgation of "socialism in one country," there was an increasing critique of Western culture and a striving to emphasize the development of a uniquely Soviet one. As Stalin continued to talk about the capitalist encirclement of Russia and the need to resist it, any link with artistic strategies that were identified with the West became a liability.

This was the atmosphere in which the first serious debates about Soviet photography took place in the late 1920s. Until 1926, there was no journal devoted explicitly to photography and, in fact, little of critical import had been written on the subject before then. By 1927 there were no less than four journals that took a strong interest in photography: *Sovetskoe kino*, (Soviet Screen), a journal devoted primarily to film which started publication in 1925 under the sponsorship of the Central Committee for Political Enlightenment; *Sovetskoe foto*, begun in 1926 under the sponsorship of the People's Commissariat of Enlightenment; *Proletarskoe foto*, (Proletarian Photo) also initiated in 1926 as the official organ of ROPF, the All-Russian Organization of Photographers; and *Novyi lef*, which had

printed Rodchenko's photographs frequently on its covers.

Rodchenko also published his photographs in *Sovetskoe kino* and *Sovetskoe foto,* and, in fact, was in charge of a section on photography and cinema in *Sovetskoe kino*. Both of these journals were opposed, like *Novyi lef,* to the older art photography which took its compositional and atmospheric models from traditional painting. The aim of *Sovetskoe foto* was not to foster photography as an art form but to promote it as a democratic means for all Soviet citizens to apprehend the events of daily life.

Initially *Sovetskoe foto* addressed itself primarily to amateur photographers whose interest in photography it hoped to harness for social ends. In line with the aim of persuading these amateurs not to copy traditional paintings as they learned how to photograph, the journal published Osip Brik's aforementioned article "The Photo-Frame versus the Painting." Brik promulgated both the cheapness and speed of photography and claimed that the photograph was a more *precise* record of nature than the painting, even though it was black and white.

> In struggling against the esthetic deformation of nature, the photographer will gain his right to social recognition. But he will not gain this by fruitless attempts to imitate painterly models so foreign to photography.[53]

Brik cited Rodchenko as an example of a photographer who had rejected the painterly aesthetic:

> The public at large is not well acquainted with his photographic work because it is predominantly of an experimental kind. One should appear in public only when one has the finished result. Still, professional photographers and those photographers who are interested in the development of the photographic art must definitely get to see Rodchenko's experiments.[54]

At the time Brik's article appeared, the cultural climate in the Soviet Union was still sufficiently pluralistic to allow the promotion of the avant-garde without impunity. By late 1927, however, *Sovetskoe foto* was engaging in exhaustive dialogue about the sociopolitical function of photography. This was in conjunction with discussions at the Fifteenth Party Congress about the meaning of the cultural revolution for the advancement of socialism.[55] Since critics identified Rodchenko's photographs with the avant-garde, it is not surprising that *Sovetskoe foto* would reverse its acknowledgement of him as someone to emulate. In the April 1928 issue the editors published an anonymous letter, perhaps written by one of them, which pointed out the similarities between several of Rodchenko's photographs and those of photographers abroad, notably Moholy-Nagy and Albert Renger-Patzsch. The dates of all the foreign pictures, except one which

53 Osip Brik, "The Photo-Frame versus the Painting" (Bowlt translation).
54 Ibid.
55 Rosalinde Sartori and Henning Rogge, eds., *Sowjetische Fotografie 1928–1932* (München: Carl Hanser Verlag, 1975), 8–9.

was undated, preceded those of Rodchenko's pictures, the implication being that Rodchenko had simply copied the foreign sources. The author of the letter noted of the comparison that one might initially conclude that "the foreign photographers shamelessly make use of Soviet photography's success for their imperialistic purposes, in fact, passing it off as their own," but, he stated, the reader should draw his own conclusions.[56]

The editors then appended a note to verify the information, stating that all the photographs had been published in foreign and Soviet publications, and the dates had been checked. Although the letter was only several paragraphs long, its full presentation with the photographs raised a series of issues that were to be central to the photographic debates in the Soviet Union as they unfolded, particularly between 1928 and 1932. These had to do with the artist's accountability to the Communist Party and his or her ability to adjust art making to a larger and increasingly centralized process of social development.

The *Sovetskoe foto* letter did not criticize Rodchenko in those terms as others were subsequently to do, but the journal's editors did attempt to undermine Rodchenko's character and his position as an important contributor to Soviet photography. They did so in a way that was supported by the changing political climate which the Fifteenth Party Congress helped usher in. First they challenged Rodchenko's originality by charging that he had plagiarized his pictures, and then they noted that what he copied were specifically experimental photographs from the West. In the emerging climate of anti-Westernism, this could be seen as un-Soviet and thus antithetical to the party. Rodchenko prepared a written response to the letter, but the editors refused to publish it. It appeared in *Novyi lef* instead, along with eight examples of photographs taken from bird's-eye or worm's-eye positions by various photographers, which were previously published in *Sovetskoe kino* and *Sovetskoe foto*. In his response, Rodchenko vigorously defended photographing "from above down and below up" but disclaimed that these views were his own invention.[57] He also contrasted photographs taken from the new positions with those influenced by traditional painting against which he, Brik, and a few others were fighting.

Rodchenko refuted the charges of plagiarism by arguing that a number of photographers were promoting these new modern views and, hence, some of their photographs were bound to look similar; he also noted in relation to Moholy-Nagy's Bauhaus balcony photo that his own balcony picture had been published in 1926 while Moholy-Nagy's did not appear until 1928. Although he gave an admirable defense of his integrity and position as a photographer, Rodchenko did not recognize at the time that larger political forces, which had little to do

56 "Revolution der Fotografie, Fotografie der Revolution: Ein Briefwechsel," in *Sowjetische Fotografie*, ed. Sartori and Rogge, 101 (my translation).

57 Alexander Rodchenko, "Downright Ignorance or a Mean Trick?" *Novyi lef* 6 (1928) (Bowlt translation).

58 For a discussion of the "literature of fact," within the context of *Lef*'s and *Novyi lef*'s literary theories, see Halina Stefan, *"Lef"* and the *Left Front of the Arts* (München: Verlag Otto Sagner, 1981 [Slavistische Beiträge vol. 142]), 158–90 (see chap. 3n.54).

with the aesthetic merits of cultural strategies, were moving into place in such a way as to undermine the discursive space he had occupied during the NEP years. The publication of his letter in *Novyi lef* initiated an exchange with several of the journal's staff that deflected Rodchenko's differences with his critics away from accusations of plagiarism and Western influence and relocated the photographic debate around the relation between photography's aesthetic qualities and its social functions.

What we should recognize about the *Novyi lef* exchange is that it was not the kind of confrontation between party politics and independent art that would characterize the discourse about art under the Five-Year Plans. Instead, it was a much more internal matter that primarily concerned issues central to the journal, notably its commitment to a literature of fact, and the question of how facts might best be represented.[58] Unfortunately, the exchange occurred at a moment when the discursive space for such debates was about to be closed out, and it has thus achieved a more significant position in the history of photography than the articulation of the issues might otherwise have warranted.[59]

Rodchenko's principal adversary in this exchange was Boris Kushner, the cultural critic and production art theorist who was an editorial board member of *Novyi lef* and had formerly worked at INKhUK. In his response to Rodchenko's letter, Kushner stated that his concern was not to denigrate per se the new photographic viewpoints espoused by Rodchenko but to raise the issue of whether or not the photographs produced from those viewpoints had meaning within the individual's life experience.[60] Kushner was not opposed to new angles in a doctrinaire way as Rodchenko's political opponents were to be. A photograph lost its value for him only when its subject was distorted beyond recognition and therefore could not provide any useful social information.

In his reply to Kushner, published in *Novyi lef* 9, Rodchenko justified his own argument for the new angles by his claim that they more accurately represented the way people viewed objects in the modern city. He, in fact, critiqued the conventional "belly-button" view as a distortion of how the public actually experienced urban life.

> As you go along the street, you see buildings from below up. From their upper storeys [sic] you look at the automobiles and pedestrians scurrying along the street. Everything you catch a glimpse of from the streetcar window or from the automobile, what you see from above down as you sit in the theater auditorium—all is transformed and straightened into the classical, "belly-button" view.[61]

59 The full exchange between Rodchenko and his critics has been published in German in *Sowjetische Fotografie 1928–1932*, ed. Sartori and Rogge, 104–25; and *Alexander Rodtschenko Fotografien 1920–1938*, ed. Weiss, 51–60. A somewhat shortened English version of this exchange appeared in Colin Osman, ed., "Alexander Michailovitch Rodchenko 1891–1956: Aesthetic, Autobiographical and Ideological Writings," *Creative Camera International Yearbook 1978* (London: Coo Press, 1977), 189–92, 225–34.

60 Boris Kushner, "An Open Letter," *Novyi lef* 8 (1928) (Bowlt translation).

61 Alexander Rodchenko, "The Paths of Modern Photography," *Novyi lef* 9 (1928) (Bowlt translation).

In the final issue of *Novyi lef* Kushner replied for the first time on behalf of his editorial colleagues and sharpened the tone of his disagreement by casting Rodchenko as an artist with more concern for technique than subject matter.[62] While noting that Rodchenko's interest in the portrayal of "new socialist facts" merited praise, he defended the social value of facts themselves in contrast to Rodchenko's concern for their interpretation.

The last word in the debate was had by Sergei Tretiakov, *Novyi lef*'s editor, who criticized both Rodchenko *and* Kushner.[63] Tretiakov raised the issue of why the image was made in the first place.

> For the functionalists, apart from the links of "what" and "how" (the notorious "form" and "content"), there is an even more important link—"why." This is the link that transforms a "work" into an "object," i.e. into an instrument of expedient effect.[64]

But Tretiakov did not argue against the innovative visual interpretation of facts. Using the example of how a crowd of people might be photographed, he outlined several different options, depending on the point one wanted to make about the crowd. In this, he would seem to have been at odds with Rodchenko only to the degree that he characterized Rodchenko's principle concern as aestheticism. He even noted earlier in his response that Rodchenko understood very well the importance of utilitarian goals. What, in fact, Tretiakov did not acknowledge in his remarks was that Rodchenko had already begun to work as a photojournalist for the illustrated magazines, creating photographic sequences quite similar to the very themes that Tretiakov had espoused as subject matter for the literature of fact. Although there was considerable agreement as well as differences between Rodchenko and his *Novyi lef* colleagues, the debate, which was in sharp contrast to the attack on Rodchenko's character that appeared in *Sovetskoe foto*, was nonetheless a foretaste of the heavy-handed criticism he would experience several years later, particularly at the hands of *Proletarskoe foto*. It also made clear something Rodchenko had already recognized by starting to work as a photojournalist. The window he had during the NEP years to struggle with formal issues, even though these issues were rhetorically loaded with social meaning, was closing. While this did not force a negation of all he had fought for during the NEP, it did require him to argue more vigorously for the social relevance of the photographic strategy he espoused. From the late 1920s on, criticism in all the arts became heavily politicized and Rodchenko had to contend with a community of photographers and critics who were more intent on preserving their own careers than in addressing the question of what the most socially effective forms of photography might be.

62 Boris Kushner, "Fulfilling a Request," *Novyi lef* 11 (1928) (Bowlt translation).

63 Sergei Tretiakov, "From the Editor," *Novyi lef* 12 (1928) (Bowlt translation).

64 Ibid.

65 László Moholy-Nagy, *Malerei, Photographie, Film*, 28–29.

66 The history of photo exhibitions in Germany in the 1920s is chronicled in Ute Eskildsen, "Fotokunst statt

5

Unlike the Soviet Union, where issues of what to photograph and why became central to the debates on photography in the late 1920s, there was no social command for photographers in Weimar Germany, with the exception of that formulated by the worker-photographers. Photographic discourse during the same period, though dominated by discussions of visual discovery and technique, was nonetheless firmly embedded in captalist culture. Progressive entrepreneurs recognized that new sharply focused photographs taken from unusual angles could enliven contemporary advertising layouts and thus strengthen the sale of products, and new ways of photographing could also help to sell photographic equipment, regardless of what was photographed.

The promotion of the "new photography" in Germany as a force of change was largely due to Moholy-Nagy. In the first edition of *Malerei, Photografie, Film*, he noted that the possible uses of photography were uncountable, giving as examples reality photos, advertising posters and political propaganda, book and advertising layouts, and material for nonobjective light projections.[65] Moholy-Nagy's inclusion of press photographs and other anonymous pictures in the book also set the precedent for the incorporation of such photographs in the various major photo exhibitions that began in the mid-1920s.[66]

Moholy-Nagy had shown work in the Deutsche Photographische Ausstellung (German Photographic Exhibition) in Frankfurt in 1926 but, as Ute Eskildsen has written: "The name of Moholy-Nagy was somewhat lost in the amateur section of this exhibition."[67] His work and views on photography received more attention the following year when an article by him was featured in the photography annual, *Das Deutsche Lichtbild* (The German Photo Image), where he promoted photography as a new experimental art.

His quest for a photographic practice that was distinct from the tradition of art photography dovetailed with a larger cultural movement to create visual forms that took contemporary life as their subject matter and presented it in a sober, matter-of-fact way.[68] The first exhibition to promote photography within this larger movement was probably "Neue Wege der Photographie" (New Paths of Photography), which Walter Dexel curated at the Jena Kunstverein in 1928. Dexel featured Moholy-Nagy's photographs along with those of Lucia Moholy, Albert Renger-Patzsch, Hugo Erfurth, and others. He presented Moholy-Nagy's photographs as examples that "open up for us a new world, not otherwise perceptible to the eye."[69]

Kunstphotographie," in *Film und Foto der Zwanziger Jahre: Eine Betrachtung der Internationalen Werkbundausstellung "Film und Foto" 1929*, ed. Ute Eskildsen and Jan-Christopher Horak (Stuttgart: Würtembergischer Kunstverein, 1979), 8–25.

67 Ute Eskildsen, "Fotokunst statt Kunstphotographie," 9.

68 As examples, we can cite the "Neue Sachlichkeit" (New Objectivity) exhibition of painting at the Mannheim Kunsthalle in 1925, as well as various exhibitions of "neue werbung" (new advertising) and Jan Tschichold's book, *Die Neue Typographie* (The New Typography) of 1928.

69 Walter Dexel, writing in *Das Volk* (April 14, 1928), cited in Eskildsen, "Fotokunst statt Kunstphotographie," 10.

As the discourse of the new photography developed in the late 1920s, the emphasis came to be placed on how photographers could create innovative images rather than on what it meant to see the world in a different way. This shift is not surprising, given the context in which the discourse developed. The new photography was processed into the larger discourse of modernization in Germany as a means of production. Photographers such as Renger-Patzsch were admired for their ability to produce novel images just as a manufacturer might invent a new product. The creation of new images was also consistent with the cultural discourse of modernity which argued that the forms of the past, whether buildings, paintings, advertisements, or photographs, were no longer expressive of contemporary sensibilities and had to be replaced by new ones. Hence, Dexel, as a curator committed to exhibiting modern art and design, saw Renger-Patzsch and Moholy-Nagy, despite their profound differences, as both representing a cultural modernity that negated outmoded art forms of the past.

The incorporation of the new photography into a discourse on modernity was also the basis for the summative photographic exhibition of the 1920s, the Film und Fotografie exhibition or Fifo. Organized by the Württembergerische Arbeitsgemeinschaft (Wurtemburg Working Group) of the Deutscher Werkbund, Fifo was directed by Gustav Stotz, who had initiated two prior Werkbund exhibitions, "Form ohne Ornament" (Form without Ornament) in 1924 and "Die Wohnung" (The Dwelling), otherwise known as the Weissenhof exhibition, of 1927. In both prior instances the exhibition concepts were based on the presentation of new cultural forms.[70] Fifo opened in Stuttgart in May 1929 and ran until early July. Stotz was assisted in the planning by a three-man selection committee that included the art historian Hans Hildebrandt, who had given attention to photography in his widely recognized book, *Kunst des 19. und 20. Jahrhunderts* (Art of the 19th and 20th Centuries); Bernhard Pankok, architect, artist, and designer; and Jan Tschichold, the typographer who had become the promoter of the "new typography" as early as 1925 and had a keen interest in how photography could be used in advertising. In his early espousal of photography as the optimal means of image production, Tschichold had been particularly influenced by Moholy-Nagy. Collaborators abroad included Edward Weston in the United States, Man Ray in Paris, Piet Zwart in the Netherlands, and El Lissitzky in the Soviet Union.

Fifo was the first large international survey of contemporary photography to be held in Germany. The sizable section devoted to photography in advertising and book design helped position the medium at the intersection of economic modernization and cultural modernity, a project in which the Werkbund had a profound stake. The emphasis on applied photography was most likely due to Tschichold's influence since he had addressed it in his influential book *Die Neue Typographie (The New Typography)*, which was published the year before.

70 On Fifo, see *Film und Foto der Zwanziger Jahre*, ed. Eskildsen and Horak; the special issue of *Camera* 58, no. 10 (October 1979), which includes Karl Steinorth's essay, "The International Werkbund-Exhibition, 'Film und Foto,' Stuttgart 1929," 4, 13–14; and Beaumont Newhall, "Photo Eye of the 1920s: The Deutsche [sic] Werkbund Exhibition of 1929," in *Germany: The New Photography, 1927–1933*, ed. Mellor, 77–86.

Tschichold may also have been the one who brought Moholy-Nagy's views on photography, and in fact Moholy-Nagy himself, to the center of the Fifo planning process. The plan for the exhibition which Stotz published in *Das Kunst-blatt* in May 1929 certainly drew heavily on Moholy-Nagy's arguments as he had stated them in *Malerei, Photographie, Film*, although it incorporated Renger-Patzsch's position as well, notably in Stotz's statement:

> A new optic has developed. We see things around us differently than before, without painterly aims in an impressionistic sense. Also things are important to us today which were hardly noticed before, i.e. shoe trees, a gutter, spools of thread, material, machines, and so forth. They interest us in their material substance, in their simple thingness.[71]

Moholy-Nagy's influence was particularly evident in the scope of the exhibition which included scientific photos (X-rays, microphotographs), aerial photographs, and photograms as well as examples of realistic photography, both by professionals and anonymous photographers. While the inclusion of photography's commercial applications in the exhibition may have been strongly promoted by Tschichold, it was also one of the themes that Moholy-Nagy himself had emphasized in *Malerei, Photographie, Film* and elsewhere.[72]

Moholy-Nagy was invited by the planning committee to organize a lead-in exhibition in the first room which would, in effect, locate the contemporary work in Fifo on a historical continuum that suggested a teleological advance toward the present situation.[73] The title, "Where is Photographic Development Going?" clearly stated his position. Next to historical photographs from the well-known collection of Erich Stenger, Moholy-Nagy hung a wide variety of other examples from the press agencies, scientific institutes, public archives, and from individual photographers whose work fit within his programatic thesis.[74]

While the exhibition was broadly inclusive, it was nonetheless framed by the capitalist vision of modernity that the Werkbund espoused. This was embedded in the fundamental thesis of Fifo which privileged the techniques of representation, whether these resulted in photograms, photomontage, or reality photos, over questions of what to photograph and why, questions that had concurrently become central to the Soviet photography debates.

Hence, the political book covers which John Heartfield designed for the left-wing Malik Verlag were included as examples of new applications of photography in book design rather than as interpretations of the authors' political views. At

71 Gustav Stotz, "Werkbund—Ausstellung, 'Film und Foto,' Stuttgart 1929," *Das Kunstblatt* 13 (May 1929): 154.

72 See "Die Neue Typographie," *Staatliches Bauhaus in Weimar, 1919–1923*, n.p. English translation in *Moholy-Nagy*, ed. Kostelanetz, 75; and "Die Photographie in der Reklame," *Photographische Korrespondenz* 9 (1927): 257–60, reprinted in *Film und Foto der Zwanziger Jahre*, ed. Eskildsen and Horak, 146–48, 150 (English translation in *Photography in the Modern Era*, ed. Phillips, 86–93).

73 See Ute Eskildsen, "Raum 1—Eine Bildzusammenstellung von Laszlo Moholy-Nagy," in *Film und Foto der Zwanziger Jahre*, ed. Eskildsen and Horak, 68–70.

74 At least one influential critic contested the interpretation of photo history that Moholy-Nagy stated on a **157** series of large panels which accompanied the images.

the same time photographs of the German worker-photographers were not in-cluded in the press photography section because they were firmly embedded in a photographic practice that was blatantly opposed to capitalism.

In a strong critique of "modern" photography, published in *Der Arbeiter-Fotograf* in 1929, Walter Nettelbeck stated the difference between the aesthetic preoccupa-tions of the "new photography" and the political engagement of the worker-pho-tographers:

> The goal (of photography) must be to express the motive in its most exact and persuasive form. When this goal requires a distorted per-spective, there must always be the aim to justify the means. But the aim lies neither with things themselves nor in their artistic value. It is based in the interests of the proletarian class.[75]

Nettlebeck's definition of a political photograph, as one that *explicitly* revealed the social position of the photographer through its content, was in sharp con-trast to the way the organizers of the Fifo *implicitly* represented the underlying capitalist values of the Weimar Republic through their emphasis on the techno-logical capability of the camera. The technology they espoused was specifically embedded within the expanding German industrial culture of the 1920s, a fact which reinforced the political signification of the exhibition.

While Moholy-Nagy's sympathies, as he had embodied them in his democratic vision of a world transformed through the heightened awareness of its citizens, were with a vague socialist order; his reluctance to affiliate with a political party and his quest for an "objective" reading of his photographs made them extremely vulnerable to incorporation within the Werkbund's vision of capitalist moder-nity. Moholy-Nagy's own vision of photography fit within no cultural discourse of the time, except perhaps the pedagogical philosophy of Walter Gropius while he was director of the Bauhaus between 1919 and 1928. But Gropius went to great lengths to exclude political activity from the Bauhaus community, both in Weimar and Dessau, and Moholy-Nagy did not at that time connect his media theories to any program of social action. Without such a program and given Moholy-Nagy's own inclination to repress the subjective narrative embedded in his pictures, his work could easily be assimilated into a general discourse that celebrated the "new vision" as a means of technological production. This was the case with Franz Roh's introduction to the 1930 book of Moholy-Nagy's photographs, photograms, and photoplastics which Roh edited as the lead volume in a new series on pho-tography published by Klinkhardt and Biermann in Berlin.[76]

Roh praised Moholy-Nagy as a pioneer in three specific areas of photography—the reality photo, the photogram, and photomontage. In his discussion of these areas, Roh emphasized Moholy-Nagy's technical and esthetic contributions to

75 Walter Nettelbeck, "Sinn und Unsinn der 'Modernen' Fotografie," reprinted in Joachim Büthe, Thomas Kuchenbuch, et al. *Der Arbeiter-Fotograf*, 107 (my translation).

76 Although a sizable number of books were projected for the series, only two were published, the one on Moholy-Nagy and a collection of photographs by Aenne Biermann. Among the projected volumes were books on photographic kitsch, fotomontage, police photos, sports photos, El Lissitzky, and a book of stock

them. In regards to the reality photo, he said the following about Moholy-Nagy:

> Old objects were seen anew: through bolder plasticity, new grada-
> tions of light and dark, a different distribution of degrees of sharpness,
> and above all by a new employment of perspective. . . . Moholy was
> one of the first to take pleasure in those aboves and belows.[77]

Regarding Moholy-Nagy's photograms, he stated:

> In the photogram, one is most clearly conscious of Moholy the
> Constructivist, for the rest of non-objective painting or graphics is
> not something that has been displaced by photography. Photography
> for Moholy is only one form of shaping light, besides which other
> types continue to endure and new ones come forward.[78]

Roh also noted that Moholy-Nagy's photomontages often had a "lively-fanciful
mood" but contained depth as well. However, he made no attempt to reflect on
the subjective meanings of the photomontages which, in fact, embody some ex-
tremely personal and political statements. In closing Roh suggested that Moholy-
Nagy's photographs, as examples of the "new photography," could unlock "the
world picture of today and tomorrow" for the accustomed viewer who was willing
to engage with them.[79] Roh thus presented Moholy-Nagy as a pioneer of the "new
photography" as part of his larger project as a critic to promote this approach
as the vanguard photographic ideology in Weimar Germany.

Moholy-Nagy gained significant recognition from his inclusion in the discourse
of the "new photography." Since he did not stake out a strong oppositional posi-
tion to this discourse as the worker-photographers did, his photographs were
available for such an interpretation regardless of what he intended them to sig-
nify. It may well have been Moholy-Nagy's uneasy relation to the full subjective
power of his images that prevented him from claiming a different meaning for
them, one that would have offered more resistance to those forces of capitalist
modernity toward which he had such ambivalence yet which so easily drew him
into their orbit.

6

The sharp drawing of lines in Soviet photographic circles of the late 1920s was
not evident in the exhibition that the Soviets sent to Fifo. This exhibition, which
included several photographs by Rodchenko, was organized by El Lissitzky, a
longtime friend of Jan Tschichold's, under the auspices of VOKS, the Society for
Cultural Relations with the Soviet Union. As Rosalinde Sartori points out, the
exhibit conflated the exponents of two opposing trends of photoreportage in
"a homogeneous assortment of new Soviet photography," obscuring the differ-
ences between Rodchenko, Debabov, and Ignatovitch who were members of

photos that were to show how ideas of eroticism and sexuality had developed over a century.
77 Franz Roh, "Moholy-Nagy und die Neue Fotografie," *Moholy-Nagy: 60 Fotos*, ed. Roh, 4 (my transla-
tion).
78 Ibid.
79 Ibid., 5.

the more experimental October group, and Alpert, Fridland, and Shaiket who would soon cast their lot with ROPF, the doctrinaire association of proletarian photographers.[80]

For the Soviets it was more important to present a unified front at Fifo than to expose the ideological struggles that were as yet unresolved within their photographic community. As a result, Rodchenko was not singled out for the German audience as a fighter for new viewing positions, which would have indicated important parallels and distinctions between his work and the "new photography," although it would also have confused the situation since the discourse of the "new photography" was so clearly resistant to the political relevance of a picture's subject matter.[81]

In contrast to Rodchenko's presentation at the Fifo without differentiation from his colleagues, Moholy-Nagy achieved a higher profile within the Soviet photographic debates of the late 1920s and early 1930s. Specifically, he was regarded as a German leftist whose work did not represent a fruitful direction for Soviet photographers.[82] This was initially evident in the introduction by A. Fedorov-Davydov to the Russian translation of *Malerei, Fotografie, Film* which was published in Moscow in 1929.[83] While Fedorov-Davydov praised some of Moholy-Nagy's ideas, such as his promotion of photography as a way of expanding human perception, he also accused him of being a formalist and thus out of touch with social needs. Fedorov-Davydov was particularly opposed to Moholy-Nagy's definition of art as something independent of a particular social situation, and called him to task for not identifying concrete practical applications for the new forms of typofoto, photography, and film which he espoused.

> When the problem of new form is not only a problem of technique, but also one of satisfying new social needs, then the class-related exploitation of this technique plays a decisive role.[84]

As a counterpoint to the lack of social utility he claimed for Moholy-Nagy's theories, Fedorov-Davydov cited the Soviet amateur photographers and those in

80 Rosalinde Sartori, "'Jeder Fortschrittliche Genosse muss nicht nur eine Uhr, sondern auch einen Fotoapparat haben': Bemerkungen zur sowjetischen Abteilung der Stuttgarter Ausstellung 'Film und Foto' 1929," in *Film und Foto der Zwanziger Jahre*, ed. Eskildsen and Horak, 184.

81 The Fifo catalog did not cite the specific images shown by the Russians. The photographers were simply listed as participants. See the reprint edition of the catalog *Internationale Ausstellung des Deutschen Werkbundes Film und Foto Stuttgart 1929*, ed. with intro. Karl Steinorth (Stuttgart: Deutsche Verlags-Anstalt, 1979), 73–74. However, the 1930 catalog for the traveling version of the show, included in the reprint edition, indicates that Rodchenko had six photographs in that exhibition, one portrait, two illustrations from the children's book, *Samozveri*, and three unidentified images (12).

82 A number of leftist artists, actors, and musicians in Germany, such as John Heartfield, Bertolt Brecht, and Erwin Piscator, visited the Soviet Union in the early 1930s to establish closer relations with their counterparts, but Moholy-Nagy was not among this group.

83 The book was part of a series for amateur photographers published by *Sovetskoe foto*.

84 A. Fedorov-Davydov, "Einleitung zu Moholy-Nagys Buch 'Malerei Fotografie Film'" (1929), in *Zwischen Revolutionskunst und Sozialistischem Realismus: Dokumente und Kommentare Kunstdebatten in der Sowjetunion von 1917 bis 1934*, ed. Hubertus Gassner und Eckhart Gillen (Köln: DuMont Buchverlag, 1979), 221 (my translation). This is a slightly abridged version of the introduction. An English translation of the complete document is published in Krisztina Passuth, *Moholy-Nagy* (London: Thames and Hudson, 1985), 418–422.

the proletarian photography movement as offering a better direction for photography's future. Thus, Moholy-Nagy became a foil for this new tendency and was increasingly positioned as a Western bourgeois photographer whose techniques were to be strongly opposed.

Hence, neither Rodchenko nor Moholy-Nagy were fully understood on their own terms either at home or abroad. The lack of a unified cultural doctrine during the NEP years in the Soviet Union had allowed Rodchenko to explore a new photographic strategy of representation without immediate accountability to a programmatic aim. Such an aim was never foreign to his work, particularly as exemplified by his notion of the sequence, which emphasized a fuller view of a situation than a single photograph could provide. But, when confronted with a demand for social engagement in terms that reduced his own conviction of what a photograph should be, Rodchenko was unable to mount an argument that might have brought these intentions into closer relation with those who disagreed with him.

Moholy-Nagy, conversely, was celebrated in Weimar Germany for the very reasons that the *Novyi lef* critics claimed Rodchenko's deviance. Both photographers were identified as formalists, although with different consequences. In each case, their public image did not take full account of the discourses they attempted to construct. Moholy-Nagy and Rodchenko intended these discourses to demonstrate the superior social value of their work to other forms of image production in their respective countries. What distinguishes the two photographers from each other, however, is their definitions of how photography could function as an instrument of social change. While Rodchenko always considered the social world as the reference point for his photographs, even though he differentiated the conventions of a distinctly photographic perspective from those of ordinary human sight, Moholy-Nagy wanted to demonstrate the possibilities of an expanded vision that was not represented through the objects of the world but in the process of seeing it anew. In Moholy-Nagy's equation of enlightened vision and social change, photographs that gave evidence of how to see the world more expansively would contribute to the enrichment of humanity and to a better society. Photography for him was not an instrument of criticism but rather of enlightenment through the demonstration of positive examples. This is true to some extent for Rodchenko as well, but he was more engaged with the subjects of his photographs than with documenting the act of seeing. Rodchenko was a materialist for whom the photograph established a relation to something concrete, while Moholy-Nagy was an idealist who suppressed the object's identity in favor of the sensory experience that the photograph of it offered. The irony of their respective receptions both at home and abroad is that they were seen to be more alike than distinct, and yet each sustained completely different consequences for this alleged similarity.

We are advancing full steam ahead along the path of industrialization to socialism, leaving behind the age-long "Russian" backwardness . . . when we have put the USSR in a motor car and the muzhik upon a tractor . . . we shall see which countries may then be classified as backward and which as advanced.

Joseph Stalin (1929)[1]

Our generation has set itself the aims of working precisely in accordance with commission. But practice has shown that the work of true artistic worth can be created only when the artist sets his own objective (the internal social commission).

El Lissitzky (1941)[2]

We photoreporters are always in danger of losing our individuality because we accept all assignments from the editors. One must set forth his own problems and test his own possibilities.

Alexander Rodchenko (n.d.)[3]

With the formal adoption of the first Five-Year Plan in April 1929, the Soviet Union embarked upon an ambitious program of collectivizing its agricultural production and making itself into a major industrial power. Joseph Stalin, who had assumed Lenin's mantle of leadership in the Communist party by engineering the defeat of his closest rivals, Trotsky and Bukharin, had begun to shift the nation's political agenda from the fomenting of permanent revolution abroad, as Trotsky had urged, to building a socialist state at home. This state came to be characterized by a strong central bureaucracy, an aggressive labor force under its control, and a powerful military to deter potential invaders. In the years after Stalin came to power, the desires of Lissitzky, Rodchenko, and other avant-garde artists to actively participate in the construction of Soviet society were put to a test.[4] With the instigation of the big agricultural and industrial projects, the state adopted a centralist coordinating role that meant more accountability to social commands than the avant-garde had previously been accustomed to.

1 Joseph Stalin, cited in Donald Treadgold, *Twentieth Century Russia*, 6th ed. (Boulder: Westview Press, 1987), 245.

2 El Lissitzky, "Information on the Work of the Book Artist" (April 13, 1941), in *El Lissitzky* (Köln: Galerie Gmurzynska, 1976), 81.

3 Alexander Rodchenko, quoted from an unpublished manuscript in Hubertus Gassner, *Rodçenko Fotografien*, (München: Schirmer/Mosel Verlag, 1982), 119 (my translation).

4 Some artists of the avant-garde declined to participate actively in this collaboration. Kazimir Malevich, e.g., specialized in figurative portraiture during the final years before his death in 1935, while Vladimir Tatlin spent much of the years between 1929 and 1932 working on his flying machine, Letatlin, and also undertook extensive commissions for theater sets, costumes, and maquettes after that.

Art historians writing about this period have tended to regard it as a time of monolithic repression and thus have treated its artistic production as a subservient capitulation to oppressive forces that closed out any possibility of meaningful statements or creative invention.[5] The definition of the Stalin era as totalitarian makes it easy to draw a line between the artistic work done before Stalin, when artists were ostensibly free to create what they wanted, and after Stalin came to power, when they were constrained by the state. For the most part, art historians see the latter work as being of lesser value or of no artistic value at all.

Scholars of Soviet history, however, have long been uncomfortable with this monolithic description of the Stalin period. As historian Abbott Gleason notes in an article on the concept of totalitarianism in Soviet studies, "'Totalitarianism,' then, is not merely the phenomenon described, but also a particular generational perspective, a gruesome collection of insights at which people arrived during a particular period, having been through a particular historical experience."[6] Making reference to the specific Cold War connotations of the term, Gleason suggests that it obscures more than it clarifies about how society under Stalin actually worked. It implies that the party and the state apparatus were all powerful and that everyone under them was simply obedient to their will.

The totalitarian model does not accommodate the views of revisionist his-

5 Boris Groys argues that the Stalinist regime became the avant-garde of the 1930s by taking over the role of artistic innovation and imposing a standardized aesthetic on all cultural production. See "The Birth of Socialist Realism from the Spirit of the Russian Avant-Garde," in *The Culture of the Stalin Period*, ed. Hans Günther (New York: St. Martin's Press, 1990): 122–47. Groys develops this theme in his book *The Total Art of Stalinism: Avant-Garde, Aesthetic Dictatorship, and Beyond*, trans. Charles Rougle (Princeton: Princeton University Press, 1992). Vassily Rakitin claims, "Only artists of the former left who could show that they had completely broken with their disgraceful past made their way into the ranks of Socialist Realism." See Rakitin, "The Avant-Garde and Art of the Stalinist Era," in *The Culture of the Stalin Period*, ed. Günther, 178. Igor Golomstock subordinates art completely to politics by his use of the term "totalitarian art" which he identifies with "a style that one can justifiably term the international style of totalitarian culture." See Igor Golomstock, *Totalitarian Art in the Soviet Union, the Third Reich, Fascist Italy and the People's Republic of China*, trans. from the Russian by Robert Chandler (New York: Icon Editions, 1990), xiv. And Jaroslav Andel asserts that the avant-garde "was annihilated by the very system that supported it." See "The Constructivist Entanglement: Art into Politics, Politics into Art," in *Art into Life: Russian Constructivism, 1914–1932*, with intro. Richard Andrews and Milena Kalinovska (New York: Rizzoli, 1990), 223. One should note that all these scholars are Eastern Europeans whose lack of distance from the Stalinist period may have made a more balanced assessment of the avant-garde's relation to Socialist Realism difficult for them. This position is countered by several authors, two of them Russians, who discuss the design work of Lissitzky, Rodchenko, and Stepanova during the 1930s. Sophie Lissitzky-Küppers writes extremely favorably about her husband's work for *USSR in Construction* in *El Lissitzky: Life, Letters, Texts* (London: Thames and Hudson, 1980 [c. 1968]), 96–102, while Alexander Lavrentiev, the grandson of Rodchenko and Stepanova, provides a positive account of their publication designs of the 1930s in *Varvara Stepanova: The Complete Work*, ed. John Bowlt (Cambridge, MA: MIT Press, 1988), 124–53. See also Margarita Tupitsyn "Gustav Klutsis: Between Art and Politics," *Art in America* 79, no. 1 (January 1991): 41–47. Tupitsyn, a Soviet émigré scholar, does a close reading of Klutsis's Five-Year Plan posters and regards them as "perhaps Klutsis's most successful efforts" (45). Assessing the role of the avant-garde under Stalin, she states, "The combination of photography and photomontage with the poster medium by artists like Klutsis was the last major avant-garde experiment in this direction. This experiment proved, however, surprisingly adaptable to the needs of Stalinist visual propaganda" (47).

6 Abbott Gleason, "'Totalitarianism' in 1984," *Russian Review* 43, no. 2 (April 1984): 146.

7 For a number of scholars in Soviet studies, it is not possible to study the Stalinist period without invoking its acts of terror. Hence, when Sheila Fitzpatrick, in a 1985 scholarly debate, proposed a more objective revisionist approach to the 1930s, other historians, notably Stephen Cohen, argued that her approach was unsat-

torians, such as Sheila Fitzpatrick, who argue for a reciprocal relation between the policies of Stalin and the party and various groups that benefited from them, nor does it allow for a discussion of any benefits to the populace that Stalinist policies brought about such as improvements in housing, the status of women, child care, recreational facilities, employment opportunities, and so forth.[7]

Benjamin Buchloh has been one of the few art historians to argue for the necessity of a paradigm shift within the Soviet avant-garde, from the modernist focus on the individual viewer to a "simultaneous collective reception." This, he claims, was an inevitable consequence of the avant-garde's espoused intention to reach the masses.[8] Most scholars, however, have never fully acknowledged the radical change of situation that occurred for both Rodchenko and Lissitzky when these two artists began to cooperate more closely with the state. They have compared the artists' projects during the Stalin years with their avant-garde work and generally found the latter work wanting.[9]

Several issues are involved in differentiating our interpretation of Lissitzky's and Rodchenko's work during the Stalin years from their avant-garde production. One is that the design demands of a centralized state reduced their control over what they produced, and we can never be sure that the outcomes were completed as they envisioned them.[10] Another is the necessity to evaluate their

isfactory because it ignored the emotional resonance of the purges. See Sheila Fitzpatrick, "New Perspectives on Stalinism," (358–73); and Stephen F. Cohen's response, "Stalin's Terror as Social History," (375–84), in *Russian Review* 45, no. 4 (October 1986). The issue also includes a number of other responses to Fitzpatrick by Geoff Eley, Peter Kenez, and Alfred G. Meyer, along with an "Afterword" by Fitzpatrick. Additional contributions to the debate were published in *Russian Review* 46, no. 4 (October 1987): 339–431. Excellent examples of Fitzpatrick's approach to Soviet history, particularly the late 1920s and 1930s, can be found in her collection of essays, *The Cultural Front: Power and Culture in Revolutionary Russia* (Ithaca: Cornell University Press, 1992).

8 Benjamin Buchloh, "From Faktura to Factography," *October* 30 (Fall 1984): 83–119.

9 Peter Nisbet, for example, notes that "Lissitzky was something of the chameleon, adapting to his surroundings without a strong countervailing individuality that might consistently deny circumstance and propose a defiant alternative." However, it has never been the designer's role to deny the circumstances of the commission. In expecting Lissitzky to have more strongly resisted the briefs he was given, Nisbet substitutes the working conditions of an artist for those of a designer. As a counter argument one could say that Lissitzky was exceptional in his creation of a visual form for *USSR in Construction*'s rhetorical objectives. Nisbet makes his comments in the context of his catalog essay for the exhibition of Lissitzky's work he organized in 1987. See Nisbet, "An Introduction to El Lissitzky," in his catalog *El Lissitzky, 1890–1941*, (Cambridge, MA: Busch-Reisinger Museum, 1987), 46. Jan Leering also imposes artistic criteria on Lissitzky's design work. Of Lissitzky's projects in the 1930s, Leering states that the artist was "overtaken by propaganda whose aims and content were dictated by others, and this conflicted with the freedom to set consciousness in motion." Jan Leering, "Lissitzky's Dilemma: With Reference to his Work after 1927," in *El Lissitzky: Architect, Painter, Photographer, Typographer, 1890–1941* (Eindhoven: Municipal Van Abbemuseum, 1990), 64. In the same essay, Leering says of Lissitzky's work for *USSR in Construction*: "Here we can see how decline set in, despite fine examples of photomontage and typographic composition . . . " (60).

10 Much has been made of Lissitzky's comment in a letter to the Dutch architect J. J. P. Oud that he considered the Soviet pavilion for the Pressa exhibition in Cologne to be "theater decor." What has not been sufficiently recognized is that Lissitzky was no longer working under the conditions of an artist and had to make compromises due to a shortage of preparation time and other factors. See Lissitzky's letter to Oud in El Lissitzky, *Proun und Wolkenbügel: Schriften, Briefe, Dokumente*, ed. Sophie Lissitzky-Küppers and Jen Lissitzky (Dresden: VEB Verlag der Kunst, 1977), 136. We also should note that the Pressa pavilion was praised by German colleagues such as Jan Tschichold who called it "the most revolutionary among the foreign sections." Tschichold also had a high regard for Lissitzky's 1930 pavilion for the International Hygiene Exhibition in Dresden. See his article "Display That Has Dynamic Force: Exhibition Rooms Designed by El **165**

work in relation to the nation's social projects and political goals. Because both were so closely allied, their projects do not have an independent existence. That in itself creates yet more complications, particularly in relation to the historical judgment of the Stalin era to which an interpretation of Lissitzky's and Rodchenko's design projects must be related. The Stalin period is, in fact, extremely complex, combining as it does inhumane labor policies, oppression of minorities, and widespread terror with an extraordinary momentum to improve the Soviet Union's economic situation and political standing in the international community. We therefore need to distinguish these elements, one from another, in order to comprehend the subtleties and nuances of what happened rather than evaluate the design projects of that period in an overly reductive manner.

This is particularly important in considering the work of Lissitzky and Rodchenko during the Stalin years. Just as I don't wish to recognize an oversimplified repressive force that reduced their work to obligatory capitulation, neither do I want to suggest that they had an unambiguous positive relation to the Stalinist regime, particularly as information about its repressive policies and acts of terror surely became known to them. Both Lissitzky and Rodchenko undertook a wide range of commissions after Stalin came to power. Not only were the projects they worked on varied in form, ranging from books and magazines to exhibitions, but the political implications and artistic constraints of those projects also varied from one to another and even changed within a single project.

One might study all of their work from the Stalin years in order to form an assessment of Lissitzky's and Rodchenko's practice, but I want to focus on one publication, *USSR na stroike* (USSR in Construction), for which they both designed extensively during the 1930s. Using a single magazine allows one to observe the changes in their work over time in relation to the sociopolitical events of the 1930s as well as to the strategies of representation that were sanctioned by the Stalinist regime.

2

USSR in Construction was a propaganda magazine whose principal mission was to promote a favorable image of the Soviet Union abroad.[11] Published monthly between 1930 and mid-1941, it was intended primarily for foreign distribution, but it was also distributed within the Soviet Union where it performed a related function of encouraging enthusiasm and support for state policies and practices.[12] Initially it appeared in four separate editions—German, English, French, and Russian; later a fifth edition in Spanish was added. The magazine

Lissitzky," *Commercial Art* 21, no. 1 (January 1931): 21–26.

11 *USSR in Construction* was one of many instruments that the Soviet government employed to inform the public abroad of its accomplishments. Initially, the government invested heavily in big exhibitions such as the Pressa and the International Hygiene Exhibition in Germany, but with Hitler coming to power in 1933 these projects ended. Other, more modest, means of gaining influence abroad included the distribution of films and the invitation of prominent foreign intellectuals to tour the Soviet Union and see for themselves what was happening. On films made during the 1930s, see Jay Leyda, *Kino: A History of the Russian and Soviet Film*

was conceived in the spirit of the first Five-Year Plan as an optimistic chronicle of Soviet achievements.[13] Founded on the initiative of the writer Maxim Gorky, the magazine was intended to gain friends for the Soviet Union abroad and thus formed part of an aggressive foreign policy. Its creators envisioned it as a picture magazine that would "reflect in photography the whole scope and variety of the construction work now going on in the USSR."[14]

Stalin recognized that the Soviet Union would be dependent on other nations for heavy machinery and technical expertise until it could become self-sufficient. He was therefore determined to maintain civil relations with countries that could supply badly needed equipment and expert assistance for the huge projects that were central to the Five-Year Plans. An additional foreign policy aim was to assert the Soviet Union's capacity to defend itself in case of attack. In order to achieve both of these ends, the nation had to represent itself as an emerging industrial power that could command respect from other industrialized nations. This was particularly important to Stalin who feared that the West might organize a new capitalist coalition against his country.

Stalin was extremely competitive and sought to project an image of the Soviet Union as a workers' paradise that was far superior to the decadent capitalist countries of the West. The principal characteristics of this paradise, as they were embodied in Soviet propaganda abroad during the 1930s, were heroic achievements in all spheres of life, generous rights and entitlements for Soviet citizens, and a shared vision of the future among the diverse ethnic and national groups that had been incorporated into the Soviet Union since the Revolution. In the creation of this image, *USSR in Construction* played a central role.

The first few issues featured a variety of articles on state projects, but after that each issue was devoted to a single theme. During the first Five-Year Plan, *USSR in Construction* gave particular emphasis to the huge industrial projects—

(London: George Allen and Unwin, 1960), 245–364. For a discussion of visits by intellectuals from abroad to the Soviet Union, see Sylvia R. Margulies, *The Pilgrimage to Russia: The Soviet Union and the Treatment of Foreigners* (Madison, Milwaukee, and London: University of Wisconsin Press, 1968); and Paul Hollander, *Political Pilgrims: Travels of Western Intellectuals to the Soviet Union, China, and Cuba, 1928–1978* (New York and Oxford: Oxford University Press, 1981), 102–76. One of the most influential books about the Soviet Union by a visiting intellectual in the 1930s was André Gide's *Return from the U.S.S.R.*, trans. Dorothy Bussy (New York: Knopf, 1937). Although Gide found much to criticize in the Soviet Union, he refused a wholesale condemnation of the Stalin regime, declaring in his closing sentence, "The Soviet Union has not yet finished instructing and astonishing us" (62).

12 After its demise, *USSR in Construction* resumed publication again for one year in 1949 in three languages—English, Russian, and French. It became a general feature magazine rather than one that focused on theme issues as it had done in its previous incarnation. It ceased publication with its original title at the end of 1949 and was reborn in March 1950 as *Soviet Union*.

13 The Editorial Board, headed by G. L. Piatakov as editor-in-chief, was a mixture of politicians and writers. The author Maxim Gorky was a member from the magazine's founding until his death in 1936. Another prominent writer on the board was Mikhail Koltsov, one of the Soviet Union's best-known journalists, who had been the editor-in-chief of the nation's first illustrated magazine *Ogonyok* and the first editor of *Sovetskoe foto*. He also played an active role in the Union of Soviet Writers. Among the politicians were G. F. Grinko, S. P. Uritsky, and later E. Yezhova, the wife of Nikolai Yezhov, who became head of the NKVD or security police in 1936. The presence of so many political figures on the editorial board suggests that the magazine was considered to be an extremely important project by the regime.

electrosteel plants, textile mills, hyrdoelectric stations, coal mines—as well as to the collectivization of agriculture. This coverage eventually expanded into special issues on the different republics and autonomous regions, accounts of building projects such as the White Sea Canal and the Moscow Metro, the rise of rail and air travel, features on raw materials such as coal, gold, and timber, and themes of daily life such as children, sports, and old-age. There were also special political issues on the Stalin Constitution, the election of the Supreme Soviet, and the occupation of the Western Ukraine. As the decade progressed, *USSR in Construction* reflected the changes in national policies such as the growing cult of Stalin, the celebration of shock workers and Stakhanovites, the incorporation of the ethnic republics and regions into the national body, and the emphasis on national defense.

The subjects of *USSR in Construction* in the early 1930s had much in common with those of Soviet literature. Katerina Clark has identified "The Struggle with Nature" as a powerful theme which underlay the descriptions of the huge construction projects and collectivized agriculture of the early Five-Year Plan years.

> The great hydroelectric stations, which were the pride of all, were built to tame the arbitrary and destructive powers of the rivers. Collectivized modernized agriculture would not be the slave to the whims of climate. Drought was to be combated with dams, shallow waterways with canals, and so on.[15]

As a reaction to the rhetoric of the first Five-Year Plan, Clark notes that "the aura of the god-machine was eclipsed by the aura of the god-man."[16] She states that the theme of socialist construction was transformed from a focus on huge agricultural and industrial projects, presented as triumphs of technology and social organization, to an emphasis on the depiction of individual heroism in conquering the elements. This transition was evident in *USSR in Construction*, which initially emphasized the large projects. During the second Five-Year Plan, the magazine featured more frequently the exploits of individual heroes, exemplifying Clark's claim that

> [t]he drama of man pitted against the elements, a common theme of thirties fiction and rhetoric, functioned as a symbolic saga of struggle that stood in for and enhanced that other "struggle" then taking place all over the land.[17]

To realize the theme for each issue, the Editorial Board assembled a different production team. These teams included one or more writers, a group of photographers, often with a principal photographer, a designer or layout artist, and sometimes a special designer of charts and maps.[18] Many of the Soviet Union's leading authors—Isaac Babel, Nikolai Fadeyev, Sergei Tretiakov, and El Registan, among others, planned and wrote the texts. They worked closely with teams of

14 *USSR in Construction*, no. 1 (1930), n.p. This quote and all subsequent ones in this chapter are taken from the English edition of the magazine.

15 Katerina Clark, *The Soviet Novel: History as Ritual*, with a new Afterword (Chicago: University of Chicago Press, 1985), 100–101.

photojournalists who included the best photographers working in the Soviet Union in the 1930s—Max Alpert, Viktor Bulla, Dmitry Debabov, Semyon Fridland, Boris and Olga Ignatovich, Yakov Khalip, Eliezer Langman, Georgy Petrusov, Mikhael Prekhner, Ivan Shagin, Arkady Shaiket, Abram Shterenberg, and Georgy Zelma.[19]

Initially the magazine's editors provided the designers with wide latitude to interpret the texts, but gradually *USSR in Construction* evolved a style of visual rhetoric that shared the characteristics of Socialist Realism as introduced by Zhdanov, Gorky, and others at the All-Union Congress of Soviet Writers in 1934.[20] Lissitzky was instrumental in creating this style and became its foremost exponent. Unlike painting, literature, or music, however, there were no clear guidelines for Socialist Realism in magazine design. It was thus possible for Lissitzky, Rodchenko, and their spouses with whom they frequently collaborated, to include material that was consistent with the principles of layout and typography the avant-garde had used in the 1920s.[21]

But two issues of content contribute to our estimate of Lissitzky's and Rodchenko's designs for *USSR in Construction*; first, the growing cult of Stalin which imposed increasing obligations on the editors of the magazine to pay homage to the leader in visual form as well in the written text; and then the frequent dissonance between the magazine's rhetoric, which presented all aspects of Soviet life positively, and the oppressive or destructive nature of particular events and policies.[22] This dissonance, however, varied from one issue of the

16 Ibid.

17 Ibid., 103.

18 *USSR in Construction* developed sophisticated displays of visual statistics that were strongly influenced by the ISOTYPE figures of Otto Neurath. Sophie Lissitzky-Küppers notes that she and Lissitzky met Neurath in Vienna in 1928 and that Lissitzky may have been the one responsible for Neurath's coming to Moscow with a team around 1930 to found Isostat, an institute for art-in-statistics. See Lissitzky-Küppers, *El Lissitzky: Life, Letters, Texts*, 86, 95. Neurath stated that Isostat trained whole staffs from government bureaus in the use of pictorial statistics, noting also that "a new clarity and purposefulness is developing in communication that may be regarded as preparation for more incisive social planning." See Otto Neurath, "From Vienna Method to Isotype," in Otto Neurath, *Empiricism and Sociology*, ed. Marie Neurath and Robert S. Cohen (Dordrecht and Boston: D. Reidel, 1973), 226. See also Clive Chizlett, "Damned Lies and Statistics: Otto Neurath and Soviet Propaganda in the 1930s," *Visible Language* 26, nos. 3–4 (Summer/Autumn 1992): 299–321.

19 Photographs from *USSR in Construction* have been published as separate prints in several books devoted to Soviet photography between the wars. See, e.g., Sergei Morozov, Anry Vartanov, Grigory Shudakov, Olga Suslova, and Lilya Ukhtomskaya, eds., *Soviet Photography: An Age of Realism* (New York: Greenwich House, 1984); and Grigory Shudakov, Olga Suslova, and Lilya Ukhtomskaya, eds., *Pioneers of Soviet Photography* (London: Thames and Hudson, 1983).

20 For a collection of extracts from speeches given at the Congress as well as a section from the Charter of the Union of Soviet Writers of the U.S.S.R., see "Contributions to the First All-Union Congress of Soviet Writers [Extracts], 1934," in *Russian Art of the Avant-Garde: Theory and Criticism, 1902–1934*, rev. and enlarged ed., ed. and trans. John Bowlt, 290–97. An account of the Congress appears in Régine Robin, *Socialist Realism: An Impossible Aesthetic*, trans. Catherine Porter (Stanford: Stanford University Press, 1992), 9–36.

21 Lissitzky worked more often as an independent designer for *USSR in Construction* and sometimes together with his wife, Sophie. Rodchenko worked primarily in collaboration with his wife Varvara Stepanova. The two men and their spouses were responsible for more than twenty-five issues of the magazine.

22 On the cult of Stalin and his tactics of self-representation, see Robert C. Tucker, "The Rise of Stalin's Personality Cult," *American Historical Review* 84, no. 2 (April 1974): 347–66; and Graeme Gill, "Political Myth and Stalin's Quest for Authority in the Party," in *Authority, Power, and Policy in the USSR: Essays Dedicated to Leonard Shapiro*, ed. T. H. Rigby, Archie Brown, and Peter Reddaway (London: Macmillan, 1960): 98–117.

magazine to another. In some instances, there was no significant difference between the positive presentation and the actuality that was described. This was the case, for example, with the 1934 issue that featured the Gorky Park of Culture and Rest and another in 1935 that focused on the production of particular consumer goods—watches, record players, and bicycles.[23]

In other instances, the magazine's interpretation of a theme clearly glossed over the conflicts, resistances, or destructive consequences inherent in it. Depending on which theme they were interpreting, Lissitzky and Rodchenko were either legitimately promoting a positive achievement of the state, or helping to conceal or distract the magazine's readers from something oppressive. In the years between 1935 and 1939, when a sequence of major show trials and purges took place, the dissonance between those events and the uplifting rhetoric of *USSR in Construction* increased dramatically. During this period, the magazine conveyed an image of the Soviet Union as a site of democracy, unity, and productivity even as thousands were being killed at the hands of the regime. Those engaged in Soviet propaganda during the purge years were inevitably implicated in maintaining this dissonance. But outright opposition to Stalin's tactics was not an option.

3

The most original graphic language developed in the Soviet Union during the 1920s was that of the avant-garde whose book covers, posters, and typographic experiments were the result of conversations and debates among themselves and not derivatives of foreign models. As noted in Chapter 3, the Soviet Union had no strong tradition of design for commerce and industry that could compare with Western Europe, and thus the production artists of the avant-garde were forging a new profession as well as a new visual language. Despite these indigenous accomplishments, which also included the design of various Soviet photo magazines, the format of *USSR in Construction* was modeled more closely on the German bourgeois illustrated magazines of the early 1920s as well as the left-wing German publication, the *Arbeiter Illustrierte Zeitung*.[24] The statement from the editorial board in the first issue declared:

> The State Publishing House has chosen the photo as a method to illustrate socialist construction, for the photo speaks much more convincingly in many cases than even the most brilliantly written article.[25]

23 See *USSR in Construction*, no. 9 (1934) "The Maxim Gorky Central Park of Culture and Rest"; and no. 7 (1935), "Watches, Bicycles, and Gramaphones."

24 The *Arbeiter Illustrierte Zeitung* (AIZ), was published by Willi Münzenberg in Germany beginning in 1925 on behalf of the Internationale Arbeiter-Hilfe (IAH) a Soviet-front organization that was directed by the Comintern. In 1921, IAH had begun to publish *Sowjet-Russland im Bild* (Soviet Russia in Pictures), an illustrated magazine with a circulation of 100,000 copies. In 1923, when it had a circulation of 180,000, it was renamed *Sichel und Hammer* (Sickle and Hammer). These earlier publications as well as the AIZ may have influenced *USSR in Construction*. See Friedrich Pfafflin, "Heartfield's Photomontages of 1930–38," in *Photomontages of the Nazi Period: John Heartfield* (New York: Universe Books 1977), 27–32.

25 *USSR in Construction*, no. 1 (1930), n.p.

26 Favorsky, a woodcut artist and illustrator, had been rector of the VKhUTEMAS (1923–25) and taught in

The photographs were printed by rotogravure, an intaglio technique whereby the ink is pressed into grooves in the printing plate rather than rolled across a raised surface. The rich texture and soft-focus of rotogravure printing gave the images a heightened dramatic effect which suited the magazine's rhetorical objectives. This effect was also achieved through other techniques such as gate-folds which resulted in spreads that were as wide as four pages, die cuts, and other elaborate paper folds that produced some striking visual effects. Besides, El and Sophie Lissitzky, and Rodchenko and Varvara Stepanova, a number of other designers did layouts for the magazine. The most active of these was N. S. Troshin, but others included Vladimir Favorsky, Salomon Telingater, I. Urasov, and V. Khodasevich.[26] Zoe Deineka did most of the maps and charts.

The early issues of *USSR in Construction* were quite plain visually. Initially the designer had a subordinate role and was credited on the masthead only with the arrangement of photographs. During the first several years, the magazine was rarely more than a sequence of pictures with explanatory texts that told viewers what they were looking at. The first cover, designed by O. Deineka and used alternatively throughout the life of the magazine, was simply a solid-colored page with a huge typographic logo in the center of it. The designers had very few Western typefaces to choose from and thus made hardly any significant typographic innovations. When John Heartfield, the German photomontage artist, visited Moscow for an extended stay in 1931, he contributed a powerful composite photograph of Lenin superimposed on an aerial view of Moscow to the September issue of the magazine. He then designed both the layout and cover for the December issue on the Soviet petroleum industry.[27] Even after Heartfield forcefully demonstrated the possibilities of a strong cover and pho-tographic layout, however, the editors failed to encourage further graphic innovations until Lissitzky's first project for the magazine in October 1932, a theme issue on the Dnieper hydroelectric station and dam.[28]

When he returned to the Soviet Union from Europe in 1925 after recuper-ating from tuberculosis in Switzerland, Lissitzky had apparently resolved any ambivalence he previously had about working with the regime, and he began to focus his energies on problems of Soviet development. In 1927 he received a commission to design the All-Union Printing Trades Exhibition which was visited by over 100,000 people in Moscow's Gorky Park of Rest and Culture.[29] His work on this exhibition was an important transition project for him. From

the school's Graphic Arts Department. Telingater was a young designer who first assisted Lissitzky with the All-Union Printing Trades Exhibition in 1927 and subsequently garnered a reputation as an outstanding book and periodical designer. On Telingater, see Salomon Benediktovic, *Telingater: L'oeuvre graphique, 1903–1969* (Paris: Association France-URSS, 1978).

27 For a firsthand account of Heartfield's work on the magazine, see "Gespräch mit Maks Alpert und Kinelowski," in John Heartfield, *Der Schnitt Entlang der Zeit: Selbstzeugnisse, Erinnerungen, Interpretatio-nen*, ed. Roland März (Dresden: VEB Verlag der Kunst, n.d.), 286–89. A transcript of Heartfield's 1931 lec-ture on photomontage to the Polygraphic Institute in Moscow, which may have influenced the subsequent use of photomontage in *USSR in Construction*, can be found in the same volume, 274–75.

28 *USSR in Construction*, no. 10 (1932), "Dnieprostroy."

29 Lissitzky-Küppers, *El Lissitzky: Life, Letters, Texts*, 84.

there he went on to become the Soviet Union's leading exhibition designer. The huge Soviet pavilion for the Pressa Exhibition in Cologne was completed in 1928 and others followed, notably pavilions for the International Hygiene Exhibition in Dresden in 1930 and the International Fur Trade Exhibition in Leipzig the same year. Lissitzky also continued his work as a publication designer during this period.

He was the first designer for *USSR in Construction* to be identified on the masthead as an "Artist."[30] Besides denoting him as such in the issue on the Dnieper dam and hydroelectric station, also known as Dnieprostroi, the editors gave him joint credit with the photographer Max Alpert for the issue's initial plan. Lissitzky's involvement with the magazine right from the start exceeded that of any designer before him except Heartfield. Sophie Lissitzky-Küppers describes her husband's participation in the Dnieprostroi issue thus:

> For the first installment [sic] B. Agapov wrote the text-scenario; he and Lissitzky exchanged views on the photographic lay-out. Lissitzky travelled with the photographer Alpert to Dnyeprostroy [sic], where together they took the photographs. It was this readiness on the part of the collaborators to help each other which gave the issue its almost cinematic animation; once again, as in the case of the exhibitions, the individual items blended into a whole, and the whole illuminated the individual items.[31]

Lissitzky conceived the issue as a visual narrative that employed all the devices and techniques of modern art, typography, and printing technology, including large bold letters, photomontage, strong colors, and gatefolds. In this and other early issues of *USSR in Construction* that Lissitzky designed, we can, in fact, see continuations and amplifications of the visual strategies he developed in his avant-garde publications of the 1920s, particularly the narrative sequence in *Of Two Squares* and his use of icons to visualize Mayakovsky's poems in *Dliagolosa* (For the Voice.)[32] The colors he chose for the front and back covers were black, white, and red—the staples of avant-garde book design—which he contrasted with the sepia tone of the photographs and photomontages.

Compared to his earlier avant-garde book *Of Two Squares*, whose narrative strategy was based on a metaphoric reading of abstract forms, the political nar-

30 Terms used in *USSR in Construction*'s early years to describe the designer's role included "Layout," "Composition," "Mounting," and "Photographic Arrangement." Following Lissitzky's Dnieprostroi issue, Troshin and other designers were frequently listed as "Artist," or "Art Editor." Other terms applied in later years were "Art Composition," "Art Arrangement," and "Design and Make-up."

31 Lissitzky-Küppers, *El Lissitzky: Life, Letters, Text*, 96.

32 The influence of *Dliagolosa* is particularly strong in the issues Lissitzky designed during the late 1930s where he used various seals and banners to demarcate specific sequences. See, e.g., *USSR in Construction*, nos. 4–5 (1936), "Dedicated to the 15th Anniversary of Soviet Georgia"; and nos. 9–12 (1937), "The Stalin Constitution."

33 In an early essay on typography, Lissitzky referred to "The continuous page-sequence—the bioscopic book." See Lissitzky, "The Topography of Typography," (1923) in Lissitzky-Küppers, *El Lissitzky: Life, Letters, Texts*, 359. Lissitzky-Küppers also notes in the same volume that her husband became friendly with the filmmaker Dziga Vertov in the late 1920s and was deeply moved by Vertov's montage film *Man with a Movie Camera*. She states that "in the periodical *Building the USSR* [sic] Lissitzky presented his photographic illustration material like Vertov's running of a documentary film" (88).

rative in the Dnieprostroi issue of *USSR in Construction* was rooted in documentary images, and Lissitzky was faced with devising a powerful visual format for it, albeit one that also used metaphor but in a different way. Although constrained by an editorial policy that required a certain amount of text, Lissitzky managed to create a visual flow for the issue that reinforced his early interest in film as a narrative medium for the modern world.[33] On the front cover he used a retouched night photograph of the hydroelectric station's opening ceremony. Searchlight beams were airbrushed in, along with the name of the project in white letters against the black sky as if the letters were projected from giant floodlights (**FIGURE 5.1**). The photo appeared again toward the end of the issue, thus creating a reprise of the initial image with a text that explained it more fully. As one of the major projects completed during the first Five-Year Plan, the Dnieper dam and hydroelectric station personified the Soviet Union's technological accomplishments during that period, and their grand scale was used to represent the inherent superiority of communism as a driving force of industrialization.

Lenin's quote, "Communism is Soviet government plus the electrification of the whole country," which Lissitzky placed on the inside cover, established the context for assessing the project's importance. The quote was printed in large red letters on widely spaced lines, and its dramatic effect was increased by its location on a light ground surrounded by empty space. Lissitzky continued this

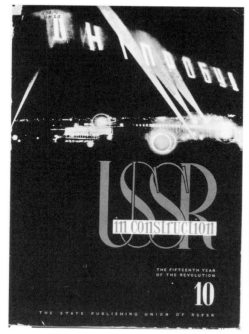

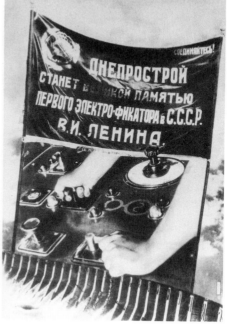

FIGURE 5.1
Lissitzky *USSR in Construction*, no. 10, cover, 1932

FIGURE 5.2
Lissitzky "'Communism in Soviet government plus the electrification of the whole country.' V. I. Lenin" *USSR in Construction*, no. 10, 1932

173

effect with a series of bold photomontages and photographs. Through such strategies he was instrumental in creating a narrative style whose rhetorical impetus was to represent the achievements of the first Five-Year Plan as extraordinary events. In terms of foreign propaganda, such rhetoric was a means of asserting the industrial power of the Soviet Union and its potential to strengthen the country. It may be the visual amplification and hyperbole in these images that has led some critics to dismiss Lissitzky's work for *USSR in Construction* as politically compromised and thus of lesser artistic value than his avant-garde books and journals.[34] But what these critics have not recognized is that Lissitzky's narrative style in the early years of *USSR in Construction* was an absolutely appropriate means to visualize the rhetorical intentions of the magazine.[35]

Lissitzky composed heroic photographic views of the hydroelectric station's and dam's construction by juxtaposing images and image fragments to emphasize extreme contrasts of scale.[36] With the use of an airbrush, the fragments were made to look like seamless images despite the contrasts. Such photomontages were intended to appear mythic and natural at the same time, foreshadowing Maxim Gorky's literary concept of "romantic realism," the simultaneous representation of life as how it was and how it could ideally be.[37] As such, they were indicative of a visual style that characterized *USSR in Construction* in the 1930s.[38]

As Katerina Clark has pointed out, Soviet novelists described the gigantic construction projects as assaults on nature, which led them to demonstrate how nature was transformed into dams, power stations, and canals.[39] Lissitzky designed the Dnieprostroi issue in this spirit, but he did not follow a conventional sequence in portraying the construction of the hydroelectric station and dam. Instead of beginning with an image of a construction site, he initiated the narrative with a photomontage that recapitulated the translation of Lenin's visionary rhetoric about electrification into water rushing through the sluices of the completed dam. The two muscular hands turning on the power in the center of the photomontage mediate between the ambitious rhetoric of the banner, which announces, "Unite! Dnieprostroi will become a great memorial to the first electrificator, V. I. Lenin,"

34 See n. 9, this chapter.

35 This was recognized some years ago by Benjamin Buchloh who stated, "The problem with this criticism, however—as with all previous rejections of the later work of Rodchenko and Lissitzky—is that the criteria of judgment that were originally developed within the framework of modernism are now applied to a practice of representation that had deliberately and systematically disassociated itself from that framework in order to lay the foundations of an art production that would correspond to the needs of a newly industrialized collective society." See Buchloh, "From Faktura to Factography," 108.

36 Lissitzky was not alone in developing a style of "heroic photomontage" in the 1930s. Margarita Tupitsyn discusses this phenomenon in her essay "From the Politics of Montage to the Montage of Politics," in *Montage in Modern Life, 1919–1942*, ed. Matthew Teitelbaum (Cambridge, MA: MIT Press, 1992), 82–127.

37 Roland Barthes distinguished between the "mythic" and the "natural" in his essay "Myth Today," published in his book, *Mythologies*, selected and trans. Annette Lavers (New York: Hill and Wang, 1972 [c. 1957]), 109–59. Barthes made the important distinction between a previous notion of myth as a separate subject matter and his own definition of it as a type of speech.

38 Unlike his own book projects of the 1920s, Lissitzky had no control of the magazine's text. Constrained by a limited choice of typefaces and point sizes, he confined the written text to boxes and columns so that it would not impede the visual flow.

39 Katerina Clark, *The Soviet Novel*, 100–101.

and the rushing water below (FIGURE 5.2). The hands personify the heroic work-ers at the building site who translate the leadership's ideology into enormous industrial projects. The grandeur of the project is enhanced by the clouds behind the banner, which in many Soviet photomontages of the 1930s serve as a metaphor for the lofty height of Soviet aspirations. The hands turning on the power recall Lissitzky's hand holding a compass in his self-portrait of 1924. Only now this limb controls the vast power of the Dnieper dam instead of a drawing compass.

Having begun with a celebratory image of Soviet power and achievement, Lissitzky then moved to a two-page spread that shows H. G. Wells on the verso side holding an oversized page from his book, *Russia in the Shadows*, which strongly crit-icized the Soviet Union's ability to undertake huge electrification projects like Dnieprostroi (FIGURE 5.3). Lissitzky juxtaposed the picture of Wells with a much larger photograph of Lenin on the recto side. A photograph of an electric power grid in the center of the spread leads the eye from the negative image of an old Russian village behind Wells to the cloud-filled sky in back of Lenin that suggests, as already mentioned, the boundlessness of Soviet potential. In this spread enti-tled "A Conversation between Two Worlds," Lissitzky set up a contrast between Wells's pessimism and Lenin's positive vision of electrification. He did so through graphic means such as contrasts of image scale, placement of images, and the use of visual metaphors.[40]

Working with the writer B. Agapov, Lissitzky designed a sequence to depict the actual events that led up to the Dnieprostroi project. To reinforce the image of Lenin as a visionary, he superimposed a photograph of the Soviet leader speak-ing at the Eighth Congress of Soviets in 1920 over a map of the Soviet Union (FIGURE 5.4). The site of the Dnieper project is circled on the map and a dotted line extends across the page, ending in an arrow on the next page that points to an airbrushed photomontage of the rushing waters to be tamed by the hydro-electric station. Besides connecting an abstract mark on the map to a pictorial image of the region, the arrow also becomes a metaphor for Lenin's vision, which is reinforced by the photograph of him looking in the direction of the rushing waters. Here Lissitzky makes the arrow operate simultaneously as an informational device and a metaphor. This skillful economy of means invites a reading of the spread on several levels at once.

In another spread that illustrates the movement from idea to finished project, Lissitzky featured the engineer Krzhizhanosky who authored a plan for the elec-trification of the Soviet Union (FIGURE 5.5). We see Krzhizhanosky announcing his plan from the podium of the Great Theater in Moscow. Beneath his photo are reproductions of some notebook pages on which he wrote ideas for the project. On the facing page is a three-tiered sequence of photographs that moves from four men reviewing the drawings for the Dnieprostroi dam to a model of

40 Lissitzky's capacity for creating visual drama and multiple readings of images was inherent in his earliest book designs and was particularly evident in his avant-garde projects such as *Of Two Squares*. Although he strongly influenced the "new typography" in Germany, Lissitzky was never a functionalist even though he was often described by Jan Tschichold and others as an initiator of functional typography. **175**

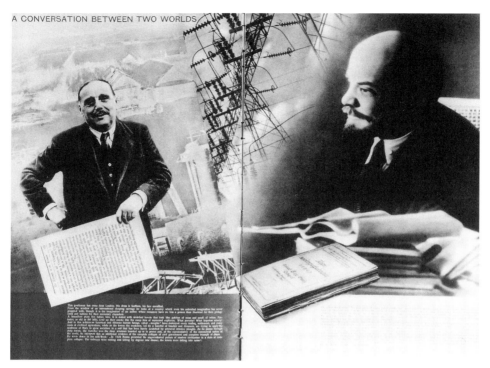

FIGURE 5.3
Lissitzky "A conversation between two worlds," *USSR in Construction*, no. 10, 1932.

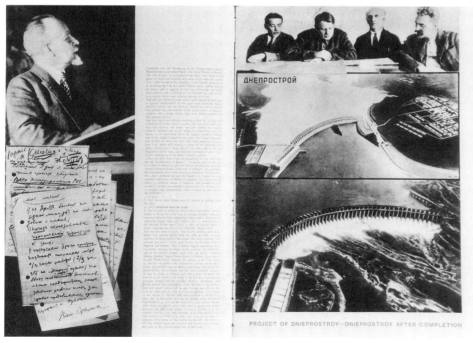

FIGURE 5.5
Lissitzky, "Project of Dnieprostroy—Dnieprostroy after completion," *USSR in Construction*, no. 10, 1932

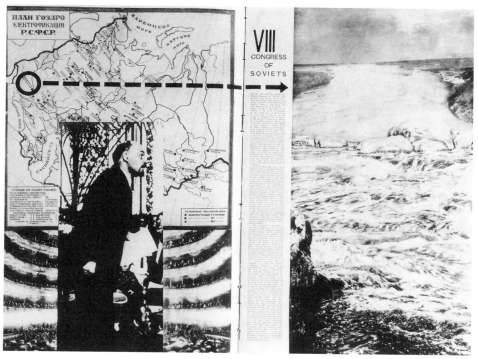

FIGURE 5.4
Lissitzky "VIII Congress of Soviets," *USSR in Construction*, no. 10, 1932.

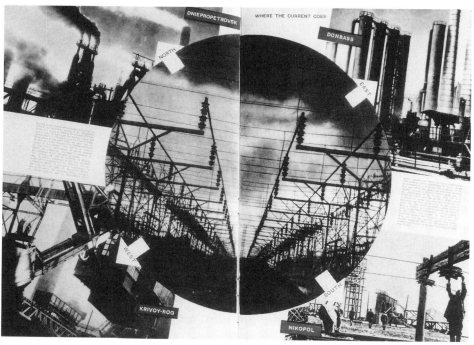

FIGURE 5.6
Lissitzky, "Where the current goes," *USSR in Construction*, no. 10, 1932

the dam and finally to a photo of it with the water rushing through. The sequence from sketch to final construction is a metaphor for the Soviet capacity to turn visionary ideas into completed projects.

Within the following section on the launching and completion of the project, Lissitzky included a series of photomontages that depict the construction of the dam and culminate in a pull-out section that shows the last bucket of concrete being lifted up by a crane to be poured. A subsequent spread reprises the electric power grid from the pages with Wells and Lenin (**FIGURE 5.6**). The grid is featured in an enormous circle with arrows placed along the rim pointing in four directions to industrial sites where the current generated by the new hydroelectric station is dispersed. Lissitzky used the photographs as metaphors, substituting the grid for electric power itself, and employing photographic fragments of industrial regions to represent the magnitude of Soviet industry electric power was making possible. The larger scale of the photograph in the circle and its central placement in the layout denotes the importance of electricity in animating Soviet industry, and indirectly affirms the force of Lenin's vision embodied in the opening quote and in several of the preceding spreads.

Toward the end of the issue, Lissitzky created a montage, spread across two pages, entitled, "The Current Is Switched On," the function of which was to credit Stalin with realizing Lenin's vision of electrification in the Soviet Union (**FIGURE 5.7**). Lissitzky imposed a huge head shot of Stalin on the same photograph of the hydroelectric station's opening that appeared on the cover. The station is illuminated by a searchlight beam that cuts diagonally across the photomontage, drawing the image of Stalin into relation with the huge hand that

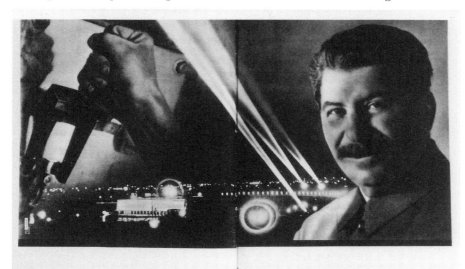

THE CURRENT IS SWITCHED ON

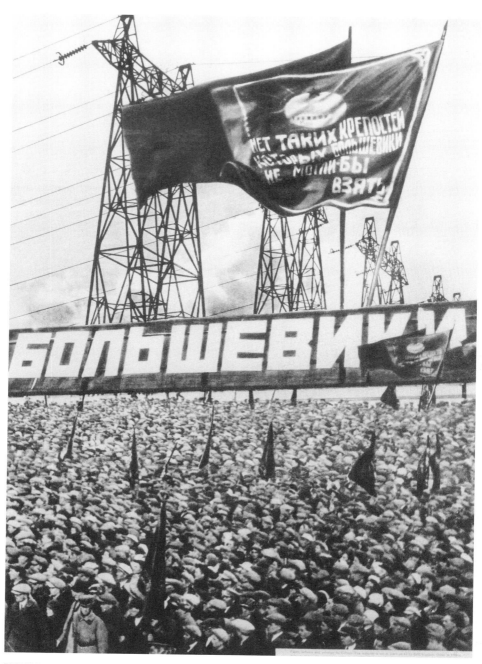

FIGURE 5.7 (p. 178)
Lissitzky "The current is switched on,"
USSR in Construction, no. 10, 1932

FIGURE 5.8
Lissitzky "Bolsheviks,"
USSR in Construction, no. 10, 1932

is pulling the switch to turn on the power.[41] Lissitzky closed the issue with a final full-page montage that moved the reader from a recognition of Stalin as the animator of the Dnieprostroi project to a larger vision of Bolshevism as the driving force behind it (FIGURE 5.8). He created this effect by placing a photograph of a crowd at a demonstration below an image of power grid masts that rise like cathedral spires against a background of clouds. Dividing the two photographs is a banner that says "Bolsheviks," a term that unites the human mass with the technological achievements of the regime. This emphasis on the Soviet masses as animators of the Bolshevik efforts, as well as beneficiaries of them, confirms the point of Lissitzky's narrative, which represents the hydroelectric station and dam as both a heroic accomplishment of the Communist system and evidence of the system's merit.

In this early stage of *USSR in Construction*, Lissitzky had extensive freedom to invent a visual style that characterized the state's own sense of achievement. Reflecting on the Dnieprostroi project as well as others he undertook for the magazine, he noted:

> I was invited to collaborate on *Building the USSR* [sic] in 1932 and my first assignment was the issue about the Dniepr power station. The word layout does not adequately describe the whole nature of our work. I would go so far as to say that the work involved in the presentation of an issue of the periodical, for instance "Chelyuskin" or "The Constitution of the USSR" requires no less effort than a painting. And it makes no less of an impact on the public.[42]

Lissitzky gave visual form to the forceful argument made by *USSR in Construction* for the superiority of communism, and we can see his role in publicizing the state's achievements abroad as a substantial contribution to the Soviet Union's foreign propaganda objectives.

He continued this effort in two issues he designed the following year, when the second Five-Year Plan began. One issue was devoted to the fifteenth anniversary of the Red Army and the other to the Soviet Arctic.[43] The most characteristic technique of his new evolving narrative style was hyperbole, or exaggeration, a rhetorical device that was central to the Soviet Arctic issue. This issue recounted the heroic expeditions of several Soviet ice breakers that opened up a vast and desolate territory of the Soviet Union for exploration. As the editors stated in the introductory text,

41 Lissitzky used the image of a hand on several occasions in his photomontages of the 1920s. In his self-portrait of 1924, "The Constructor," the hand held a compass, anticipating the act of designing. The two uses of this icon in the Dnieprostroi issue of *USSR in Construction* show the hand actually accomplishing powerful acts by turning on the hydroelectric station's power. In the contrast of these images we can see a difference between the avant-garde artist anticipating an act of drawing and the activist of the Five-Year Plan building up the country by releasing the dam's water power.

42 El Lissitzky, quoted in N. Khardzhiev, "El Lissitzky, Book Designer," in Lissitzky-Küppers, *El Lissitzky: Life, Letters, Texts*, 387.

43 *USSR in Construction*, no. 2 (1933), "15th Anniversary of the Red Army"; and no. 9 (1933) "Soviet Arctic."

44 Ibid., no. 9 (1933) "Soviet Arctic," n.p.

45 Katerina Clark, *The Soviet Novel*, 146.

> The conception of the Arctic as a country walled off from cultured lands by an impenetrable barrier of ice has been destroyed. The Arctic desert is slowly but surely retreating before the onslaught of the Bolsheviks.[44]

The account of heroic Soviet sea captains, explorers, and pilots subduing the harshness of nature exemplifies Katerina Clark's observation that two orders of reality, the ordinary and the extraordinary, characterized Stalinist culture of the 1930s. "Ordinary reality," she writes, "was considered valuable only as it could be seen to reflect some form, or ideal essence, found in higher-order reality. The distinctions between ordinary reality and fiction lost the crucial importance they have in other philosophical systems."[45]

As the artist responsible for the Arctic issue, Lissitzky had the task of depicting the higher-order heroism the regime intended the Arctic explorations to represent. To do so he designed a cover that featured a photographic detail of a Soviet ice breaker showing two smokestacks and the mast (FIGURE 5.9). This image functioned as a metaphor for the achievements of Soviet technology as well as for the courage and skills of the icebreaker crews. Lissitzky made the image dynamic by tilting it slightly, turning the mast and smokestacks into diagonal lines. The smoke billowing from the smokestacks indicates that the icebreaker is in motion, clearing a path through the solid blocks of ice. In a larger sense, the image also functions metaphorically as a representation of the Soviet people who,

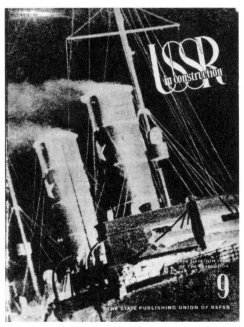

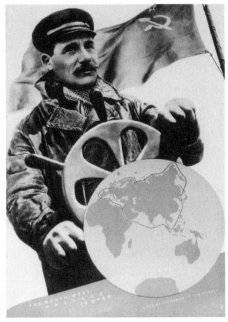

FIGURE 5.9
Lissitzky *USSR in Construction*, no. 9, cover, 1933

FIGURE 5.10
Lissitzky "The Northwest Passage is open," *USSR in Construction*, no. 9, 1933

according to *USSR in Construction*, were building a new society through heroic and unstinting action against difficult odds.

There is no dramatic quote from Lenin or Stalin on the inside cover as there were in Lissitzky's two previous issues. The brief introductory text is more descriptive and explanatory, and Lissitzky had it printed in small type so that it would not overshadow the image on the opening page, a large photograph of a Soviet helmsman at the steering wheel of an icebreaker (**FIGURE 5.10**). Behind the helmsman flies the Soviet flag, while just in front of his steering wheel is a globe-shaped map that depicts the course of the Soviet icebreaker fleet through the Northwest Passage. The proximity of the globe to the steering wheel connects the helmsman both to his own ship and the larger project of opening the Northwest Passage. The difference in scale between the helmsman and the globe suggests the confidence with which the helmsman, who personifies all the Soviet adventurers engaged in Arctic exploration, conquers the Arctic terrain. Through the use of a scale contrast, Lissitzky established a heroic identity for the helmsman which he then enhanced by describing an actual event, the Northwest Passage expedition, marked with a red line on the map. As with the arrow in the photomontage of Lenin envisioning the electrification of Russia, the line functions as both an informational and emotional device. As a conveyer of information, it depicts the actual route taken to open up the Northwest Passage; but it also becomes a sign of heroic achievement through its relation to the other narrative elements in the layout.

In the next spread, Lissitzky moved to a large photograph that showed the vastness of the Arctic with a single man standing at the base of a huge snow formation. He is the only human presence in this "boundless icy desert stretching for thousands of kilometers on all sides of the Pole."[46] This image conveys the starkness of the terrain and the courage of the Soviet explorers, which is characterized by the single man dwarfed by a massive snow drift—a relation that also suggests the Soviet will to conquer overwhelming obstacles. The image functions as well to introduce the terrain itself in a form that is both natural and mythic. Throughout the issue, Lissitzky alternated detailed accounts of particular expeditions, including route maps, with dramatic photographs spread over two pages. The photographs function as more general metaphors for Soviet heroism through their depiction of a single figure surrounded by the snowy vastness of Arctic space (**FIGURE 5.11**). Stalin appears early in the narrative as a huge figure presiding over a montage of the different ships, dirigibles, sea planes, and dog sleds that have conveyed expedition crews to various Arctic sites. An accompanying text blatantly gives Stalin credit for guiding the "mastery of the Soviet Arctic."[47]

46 *USSR in Construction*, no. 9 (1933), n.p.

47 Ibid.

48 *USSR in Construction*, no. 12 (1933), "The Baltic—White Sea Canal." This issue was the only one to feature Rodchenko's photographs exclusively, although they were occasionally published in other issues of the magazine.

Other themes woven into the issue include the technological achievements of radio communication that enabled explorers stationed in remote Arctic regions to communicate with each other and with the populace back home, the incorporation of the Asian nationalities of the North into the Soviet Union, and the industriousness of Soviet hunters who were contributing to the Soviet economy by bringing back pelts of foxes and other Arctic animals. Lissitzky ended the Arctic narrative with a special photographic foldout section entitled "Through the Soviet Arctic," which is sequenced like a film as it depicts in detail the activities of the explorers and portrays in closeup the animals of the region as well as the vastness of the landscape. The rhetorical intent of the issue was to stimulate the foreign and Soviet public's interest in the Arctic region, and to arouse their admiration for the heroic explorers who were risking their lives to map and occupy this territory. A subtext intended for foreign readers of *USSR in Construction* was the presentation of the Arctic explorations as metaphors for the boldness and expansiveness of the Five-Year Plans. Lissitzky was thus operating in a complex context in which the editors intended to satisfy several rhetorical aims simultaneously.

Through his projects with *USSR in Construction*, Lissitzky was becoming skilled at blending logos and pathos, information and emotion, in his layouts. Using scale contrasts, maps, photomontage, and expansive photographic displays, he was able to describe the history of the Arctic expeditions in great detail while also conveying a sense of the extraordinary in the ordinary that characterized one aspect of Soviet artistic production in the 1930s.

4

In the issues of *USSR in Construction* that Lissitzky designed in 1932 and 1933, he did not have to directly confront the problem of dissonance between representation and reality that Rodchenko faced in his first project for the magazine, the special issue on the White Sea Canal.[48] Unlike the subjects of his earlier journalistic projects, the construction of the White Sea Canal was rife with controversial political issues that were implicated in any attempt to document it.

In 1931, Rodchenko, under pressure from militants in the All-Russian Organization of Proletarian Photographers to visit actual building and industrial sites, made the first of three trips to the construction site of the White Sea Canal in Karelia. He continued his documentation of the project for two years until its completion, taking more than 2,000 photographs. Selections of these were used in *USSR in Construction* as well as in several books that publicized the canal. By contrast with the Dnieper hydroelectric station and dam, the construction of the White Sea Canal had a draconian schedule and a minimal budget which required the extensive use of prison labor rather than machines bought with

Figure 5.11 (pp. 184–85)
Lissitzky "Soviet explorers on Severnaya Zeml'ya," *USSR in Construction*, no. 9 (1933).

183

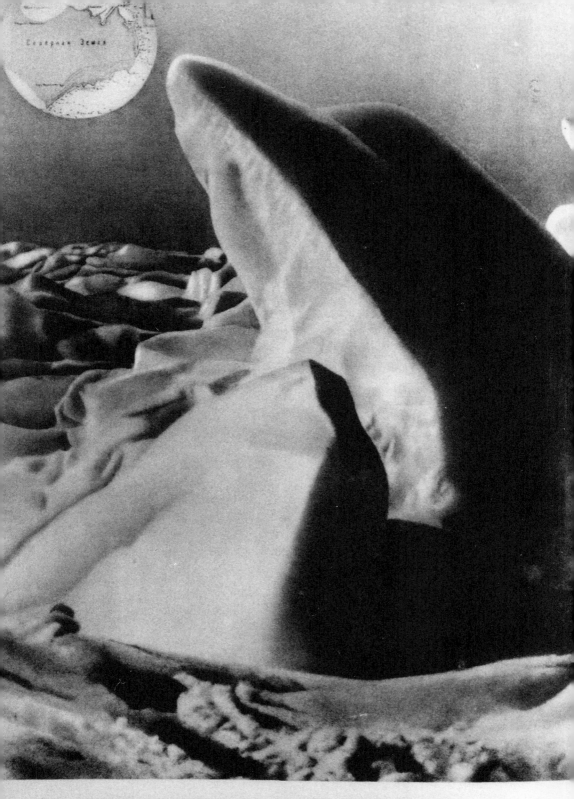

SOVIET EXPLORERS ON SEVERNAYA ZEMLYA

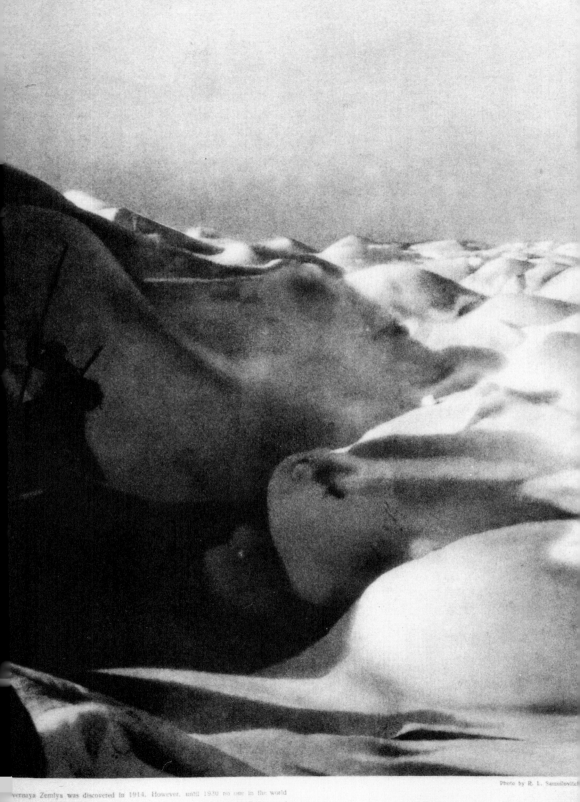

...vernaya Zemlya was discovered in 1914. However, until 1930 no one in the world
...ew what kind of a country it was and what was its size. Above: the map of
...vernaya Zemlya as it appeared in 1929.

scarce foreign currency.[49] Thousands of laborers from prisons run by the secret police (GPU) are said to have died during the construction, and this inevitably forms the context for reading Rodchenko's photographs.[50] As I argued in the previous chapter, Rodchenko always intended his pictures to have a political value, but he conveyed that value through subjects that were inherently positive; hence, he could presume their consonance with his own revolutionary ideals. In the case of the White Sea Canal, the situation involved a controversial policy that imposed harsh working conditions on prison laborers in order to complete an important public works project. L. Slavin, who wrote the text for the White Sea Canal issue, made it clear that prisoners were being used to construct the canal, but he claimed that working on the project was a way of rehabilitating them and transforming them into positive citizens.[51]

> They were the people of the depths, people taken from the very dregs. As they came they thought: "This is the end of life for us." But real life had only begun for them. For not only was the nature of the landscape changed but the nature of the people also.[52]

Thus, the White Sea Canal narrative had two purposes; it recounted the planning and completion of a major project initiated during the first Five-Year Plan, while also asserting that such projects could transform the attitudes of dissidents, NEPmen, kulaks, and others who had been put into GPU prisons for being out of step with the Stalinist regime.

Rodchenko had to insert his photographs into a rhetorical frame that considerably altered their meaning. A number were incorporated into photomontages while others were heavily retouched. The text also conditioned the interpretation of the photographs which were, in fact, subordinated to it. But one can argue that Rodchenko himself did not approach the project with a critical view. Soviet photoreportage developed as a celebration of social life rather than a critique of it. There were, in fact, no precedents for a technique of reportage that criticized

49 I have chosen the term "prison labor" rather than "forced labor" or "slave labor" found in Cold War histories, such as David J. Dallin and Boris I. Nicolaevsky's *Forced Labor in Soviet Russia* (New Haven: Yale University Press, 1947). While "forced labor" is an accurate description of what occurred, it bears the emotional overtone of a society that is under totalitarian control, as does "slave labor," a term that enables Dallin and Nicolaevsky to compare the prison labor in the Soviet Union to the use of slaves in ancient Greece and Rome. I do not wish to minimize the elements of power and control that directed the labor force on the White Sea Canal project, but I prefer to address the issue in more objective terms than the heavily loaded ideological ones of the Cold War literature.

50 There is as yet no scholarly study of the White Sea Canal that could be considered to provide a reliable estimate of the number of prisoners who died during its construction. Jaroslav Andel claims that a quarter of a million laborers are said to be buried at the construction site, but he gives no source for his figures. See Andel, "The Constructivist Entanglement: Art into Politics, Politics into Art," 232. Hubertus Gassner claims 100,000 deaths, but he relies on Alexander Solzhenitsyn's *Gulag Archipelago*. See Gassner, *Rodčenko Fotografien* (München: Schirmer/Mosel Verlag, 1982), 104, and n. 475. I was drawn to these references through an unpublished paper of 1991, "Belmostroi: The Visual Economy of Forced Labor," by Erika Wolf, a doctoral candidate in the Department of Art History at the University of Michigan.

51 The treatment of laborers on the construction sites and in the factories was a sensitive topic for the editors of *USSR in Construction*. A refutation of claims that laborers were treated badly was made in no. 6 (1931), an issue devoted to "Soviet Timber."

52 Ibid., no. 12 (1933), n.p.

53 Alexander Rodchenko, "Perestroike khudozhnika" (An Artist's Transformation)," *Sovetskoe foto* 5–6 (1936): 19–20 (Bowlt translation).

the Bolsheviks by exposing injustices or oppression. Speaking about his White Sea Canal photographs at a debate on photographic formalism and naturalism in Moscow during 1936, Rodchenko gave a favorable impression of what he had observed at the building site:

> People were excited, they made self-sacrifices, heroically they over-came every obstacle. People whose life, it had seemed, had come to an end, showed that it had begun anew and that it was full of extra-ordinary interest, promising struggle and strife. They took granite cliffs and quicksand by storm. This was a war between man and wild nature. Man came and conquered, he conquered and transformed himself. He had come downcast, punished, embittered, and left with his head held high, with a medal on his breast, and with a passport to life . . . I photographed simply giving no thought to formalism. I was staggered by the acuity and wisdom with which people were being re-educated.[53]

Rodchenko's own interpretation of what he saw is actually similar to that presented in *USSR in Construction*, and it suggests that he did not acknowledge the difference between the magazine's favorable presentation of the canal's construction and the harsh working conditions which have been subsequently recounted by critics of Stalin's regime. His published pictures in *USSR in Construction* do not portray any suffering at the building site. Instead, he photographed men hard at work drilling, pushing wheelbarrows, digging, and constructing the locks (**FIGURE 5.12**). The photographs give the impression that masses of workers were dedicating themselves to a project which had great value for their country and enormous social redemption for them.

In the White Sea Canal issue, the editors contrasted photos and photomontages of industrious workers with commanding views of the canals and locks, some with boats passing through and some with the locks empty. Although criticized as formalistic, these latter photographs play an integral part in the issue's narrative. The canal is depicted on the cover and elsewhere in the issue as a strong object, the result of man's triumph over nature. This point is accentuated in a spread entitled "Mighty dams sprang up where there had formerly been forest," which features an image of a huge dam, tinted blue, placed above a rocky terrain, printed in plain gray (**FIGURE 5.13**). Between the images is an airbrushed section that merges the clouds of the forest photograph with the water of the dam, so that the dam appears to float above the forest as its heavenly apotheosis.

Some of Rodchenko's photographs are displayed to great advantage in the White Sea Canal issue, either in black and white or tinted versions. Particularly impressive is a two-page foldout image of the canal without a human presence. Flanked by two black and white photographs of boats passing through a lock, this photograph becomes the triumphal image of the issue. The canal in fact is

turned into a metaphor for Soviet independence from the West. The Soviet Union's ability to carry out its construction projects without assistance from abroad became an important theme in *USSR in Construction*, and the White Sea Canal was one of the first projects to exemplify this achievement. Given Rodchenko's inclination to empower his subjects through a photographic transformation, it is not surprising that he interpreted the White Sea Canal as evidence of strong national character and purpose. The question of how much he knew about the actual situation at the building site remains unanswered, however, thus obliging us to recognize the parallels between his own reading of the White Sea Canal project and what was presented to the readers of *USSR in Construction*.

Rodchenko's next assignment for the magazine was an issue on the fifteenth anniversary of Kazakhstan in 1935.[54] He collaborated on this issue with his wife Varvara Stepanova as he did on all subsequent projects for *USSR in Construction*. Following the White Sea Canal issue, however, his own photographs rarely appeared in the magazine, and he worked primarily on problems of layout. By the time the Kazakhstan issue was published, both the editorial policy and the photographic rhetoric of the magazine were showing the results of the speeches on Socialist Realism given at the First All-Union Congress of Soviet Writers in Moscow the previous year.

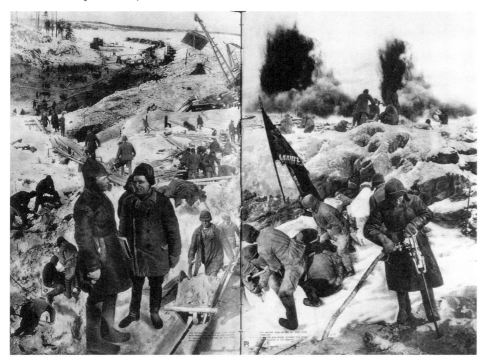

FIGURE 5.12
Rodchenko "The attack on the land took place with spades and explosives," *USSR in Construction*, no. 12, 1933

54 *USSR in Construction*, no. 11 (1935), "The 15th Anniversary of Kazakstan."

Following his return to the Soviet Union from Sorrento in 1928, Maxim Gorky, a member of *USSR in Construction*'s Editorial Board since its inception, had been promulgating a literature that was intimately linked with the nation's social and economic ambitions. At the Writer's Congress he had put forth the concept of "revolutionary romanticism," by which he meant a melange of fact and aspiration. This concept was taken up by party spokesman Andrei Zdhanov in his speech to the Congress:

> We say that socialist realism is the basic method of Soviet artistic literature and literary criticism, and this presupposes that revolutionary romanticism must enter literary creativity as an integral part, because the whole of life of our Party, of our working class and its struggle consists of a combination of the most severe, most sober practical work with supreme heroism and grand prospects. Our Party has always derived its strength from the fact that it united—and continues to unite—particular activity with grand prospects, with a ceaseless aspiration onward, with the struggle for the construction of a Communist society.[55]

Socialist realism was more difficult to identify in photography than in literature, painting, or sculpture, and *USSR in Construction* continued to publish pho-

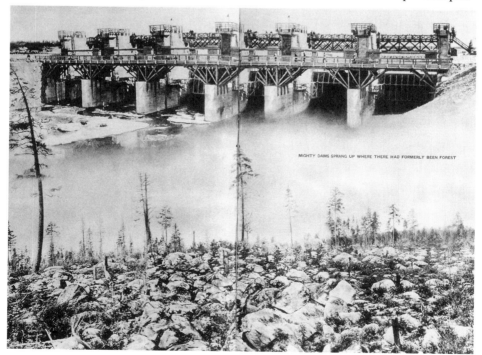

MIGHTY DAMS SPRANG UP WHERE THERE HAD FORMERLY BEEN FOREST

FIGURE 5.13
Rodchenko "Mighty dams sprang up where the land had formerly been forest," *USSR in Construction*, no. 12, 1933

55 "From Andrei Zhdanov's Speech," in John Bowlt, ed., *Russian Art of the Avant-Garde*, 293–94.

tographs that represented a diversity of aesthetic strategies. Many of the photographs in the Kazakhstan issue were inspired by the new angles and viewpoints that Rodchenko himself had argued for in the 1920s, and they make a powerful impact when printed at such a large scale in a range of tints. One convention which can clearly be attributed to Socialist Realism, however, came to be used frequently by Soviet photographers: the image of a smiling face taken from below or shown in a stark close-up. From these positions, the face was enlarged, thus giving it a heroic cast. On the opening page of the Kazakhstan issue, Rodchenko and Stepanova constructed a montage of such faces, which represented different ethnic groups of the region (**FIGURE 5.14**). The juxtaposition of these smiling faces was intended to denote the region's social coherence, which in turn was framed by the assertion of Kazakhstan's unity with the rest of the USSR. Although the montage in question does not refer to a specific situation in Kazakhstan, it suggests that the native population welcomed the central government's efforts to gain control of the borderlands. Stalin took a particular interest in the Soviet Union's ethnic minorities since his first specialty as a party official had been the nationality question. His objectives for the borderlands included substituting allegiance to the Soviet Union for local nationalism, instituting economic and social transformations designed to bring the native society under Moscow's control, and exploiting the natural resources and labor potential of each region.[56]

The narrative of the Kazakhstan issue claims that the people supported the region's industrialization from which they benefited by a chance to work in new professions and improve their standard of living. This is supported by the

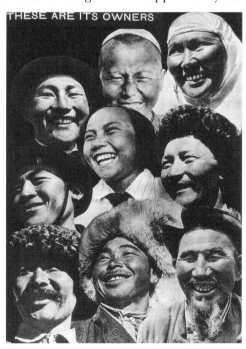

FIGURE 5.14
Rodchenko and Stepanova "These are its owners," *USSR in Construction*, no. 11, 1935

design sequence which exemplifies a classic rhetorical strategy, the negation of a so-called false image, and the substitution of a purported true one. A picture of Kazakhstan as an undeveloped region known primarily for its agriculture is replaced by one that shows it as a powerful industrial region. Hence, the photographs in the first part of the issue portray Kazakhstan as a place of vast natural beauty and farming activities. Following these, Rodchenko and Stepanova presented a panorama of photographs that depict Kazakhstan's industrial activity, notably mining for metals and coal and drilling for oil. To dramatize the contrast between the agricultural and industrial representations of the region, the designers used foldout sections to present the new Kazakhstan. Beneath photographs of the natural landscape, we see images of mining and drilling where holes have been cut in the overlay pages (FIGURE 5.15). When one turns the pages, one sees these photos embedded in diagrams of industrial processes, which are then contrasted with smaller views of the natural landscape. Thus, the reader actively discovers the new Kazakhstan.

The subsequent section dramatizes the process of mining ore and smelting it into metal. Rodchenko and Stepanova combined images and texts to depict the construction of an electric power station, and they portrayed the oil fields of Emba-Neft which were described as a "second Baku." The final section then recounts how the natural resources are made into products that improve the lives of the people of Kazakhstan, who are then able to do research, serve in the army, and generally contribute to the health and development of the nation. On the next to the last page, Rodchenko and Stepanova superimposed a large photograph of Stalin over a montage of the many newspapers in the Kazak language. In the final text we read:

> Thus has a tsarist colony been transformed by the Bolsheviks into a free socialist land . . . Children have a future before them which we cannot see through the blinding light of the Five-Year Plans, a future of which we cannot even dream.[57]

The narrative of the issue claims that the people of Kazakhstan welcomed the region's industrialization from which they benefited by a chance to work in new professions and improve their standard of living. The integration of ethnic minorities into the state apparatus was at the core of the party's policy toward the autonomous regions and republics, and this issue of USSR in Construction made the perfect argument for it.

In the issues on the White Sea Canal and Kazakhstan we can see a narrative voice emerging. It is characterized by an attentiveness to the visual power of the photographic image and the way this power can be enhanced by the image's location in a sequence. Both Rodchenko and Stepanova were also alert to the possibilities of special tricks, such as foldout pages and die cuts, which they could

56 Martha Brill Olcott provides a thorough account of the Soviet assimilation of Kazakhstan in *The Kazakhs* (Stanford: Hoover Institution Press, 1987).

57 *USSR in Construction*, no. 11 (1935), n.p.

use to create a sense of surprise for the reader. This voice was developed in a subsequent issue on Soviet parachuting.[58] Like the Arctic explorers whose exploits Lissitzky had recounted, Soviet parachutists were also presented as heros who were conquering nature. As the writer of the introductory text noted:

> The parachutists are written about, spoken about and thought about so much because their dizzy but cool-headed leaps are a reflection of our Stalinist striving forward, our urge to soar higher, our desire to widen the horizon of life, to make it brighter, bigger and more joyous.[59]

The theme of parachuting offered Rodchenko and Stepanova great opportunities for visual experimentation, which resulted in several unusual foldout sections as well as a number of striking spreads. While the text referred to parachuting as a metaphor for the energetic Soviet character, the designers did not need to illustrate this in their layouts by comparing the parachutists to industrial workers, for example. Even though they had to include photographs of Stalin to make the previously mentioned metaphor more graphic, they still had considerable leeway to work in the interstices of the magazine's polemical editorial objectives. They used photographs that portrayed a number of variations on the parachuting theme, frequently glorifying the activity with dramatic views of

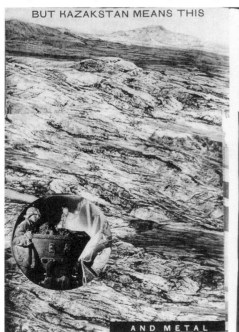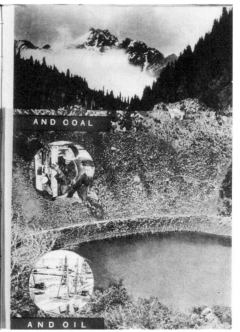

FIGURE 5.15
Rodchenko and Stepanova "But Kazakstan [sic] means this," *USSR in Construction*, no. 11, 1935

58 Ibid., no. 12 (1935), "The Fearless Soviet Parachutists." A small note in the following issue (no. 1, 1936) stated, "Due to technical reasons issue no. 12 of 'USSR in Construction' 1935 has been held up. This issue will be forwarded to subscribers at the end of this month." The delay was most likely due to the complexity of the paper folds which would surely have taxed the ingenuity of any printing plant.

parachutists floating down to earth. In the center of the issue Rodchenko and Stepanova introduced an extremely complex foldout section that moves from two triangular images of parachutist heros to an interior diamond celebrating four women jumpers. This then opens up into a large square where a photograph of Stalin is superimposed on a photomontage of a sky filled with parachutes (**FIGURE 5.16**).

The August 1936 number on Soviet timber exports also provided Rodchenko and Stepanova with extensive leeway for thematic development through the sequence, juxtaposition, scale, texture, and tinting of photographs.[60] For the front and back covers, the designers used an enlarged photograph of wood grain which recalls the experiments with *faktura*, or texture, of their early Constructivist paintings. Among the initial images is a photograph by Rodchenko of a Soviet forest. Tinted in a deep green and spread over two pages, it is a more straightforward image than his Pushkino forest pictures of 1927 where he photographed the trees from below. While altering the viewing position in this photograph might be seen as Rodchenko's capitulation to a more conventional technique of representation, it also satisfies an editorial purpose by displaying the forest in a panoramic view that supports the text—" One third of the forests of the world

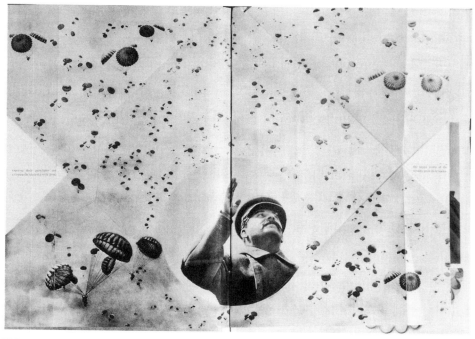

FIGURE 5.16
Rodchenko and Stepanova "Opening their parachutes and covering the sky with them . . . ,"
USSR in Construction, no. 12, 1935

59 Ibid., n.p.
60 Ibid., no. 8 (1936), "Soviet Timber Exports."

belong to the USSR."[61] In other spreads, we see close comparisons to the dynamic symmetrical layouts of Rodchenko's avant-garde posters and book covers in the 1920s. One spread that describes how timber is brought to the various ports from the sawmills and factories around the country features a circle with a partial facade of a public building, including a hammer and sickle, flanked by two dynamic photographs of wooden planks recalling the strong use of symmetrical diagonals in some of Rodchenko's earlier logos, book covers, and posters (**FIGURE 5.17**). There is only a modest formal difference between this spread and some of Rodchenko's avant-garde projects, even though he and Stepanova included more required editorial content in it. The point of the comparison, however, is to emphasize that the aesthetics of Socialist Realism were not imposed in any uniform way on *USSR in Construction*, and Rodchenko and Stepanova had varying degrees of license to interpret the writers' plans and text according to visual principles and representational strategies that were congenial to them. This license was tempered, however, by the fact the purges had begun by the time the issue came out, and *USSR in Construction* assumed a new function of contributing to a Popular Front mentality abroad by drawing attention away from the purges and substituting a positive image of Soviet life.[62]

5

As visually strong as some of Rodchenko's and Stepanova's layouts and individual spreads for *USSR in Construction* were, they lacked the preoccupation

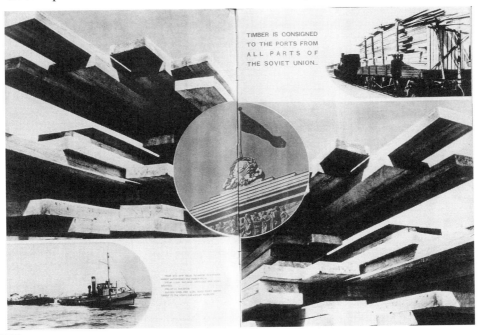

TIMBER IS CONSIGNED
TO THE PORTS FROM
ALL PARTS OF
THE SOVIET UNION...

FIGURE 5.17
Rodchenko and Stepanova "Timber is consigned to the ports from all parts of the Soviet Union," *USSR in Construction*, no. 8, 1936

with the multiple devices of narrative that Lissitzky had been concerned with in his writings and book projects since the Revolution.[63] In various issues of *USSR in Construction* during the middle and late 1930s, he gave a visual presence and order to a number of extremely complex themes, including some that had a grand historical sweep. These included "The 15th Anniversary of the Azerbaijan Oil Industry," "The 15th Anniversary of Soviet Georgia," the "Kabardino-Balkarian Autonomous Region," and "The People of the Orjonikidze Territory (Northern Caucasus)."[64]

During the 1930s, the political objectives of *USSR in Construction* evolved from an almost exclusive focus on large industrial projects to creating an image of national unity and well-being. The editors paid considerable attention to the republics and autonomous regions as well as to representing the political process itself. In addition, they placed a great deal of emphasis on historical summations of the nation's various regions, republics, and enterprises since the Revolution. This may have been part of Stalin's larger project to rewrite Soviet history in terms of his own goals, a project that culminated in his *Short Course* on the history of the Soviet Communist party in 1939.[65] Because information about the mass arrests and murders which began in 1936 was getting out to the West through travelers' accounts and the press, the magazine's role in Soviet foreign policy became one of countering these stories by preserving the image of the Soviet Union as a multicultural industrial paradise and a legitimate partner in the united front against Fascism. As the "cult of Stalin" resulted in the rewriting of history and increasing mythic depictions of the leader in art and literature, so was he a more central figure in *USSR in Construction*.[66]

Lissitzky had been developing a narrative style for the magazine that became

61 Ibid., n.p.

62 Historians disagree on how great the impact of the purges was on the general populace. Robert W. Thurston, e.g., disputes previous claims that the entire population or even the majority was terrorized. See Thurston's article, "Fear and Belief in the USSR's 'Great Terror': Response to Arrest, 1935–1939," *Slavic Review* 45, no. 2 (Summer 1986): 213–37. In his response to Thurston, Robert Conquest, who wrote a major book on the purges, *The Great Terror: Stalin's Purge of the Thirties*, rev. ed. (New York: Macmillan, 1973 [c. 1968]), disputes the idea that "the *Ezhovshchina* was not a terror operation of the most extreme type . . ." See Robert Conquest, "What Is Terror?" *Slavic Review* 45, no. 2 (Summer 1986): 235–37. Thurston defends his views in a rejoinder to Conquest, "On Desk-Bound Parochialism, Commonsense Perspectives, and Lousy Evidence: A Reply to Robert Conquest," in the same issue, 238–44. See also J. Arch Getty, *Origins of the Great Purges: The Soviet Communist Party Reconsidered, 1933–1938* (Cambridge: Cambridge University Press, 1985). Getty interprets the purges as a phenomenon that cannot simply be explained by Stalin's personality.

63 In his 1926 essay "Our Book," Lissitzky envisioned the book as a mediating device between the individual and the world. "By reading our children are already acquiring a new plastic language; they are growing up with a different relationship to the world and to space, to shape and to colour; they will surely also create another book. We, however are satisfied if in our book the lyric and epic evolution of our times is given shape." El Lissitzky, "Our Book," in Lissitzky-Küppers, *El Lissitzky: Life, Letters, Texts*, 363.

64 *USSR in Construction*, no. 5 (1935), "The 15th Anniversary of the Azerbaijan Oil Industry"; nos. 4–5 (1936), "Dedicated to the 15th Anniversary of Soviet Georgia"; no. 10 (1936), "Kabardino-Balkarian Autonomous Region"; and no. 3 (1937), "The People of the Orjonikidze Territory (Northern Caucasus)."

65 Robert C. Tucker discusses Stalin's attempts to rewrite Marxist philosophy and Soviet history as a means to create a significant place for himself in both disciplines, in "The Rise of Stalin's Personality Cult," 347–66.

66 For a discussion of how Stalin sought to create a mythic image to secure his authority, see Graeme Gill, "Political Myth and Stalin's Quest for Authority in the Party," in *Authority, Power, and Policy in the USSR*, ed. Rigby, Brown, and Reddaway, 98–117.

FIGURE 5.18
Lissitzky *USSR in Construction*, nos. 4–5, cover, 1936

increasingly ceremonial in its portrayal of historical and contemporary events. He paid considerable attention to the ways that scale, sequence, and the placement of images on a page transmitted political messages and created a visual protocol in which the graphic decisions that were often made in the West on a formalist basis became meaningful as signifiers of a political stance. He moved from his early narrative style, derived from avant-garde experiments, to a grander style I will call "epic narrative." This new style was characterized by its historical sweep and the way it held together large amounts of visual information—notably photographs, photomontages, drawings, paintings, and maps in a coherent framework. It was also marked by visual devices such as heraldic emblems, banners, and other regalia which gave dignity or nobility to the theme. This style was characterized as well by a sense of visual flow that could convey the diversity of a region while featuring singular iconic images and events as metaphors that characterized it.[67]

Lissitzky's most frequent collaborator on *USSR in Construction* was the photographer Max Alpert with whom he had worked closely on a number of issues since his first project on the Dnieper hydroelectric station and dam. For the issue on the fifteenth anniversary of Soviet Georgia, which received special attention because Georgia was Stalin's birthplace, Lissitzky and Alpert shared the planning. Alpert then took most of the photographs, which were combined with archival material, while Lissitzky created the photomontages and did the layout.[68]

The issue exemplifies Lissitzky's full-blown epic narrative style. For the cover, printed in red and brown, Lissitzky superimposed a seal of the Georgian Republic on close-ups of Soviet banners. As a tribute to Lenin's place in Soviet history,

67 The issue of discontinuity between Lissitzky's avant-garde work and his projects under Stalin is raised by Yves-Alain Bois in his review essay, "El Lissitzky: Radical Reversibility," *Art in America* 76, no. 4 (April 1988): 161–81. Bois identifies three Lissitzkys (L1–L3), the third being the Stalinist one. He claims that during the Stalinist period Lissitzky "attempted to turn art into a mere tool, that is, into a non-critical artifact, serving the established power" (175). Bois's lack of appreciation for Lissitzky's expertise in creating a new narrative style comes from his assumption that the conditions of making art, rather than design, are those by which the quality of Lissitzky's work should be judged as well as from the belief that the quality of art is determined by the political ends it serves.

68 Lissitzky-Küppers, *El Lissitzky: Life, Letters, Texts*, 98.
69 *USSR in Construction*, nos. 4–5 (1936), n.p.

a small medal with Lenin's head on it rests on the seal, which was photographed from an angle that enlarged its scale (**FIGURE 5.18**). But Lenin's image is dwarfed by the seal which functions as a personification of Stalin. On the inside cover Lissitzky presented the seal again to establish a visual identity for the issue. Framed in an architectonic structure, it was printed in four colors, the first time that the magazine employed four-color printing for flat art work. Flanking it is the opening page which contains two flaps, one with a letter to the leading Georgian officials from Stalin and Molotov printed in the language of the foreign edition, and the other with the letter in Georgian script. Above the left column is a red banner with the Lenin medal from the front cover on it. Over the Georgian text is an ocher banner with the Roman numerals for "15," along with several Georgian letters, denoting the fifteenth anniversary of the republic.

The two flaps can then be opened like theater curtains to reveal a huge photomontage of a Georgian youth superimposed on a painting of angry people on the march, most likely rising up against the tsar (**FIGURE 5.19**). The narrative movement from the seal of the Georgian republic to the Stalin-Molotov message and then to the image of a Georgian youth is reinforced by the text which is the youth's response to Stalin's message:

> Our own dear comrade Stalin! On this festival of the people, this 15th anniversary of Soviet Georgia, we turn to you, great leader, wise teacher, friend of the toilers of the whole world, with joyous sincere feelings of boundless love and devotion.[69]

After this dramatic introduction is a long sequence of photographs that recounts

FIGURE 5.19
Lissitzky Georgian youth, *USSR in Construction*, nos. 4–5, 1936

Georgia's history, frequently intertwining it with images of Stalin's birthplace, tipped in paintings of Stalin engaged in heroic acts as a youth, and pictorial accounts of present-day Georgia. To contain this mass of visual information, Lissitzky created an architectonic structure for each spread with columns, arches, beams, and other architectural motifs serving as frames and borders for the images which were reproduced in either sepia or green tones. After taking the reader through fifteen years of Georgian history, conveyed in a myriad of photographs, Lissitzky returned to the ceremony of the opening section with a closing photomontage covered by two triangular flaps that must be opened to see the full display (**FIGURE 5.20a**). On each flap he placed a photograph of a young herald blowing a trumpet, thus announcing to the reader the final epiphany, a photomontage that combines large scale images of Georgian athletes with crowded rows of many marching figures stacked one on another (**FIGURE 5.20b**). Beneath the photomontage is a caption that concludes with the following words:

> The Georgian soil sings and the mills and factories shout: "May the great leader and friend of the peoples long be spared for the joy of the world."[70]

One can only speculate that such hyperbolic rhetoric may have been encouraged by the Editorial Board as a gesture to flatter Stalin and protect themselves from arrest.[71] In the Georgian issue, Lissitzky began to articulate the rhetorical style

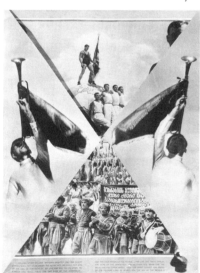

Figures 5.20a (closed) and **20b** (open). **Lissitzky** "Column after column marches mightily on," *USSR in Construction*, nos. 4–5, 1936

70 Ibid., n.p.

71 Sophie Lissitzky-Küppers notes that the Georgian issue was presented to the Central Committee of the Politburo in a specially designed case, and the Lissitzkys received high awards for it. See Lissitzky-Küppers, *El Lissitzky: Life, Letters, Texts*, 98.

72 *USSR in Construction*, nos. 9–12 (1937), "The Stalin Constitution."

of epic narrative that both suited the ceremonial response which Stalin now demanded from the nation and in fact imposed that response on the magazine's readers abroad.

Lissitzky's album on the Stalin Constitution, published as the equivalent of four issues in late 1937, was his most ambitious project for *USSR in Construction*.[72] Representing the zenith of his epic narrative style, the album combined archival materials with documentary photos, drawings, charts, and graphs. Lissitzky was quite ill at the time he worked on the issue and Sophie describes her role as "assembling material and doing all the running around which had now become impossible for Lissitzky in his invalid condition."[73]

The cover established the theme of national unity by featuring a plaster seal that represented all the republics of the USSR. For the introductory photomontage on the title page, Lissitzky placed Vera Mukhina's iconic sculpture, *Worker and Collective Farm Girl*, atop a globe on which the Soviet Union is outlined in red. A red flag was also planted at the center of the North Pole (**FIGURE 5.21**).[74] Both the flag and the sculpture's location above the globe convey a sense of national triumph, while the sky behind the sculpture, a frequent image in the magazine's photomontages, signifies infinite possibilities for the Soviet Union. The opening photomontage establishes a rhetorical frame for the issue whose intent is to extol the superiority of life in the Soviet Union as exemplified by the new Constitution.

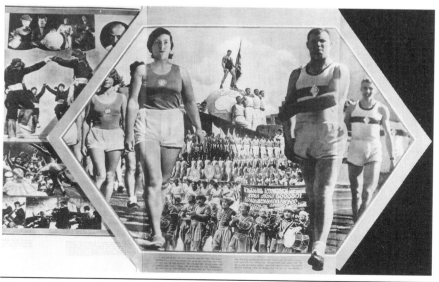

73 Lissitzky-Küppers, *El Lissitzky: Life, Letters, Texts*, 100. From about 1934 Lissitzky was frequently ill and had to depend a great deal on others, particularly his wife who gathered material for him and attended to many of the details of his projects.

74 *Worker and Collective Farm Girl* was originally designed to stand atop Boris Iofan's Soviet pavilion at the 1937 World's Fair in Paris. It was a symbol of forward movement that confronted the huge eagle on Albert Speer's German pavilion across from it. Mukhina's huge stainless steel sculpture also served as an emblem for the Soviet Union which the 1936 constitution defined as "a state of workers and peasants." Thus it had particular resonance in the Stalin Constitution issue of *USSR in Construction*.

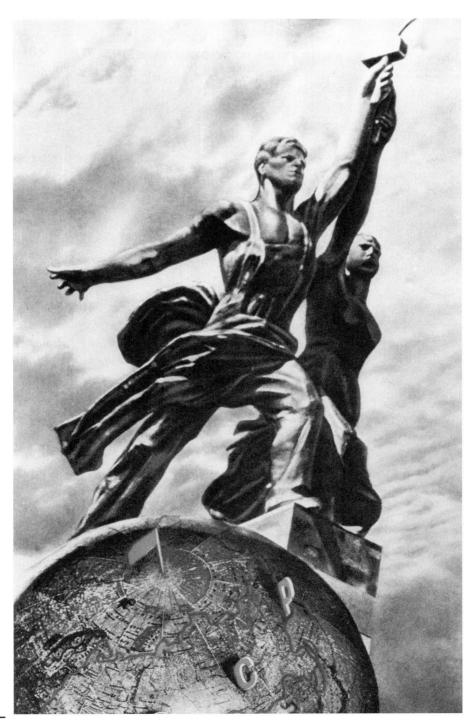

FIGURE 5.21
El and Sophie Lissitzky *Worker and Collective Farm Girl,*
USSR in Construction, nos. 9–12, 1937

Following the photomontage is a sequence of pages that contrast the evils of tsarism with the virtues of scientific socialism. This sequence leads into a spread that celebrates the Bolshevik triumph in the Civil War. The pages in this spread can then be folded out to become a huge four-sheet photomontage poster. Incorporating images of Stalin along with a peasant and a worker, the poster dramatically introduces the first article of the Constitution, "The Union of Soviet Socialist Republics is a socialist state of workers and peasants." The poster image prepares the reader for the following spread which features photographs of the meeting where the Constitution was ratified. The photos are flanked by an effusive text which narrates a mythic account of how Stalin presented the Constitution to the Eighth Congress of Soviets. Stalin tells those in the assembly hall and throughout the nation listening on the radio that the Constitution "is the justest, the wisest and the most humane of laws in the history of man."[75] Lissitzky then presents several spreads with statistics on national resources which he visualizes with small maps, photographs, and numerical data. Above these are photographs of mines, timberlands, factories, farmlands, railroads, and riverways flanked by full-size images of Soviet workers. He locates the photographs above the information graphics to emphasize the extent and character of Soviet achievements. In particular, the images of workers reinforce a point made consistently in *USSR in Construction* that the Soviet Union was being built up by heroic laborers who gave their all for their country.

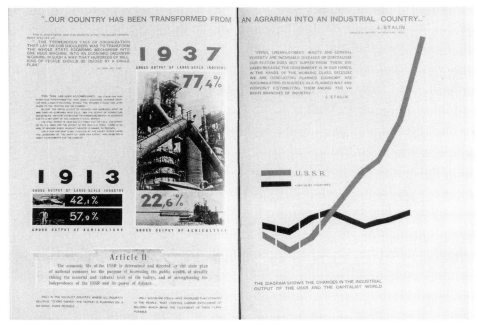

FIGURE 5.22
El and Sophie Lissitzky "Our country has been transformed from an agrarian into an industrial country," *USSR in Construction*, nos. 9–12, 1937

75 *USSR in Construction*, nos. 9–12 (1937), n.p.

The intention of the issue was to celebrate the superior character of the Soviet Union through a presentation of the Constitution, while also documenting the nation's achievements with detailed statistics. Lissitzky recognized both of these aims and combined graphic styles appropriate to each. For example, he designed a spread that includes charts demonstrating the shift from agricultural to industrial production as well as a full-page graph that uses thick bars to compare the industrial output of the Soviet Union with that of the capitalist world (**FIGURE 5.22**). He gives this chart an emotional value as well by using red for the Soviet Union and black for the capitalists and making the lines thick enough so that they assume qualities of character (the red line moves dramatically upward and the black one fluctuates only slightly) instead of simply denoting statistical trends. The photographs he incorporated into the charts on this page were also printed in a plain gray rather than a more emotional sepia or blue as were other photographs in the issue. And yet this factual spread is followed by a sentimental one that celebrates the citizens of the Soviet Union whose photographs are combined in a montage surrounded by a beribboned wreath of leaves and berries, a clear example of the epic narrative style (**FIGURE 5.23**). In the next section, where Lissitzky introduced the eleven republics of the Soviet Union, he established a consistent format that combined rational and emotional techniques. On the first verso page of each spread is a tipped-in color photograph of the repub-

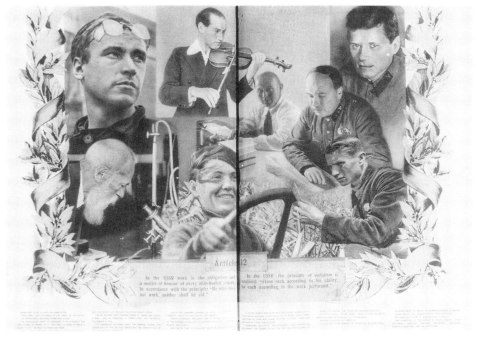

FIGURE 5.23
El and Sophie Lissitzky "Article 12," *USSR in Construction*, nos. 9–12, 1937

76 Ibid.
77 Donald Treadgold emphasizes this locus of power in the Communist party, which sharply differentiates the Stalin Constitution from those of the Western "bourgeois democracies" on which is was partially modeled.

lic's seal placed on a background with some folk object such as a woven carpet. On the recto page is a photomontage with a map of the republic surrounded by the smiling faces of its inhabitants. After turning the right-hand page, the reader is then confronted with a huge two-page photomontage that characterizes the region with an accompanying text explaining what has been accomplished there.

Within the magazine's rhetorical protocol, sequential position and scale denoted relative importance. For example, Lissitzky signified the Russian Republic's dominance in the nation by placing it first in the sequence of republics and adding to it an extra two-page photomontage. After the lengthy exposition of the eleven republics he placed a huge photomontage that features Stalin introducing the Constitution, flanked on the left by a red bar with a section of his speech reversed out in white. Stalin states,

> For the peoples of the USSR it [the Constitution] is significant as the summary of their struggles, the summary of their victories on the front of the emancipation of mankind.[76]

This image and quote thus incorporate the preceding section, enfolding the full array of life in the republics within the magnitude of Stalin's vision. The narrative concludes with two spreads that locate the nation's political power in the Communist party and the military.[77] The first spread, illustrating Article 126 of the Constitution, which asserts that the party is the "vanguard of the toilers

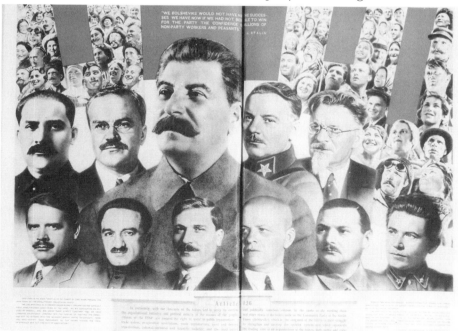

FIGURE 5.24
Sophie Lissitzky "Article 126," *USSR in Construction*, nos. 9–12, 1937

He further stresses that the freedoms granted to Soviet citizens existed only for those who wanted to strengthen the system and not for those who wanted to weaken it. See Treadgold, *Twentieth Century Russia*, 6th ed., 263–66.

in their struggle to strengthen and develop the socialist system," includes mid-sized photographs of high-ranking party members with a considerably larger photograph of Stalin in the center of the group (**FIGURE 5.24**). Above them are two sections that incorporate montages of much smaller smiling faces of the masses. Behind Stalin's head is a red banner with the quote:

> We Bolsheviks would not have the successes we have now if we had not been able to win for the Party the confidence of millions of non-Party workers and peasants.[78]

In this carefully arranged photomontage, Stalin dominates the group by virtue of his central placement and the larger scale of his image, while the faces of the multifarious ethnic groups that make up the Soviet Union are only seen by contrast in the montages where they are crowded together as anonymous masses.

The issue culminates with the theme that the Soviet Union's children and youth will carry into the future the nation's virtues, which are embodied in the Constitution. To depict this theme, Lissitzky created a sepia photomontage of smiling young mothers with children on their shoulders, athletes parading with banners, and children holding up bunches of flowers, all surrounding the state seal above which are the words, "Stalinist constitution, happy Soviet people" (**FIGURE 5.25**). He placed the photograph of the plaster seal from the front cover at the center of the photomontage to reprise the theme of national unity and harmony, only now the reader has been led to see how splendid and just is the nation which the seal represents. The narrative thus ends in an apotheosis of happiness and national glorification.

Given the fact that this album was published at the height of the purges and was intended to deflect attention from them abroad, it raises a number of issues. First, it is superbly designed and rests as one of the outstanding graphics projects of the Stalin period. As the narrative shifts thematically, so do Lissitzky's layouts, which move from highly emotional adulation of Stalin to sober presentations of industrial statistics.

We can only speculate on how the Constitution issue relates to Lissitzky's own political views at this time. Beginning in 1936, the masthead of *USSR in Construction* began to change as active members of the editorial board were taken off and were then replaced by new names. As a frequent collaborator on the magazine, Lissitzky would have most likely noted these changes and understood their meaning in terms of the purges. He would also have heard about other friends and colleagues who had disappeared by this time and who continued to disappear.[79] Lissitzky might well have been in danger himself had he not been so heavily involved in state projects; not only *USSR in Construction* but also various books, the planning of the main pavilion for the All-Soviet Agricultural Exhibition, and the design of a restaurant for the Soviet pavilion at the 1939 World's Fair in New York.

78 *USSR in Construction*, nos. 9–12 (1937), n.p.
79 Among the avant-garde artists and critics who were killed in the purges were Nikolai Chuzhak, Alexei Gan, Boris Kushner, Gustav Klutsis, and Vsevolod Meyerhold.

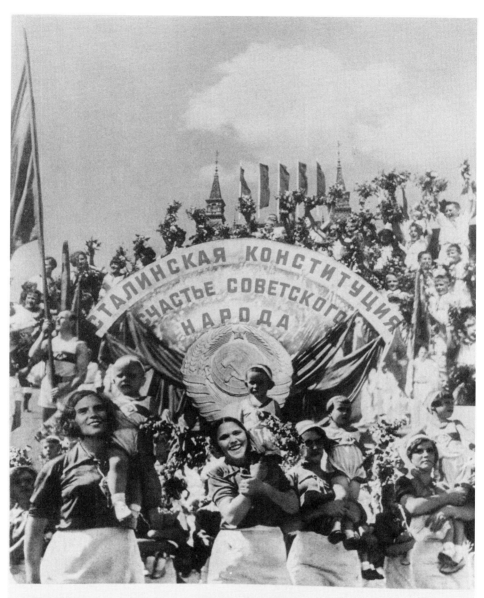

"TODAY, WHEN THE TURBID WAVE OF FASCISM IS BESPATTERING THE SOCIALIST
MOVEMENT OF THE WORKING CLASS AND BESMIRCHING THE DEMOCRATIC STRIVINGS
OF THE BEST PEOPLE IN THE CIVILIZED WORLD, THE NEW CONSTITUTION OF THE USSR
WILL BE AN INDICTMENT AGAINST FASCISM, DECLARING THAT SOCIALISM AND DEMOCRACY
ARE INVINCIBLE. THE NEW CONSTITUTION OF THE USSR WILL SERVE AS MORAL ASSISTANCE
AND REAL SUPPORT TO ALL THOSE WHO ARE TODAY FIGHTING FASCIST BARBARISM."

J. STALIN
ON THE DRAFT CONSTITUTION OF THE USSR

FIGURE 5.25
El and Sophie Lissitzky "Stalinist constitution, happy Soviet people,"
USSR in Construction, nos. 9–12, 1937

6

More than Rodchenko, Lissitzky adapted his talents to the regime's rhetorical needs and invented an arresting narrative style. Ever attentive to the emotional nuances of epic narrative, as well as the communicative possibilities inherent in color, scale, arrangement, and typographic distinctions, he became the most successful designer to work for *USSR in Construction*. In a special issue on the Far Eastern Territory, Lissitzky, assisted by his wife, subordinated the more stately elements of epic narrative, notably the ceremonial depiction of national symbols and the celebration of Stalin, to the story of how the taiga or native forestland of the region was transformed into a site of productive industry and agriculture. In this issue he introduced national defense as an important theme, and the issue was published at a moment when the Soviet Union was working hard abroad to organize the Popular Front against Fascism. Thus an account of the Far Eastern Territory became cause to portray the defensive strength of the army stationed in that region under the command of Marshall Bluecher.

Subsequent to this project, Lissitzky designed an issue devoted to the Western Ukraine and Western Byelorussia. Here the intent was the opposite of the Far Eastern one.[80] Instead of promoting the Soviet Union's defensive posture, this issue justified its recent occupation of eastern Poland.[81] Lissitzky thus had to work with a narrative that recounted how the Poles welcomed the Russians and willingly voted to support the occupation. His layout portrayed the territory under Polish rule as a site of poverty and oppression, which was followed by photographs that showed how life improved once the Soviets took over. The issue closes with a quote in large letters from Viacheslav Molotov, who was in charge of foreign affairs, stating that the occupation was one of the most notable Soviet foreign policy successes of recent times.

> We may reckon this as one of our most glorious achievements, one of which the Soviet Union, true to the principles of its peaceable foreign policy and proletarian internationalism, may be justly proud.[82]

The issue's narrative was based on a blatant revision of history that interpreted the occupation as an advantageous event for the Poles. In this instance, the conflict between the optimistic depiction of the occupation and what happened is severe. It is particularly evident on the cover, a mixture of photography and drawing that constructs an image of a Ukrainian or Byelorussian peasant embracing and kissing a Red Army soldier who has come to liberate him from Polish oppression (**FIGURE 5.26**). The issue on the Western Ukraine and Byelorussia implicated Lissitzky directly in the occupation as a participant in its reinterpretation to the public abroad and at home. Whether he could have refused the work on grounds that he had other projects or whether, indeed, he even felt conflicted about the occupation and its representation is not known. We can only note the degree to

80 *USSR in Construction*, nos. 2–3 (1940), "Western Ukraine and Western Byelorussia."

81 The scope of the occupation was based on protocols worked out with the Germans to divide Poland. One public justification for the Russian entry into Poland was to protect the Ukrainians and Byelorussians living there, hence the issue theme title which renames the territory as "Western Ukraine and Western Byelorussia."

FIGURE 5.26
Lissitzky *USSR in Construction*, nos. 2–3, cover, 1940

which the narrative involves Lissitzky in the official representation of the event.

Unlike Lissitzky, Rodchenko and Stepanova made little contribution to the development of an epic narrative style in the later issues they designed. With the exception of an issue in 1940 to commemorate the tenth anniversary of the poet Vladimir Mayakovsky's death, which helped to confirm for the poet a position of favor in the Stalinist pantheon, most of their work was of modest visual interest.[83] They usually had to contend with material that was imposed on them such as the flowery folk art by a collective farm woman that filled the front and back inside covers of the issue on Kiev (**FIGURE 5.27**) as well as the tipped-in color photograph of a tapestry whose central image was a portrait of Stalin. In the issue they designed on the Election of the Supreme Soviet, which described the event, particularly the election of Stalin, as a free choice of the people, the dissimilarity between the representation of a purported free election and the control the party exercised over its outcome was increased by the photographs of roses that bedecked some of the layouts, particularly the spread featuring a portrait of Stalin looking off into the distance along side an effusive paean to him by the poet Victor Gusev (**FIGURE 5.28**) that ended with the lines:

> The million voices blend, naming their first candidate Stalin, leader, friend.[84]

82 *USSR in Construction*, nos. 2–3 (1940), "Western Ukraine and Western Byelorussia."
83 Ibid., no. 7 (1940), "Vladimir Mayakovsky."
84 Ibid., no. 4 (1938), n.p.

Stalin is also a pivotal figure in the Mayakovsky issue, which was a mixed bless-ing for Rodchenko, Stepanova, and one of the writers Victor Pertsov, who later published a major three-volume biography of the poet.[85] Essentially, Mayakovsky was reconstructed as a patriotic figure who was intensely loyal to the state. This differed from the facts of his life. Although the poet had been devoted to the Bolshevik cause, he also valued artistic independence highly. Mayakovsky was considerably distressed by the attacks on the avant-garde from the proletarian writers groups of the late 1920s, a situation that may have contributed to his suicide in 1930.

USSR in Construction praised Mayakovsky as an ambassador of Soviet poetry abroad, a supporter of the state trusts through his advertising slogans, a contribu-tor to the daily press, an inspiration to the Red Army, and a role model for Soviet youth. We see him first standing in front of a panoramic view of Moscow (**FIG-URE 5.29**). The caption states:

> Read it. Envy Me. I am a Citizen of the Soviet Union, the Socialist State.[86]

The photograph is one of the initial portraits that Rodchenko made of Mayakovsky in 1924 (**FIGURE 4.3** in the previous chapter) but was extensively retouched for

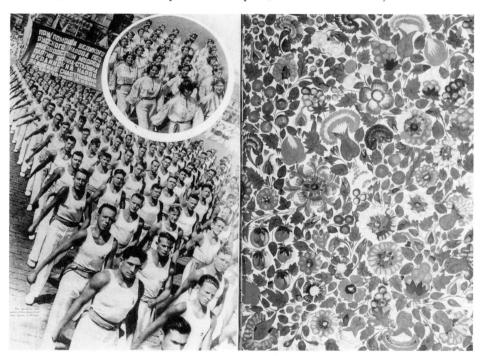

FIGURE 5.27
Rodchenko and Stepanova *USSR in Construction*, nos. 11–12, 1938

85 Pertsov was a critic who devoted most of his attention to literature, but he wrote on art as well and was one of the few critics in the early Constructivist years to argue for the separation of art and industry. During the 1920s, he worked for the People's Commissariat of Enlightenment in the Ukraine, the Central Institute

this page.[87] Mayakovsky stands, legs spread apart, before a panoramic view of Moscow. He has an oversized passport in his hands rather than the sheaf of notes he held in the original photograph.

The strongest spread in the issue is related to the Mayakovsky Museum. Rodchenko and Stepanova illustrated it with a head shot of Mayakovsky, one of Rodchenko's images from 1924, which was paired with a photograph of a writing pen on the opposite page (**FIGURE 5.30**). In this spread, the designers established a visual resistance to the writers' construction of Mayakovsky as a loyal citizen of the state. Both Mayakovsky and Rodchenko were fighters for a new culture, and Rodchenko conveyed the strength of this effort in his powerful portrait, which reveals a quality of independence and defiance in Mayakovsky's character. This belies the issue's prose which made the poet out to be an artist who unquestioningly placed his art in the service of the nation's political goals. A small moment of resistance such as this is particularly poignant, since Rodchenko was obliged to remain silent in the issue about his own friendship with Mayakovsky. In fact, the editors used several of Rodchenko's photographs and poster designs in the issue without giving him credit for them. While Rodchenko and Stepanova created a visual subtext to portray Mayakovsky's

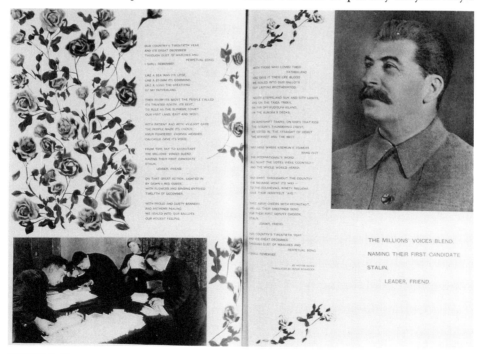

FIGURE 5.28
Rodchenko and Stepanova "Our country's twentieth year," *USSR in Construction*, no. 4, 1938

of Labor, and Proletkult.
86 *USSR in Construction*, no. 7 (1940), n.p.
87 Rodchenko's other photographs of Mayakovsky in the issue, also from 1924, were used without alteration.

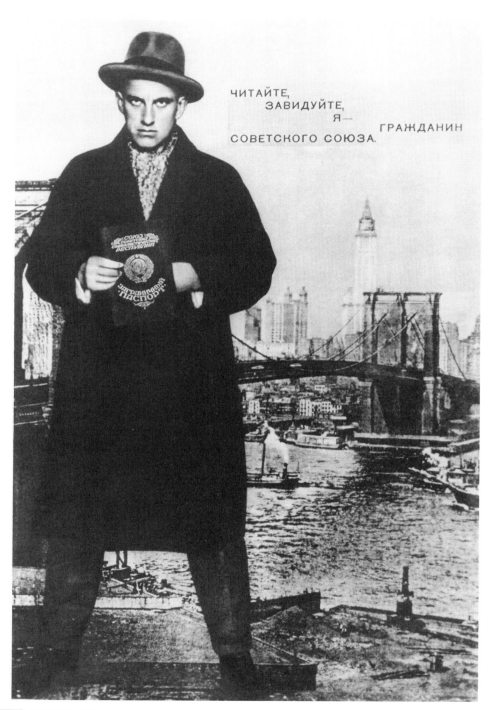

ЧИТАЙТЕ,
ЗАВИДУЙТЕ,
Я— ГРАЖДАНИН
СОВЕТСКОГО СОЮЗА.

FIGURE 5.29
Rodchenko and Stepanova "Read it. Envy me,"
USSR in Construction, no. 7, 1940

strength of character, they were unable to say anything about Rodchenko's own relation to the poet, which would have emphasized his own role as an avant-garde artist and would have countered the portrait of Mayakovsky that the editors wished to convey. Thus the Mayakovsky issue was both a victory and a defeat for Rodchenko, a victory in that it helped assure Mayakovsky a place in the nation's literary pantheon even with a made-over image, and a defeat in that Rodchenko had to write himself out of the history he had shared so closely with his comrade.

7

In mid-1941 *USSR in Construction* ceased publication. For almost twelve years the magazine was the Soviet Union's most extensive visual record of everyday life. It presented a view of Soviet society intended to sustain the beliefs of fellow travelers and sympathizers abroad that the Soviet Union was a paradise in the making. The editors expanded its themes from a focus on industrial and agricultural projects to the promulgation of a total way of life that resulted from the beneficence of Stalin. Soviet citizens were portrayed as being capable of Herculean tasks in the factories as well as on the farms. They always expressed immense joy in being part of a heroic social experiment that vastly exceeded the hopes and capabilities of all other nations of the world. For Stalin and the Soviet bureaucracy human happiness was inextricably bound up

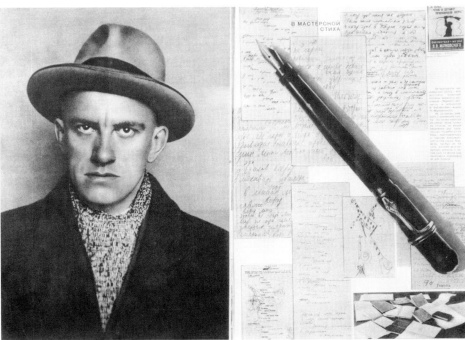

FIGURE 5.30
Rodchenko and Stepanova *USSR in Construction*, no. 7, 1940

with the ambitious material achievements of the Five-Year Plans. Those whose own projects did not fit into the plans were considered wreckers or obstructionists and suffered severe consequences.

We know little about how Lissitzky, Sophie, Rodchenko, and Stepanova considered their work on *USSR in Construction* or their place in Soviet society under Stalin. Both Lissitzky and Rodchenko had a complex relationship to the state that involved their disillusion with Western values and their hope to find fulfillment within a new Soviet culture. Lissitzky showed his willingness to undertake any commission given to him; in fact, he became the Soviet Union's most knowledgeable designer of publications and exhibits during the 1930s. Rodchenko did not engage as actively in state projects as Lissitzky did. Whereas Lissitzky actually defined the practice of graphic and exhibition design in the 1930s, Rodchenko was marginalized by his primary creative community, photography, despite the fact that his work of the 1920s profoundly influenced work by other photographers who gained recognition in the Stalin years.

The principal function of *USSR in Construction* was to celebrate the accomplishments of the regime in order to gain adherents abroad. But the disparity between reality and its representation in the magazine was often extreme. Since this disparity varied from one issue to the next, however, we cannot characterize the relationship of Lissitzky and Rodchenko to the magazine in a singular or simplistic way. Rather, we can note the complexity of this relationship, particularly as it may be understood from their situation at the time. Looking at the varied projects that Rodchenko and Lissitzky did for *USSR in Construction*, we can find both fulfillment and disillusion: fulfillment in the sense that a number of the themes they addressed such as the construction of the Dnieper hydroelectric station and dam, the exploration of the Arctic, the accomplishments of Soviet parachutists, the exploitation of natural resources like coal and gold, and a strong national defense posture were vital to the Soviet Union's economic development and to strengthening its political position in the international community; disillusion owing to the fact that, by the later 1930s, even the promulgation of legitimate accomplishments had become embedded in a mythic representation of the state that masked the perpetration of cruel and shameful deeds. Lissitzky and Rodchenko were caught in this contradiction of national development and ruthless politics just as was *USSR in Construction* itself. The magazine's positive vision of Soviet life in the late 1930s helped the Soviet Union to gain credibility as a participant in the Popular Front against Fascism while contradictorily attempting to deter world opinion from condemning the regime for mass murder and overall gross internal violations of human rights.

Knowledge of the purges, as it must have come to Lissitzky and Rodchenko through the disappearance of friends and colleagues, could only have been

painful and possibly fear-inducing. Having committed themselves to the Soviet state, unlike those artists who left the country in the early years after the Revolution, they would surely have wanted the Five-Year Plans to succeed. But the recognition that they were increasingly engaged as artists in a myth-making enterprise whose departure from actual events became extreme could only have been saddening. Lissitzky's last commissions took a more positive turn, however. They were for three posters to abet the Soviet war effort, of which only one, "Produce More Tanks," was printed. Lissitzky died of physical illness on December 21, 1941. Rodchenko lived fifteen years longer than Lissitzky, until December 3, 1956, when he passed away. Around 1940 he shifted his activity from graphic design and photography back to painting and drawing, although he produced no works of major import in his later years.

One regrets the inability of the former Soviet Union to become a viable model of economic and social organization that could have fulfilled the hopes and expectations of Lissitzky, Rodchenko, and others of the Russian avant-garde. It is not hard to imagine their ambivalence about the Stalin regime, however, as they noted the increasing disparity between their artistic practice and the events of daily life. In the face of imminent danger, Lissitzky's and Rodchenko's struggle for utopia became instead a striving for survival, and modest acts of resistance in an imperfect world became an acceptable end. And that can be read more usefully as failed hope rather than tragedy.

If the Chicago Bauhaus can adapt itself, without adulterating its own spirit, to the peculiar needs and conditions of the American scene, it will be a success. Otherwise it will be just another valiant attempt to create light where there was darkness, beauty where there was only profit.

E. M. Benson (1938)[1]

Visionaries may dream of Utopia, but it will be built by men whose estimates of subjective values is constantly corrected by experience with tangible realities.

Walter Dorwin Teague (1940)[2]

The duty of the educator is to uncover the forces which form society so that the individual, equipped with the knowledge of the processes, may form his own opinion and make a decision about his position in the world.

László Moholy-Nagy (1947)[3]

This, the final chapter, is set in Chicago where Moholy-Nagy arrived in 1937 to direct a new school of design. While Lissitzky and Rodchenko had to operate within a Soviet regime that became increasingly hostile and even threatening to their early avant-garde positions and values, Moholy-Nagy did not have to confront the personality of a dangerous and unpredictable leader like Stalin as they did. Nonetheless, he had to work with a group of capitalist businessmen whose values, for the most part, did not fully accord with his own and who expected him, as a design educator, to respond to their concern for improving the design and marketing of American products. The shift of Moholy's struggle for utopia from Europe to America produced some of the same tensions between artistic vision and political expediency that Lissitzky and Rodchenko faced in the Soviet Union, though the stakes for Moholy-Nagy were nowhere near as high as they were for his Soviet colleagues.

1 E.M. Benson, "Chicago Bauhaus," *American Magazine of Art* 31, no. 2 (February 1938): 83.

2 Walter Dorwin Teague, *Design This Day: The Technique of Order in the Mechanical Age* (New York: Harcourt, Brace, 1940), 37–38.

3 László Moholy-Nagy, *Vision in Motion* (Chicago: Paul Theobald, 1947), 354.

With Walter Gropius, Marcel Breuer, and Herbert Bayer, Moholy had resigned from his teaching position at the Bauhaus in 1928 and gone to Berlin where he worked as a freelance designer. In 1934 he was a consultant to a printing firm in the Netherlands, and in 1935 he emigrated to London. There he again became a freelance designer and photographer until 1937, when he was called to Chicago by the Association of Arts and Industries to head a new design school based on the Bauhaus model.[4] The New Bauhaus: American School of Design closed after one year because the association withdrew its support. A second school, which Moholy-Nagy founded himself, the School of Design, survived until 1944 before being reorganized and renamed the Institute of Design.[5] The political and fiscal difficulties Moholy-Nagy faced in keeping his schools afloat form the backdrop for this chapter's theme, which is how he tried to reconcile his vision of a holistic and humanistic European art and design education with the pragmatic expectations of the American businessmen on whose support he depended. Although the businessmen's expectations were not uniform, underlying them was the general anticipation that Moholy-Nagy would show design students how to enhance the product quality and competitive advantage of industries in the American midwest by instilling in them a new kind of knowledge.

Because Moholy-Nagy believed that education should first and foremost be a transformative experience for the student, he resisted vocational training as his schools' primary goal and held human development to be his ultimate concern. This made his educational enterprises particularly controversial. Though many students and teachers at the New Bauhaus, the School of Design and the Institute of Design found Moholy-Nagy's broad philosophical approach to art and design education personally liberating, few of them became active industrial designers.[6] Moholy-Nagy's feelings about industry were, in fact, ambiguous. In his last book, *Vision in Motion*, which was completed in 1945 but not published until 1947 after his death, he referred to "the ruthless competitive system of capitalism,"[7] and warned of "the hazards of a planlessly expanding industry which, by the blind dynamics of competition and profit, automatically leads to conflicts on a world scale."[8] As an antidote, he speculated on the possibilities of a "planned cooperative economy."[9]

4 For an account of Moholy-Nagy's emigration from Germany to England, see Krisztina Passuth, *Moholy-Nagy* (London: Thames and Hudson, 1985), 61–65.

5 The definitive work on the three schools is that of Alain Findeli, *Du Bauhaus à Chicago: Les années d'enseignement de László Moholy-Nagy*, 2 vols. (Ph.D. dissertation, Université de Paris VIII, 1989). See also the catalog of a comprehensive exhibition at the Bauhaus Archiv in Berlin, *50 Jahre New Bauhaus: Bauhausnachfolge in Chicago* (Berlin: Bauhaus Archiv and Argon Verlag, 1987); and Terry Suhre, ed., *Moholy-Nagy: A New Vision for Chicago* (Springfield: University of Illinois Press, and Illinois State Museum, 1991). There is also a section on the schools in Hans Wingler, *The Bauhaus: Weimar Dessau Berlin Chicago* (Cambridge, MA: MIT Press, 1969), 577–611. The difficult first year of the New Bauhaus is described in Lloyd Engelbrecht, *The Association of Arts and Industries: Background and Origins of the Bauhaus Movement in Chicago* (Ph.D. dissertation, University of Chicago, 1973), 273–322. For firsthand accounts of life at the New Bauhaus and School of Design, see Richard Koppe, "The New Bauhaus, Chicago," in *Bauhaus and Bauhaus People*, rev. ed., ed. Eckhard Neumann (New York, Van Nostrand, 1993), 258–66; and John E. Walley, "The Influence of the New Bauhaus in Chicago 1938–1943," in *Selected Papers: John E. Walley 1910–1974*, ed. Elinore Pawula (Chicago: Department of Art, University of Illinois at Chicago, 1975), 74–87.

Moholy-Nagy frequently spoke of a dichotomy between business profits and social needs and equated functional design with socialism. Discussing late nineteenth-century design in *Vision in Motion,* he noted that "the rise of socialist doctrines and antiauthoritarian republican tendencies supported a movement toward true, functional design. This had its climax in the years from 1920 to 1930."[10] The subtext of socialist idealism which runs through *Vision in Motion* echoes similar statements in some of his previous writings and recalls his left-wing polemicizing in the early 1920s with Hungarian émigré colleagues, as was discussed in Chapter 2.

Moholy-Nagy's political values did influence the philosophy and curriculum of his schools in Chicago, though not explicitly. While he and his faculty at the New Bauhaus, School of Design, and Institute of Design encouraged students to create products to satisfy social needs, they neither trained the students in research methods to determine these needs nor taught them how to relate the development of new products to the existing system of production. Design for Moholy-Nagy was meant to lead industry, not to follow it. This was a difficult position to maintain because he depended on industrialists to support his school. To solicit financial contributions, he developed programs such as night classes that were intended to appeal to the business community, but he rarely included as faculty or visiting lecturers design practitioners who had established successful professional relations with or within industry.

Moholy-Nagy's belief that designers should lead industry was consistent with the way the Bauhaus operated in Germany when he taught there from 1923 to 1928. Students at the Bauhaus learned to develop prototypes in the school's workshops, and these were then offered to manufacturers. Successful projects completed at the school were generally innovative in terms of form and materials rather than product type or production technique. The concentration was on objects that had traditionally belonged to the crafts or decorative arts such as furniture, lighting, and ceramics. Thus Moholy-Nagy's attitude toward industry was conditioned by a European avant-garde view that considered the designer to be in control of the product. Acknowledging the avant-garde impulse in his design philosophy helps to explain why he was not drawn to the pragmatic management-oriented methods of the American consultant designers as a model for his students, particularly since his Bauhaus experience represented a very different way of relating design to industry than was the case in the United States.

In adopting this position, however, he ignored two important points about the consultants' practice. First, they had made considerable advances in the functional design of many products as well as making changes in their visual forms; and second, they were successful because they recognized the conditions of American industrial production as the starting point for negotiating design

6 A number of students, however, did become design educators.

7 László Moholy-Nagy, *Vision in Motion*, 340.

8 Ibid., 14.

9 Ibid., 22.

10 Ibid., 49.

improvements with their clients.[11] The best known consultants—Walter Dorwin Teague, Norman Bel Geddes, Raymond Loewy, and Henry Dreyfuss—became skilled managers who built effective multidisciplinary design teams comprised of industrial designers, architects, engineers, and artists. It was due to their ability to manage these teams that they could take on such a wide variety of projects that ranged, in Raymond Loewy's phrase, "from a lipstick to a locomotive."

Moholy-Nagy's utopian view of the designer led him to overlook the important multidisciplinary aspect of the consultants' practice and to regard their accomplishments primarily in terms of styling. This was unfortunate because the integration of disciplines which the consultants relied on to maintain the wide scope of their activities was certainly consistent with Moholy-Nagy's argument for a closer relation between art, technology, and science. Because he was neither sufficiently familiar with American industry and its marketing philosophy to fully grasp what the consultants had accomplished nor was he inclined to support their recognition of marketing as an essential aspect of production, he held out for a competing model of practice in which the designer would operate more autonomously in the conception of products. This was a model that had much less chance of acceptance by American industrialists.

The story of Moholy-Nagy's Chicago enterprise is thus a complex one. The Association of Arts and Industries expected him to prepare students for design positions in industry, and he continued to promise this result to the supporters of his successive schools. However, he was personally ambivalent about the values of capitalism and thus did not espouse a form of design education that would specifically address the nature of American industrial culture. Because he operated his schools independently of a larger university structure, he had the leeway to develop a personal vision of design education. But he paid a high price for this through his continual accountability to businessmen who were asked to provide the funds to keep the schools afloat.

As American educators and industrialists struggled with the problem of training designers for industry in the 1920s and 1930s, many considered the Bauhaus in Europe to be a model of how this should be done. Little was known about the Bauhaus in the United States, and thus an elaborate mythology grew up which identified it as a successful experiment in joining art to commerce. The school's closing in 1933 because of Hitler's coming to power in Germany may well have been a factor in the Association of Arts and Industries' eventual consideration of it as a prototype for a new design school in Chicago. The American attraction to the Bauhaus was as much rooted in the potency of its myth as in the fact that no American design school or design department had been able to gain sufficient public recognition to persuade the Chicago industrialists or anyone else that the United States already had a few promising programs that might serve as guideposts for others.

11 On the consultant designers in the 1930s, see Jeffrey L. Meikle, *Twentieth Century Limited: Industrial Design in America, 1925–1939* (Philadelphia: Temple University Press, 1979); and Arthur J. Pulos, *American Design Ethic: A History of Industrial Design to 1940* (Cambridge, MA: MIT Press, 1983), 336–419.

Although in the early 1930s design departments such as those at the Carnegie Institute of Technology and Pratt Institute had begun to develop successful courses to prepare students to design for industry, they did not have a strong cultural image as the Bauhaus did, and therefore they received less recognition as potential models for programs elsewhere. The Bauhaus was known as a school where artists invented new forms for industry, and thus it fit within a perception of cultural modernity that had begun to emerge in the United States by the late 1920s. Central to that perception was the image of an appropriate machine aesthetic for mass-produced goods. Europeans had come to terms with this problem much earlier than Americans, and before 1930 European manufacturers could already show a range of modern products of which Marcel Breuer's or Mies van der Rohe's chromed steel and leather chairs were iconic examples.

Moholy-Nagy's noteworthy accomplishments as an abstract artist and photographer, as well as his association with the Bauhaus as Form Master of the Metal Workshop and teacher in the Foundation Course between 1923 and 1928, identified him as one of the central figures of the European modern movement. His leadership of the New Bauhaus, School of Design, and Institute of Design thus insured these schools a favorable public image. While much was achieved at the three schools, particularly in photography and graphic design, none of them developed significant programs in industrial design. Moholy-Nagy's widespread pronouncements on the future of design and design education received a forum more because of his reputation as an internationally recognized avant-garde artist than on account of the results he produced as a design educator. This is not surprising since his interests were much broader than a single professional specialty. He concerned himself with the development of the whole person. While his curricular orientation to this goal enhanced the artistic production of his students, its impact on education for product design was less effective.

The success of the consultant designers was built on the power of their intuitive responses to opportunities in industry rather than on a developed theory of design. Hence, despite their impressive achievements, Moholy-Nagy did not see them as role models for his students. Instead, he promulgated a social vision which he believed American manufacturers were not yet prepared to fulfill. He thus built his educational philosophy on a faith in human beings to bring about change as they devised their own ways to exercise a heightened perception and deepened social awareness.

2

Moholy-Nagy became active as a design educator in the United States at a time when a number of different groups were attempting to come to terms with the relation of art to industry. These included first and foremost the consultant designers who had devised procedures and methods for working with manu-

facturers to change the appearance and functional design of many industrial products. Besides them were teachers of the mechanical arts who wanted to make the traditional school shop curriculum more relevant to the modern age; there were also the progressive art educators who promoted a closer relation between art and everyday life through the introduction of new curricula in the lower schools that encouraged more individual expression and the relation of artistic sensibilities to practical tasks.[12] Last were the critics who advocated a shift from handicraft production to design for the machine. For all these groups, the development of a new machine aesthetic was a central theme.

The Bauhaus was particularly meaningful to some American design reformers as a model of design education because it was the most visible demonstration of how handicraft training could provide the basis for designing industrial products that were modern both in form *and* in the use of materials. The Bauhaus had a reputation in the United States as a school that had produced modern furniture and lighting, thus it could serve as a beacon for other schools that wanted to come to terms with design for the machine.

By 1922, when the Association of Arts and Industries was founded in Chicago, the Bauhaus was yet to gain recognition as a school of modern design.[13] Given the underdevelopment of American design education at the time, it makes sense that the association would have focused on the establishment of a new school as part of its larger aim of helping industries in the midwest make better use of design to increase their international competitiveness.

Soon after its founding, the association decided to cooperate with the Art Institute of Chicago in developing a School of Industrial Art instead of creating one of its own. Once the Art Institute school was established, however, the association became disenchanted with its program. At the beginning of 1936 it announced to the press a plan to found an independent school.[14] The proclamation of the new school's proposed educational program by Norma K. Stahle, executive director of the association, suggests that she had some familiarity with the curriculum of the Bauhaus, which had closed in 1933. This knowledge may have been garnered through exhibitions, articles in the press, or firsthand accounts.[15] The new school's structure, as Miss Stahle outlined it, was an amalgam of traditional decorative arts curricula, ideas from the mechanical arts movement, and the more comprehensive structure of the Bauhaus itself. As she stated in the proclamation:

12 For discussions of progressive art education in the United States, see Ralph M. Pearson, *The New Art Education* (New York: Harper and Bros., 1941); Frederick M. Logan, *Growth of Art in American Schools* (New York: Harper and Bros., 1955), 152–200; and Arthur D. Elfand, *A History of Art Education: Intellectual and Social Currents in Teaching the Visual Arts* (New York: Teacher's College, Columbia University, 1990), 187–223.

13 The Bauhaus opened in Weimar, Germany, in 1919 but did not have its first public exhibition until 1923. In an essay by Dr. James P. Haney, "Industrial Art Education in Germany," published in Charles R. Richards, *Art in Industry* (1922), note is made of a school of applied arts in Weimar, but the Bauhaus is not mentioned by name.

14 Engelbrecht, *The Association of Arts and Industries*, 214. The author thoroughly documents the long, complex, and ultimately unfruitful involvement of the Association of Arts and Industries with the School of the Art Institute of Chicago.

> Special stress will be laid on woodworking and metal departments, as they cover a wide range of industries, including furniture, electrical products, lighting fixtures, hardware etc. Other departments will include interior architecture and decoration, printing and advertising, and bookbinding. Textiles, pottery and glass departments will be added later.[16]

The lack of attentiveness to commercial practice evident in the association's curriculum proposal is significant. Even though many of its members were industrialists, their vision of design education did not exceed what was currently being done in the American design schools. Compared to these schools, the Bauhaus thus would have appeared to overcome the limitations of handicraft training. But the association's willingness to embrace a European model of design education meant ignoring the more pragmatic American achievements that were already improving product sales.

Although Norma Stahle knew Sheldon and Martha Cheney's 1936 book, *Art and the Machine*, which gave a thorough account of what the consultant designers had accomplished in their collaboration with industry, the book did not persuade her or the association to turn to the consultants for leadership in developing the new school. Conversely neither she nor the association were intimately familiar with what actually had been accomplished at the Bauhaus in relation to industry and thus tended to inflate the school's successes.

Given the association's orientation to a modernized handicraft curriculum, it is understandable that the leadership of its new school would have been offered initially to Walter Gropius, the former director of the Bauhaus who had just begun to teach at Harvard's Graduate School of Design. Although Gropius turned down the offer, he strongly supported the school's direction and recommended Moholy-Nagy to head it. Gropius praised Moholy-Nagy as a comprehensive artist who had extensive experience with industry and advertising as well as with the arts of film, photography, and painting.[17]

In this initial exchange between Gropius and Norma Stahle, we can see how Gropius's cultural imprimatur may have encouraged Moholy-Nagy to define his mission in Chicago more broadly than simply meeting the association's objective to improve the competitiveness of midwestern industries. Therefore,

15 Engelbrecht believes it unlikely that Norma Stahle had a clear idea of the Bauhaus until well into the 1930s. See ibid., 226. He cites a number of lectures and exhibits, however, that brought the Bauhaus to the attention of Chicagoans as early as 1924. Alfonso Ianelli, who had visited the Bauhaus that year, had close ties to the Association of Arts and Industries and may have shared his observations about the school with Miss Stahle. Helmut Von Erffa a former Bauhaus student, lived in Chicago between 1927 and 1929 and made reference to the Bauhaus in at least one of the public lectures on modern art he gave in May 1927. Several metal objects by Bauhaus students Marianne Brandt and Wilhelm Wagenfeld and textile samples by Gunta Stözl were shown in the Third International Exposition of Contemporary Industrial Art at the Art Institute of Chicago in 1931, and the Arts Club hosted a show the same year that included some of the Bauhaus books, as well as photographs of the Bauhaus building. See Engelbrecht, *The Association of Arts and Industries*, 87, 138–39, 153–54.

16 Ibid., 225.

17 Walter Gropius, letter to Norma K. Stahle, May 18, 1937, in Hans M. Wingler, *The Bauhaus: Weimar Dessau Berlin Chicago*, 192.

it should have been no surprise to the association that Moholy-Nagy's initial proposal for a curriculum only partially addressed its ambition to create a successful school of industrial arts. In her letter inviting Moholy-Nagy to head the new school, Miss Stahle noted that it would be "organized along the lines of the best Industrial Art Schools in Europe, with workshop practice."[18] Moholy-Nagy suggested the name "New Bauhaus," adding, at the suggestion of his wife Sibyl, the subtitle "American School of Design."[19]

The association's choice of Moholy-Nagy as director might have been supported by the Cheney assertion in *Art and the Machine* that industrial design students should be supervised by artists, particularly those who had a grounding in abstract art which, they said, had been the source of ideas for the consultant designers. According to this argument, Moholy-Nagy would appear to have been an ideal choice to head the new school since he was one of the artists who created the forms that had influenced American consultant designers.[20]

Moholy arrived in Chicago from London by way of New York in mid-July 1937. He gave his first public address to 800 interested listeners at the Knickerbocker Hotel on September 23, shortly before the New Bauhaus opened. At that time he promised the industrialists in the audience an expansive program of research and production:

> In our workshops we shall provide research possibilities for synthetic fibers, fashion, dying, printing on textiles, wallpaper design, mural painting, the use of varnishes, lacquers, sprays, and color combinations in decorating . . . We shall design stage display, window and shop display, exposition architecture, and all other architectural structures from a prefabricated bungalow to a factory; and we shall work with stone, glass, metal, wood, clay, and all plastics in the product design and the sculpture classes.[21]

Moholy-Nagy also made it clear in his expansive speech that he did not intend to create a vocational school. He outlined an extensive curriculum that included courses in the sciences, humanities, and social sciences to complement the studio experience. To assist with this curriculum, he brought in Charles Morris and two other professors from the University of Chicago as part-time lecturers.[22] Morris was active in the unified science movement and also had been strongly influenced by John Dewey's philosophy of pragmatism. By inviting the University of Chicago professors to join the faculty, he was attempting to

18 Letter from Norma K. Stahle to László Moholy-Nagy, May 29, 1937, quoted in Sibyl Moholy-Nagy, *Moholy-Nagy: Experiment in Totality*, 2d ed. (Cambridge, MA: MIT Press, 1969 [c. 1950]), 139.

19 Ibid., 145.

20 In 1936, Sheldon and Martha Cheney stated that the consultants "acknowledge an indebtedness to Moholy-Nagy and van der Rohe and Lissitzky, though not audibly in the presence of industrialists who are fearful of aesthetic theory and studio talk, and likely to be nervous in the presence of 'pure' art." Sheldon and Martha Cheney, *Art and the Machine* (New York: Whittlesey House, 1936), 38.

21 László Moholy-Nagy, quoted in Sibyl Moholy-Nagy, *Moholy-Nagy: Experiment in Totality*, 150.

22 Moholy-Nagy learned about Morris from Rudolf Carnap, then teaching at the University of Chicago. Carnap had been a central figure among philosophers of Logical Positivism and the unified science movement

redefine the prevalent idea that design value was achieved through a visual sense alone rather than by a broad understanding of contemporary culture, which included science and technology. As Morris noted in a paper written in 1937: "The New Bauhaus is a pioneer in seeing the need for the inclusion of a scientific curriculum in modern art education."[23] To support the school's aim of "uniting in its students the attitudes of the artist, scientist, and technologist," Morris introduced a course in the first-year program entitled "Intellectual Integration," which he created to help the students reflect on "the nature of the integration which the school as a whole is attempting to realize in practice."[24] Morris saw this course as the beginning of an intellectual exploration that held great promise for the New Bauhaus and for the larger culture, asserting,

> A successful Bauhaus would inevitably have a fertilizing influence on the arts and industries; no less important would be its potential influence upon clarifying the function and the teaching of the arts throughout the entire educational system of this country.[25]

This was a far more ambitious goal than Norma Stahle and her colleagues had anticipated. The views of philosophers were unprecedented in American design discourse at the time, and the breadth of Morris's vision soared well beyond the pragmatic concerns of the membership of the Association of Arts and Industries just as it exceeded those of the consultants and stylists.[26]

As prescient as the vision of both Morris and Moholy-Nagy was, it nonetheless remained considerably removed from the contemporary experience of design practice and thus ignored an important opportunity for dialogue with working designers. While Moholy-Nagy's own highly developed cultural background influenced his attraction to the philosophy of Morris, conversely his critical views on corporate marketing strategies and his emphasis on design as a continual process of experimentation made it difficult for him to recognize what the consultant designers, whom he considered to be businessmen, had already done to bring art and technology closer together. Having observed the complexity of industrial production as they worked in a number of different industries, the consultants understood the need for interdisciplinary teams to address the problems their clients gave them. They thus devised strategic methods, which enabled them to operate as managers of projects that incorporated the knowledge of diverse technical specialists. Whereas the consultants invented a strategic methodology for dealing with the complexity of industrial design

in Europe. He lectured at the Dessau Bauhaus when Hannes Meyer was the director there as part of Meyer's program to construct a scientific theory of design. See Peter Galison, "Aufbau/Bauhaus: Logical Positivism and Architectural Modernism," *Critical Inquiry* 16, no. 4 (Summer 1990): 709–52.

23 Charles Morris, "The Intellectual Program of the New Bauhaus," n.p. Institute of Design Collection, Special Collections, University Library, University of Illinois at Chicago. We might also consider the New Bauhaus as moving from the influence of William Morris to that of Charles Morris.

24 Ibid., n.p.

25 Ibid., n.p.

26 Morris taught at the New Bauhaus and then the School of Design until 1941 or thereabouts.

practice, Moholy-Nagy, who had no experience with American industry and only limited involvement with industry in Europe, made the student, rather than the methodology, the focus of his program. Because of this, the intention of integration that both he and Morris espoused had more to do with producing students with a broad general understanding of contemporary currents than it did specifically with training designers who could relate such knowledge to actual design problems in industry. This had contradictory effects. Moholy-Nagy's interest in research and his recognition of the need for a substantial humanistic framework for design teaching was years ahead of its time, although his belief that the experience of current design practice was not necessary for the development of a new pedagogical method was unrealistic.

For his New Bauhaus curriculum, Moholy-Nagy drew heavily on the Bauhaus model in Germany, starting off with a one-year preliminary course followed by three years in a specialized workshop. The preliminary course was intended to stimulate the students' senses and imagination, thus preparing them for a number of different workshops, but its function as an introduction to the practice of industrial design can be questioned. first of all, it suggested that product development was more of a tactile than a conceptual activity. While the students' experience with hand sculptures and tactile charts was an appropriate precedent for many small and midsized objects that were made in the Product Design Workshop, particularly at the School of Design (**FIGURE 6.1**), these activities had their roots in the handicrafts and were much less useful when the design problem was larger and more complex than a vase, a tool handle, or a piece of furniture. Inherent in the way personal expression was encouraged in the foundation course was the belief, also held by the handicraft reformers, that manipulating materials was fundamental to the development of new products.[27]

Moholy-Nagy was also quite specific in his views on how form should be generated.[28] Alain Findeli has called his intuitive philosophy of form "organic func-

FIGURE 6.1
Nolan tumbler, 1941

tionalism" and has related it to the nature philosophy of Goethe as well as biologist Raoul Francé's theory of *biotechnique*, the art of using natural structures as models for human-made artifacts.[29] Design for Moholy-Nagy was the expression of a profound existential philosophy of how men and women situate themselves in the world, and therefore the sources of form and their relation to a product's use were deeply symbolic issues as well as practical ones for him.

When the New Bauhaus opened, Moholy-Nagy was able to work within the aura of expectations that was generated by a faith in the German Bauhaus as an educational model. Hence, initial results from the school tended to be seen within that aura even though the work itself was confusing. For example, an exhibition of student designs from the New Bauhaus which went on public view at the end of the first school year was widely covered by the press. The art critic Clarence J. Bulliet published an extensive account of the exhibition in the *Chicago Daily News,* and other reviews appeared in *Art Digest, London Studio,* and *Time.*[30] Bulliet wrote that "the 'gadgets' exhibited at the [New] Bauhaus have no 'useful' purpose whatsoever," but he cited Moholy-Nagy's explanation that their aim was to develop the students' senses as well as "their intellectual and emotional powers."[31] *Time* noted that the "exhibition of bewildering nameless objects," which "seemed so bizarre," was nonetheless accounted for in such a way as to clarify "the methods by which Moholy-Nagy and his associates hope to revitalize U.S. architecture and U.S. design."[32]

Moholy-Nagy reiterated his promise of new and improved products in an article of November 1938 which he published in a special issue of the Chicago magazine *More Business* on the New Bauhaus. The article appeared three months after the Association of Arts and Industries withdrew its support for the school, although an editor's note stated that the opening of the New Bauhaus had been hailed by many influential people and publications as "the most significant devel-

27 This approach was countered by the experience of the consultant designers who were designing products such as cars, trains, and airplanes without having trained as engineers. They had parlayed their skills in rendering forms and managing interdisciplinary teams into the ability to work at any scale of product design from the smallest object to the largest.

28 Rayner Banham relates a story told to him by Wilhelm Wagenfeld, a former student of Moholy-Nagy at the Weimar Bauhaus. Wagenfeld encountered Moholy-Nagy at the glass factory in Jena, where Wagenfeld was changing his own earlier cylindrical milk jugs into dropped-shaped ones. Moholy-Nagy said to him, "Wagenfeld, how can you betray the Bauhaus like this? We have always fought for simple basic shapes, cylinder, cube, cone, and now you are making a soft form which is dead against all we have been after." Rayner Banham, *Theory and Design in the First Machine Age* (New York: Praeger, 1960), 282. In Chicago, Moholy-Nagy was less rigid about product shapes, but the story nonetheless helps to explain his dogmatic antipathy to streamlining.

29 Alain Findeli, "Moholy-Nagy's Design Pedagogy in Chicago (1937–46)," *Design Issues* 7, no. 1 (Fall 1990): 4–19.

30 Before Moholy-Nagy arrived in the United States, he was recognized by many American critics, journalists, curators, and progressive educators as a leading figure of the European avant-garde as well as a teacher who had contributed to the international reputation of the Bauhaus. Because of this recognition, the projects of his schools received better coverage in the press than work from other more pragmatic industrial design programs.

31 Clarence J. Bulliet, quoted in Engelbrecht, *The Association of Arts and Industries,* 294.

32 Ibid.

opment of our time in the field of design."[33] In the article that followed this note, Moholy-Nagy introduced his method:

> The basic workshop allows experiments with tools, machines and different materials, wood, metal, rubber, textiles, papers, plastics etc. No copying of any kind is employed nor is the student asked to deliver premature practical results. By working with materials, he gets a thorough knowledge of their appearance, structure, texture and surface treatment. Step by step he discovers their possibilities which enable him to get more governed results . . . But the knowledge of material, tools and function guarantees for each design, so high a quality that an objective standard, not an accidental individual result, will be obtained.[34]

One year was hardly enough time to demonstrate the value of the New Bauhaus, and therefore its closing by the Association of Arts and Industries cannot be attributed to a failure of results. The withdrawal of support was due instead to a number of factors that were both pragmatic and short-sighted. On the pragmatic side, a decline in the value of the association's stocks and its inability to raise additional funds made further financial contributions appear impossible. At the same time, differences between Moholy-Nagy and Norma Stahle, as well as complaints by a group of dissident students, added fuel to the fire. Moholy-Nagy became embroiled in a bitter fight with the association to obtain the benefits it had promised him and, as a result of his split with the group, decided to start a new school.

The Association of Arts and Industries was extremely myopic in failing to recognize the cultural prestige that Moholy-Nagy possessed and to understand the value of the extensive coverage the New Bauhaus had received as a result of it. Besides the above mentioned articles in the local, national, and international press that reported on the school's first display of student work, student projects were included in the large exhibition *Bauhaus 1919–1928* that opened at the Museum of Modern Art in December 1938 and photographs of student work were published in the widely circulated catalog.[35] Moholy-Nagy also discussed the New Bauhaus in the expanded edition of his book *The New Vision*, which was published to coincide with the opening of the MOMA exhibition,

33 Editor's Note preceding the article by László Moholy-Nagy, "New Approach to the Fundamentals of Design," *More Business: The Voice of Letterpress Printing and Photo-Engraving* 3, no. 11 (November 1938): 4.

34 Ibid., 6.

35 Herbert Bayer, Ise Gropius, and Walter Gropius, eds., *Bauhaus 1919–1928* (New York: Museum of Modern Art, 1975 [c. 1938]), 216.

36 László Moholy-Nagy, *The New Vision: Fundamentals of Design Painting Sculpture Architecture* (New York: W. W. Norton, 1938). The New Bauhaus and its curriculum are discussed on pp. 20–22. Photographs of exercises from the school's preliminary course are interspersed throughout the book, which is a translation of Moholy-Nagy's Bauhaus volume *Von Material zu Architektur*. An earlier English edition appeared in 1932 and a later one in 1947.

37 Engelbrecht, *The Association of Arts and Industries*, 305.

38 Findeli, *Du Bauhaus à Chicago*, 1:27.

39 On the Product Design Workshop, see Eva von Seckendorff, "Produktgestaltung," in *50 Jahre New Bauhaus*, 191–214, and Findeli, *Du Bauhaus à Chicago*, 1:243–50.

and he included photographs of some of the student projects in the book as well.[36] By entering into an adversarial relationship with him, the association destroyed any possibility of participating in a newly reconstituted school or garnering the cultural benefits that would arise therefrom. Lacking the affiliation with a forward-looking design school, the association, as Lloyd Engelbrecht points out, simply faded from public view.[37]

3

Had the New Bauhaus not closed, students interested in product design would have entered a three-year workshop devoted to wood, metal, and plastics after they completed the one-year preliminary course. Moholy-Nagy was to direct that workshop along with an American artist/designer yet to be hired. They were to be assisted by Hin Bredendieck, a former student at the Dessau Bauhaus, and others to be named.[38] This workshop, headed by Moholy-Nagy, was instituted after he founded the School of Design in 1939, and it was designated the Product Design Workshop in the 1940/41 catalog.[39] Among those who taught in it during the time Moholy-Nagy headed it were Eugene Bielawski, James Prestini, and Charles Niedringhaus.[40] Andi Schiltz was in charge of technical matters, except for the period of his military service.

For Moholy-Nagy, product design was part of a continuum that included architecture and city planning; hence he did not single it out as a unique practice with its own methods. In a lecture presented at the Conference on Coordination in Design, held at the University of Michigan in February 1940, he stated that man's "biological potentialities to do every type of work in a balanced status of body and mind clearly indicate that it is dangerous to press him to specialize in only one little part of his abilities instead of striving for a synthesis of all his abilities."[41] He was interested in a common principle of general education that would make it possible to set up each form of specialized teaching so that it would be "constantly connected with the great flow of the general educational scheme responsible for a controlled biological approach."[42] The objects made in the Product Design Workshop were to demonstrate the fulfillment of human biological potential which Moholy-Nagy claimed "must be the long disregarded yardstick again."[43]

Moholy also operated with strict principles of product form which caused him to criticize much of what industry was doing. Like Edgar Kaufmann Jr. at the Museum of Modern Art, he believed strongly that an object's form should express its function.[44] He therefore maintained a continuous invective against

40 Niedringhaus was a graduate of the New Bauhaus.

41 László Moholy-Nagy, "Objectives of a Designer Education," Conference on Coordination in Design, University of Michigan, February 2–3, 1940, typescript, 46.

42 Ibid.

43 Ibid.

44 László Moholy-Nagy, "Design Potentialities," *Plastics Progress* (April 1944): 6–7. A longer version of this article was published in *New Architecture and City Planning: A Symposium*, ed. Paul Zucker (New York: Philosophical Library, [c.1944], 675–87.

streamlining—the term given in the 1930s to a sleek form of product styling—which was "poured—as the brown gravy in cheap restaurants—over every product."[45] In contrast to Moholy-Nagy, Harold Van Doren, one of the early consultant designers, argued in *Industrial Design: A Practical Guide*, the first book to describe the working methods of practicing designers, that streamlining was something "no designer can ignore and no modern book on design can afford not to discuss."[46] As a method of training, Van Doren put his primary emphasis on techniques of visualizing form such as rendering, coloring, and modeling. Although students at the School of Design did learn to draw and were able to generate ideas through sketching, the focus in the workshops was on working with materials rather than on the development of rendering skills. Another difference between Moholy-Nagy's approach and Van Doren's was Moholy's stress on the value of designed objects for human welfare. Thus he favored experimentation which would lead to objects that did not yet exist as opposed to the redesign of those that were already in production, noting in an article published in 1941 that

> [t]he finest solutions in design usually came through new inventions where tradition did not hamper the freshness of approach, as the steam engine, electric motor, telephone, radio, and photocell.[47]

This led him, for example, to envision a chair of the future that would be significantly different from those of his day due to an inventive use of technology:

> Today we can produce new chair forms, such as seats using two legs

45 László Moholy-Nagy, *Vision in Motion*, 54. Moholy-Nagy expressed his antipathy to streamlining on numerous occasions. His critical opinions were also shared by others who believed in the ideals of the European avant-garde. Edgar Kaufmann, Jr., at the Museum of Modern Art inveighed against streamlining as did Siegfried Giedion who wrote to Container Corporation of America president Walter Paepcke of his astonishment at visiting a large art school and seeing, "hanging on the walls, the designs of the students which seemed inspired exclusively by the streamlined nonsense they saw in the current magazines." Siegfried Giedion to Walter Paepcke, June 29, 1945. Institute of Design Collection, University of Illinois at Chicago. See also Giedion's article "Stromlinienstil und industrielles Entwerfen in USA," in the Swiss magazine *Werk* 33, no. 5 (May 1946): 155–62.

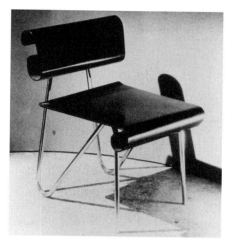

FIGURE 6.2 (p. 228)
Lerner chair from a single piece
of plywood, 1940

FIGURE 6.3 (p. 228)
Niedringhaus plywood chair
with webbed seat back,
c. 1940

FIGURE 6.4
Kahn plywood and tubular
steel chair, 1940

instead of the usual four. Perhaps tomorrow there will be no legs at all—only a seat on a compressed air jet.[48]

The motivation to invent new objects was a departure from the product design philosophy at the Bauhaus in Germany which, during the time Moholy-Nagy was there, made its principal innovations by using new forms and materials rather than creating original object types. In Chicago, by contrast, Moholy-Nagy emphasized design that was "dependent not alone on function, science and technological processes, but upon social implications as well."[49] This could result in objects that were considerably different from those to be found in the marketplace. Nathan Lerner's chair, one of the early projects from the Product Design Workshop, is a good example (FIGURE 6.2). Made from a single piece of plywood, it seems to have served as a demonstration of Moholy-Nagy's belief that "one-piece objects mass-produced by automatic action of the machine will one day eliminate the assembly line and with it change the present working conditions in which fatigue of the worker plays an important role."[50]

The School of Design had a machine for bending plywood and many experiments besides Lerner's were conducted with that material. These included Charles Niedringhaus's knockdown plywood chair with a webbed seat and back (FIGURE 6.3) and Henry Kahn's chair of bent plywood and tubular steel that combined pieces of curled plywood for the back and seat with a tubular steel frame (FIGURE 6.4). Besides plywood and steel, students also worked occasionally with plexiglass. Kenneth Evertsen's tea table (FIGURE 6.5) had a plywood surface and thick plexiglass legs. However, its combination of materials seems

46 Harold Van Doren, *Industrial Design: A Practical Guide* (New York: McGraw-Hill, 1940), 137.

47 László Moholy-Nagy, "New Trends in Design," *Task* 1 (Summer 1941): 27.

48 Ibid. This idea was originally stated by Marcel Breuer in the first number of the Bauhaus journal (1926). Breuer showed a sequence of his own chairs which ended with an image of a woman seated in mid-air. The sequence is reproduced in Hans Wingler, *Bauhaus: Weimar Dessau Berlin Chicago*, 424.

49 László Moholy-Nagy, "New Trends in Design," 27.

50 László Moholy-Nagy, "Design Potentialities," *Plastics Progress* (April 1944): 7.

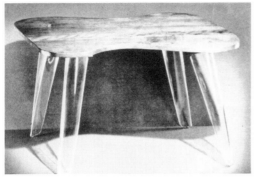

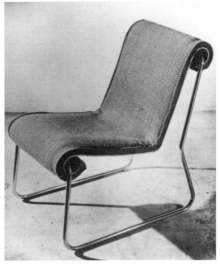

FIGURE 6.5
Evertsen tea table, 1940

FIGURE 6.6
Pratt chair, 1940

FIGURES 6.7a (top) and 7b (bottom) (p. 231)
Waldheim chair, n.d. a.a

to have been made for the purpose of experiment rather than to achieve a desirable visual effect. It was, however, one of the few pieces of furniture from the Product Design Workshop that was commercially produced with legs of bent plywood substituted for the plexiglass legs on the prototype.

In terms of form and a creative use of materials, the most successful chair among those done by students in the School of Design's product workshop was by Davis Pratt, who devised a tubular steel frame on which he hung a piece of curved plywood covered with crepe rubber (**FIGURE 6.6**). The seat appears to float in space, suspended from the tubular frame, and the rubber covering would seem to have introduced a modicum of comfort.[51] A project which was promoted as an object that fulfilled new functions was a lounge chair by Jack Waldheim (**FIGURES 6.7a** and **7b**). It changed from a chaise lounge when positioned flat on the floor to a V-shape when tilted so the sitter could relax with his or her feet in the air.[52] Moholy presented it to a journalist as a chair that had been approved by physicians for cardiac patients and which was used by beauty shops to relieve customers' stress.

In an article on new trends in furniture which Moholy-Nagy published in the trade magazine *Upholstering* in 1943, he characterized the ongoing work of the Product Design Workshop as a series of "experiments in furniture building for the post-war period."[53] While he admitted that the bent plywood furniture made at the school was "as yet perhaps not very startling," he claimed that new materials, such as plywood, plastics, and Airform, would lead to furniture that was more economical to produce and purchase. With such products, he wrote, industry could release its "dormant educational potentialities" and "raise the

51 Another version of the chair made with plywood and steel tubing only was illustrated in *Vision in Motion*, 91 Moholy-Nagy included photographs of the Lerner and Pratt chairs in his article, "New Trends in Design," *Task* 1 (Summer 1941), to illustrate his belief in Louis Sullivan's dictum "form follows function" and to suggest how new technologies and production methods could be used to produce furniture for the future. A variant of the Pratt chair made with steel rods and a nylon sleeve was later successfully produced by Pratt and Harold Cohen through their company Designers in Production.

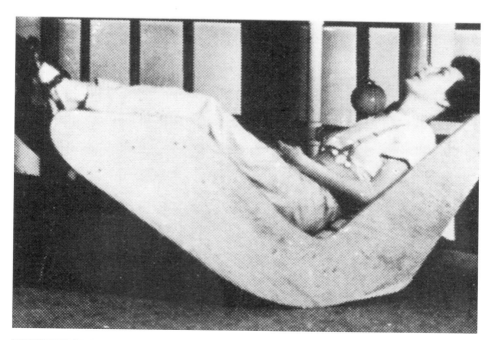

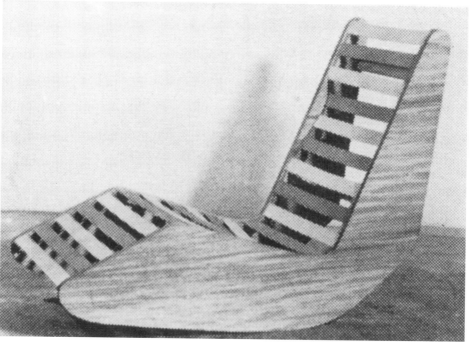

52 This chair was originally attributed to Moholy-Nagy in a *Chicago Tribune* article, but Moholy later credited Waldheim when he reproduced a photograph of it in a 1944 article, "Design Potentialities," published in *New Architecture and City Planning*, ed. Zucker, 677; and in *Vision in Motion*, 91. It was probably the model for the successful Barwa lounge chair, designed by Waldheim and Edgar Bertolucci in 1947.

53 László Moholy-Nagy, "New Trends in Furniture," *Upholstering* (March 1943): 4.

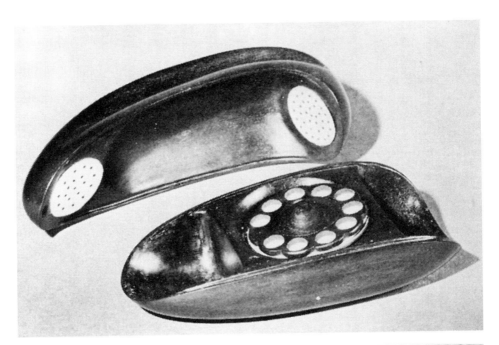

54 Ibid., 28.

55 Ibid., 10.

56 Marli Ehrmann, who headed the Textile Workshop at the School of Design, won first prize for textiles in the same competition. See the catalog by Eliot Noyes, *Organic Design in Home Furnishings* (New York: Museum of Modern Art, 1941).

57 On the furniture of the Howell Company, see Sharon Darling, *Chicago Furniture: Art, Craft, & Industry, 1833–1983* (New York and London: W. W. Norton, in association with the Chicago Historical Society, 1984): 311–17.

58 Henry Dreyfuss, *Designing for People* (New York: Grossman Publishers, 1967 [c. 1955]), 99.

59 In the Institute of Design's 1944–45 catalog, the following caption is attached to a photograph of Rhoades's telephone model: "Tactile charts and hand sculptures lead students later towards practical applications such as the design of better steering wheels, handles for refrigerators or telephones."

cultural level of the country."[54] Moholy-Nagy's article conveyed his enthusiasm for technology and his vision of how it would change the upholstery industry, but he exaggerated the importance of the experiments at the School of Design as compared to the "overstuffed, handmade upholstered furniture," which he thought dominated the furniture field.[55] Experiments with bent plywood and tubular steel were not as unique as he suggested. Charles Eames and Eero Saarinen, then working at the Cranbrook Academy of Art, had won first prize in the Museum of Modern Art's "Organic Design in Home Furnishings" competition two years earlier with a group of chairs made from laminated wood shells covered with rubber and fabric.[56] And in Chicago, the Howell Company had been mass-producing tubular steel furniture based on the work of the European modernists since 1929.[57]

Compared to the more successful applications of the new materials Moholy-Nagy espoused, the furniture prototypes made in the Product Design Workshop were less impressive. Besides these projects, however, we can consider several other product designs from the school that received wide publicity. Nolan Rhoades's model for a compact telephone (**FIGURE 6.8**) was a pleasing form that was similar to some of the hand sculptures from the preliminary course (**FIGURE 6.9**). But it was as much an imaginative projection as were Norman Bel Geddes's models for streamlined boats, trains, cars, motor coaches, and airplanes in his 1932 book *Horizons*. Rhoades's experiment in form, which was reproduced by Moholy-Nagy in a number of his articles and in *Vision in Motion*, might be contrasted with the painstaking work of the Henry Dreyfuss office for Bell Telephone in the early 1930s which led to the Dreyfuss firm's redesign of the company's basic phone in 1936 (**FIGURE 6.10**). Dreyfuss worked closely with Bell's administrative, research, engineering, and sales personnel over a number of years and considered the final product to be "a tangible monument to integration."[58] Moholy-Nagy nonetheless used Rhoades's model to demonstrate the value of the preliminary course in generating product forms, but the project gave no evidence of the extensive research and consultation that the Dreyfuss firm undertook in its work for Bell Telephone.[59]

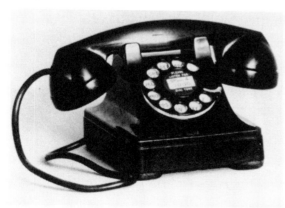

FIGURE 6.8 (p. 232 top) **Rhoades** telephone prototype, 1941

FIGURE 6.9 (p. 232 bottom) **Binkley** hand sculpture from the New Bauhaus Preliminary Course, 1939

FIGURE 6.10 **Dreyfuss and Associates** desk phone for Bell Telephone, 1935. Property of of AT&T Archives. Reprinted with permission of AT&T

Perhaps the most celebrated project was conducted in the Product Design Workshop during World War II—the design of wood springs for which machinery was provided and research was funded by Seng & Co. of Chicago. To address the wartime shortage of metal that had traditionally been used for furniture springs, Charles Niedringhaus, Jack Waldheim, and Clara McCrown, who were assisted by a carpenter, Kalman Toman, came up with a dozen prototypes for substitute springs made of thin strips of plywood (**FIGURE 6.11**). While these prototypes were effective in terms of durability and comfort, the project was not developed in relation to a production system that would make it economically feasible to use the springs for furniture manufacturing. As *Business Week* put it:

> Unless someone bobs up with a design that permits production economies which as yet seems improbable, the cost differential is too great to enable wood to compete with wire, when metal again becomes available for civilian use.[60]

Hence, the production of wood springs did not go beyond the prototype stage.

One of the more successful projects from the Product Design Workshop was a plastic helmet built by George Marcek (**FIGURE 6.12**) which filtered out the sun's ultraviolet rays. It was custom designed for two North Dakota farmers, brothers who suffered from a rare skin infection and could not work outside without protection. Like the other projects, however, it also remained in the prototype stage.

In her biography of Moholy-Nagy, his wife Sibyl was more optimistic about the results achieved in the Product Design Workshop and elsewhere in the School of

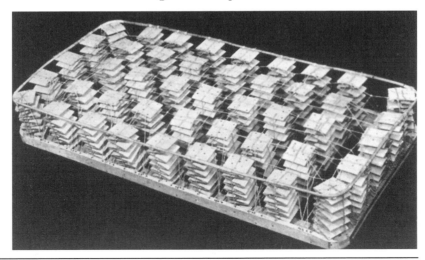

60 "Wooden Springs," *Business Week* (October 31, 1942): 36.

61 Sibyl Moholy-Nagy, *Moholy-Nagy: Experiment in Totality*, 175.

62 Ken Parker, "Obituary Note,"*Parkergrams* (December 1946), in *Moholy-Nagy*, ed. Richard Kostelanetz (New York: Praeger, 1970), 93.

63 "Message in a Bottle," *Time* 47, no. 7 (February 18, 1946): 63.

Design.[61] She mentioned the development of wire mesh cushions that served as shock absorbers for soldiers' helmets, a long chair patented by Orin Raphael, and a new method of setting stones and pearls that produced striking visual effects in jewelry. There were other successful activities, but the sum total of these was modest compared to the underlying expectations of those whose external support was solicited.

Moholy-Nagy sometimes worked as a successful design consultant himself, particularly for the Parker Pen Company in Janesville, Wisconsin. The firm's president, Ken Parker, praised him in an obituary, stating that Moholy-Nagy "had a natural feeling for the correctness of a line or a curve or shape or an embellishment or finish of a surface, a sense for all small things in combination that most of us lack. And that was really the lesser part of his value: he was always very far in the future in his thinking."[62]

When *Time* reported on the Institute of Design in its issue of February 18, 1946, it characterized Moholy-Nagy and the students as being particularly focused on the future, stating that

> Moholy and his young hopefuls have already designed a car that runs by sunlight; transparent partition walls filled with colored gases; plywood bedsprings; an infrared oven that cooks dinner at the table, a mechanical dishwasher with no motor; and a "beautyrest" chair in which the occupant had his head practically on the floor and his feet in the air (the answer to having your feet on the desk without being rude).[63]

This description, which mingles Moholy-Nagy's enthusiastic account of the school's activities with actual results, is a good example of the American postwar optimism that provided a new framework for evaluating the activities at the Institute of Design. Moholy-Nagy could easily generate a multitude of concepts for

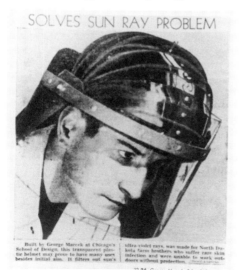

SOLVES SUN RAY PROBLEM

Built by George Marcek at Chicago's School of Design, this transparent plastic helmet may prove to have many uses besides initial aim. It filters out sun's ultra-violet rays, was made for North Dakota farm brothers, who suffer rare skin infection and were unable to work outdoors without protection.

FIGURE 6.11 (p.234)
Woodspring mattress designed by Charles Niedringhaus, Jack Waldheim, and Clara McCrown, assisted by Kalman Toman, 1943

FIGURE 6.12
Marcek plastic helmet, 1942–43

new products, but this was a far cry from a method to actually develop them to workable prototypes that were technically and economically feasible to produce. Moholy's design methodology was based strongly on intuition, which was a great source of invention. But without pragmatic guidelines for production and use, his intuition could easily lead to the kind of speculative projects that were exemplified by the futuristic plastic film sets he designed in England for Alexander Korda's interpretation of H. G. Wells's science fiction novel *Things to Come*.[64]

<div align="center">

4

</div>

Central to the success of the School of Design, and its successor, the Institute of Design, was Walter Paepcke, the president of the Container Corporation of America. Without Paepcke, who became Moholy-Nagy's strongest supporter in the Chicago business community, Moholy-Nagy would have been unable to keep his enterprises going. The relationship between the two men centers on the ambitions of both to create a new alliance between culture and commerce; yet each approached this task differently. Moholy-Nagy's view, shaped by his role in the European avant-garde, was that industry was the means to satisfy social needs as defined by visionary artists and designers. For Paepcke, however, the locus of social power was in industry itself. He believed in supporting culture for its civilizing function and public relations value, but he was a pragmatic man of affairs with no faith in the artist to lead society.[65]

What united Moholy-Nagy and Paepcke was the ability of each to transcend the reductive roles of artist and businessman. Moholy-Nagy was originally trained as a lawyer before he became an avant-garde artist and had a broad philosophic and literary background, while Paepcke sought the company of artists and scholars because he valued their ideas. This mutual respect enabled both men to accommodate each other's differences as they engaged in the common effort to keep a radical educational enterprise alive. Nonetheless, their collaboration had moments of tension which at times strained the bonds of mutual admiration.

Paepcke had been a member of the Association of Arts and Industries during the time it supported the New Bauhaus, but he did not take a strong role in that relationship.[66] It was only after the association had withdrawn its backing that he became actively involved in Moholy-Nagy's new venture, the School of Design.[67] He was in a much better position than other members of the association to grasp the potential civic value of the innovative school. His father, a

64 Moholy-Nagy used a photograph of a detail from the film's set on the cover of the New Bauhaus catalog to convey a sense of cultural modernity expressed in form.

65 James Sloan Allen provides an account of Paepcke's life and career in *The Romance of Commerce and Culture: Capitalism, Modernism, and the Chicago-Aspen Crusade for Cultural Reform* (Chicago: University of Chicago Press, 1983).

66 Engelbrecht notes that Paepcke's name first appeared on a roster of the association's board members in August 1937, although he had been listed as a "sponsor" several months earlier. Engelbrecht, *The Association of Arts and Industries*, 218.

67 Paepcke's involvement with Moholy-Nagy and his schools is discussed by Allen in *The Romance of Commerce and Culture*, 35–77.

68 Ibid., 18.

businessman born in Germany, maintained a strong connection to his native culture which he conveyed to his children. The family mingled in academic circles, and Paepcke's wife Elizabeth was the daughter of William A. Nitze, chairman of the Romance Languages Department at the University of Chicago.[68]

In 1935, advised by his wife, Paepcke hired Egbert Jacobson as the first art director of the Container Corporation of America and thus began a lifelong commitment to modern art and artists as a means of enhancing his company's image. The following year Paepcke gave a speech to the Art Directors' Club of Chicago, in which he stated that improved "eye value" was the aim of design within his company.[69] This was to be achieved through a complete remake of the company's image, from its newspaper advertising to colors of the factory walls and the logo on company invoices.[70] Paepcke was thus one of the first corporate executives, if not the first, in America to recognize that the visual appeal of a company's premises, products, and publicity was intimately tied to its competitive advantage. Asking his audience at the Art Director's Club to think of the various things they used every day, he noted that "they could all be made by companies that have their eyes on art."[71]

While Paepcke and Moholy-Nagy shared the aesthetic values of European modernism, Paepcke's probusiness views were considerably different from Moholy-Nagy's utopian socialism. This, however, did not prevent the two from cooperating in an effort to support the School of Design and the Institute of Design. Paepcke extended himself considerably to promote the schools to his corporate colleagues and wealthy friends. Moholy-Nagy continued to speak idealistically about their curricula, but he also promised the corporate supporters whom Paepcke was cultivating that his educational approach could have a positive effect on their own industries. To this end, he offered evening courses for company employees as well as a series of lectures on modern art, architecture, and design for corporate executives.[72]

Paepcke promoted the School of Design and its successor as the most important design school in America; but he did not, in fact, know a great deal about industrial design. His own company made paperboard boxes rather than consumer products. Although he had become extremely knowledgeable about how modern art might be used to create a striking corporate image, he did not have to confront the problems of integrating industrial designers into his company's manufacturing process. Nevertheless, he understood the School of Design and the Institute of Design in several different ways, which justified his continued

69 Ibid., 27–28.

70 On the origins of Container Corporation's design program, see ibid., 24–34. The design program in general is discussed in Neil Harris, "Design on Demand: Art and the Modern Corporation," in Neil Harris, *Cultural Excursions: Marketing Appetites and Cultural Tastes in Modern America* (Chicago: University of Chicago Press, 1990), 349–78; and Philip B. Meggs, "The Rise and Fall of Design at a Great Corporation," *Print* 46, no. 3 (May/June 1992): 46–55, 116–18.

71 Walter Paepcke quoted in Allen, *The Romance of Commerce and Culture*, 32.

72 These projects achieved varying degrees of success. The courses were generally thought by the employees who took them to have been worthwhile, but responses by company executives to the lectures were mixed.

support of them. One aspect of the schools he promoted to his colleagues was their importance as a cultural resource for Chicago. As he wrote to E. P. Brooks, vice-president of Sears Roebuck, regarding the School of Design

> . . . there is of course the cultural and civic aspect, namely, of improving an important and unique school of design here in Chicago which stimulates the artistic life of the city, has nationally and internationally known lecturers from time to time and many other activities such as exhibits etc. which tend to keep artists and designers in Chicago rather than have them all yearning to go to New York at the first opportunity.[73]

The lecturers Moholy-Nagy brought to Chicago included Walter Gropius, James Johnson Sweeney, Jean Carlu, Frederick Kiesler, Siegfried Giedion, and Fernand Léger.[74] Paepcke, in fact, met Gropius through Moholy-Nagy and because of the Bauhaus connection came to know Herbert Bayer and Giedion as well. When Paepcke was developing Aspen, Colorado, as a ski resort, he involved Gropius in discussions about a master plan for the town; he also invited Bayer to live there and handle all the design matters for him.[75] Bayer and Gropius also served as consultants to the Container Corporation of America, Bayer for matters of corporate identity and Gropius for the initial plan of a factory in Colombia and the design of another in North Carolina.[76] Paepcke thus recognized that he had a lot to gain personally from his association with Moholy-Nagy and therefore did not base his commitment to the school entirely on the successful education of industrial design professionals. His involvement became part of his public image as a corporate executive who knew the social value of supporting art and culture while also turning that support to his own economic advantage.

As a businessman, Paepcke realized that the School of Design had a serious image problem. When Moholy-Nagy gave his opening address to the students in February 1939 he emphasized the importance of the educational process itself rather than its outcome:

73 Walter Paepcke to E. P. Brooks, December 29, 1943. Institute of Design Collection, University of Illinois at Chicago.

74 Because of his trips to Chicago in support of the school, Gropius became involved in a major architectural and planning project there. In February 1945 he addressed 1200 business and civic leaders at a meeting jointly sponsored by the Chicago Association of Commerce, the Chicago Plan Commission, and the Institute of Design. Subsequently, he became a consultant to the Planning Staff of Michael Reese Hospital, and this relationship developed into his most extensive experience in city planning, a twelve-year project that involved the hospital's expansion and the redevelopment of a large slum area on Chicago's South Side. The project is described in Reginald Isaacs, *Walter Gropius: An Illustrated Biography of the Creator of the Bauhaus* (Boston: Bullfinch Press, 1991), 254–58, 266–67, 280.

75 On the development of Aspen, see Allen, *The Romance of Commerce and Culture*, 113–46. Bayer's American career, including his work for Paepcke, is the subject of Gwen Finkel Chanzit's *Herbert Bayer and Modernist Design in America* (Ann Arbor: UMI Research Press, 1987).

76 Allen, *The Romance of Commerce and Culture*, 70.

77 László Moholy-Nagy, opening address to students at the School of Design (February 1939), quoted in Sibyl Moholy-Nagy, *Moholy-Nagy: Experiment in Totality*, 170. Only eighteen day students began at the School of Design, followed by twenty-eight night students.

78 School of Design press release of December 21, 1939, quoted in Findeli, *Du Bauhaus à Chicago*, 1: 50.

79 "School of Design in Chicago," 1940. Institute of Design Collection, University of Illinois at Chicago.

> This is not a school but a laboratory in which not the fact but the process leading to the fact is considered important . . . You as total human beings are the measure of our educational approach—not you as furniture designers, draftsmen, photographers or instructors.[77]

In a press release sent out several months later, Moholy-Nagy stated that the educational program at the School of Design would not necessarily lead to the career of a designer but would instead provide the student with the ability to develop his or her own productive relation to society.[78]

Initially Moholy-Nagy fused the assurance of improved services to industry with his own vision of "design for living." In one of the early statements promoting the School of Design, which was probably written for Moholy-Nagy based on his ideas, universities were criticized for producing graduates who were overspecialized, while the School of Design was described as an institution intended to meet the need for "a new type of person—one who sees the periphery as well as the immediate, and who can integrate his special job with the great whole in which it is a small part."[79] The definition of design which undergirded the school's program was stated quite broadly:

> A designer trained to think with both penetration and scope will find solutions, not alone for problems arising in daily routine, or for development of better ways of production, but also for all problems of living and working together. There is design in family life, in labor relations, in city planning, in living together as civilized human beings. Ultimately all problems of design fuse into one great problem of 'design for living.'[80]

Such rhetoric made the School of Design's program appear incomprehensible to less expansive minds. In 1940, Harold Van Doren had written about Moholy-Nagy's earlier school, the New Bauhaus, in the previously mentioned *Industrial Design: A Practical Guide*:

> The Bauhaus approach is a philosophy of life as well as a method of design. It lacks, however, the realistic qualities that we Americans, rightly or wrongly demand. Much of the writing of the group is vague to the point of complete unintelligibility, strongly reminiscent of the 'manifestoes' of the modern schools of painting like the Futurists and Synchronists . . . it will be difficult, I believe, to acclimatize the esoteric ideas of the Bauhaus in the factual atmosphere of American industry.[81]

Moholy-Nagy's encompassing vision was often at odds with Paepcke's more practical conception of the School of Design and the Institute of Design although their presentations were frequently directed to different audiences. When Moholy-Nagy spoke at education or design conferences, to which he was

80 Ibid.

81 Van Doren, *Industrial Design: A Practical Guide*, 79. In the revised and updated edition of Van Doren's book, which was published in 1954, references to the New Bauhaus were deleted.

often invited, or when he wrote about his pedagogy in volumes related to those events, he presented his program in terms of its idealistic goals.[82] When addressing businessmen or those involved with public relations for the school, he tended to feature its practical side. The School of Design and the Institute of Design, in fact, had several identities, and their success was measured variously by different communities. Progressive art educators, for example, saw the School of Design as a model of how art education could be made more relevant to daily life. In *The New Art Education*, an important survey of progressive tendencies in art teaching published in 1941, Ralph Pearson devoted an entire chapter to the School of Design, which he described as a bold experiment in art training:

> I believe its exploration into all manner of new fields is a logical exten-
> sion of the potentialities of the creative mind into channels where it
> can be widely useful to the community as a whole and because, for
> many years, this school has provided the leadership which art educa-
> tion in this country so tragically needs and has so tragically lacked.[83]

While art educators such as Pearson celebrated the School of Design for its creative program of working with materials, corporate executives were exasperated because the school showed few results. Moholy-Nagy was, in fact, more committed to making art an instrument of human development than to preparing professional designers. This became advantageous, however, when Paepcke applied for financial support to the Rockefeller Foundation which provided several modest grants for film and photography equipment. The foundation also underwrote a color film about the school and funded Moholy-Nagy himself to work on the manuscript of *Vision in Motion*.

David Stevens, a former professor of English at the University of Chicago, headed the Humanities Division at the Rockefeller Foundation. He first visited the School of Design in 1942, and following a second visit early in 1944 he wrote enthusiastically to Paepcke:

> After my visit I was more impressed than ever before with the intelli-
> gence of Moholy-Nagy's program as a means to general education,
> not only as a center to train young people and specialists in design. As
> before, I felt that he or one of his disciples should write as well as teach
> on the place of handwork in [the] development of young people.[84]

Thus for Stevens the School of Design was more important as a project to reform general education and as a place to demonstrate the role of handwork in such an education than it was as a school to train designers for industry. He saw its

82 László Moholy-Nagy, "Objectives of a Designer Education," *Conference on Coordination in Design*, University of Michigan, February 2–3, 1940, 45–47; "Education in Various Arts and Media for the Designer," *Art in American Life and Education* (Bloomington, Ill.: Public School Publishing Co., 1941 [National Society for the Study of Education, Fortieth Yearbook]), 652–57; "Design Potentialities," *New Architecture and City Planning*, ed. Zucker, 675–87; and *Conference on Industrial Design as a New Profession*, Museum of Modern Art, November 11–14, 1946, esp. 213–22 and 269–72.

83 Pearson, *The New Art Education*, 199.

84 David Stevens to Walter Paepcke, February 19, 1944. Institute of Design Collection, University of Illinois at Chicago.

subsequent manifestation, the Institute of Design, as broadening the scope of the humanities by defining a new field of "art in hand crafts and industry."[85]

Stevens's perception of the Institute of Design was supported by Robert Whitelaw, a consultant to the Rockefeller Foundation, who prepared a report to the Humanities Division in 1946, in which he praised the Institute for "relating art to things of everyday life."[86] Like Moholy-Nagy, Whitelaw criticized product styling and then lamented the millions of dollars that were "to be spent in New York to enshrine non-objective paintings and sculptures which are actually the finger exercises of properly trained industrial designers, while in Chicago the school that uses these methods properly as tools is frequently close to starvation."[87]

Because Moholy-Nagy's own broad amalgam of talents and ideas defied categorization, the Institute of Design could maintain a dual identity as a site of progressive art education and a center for design training. What provided a link between the expressive parts of its curriculum and the workshops where practical outcomes were expected was Moholy-Nagy's idea of the artist as someone who could synthesize a diversity of experiences and produce various results that ranged from photographs to industrial products. As has already been stated, Moholy-Nagy's conception of design embraced almost everything. He also had unusually keen antennae for sensing ways that his school might become involved in various new problem areas. In December 1941, when the United States entered World War II, he was appointed to a committee in the mayor's office that was in charge of camouflage activities for the Chicago area. This led to a camouflage course at the School of Design, taught by Gyorgy Kepes. Moholy-Nagy also became interested in the problems of disabled persons and gave a major speech to the American Psychiatric Association in which he outlined a new philosophy of rehabilitation. He stated that the School of Design could offer an occupational therapy program to help the disabled achieve higher levels of productivity.[88] As a result of his speech and an article he published in the *Technology Review*, the School of Design did offer several innovative courses in rehabilitation during 1943. This was done in part by drawing on the exercises in the preliminary course to help disabled students become more aware of their senses.

85 David Stevens to Walter Paepcke, June 14, 1945. Institute of Design Collection, University of Illinois at Chicago. On May 1, 1946, Paepcke sent Stevens a letter requesting five-year funding from the Rockefeller Foundation at $40,000 per year. The funds were to pay for a public relations and fund-raising executive and to cover the salaries of five new teachers in painting, design, art history, science, and sculpture. Walter Paepcke to David Stevens, May 1, 1946. Institute of Design Collection, University of Illinois at Chicago. While Stevens was sympathetic to the request, he replied to Paepcke that the Foundation would not be able to fund it because he could not persuade the trustees to see the relevance of support from the Humanities Division to the Institute of Design. David Stevens to Walter Paepcke, June 14, 1945. Institute of Design Collection, University of Illinois at Chicago.

86 Robert N. S. Whitelaw, "A Study to Define the Processes for the Development and Use of the Industrial Designer in Serving Industry and the Consumer" (April 26, 1946), 3. Rockefeller Foundation Archive Center.

87 Ibid., 8.

88 László Moholy-Nagy, "New Approach to Occupational Therapy," attached to a letter from Moholy-Nagy to Walter Paepcke, May 17, 1943. Institute of Design Collection, University of Illinois at Chicago.

Walter Paepcke, however, had to promote the School of Design and the Institute of Design in terms of the services they were likely to deliver to their corporate supporters and foundation sponsors. In that role, he was always having to counter arguments that the programs were of little value to the corporations whose contributions he sought. C. R. Hennix of the Elgin National Watch Company wrote to Paepcke that his company appreciated the work of the Institute of Design, but "we have not had the pleasure of appropriating any information that has been helpful in our business."[89] John H. Collier, president of the Crane Company, writing in response to Paepcke's statement that "[t]he School of Design is the only school of industrial design of its kind in the country,"[90] replied, "Our problem has been how to relate the school to our company on a practical basis . . . We feel that eventually we might receive direct benefit from the school through their contributions to industrial designs and through their training of designers, although at this time the benefits are intangible."[91] Faced regularly with such replies from corporate colleagues, Paepcke nonetheless continued to defend the School of Design and the Institute of Design in grandiose terms. During World War II, for example, he extolled the School of Design's promise of providing industrial designers for "the difficult postwar era we are facing when trained industrial designers will be increasingly more important in the development of new products and peacetime business."[92]

While Paepcke praised both the School of Design and the Institute of Design for fund-raising purposes, he understood the difficulties of keeping them afloat as independent institutions. As early as 1942 he tried to affiliate the School of Design with one of the area universities and made overtures to Northwestern University, the University of Chicago, and the Illinois Institute of Technology (IIT). Henry Heald, president of IIT, was interested but expressed some concern about the abilities of the personalities involved to cooperate, perhaps alluding to the cool relations between Moholy-Nagy and Mies van der Rohe, who had been the last director of the Bauhaus and was then teaching architecture at IIT.[93] During the next several years, Paepcke continued to explore the prospect of a merger with IIT, and one senses his hope during this period that Moholy's school would eventually evolve into a more significant institution under university sponsorship.[94]

Through his active involvement with the School of Design, Paepcke became

89 C. R. Hennix to Walter Paepcke, September 4, 1946. Institute of Design Collection, University of Illinois at Chicago.

90 Walter Paepcke to John H. Collier, December 8, 1943. Institute of Design Collection, University of Illinois at Chicago.

91 John H. Collier to Walter Paepcke, January 19, 1944. Institute of Design Collection, University of Illinois at Chicago.

92 Walter Paepcke to John Collier, December 8, 1943. Institute of Design Collection, University of Illinois at Chicago.

93 Henry Heald to Walter Paepcke, June 22, 1942. Institute of Design Collection, University of Illinois at Chicago.

94 Paepcke finally concluded an agreement with Heald in 1949 to merge the Institute of Design with the Illinois Institute of Technology, where it has remained since.

progressively aware that Moholy-Nagy had taken on too much responsibility in trying to do everything there. In early 1944 he proposed that the school be reorganized with a board of directors who would oversee the administration while Moholy-Nagy could focus on what he did best—teaching, writing, lecturing, and making art. This was the moment when the school took on its third identity, the Institute of Design.

However, trying to make the school's administration more efficient by bringing a group of corporate executives into closer proximity with its day-to-day life only exacerbated the concerns already frequently voiced by potential contributors about the school's lack of relevance to industry. E.P. Brooks, vice-president of Sears Roebuck and one of the new board members brought in by Paepcke as part of the reorganization plan, wrote to Paepcke less than a year after he joined the board of his efforts to understand how the Institute of Design operated:

> At our different meetings I have made several attempts to get a comprehension of the school which backs up Moholy's projections of what it is. This inquiry on my part took the form of questions about the curriculum. After one or two evenings when this subject was touched on we were all left, I think, without a clear understanding.[95]

Brooks tried unsuccessfully to gain clarification from faculty members, and it was finally Moholy-Nagy himself who had to explicate the matter for him.

Alain Findeli has described how pressure from the board of directors of the reconstituted Institute of Design forced Moholy-Nagy to redesign the curriculum so that the school became more like a conventional college than an experimental laboratory.[96] Among the consequences of this change, according to Findeli, was "the gradual abandonment of a global vision of the design process and of a methodology common to all the workshops in favor of a clearer distinction between the different departments, based on the various types of products with which they were concerned and the differences between the professional practices to which they were related."[97] This policy simply exacerbated the tension between Moholy-Nagy and his board without producing a curriculum that could satisfy all parties.

Such differences, however, only occasionally intruded on Moholy-Nagy's relationship with Paepcke and then not always directly. Paepcke remained cautious about any possibility of radical activity at either the School of Design or the Institute of Design. When the architect George Fred Keck, a faculty member at the Institute of Design, suggested that someone from the labor movement be invited to join the School of Design's board, Paepcke replied that "it would be my offhand best judgement to handle the thought a little delicately and carefully." Concerned that such a proposal would make other board mem-

95 E. P. Brooks to Walter Paepcke, January 10, 1945. Institute of Design Collection, University of Illinois at Chicago.

96 Alain Findeli, "Design Education and Industry: The Laborious Beginnings of the Institute of Design in Chicago in 1944," *Journal of Design History* 4, no. 2 (1991): 97–113.

97 Ibid., 107.

bers and potential contributors nervous, he told Keck:

> I think you will agree that we should do all we can to avoid the danger of setting before the patient so many new dishes that he will have indigestion and become nervously dispeptic about the institution.[98]

Moholy-Nagy and Paepcke had only one major confrontation about politics, and that occurred shortly before Moholy-Nagy's death in November 1946. In response to Paepcke's inquiry about political radicalism at the school, Moholy-Nagy replied,

> I think this is an eternal problem of vital and promising youth, which usually leads to an unselfish evaluation of community needs as well as individual responsibility . . . But no matter what the individual political color of the students might be it is our duty to find a way for the younger generation to acquire a philosophy of life . . . which will give them the inner security that comes from a full understanding of the traditions and achievements of our civilization . . . I hope to have the chance for a prolonged conversation with you about this and similar problems since—in my belief—they are the core of education.[99]

After the reorganization in early 1944, Moholy-Nagy spoke on several occasions about developing a strong research emphasis at the Institute of Design, but he had neither sufficient resources nor staff do so. In a proposal he drafted in October 1945 for submission to an organization called the Research Foundation, he stated the Institute of Design's most urgent need as "a well equipped physics and chemistry laboratory with a farsighted scientific head who would collaborate with different design departments and workshops."[100] Its task, he noted, would be to explore the application of plastics and other new materials to peacetime use. In a letter to Walter Gropius several months later, Moholy-Nagy wrote:

> I am deeply convinced that we should have parallel with the school a separate enterprise for design research that would be most fruitful for the faculty and design students. Who should do this if not us? If we are not going to work towards this aim, Illinois Tech surely will. In fact, they have taken steps towards doing this already.[101]

Creating a solid research capability at the Institute of Design would have served several purposes for Moholy-Nagy. First, it would have given more justification to the experimental tendency that had motivated much of the work in the Product Design Workshop from its inception. Second, it would have support-

98 Walter Paepcke to George Fred Keck, February 8, 1944. Institute of Design Collection, University of Illinois at Chicago.

99 László Moholy-Nagy to Walter Paepcke, November 21, 1946. Institute of Design Collection, University of Illinois at Chicago. Moholy-Nagy died three days after he sent the letter.

100 "Draft of a letter to the Research Foundation," attached to a letter from László Moholy-Nagy to Walter Paepcke, October 5, 1945. Institute of Design Collection, University of Illinois at Chicago.

101 László Moholy-Nagy to Walter Gropius, November 18, 1945. Sybil Moholy-Nagy Papers, Archives of American Art.

ed his interest in developing new products to satisfy social needs. And third, it would have enabled him to establish an avant-garde role in relation to industry so that he could propose new products to manufacturers rather than redesign or restyle existing ones. Although farsighted in his understanding of how an advanced technical research institute could be coordinated with a design workshop, Moholy-Nagy nonetheless had ambitions that were unrealistic for a privately funded design school and his plans extended well beyond the mandate of the school's supporters.[102] His inclination to expand the boundaries of design thinking was a result of his fundamental belief that designing was a way of life rather than a professional practice. As such, it was integral to the full mental, emotional, and sensory development of the individual who could discover new ways to improve the world as he or she became more developed.

5

Moholy-Nagy was quite ill before he left for New York in early November 1946 to attend a conference on the subject of industrial design as a new profession, which was convened by the Museum of Modern Art (MOMA), in association with the Society of Industrial Designers. His wife Sibyl tried to persuade him to stay home.[103] But he decided he had to go because "it'll give me a chance to make one more statement about the place of art education. Somehow I have to make it clear that if there is such a relationship as guidance and being guided it is industry that follows vision, and not vision that follows industry."[104]

At the time of the conference, there was no consensus in the United States on what industrial design was or how future designers should be trained. Several American associations of designers had formed, notably the Society of Industrial Designers and the American Design Institute, but these had not yet established aims and standards comparable to those of recognized professional groups such as lawyers, doctors, and architects.[105] One purpose of the MOMA conference was to move the discussion of professionalism forward, but any hopes of finding common ground among the participants were dashed by sharp disagreements about who was a designer, the designer's role in industry, and what forms design education in the United States should take. The conference exposed considerable gaps of understanding between the participants who included, besides Moholy-Nagy, seasoned professionals like Raymond Loewy and Walter Dorwin Teague; Edgar Kaufmann Jr., curator of the MOMA's Design Department; and Joseph Hudnut, dean of Harvard's Graduate School of Design.

102 In his response to Moholy-Nagy, Paepcke did not refute the idea of an institute, but he raised questions about practical matters such as where it would be housed and whether the funds requested would be sufficient. Walter Paepcke to László Moholy-Nagy, October 8, 1945. Institute of Design Collection, University of Illinois at Chicago.

103 Both the complete transcript and the minutes of the "Conference on Industrial Design: A New Profession" are in the Library of the Museum of Modern Art.

104 László Moholy-Nagy, quoted in Sibyl Moholy-Nagy, *Moholy-Nagy: Experiment in Totality*, 241.

105 For a history of industrial design in postwar America, see Arthur Pulos, *The American Design Adventure: 1940–1975* (Cambridge, MA: MIT Press, 1988).

Loewy and Teague gave the participants a clear account of their working methods, which featured an attentiveness to the manufacturer's need to sell products. However, Moholy-Nagy and Kaufmann argued that design had an ethical basis that was independent of industry.[106] Moholy-Nagy spoke out strongly during the meeting against market surveys and artificial obsolescence. He also criticized "appearance design" which he, like Kaufmann, claimed was divorced from the real value of a product. Neither Moholy nor Kaufmann acknowledged the relation of design to the marketplace, and Moholy, in fact, told his colleagues that "the education of the industrial designer is a problem that is perhaps secondary to the problem of general education, of which the industrial designer's education should be a part."[107] Braced by the conviction that industry had to follow the artist's vision, he defended the educational aims of the Institute of Design:

> If I were to put it into other words, I would say that the capacities of the human being (looking at it from the biological point of view) are his ability to perceive, to have conceptual thoughts, to feel, and to express himself in different media, etcetera. Without an education that tries to bring out of an individual the best in these fields, we cannot go very far. Without it we come to a cleavage of the individual's abilities—and in extreme and unfortunate instances, to neurotic and unbalanced individuals.[108]

While Moholy-Nagy was farsighted in his conviction that industrial designers required a broad education rather than a narrow specialist training, he did not sufficiently acknowledge the designer's relation to industry, so that an adequate understanding of industrial production could become part of a design student's preparation.

In his final remarks to the conference, Moholy made a critique of its agenda:

> That is why I say that designing is not a profession, but that it is an attitude which everyone should have; namely the attitude of the planner—whether it is a matter of family relationships or labor relationships or the producing of an object of utilitarian character or of free art work, or whatever it may be. This is planning, organizing, designing.[109]

Moholy intended his comments to shift the discussion of design as a professional practice to a reflection on it as a fundamental human activity. Since he made

106 In an article published shortly before the conference in the Museum of Modern Art's new bulletin, Kaufmann had blatantly declared his views on the relation of design to industry: "A frequent misconception is that the principal purpose of good modern design is to facilitate trade, and that big sales are a proof of excellence in design. Not so. Sales are episodes in the careers of designed objects. Use is the first consideration, production and distribution second." Edgar Kaufmann, Jr., "What Is Modern Industrial Design?" *Bulletin of the Museum of Modern Art* 14, no. 1 (Fall 1946): 3.

107 "Conference on Industrial Design: A New Profession" (1946), transcript, Museum of Modern Art Library, 213–14.

108 Ibid., 214–15.

109 Ibid., 292.

his remarks at the end of the conference, however, others had no opportunity to respond and the meeting ended without any resolution of the differing views expressed there.

Moholy-Nagy's commitment to an educational experience that led to human wholeness was commendable and at the time unique among directors of design programs. He believed strongly in the individual's capacity to recognize needs and devise solutions for them. For him, the designer's role was to educate and lead industry, not the contrary. Unfortunately, he died on November 24, 1946, several weeks after returning to Chicago from the conference and three months after the curricular and structural changes pressed for by the board of the Institute of Design were made; hence, there was no opportunity to see whether the changes could have led to an outcome that might have satisfied both him and the board members.

6

The great acclaim accorded the School of Design and the Institute of Design in various circles is a testament to Moholy-Nagy's vision as an educator, but the frustration of the businessmen who were asked to support him is evidence of his unwillingness to accept the conditions of American industrial design and production as the consultants did. For those of Moholy-Nagy's European friends like Walter Gropius, Siegfried Giedion, and Herbert Read who shared with him the aims and ideals of the avant-garde, his conception of the designer as a visionary with a strong social concern and a capacity to address the problems of the environment holistically was appealing.[110] Hence, they continued to support him even as the local corporate executives in Chicago were questioning his approach. In a letter written in October 1946 to David Stevens at the Rockefeller Foundation, Read stated that Moholy-Nagy's methods and principles "have stood the test of more than twenty-five years experience. All that is most fruitful in modern design can be traced to this fountain-head. I would say that the Institute of Design is the best school of its kind that exists anywhere in the world today."[111]

Moholy-Nagy's mistrust of American capitalism can be viewed to a considerable degree in terms of his avant-garde sensibility. This mistrust was also shared by other European intellectuals who emigrated to the United States, such as Theodore Adorno, a member of the acclaimed Frankfurt School, who wrote in a 1944 essay that

> super-machines, once they are to the slightest degree unused, threaten to become bad investments. Since, however, their development is

110 Moholy-Nagy's espousal of a comprehensive design education to meet the biological needs of human beings echoes a similar vision of Walter Gropius. In 1937, shortly after Gropius arrived at Harvard University, he published a short article in the *Architectural Record* in which he stated: "Good architecture should be a projection of life itself and that implies an intimate knowledge of biological, social, technical and artistic problems." Walter Gropius, "Architecture at Harvard University," *Architectural Record* 81, no. 5 (May 1937): 8–11.

111 Herbert Read to David Stevens, October 18, 1946, appended to a Memorandum from Walter Paepcke to the Board of Directors, Institute of Design, March 17, 1947. Institute of Design Collection, University of Illinois at Chicago. **247**

essentially concerned with what, under liberalism, was known as "getting up" goods for sale, while at the same time crushing the goods themselves under its own weight, as an apparatus external to them, the adaptation of needs to this apparatus results in the death of objectively appropriate demands.[112]

Besides their opposition to the market, Moholy-Nagy and Adorno also shared misgivings about American popular culture which they saw as substituting for the realization of the true human self. In *Vision in Motion* Moholy noted that man's biological functions "were suffocated under the tinsel of an easy-going life full of appliances and amenities, much too overestimated in their value,"[113] and he claimed,

Canned music, phonographs, films and radio have killed folksong, home quartets, singing choirs, market plays, *commedia dell'arte* productions, without canalizing the creative abilities in other positive directions.[114]

Business, he continued, tended to promote novelty for its own sake, creating the "illusion of new organic demands where no need exists."[115] Moholy-Nagy's remedy for this was

the re-education of a new generation of producers, consumers, and designers, by going back to the fundamentals and building up from there a new knowledge of the sociobiological implications of design. The new generation which has gone through such an education will be invulnerable against the temptations of fads, the easy way out of economic and social responsibilities.[116]

By positioning his own educational vision against the prevailing values of American culture, Moholy-Nagy adopted an oppositional stance that made it difficult for him to satisfy the expectations of the business executives whose support he depended on. Without Walter Paepcke, he would not have been as successful in soliciting support from corporations and foundations. Although Paepcke gained much from his support of Moholy-Nagy's schools, he was also mindful of the problems this role brought with it. As he wrote to Herbert Bayer in 1945,

I do confess to becoming quite discouraged at times, because the load on my shoulders requires more or less continuous efforts in time, energy, and finances which are out of proportion to the results which we are accomplishing.[117]

112 Theodor Adorno, "Gala dinner," in *Minima Moralia*, trans. from the German by E. F. N. Jephcott (London: Verso, 1974 [c. 1951]), 118.

113 Moholy-Nagy, *Vision in Motion*, 20.

114 Ibid.

115 Ibid., 62.

116 Ibid.

248 117 Walter Paepcke to Herbert Bayer, [June] 15, 1945. Institute of Design Collection, University of Illinois at Chicago.

The legacy of Moholy-Nagy's attempt to train his students in "design for life" thus has multiple meanings. For some, it reinforced the belief that education and industry were two separate spheres and that the function of the design school was to maintain a focus on design values which was independent of design for business.[118] For others, however, Moholy-Nagy's interest in research, in the social accountability of the designer, and in experimentation with materials and new technologies added a missing element to the prevailing design discourse of his time and opened up new directions for change.[119] By severing design from a sales-driven mindset, Moholy-Nagy tried to rethink it as a new practice.[120] Yet, in refusing to connect with those designers who shaped their work in response to industrial clients, he isolated his and his students' experimental projects from a wide range of opportunities that could have both expanded their field of experimentation and increased the degree of innovation by relating the projects more closely to conditions of production.

The Product Design Workshop thus had a distinct identity in relation to other American design programs of the late 1930s and early 1940s. It was an alternative to the professionally oriented programs of the Carnegie Institute of Technology, Pratt Institute, and the California Graduate School of Design as well as to the design program at the Cranbrook Academy which was more closely allied to architecture and the handicrafts.[121] But it was considerably less successful than any of these programs in producing graduates who would make their mark in industry.

Moholy-Nagy did not have a fully articulated vision of the society he hoped would replace the one he lived in, but he tried to demonstrate its possibilities through the values he imparted and the experiences he provided for his students. As he stated on numerous occasions, the forces of change were embodied in conscious individuals rather than political systems. The end result of any political process for him was a greater degree of individual spiritual well-being. Moholy-Nagy's vision of utopia, though never fully developed, shaped his judgments of the world around him, while it also guided his instincts for improving

118 Ron Levy makes an argument for the independence of design education from industry's concerns in his article "Design Education: Time to Reflect," *Design Issues* 7, no. 1 (Fall 1990): 42–52.

119 Moholy-Nagy's social orientation to design was further extended by Harold Cohen, a former Institute of Design faculty member, who launched the Department of Design at Southern Illinois University in Carbondale in 1955 and remained its head until 1963. Cohen persuaded the university's president to hire Buckminster Fuller as an associate of the Department of Design, and Fuller's presence on campus led to an ambitious aggregate of activities embraced within the framework of a "Design Science Decade." These included Fuller's World Game, a simulation of the responsible use of global resources, which spread to universities across the country. Cohen used Moholy-Nagy's *Vision in Motion* as a basic text and attempted to create a design curriculum that followed Moholy's broad concept of design for the environment. The history of Cohen's and Fuller's activities at SIU is recounted in Laraine Wright, "Rebels with a Cause," *Alumnus: Southern Illinois University at Carbondale* (Fall 1989): 2–13.

120 This theme was picked up forcefully in the early 1970s by Victor Papanek in his book *Design for the Real World* (New York: Pantheon, 1972). It was Papanek's call for a new socially responsible design practice that inspired many who were disillusioned with the design profession to move in a new direction. The move was exemplified by firms such as Ergonomi in Sweden that began by specializing in design for the disabled.

121 Design at Cranbrook is described in *Design in America: The Cranbrook Vision, 1925–1950*, exh. cat. (New York: Abrams, 1983). See particularly the chapter "Interior Design and Furniture" by R. Craig Miller, 91–143.

life. Had this vision been more pragmatic, it might have generated a stronger dialogue with the various American discourses on design and manufacturing in the 1930s and 1940s. To put the situation in a larger perspective, however, Moholy-Nagy made a vital contribution to design education by attempting to create a social space where design could be thought about independently of market considerations. In doing so, he tried to redefine design as a humanistic discipline rather than a vocational skill. Ultimately, he made his greatest impact on the inner impulses of his students rather than on the outer structure of the industrial order. What he was unable to negotiate was a way of bringing the two closer together to realize the full benefit of his ample humanitarian concern.

It is fashionable today to scoff at the grand claims made by the artistic-social avant-garde earlier in this century. After all, they wanted nothing less than to bring about utopia through the practice of art. While the failures of this ambition are all too evident—witness Hitler's assumption of power in Germany, Stalin's in Russia, and more recently the collapse of Communism and the expansion of capitalism in Eastern Europe—the artistic-social avant-garde's extraordinary determination to infuse psychic and social power into their art, often in spite of external forces that sought to minimize it, remains exemplary. For Rodchenko, Lissitzky, and Moholy-Nagy this was no easy task. Each had to recognize that the struggle for utopia was not a shared project in which all involved agreed on means and ends. They found that artistic visions had to be fought for even among compatriots. This understanding led them to develop an art of negotiation in order to survive as circumstances changed. The idea of negotiation might seem to contradict the conventional image of the avant-garde artist who steadfastly pursues a single-minded vision, but the reality of Rodchenko's, Lissitzky's, and Moholy-Nagy's lives, like the lives of all avant-garde artists in the early part of the 20th century, involved facing a constant shift of political and economic conditions that forced them to continually reposition themselves in relation to new supporters and adversaries. They sometimes had to mute or alter their positions but this was part of their adaptation to circumstances. Lissitzky and Rodchenko managed to survive during the Stalin years and even produce work of quality. Moholy-Nagy never saw a glimmer of the socialist utopia he dreamed of, but he did change the lives of countless students by awakening in them a sense of whom they might become as artists and as human beings. It was never realistic to expect that the avant-garde could gain sufficient power to transform social institutions, but they could change individuals and in that sense, Rodchenko, Lissitzky, and Moholy-Nagy achieved a great deal. They also changed the forms of art and perhaps we need to ultimately locate our sense of their significance in this process itself, not by considering their work on purely esthetic grounds, but by recognizing that they were able to give life and energy to art practice such that it and its results were recognized as a strong and meaningful presence among their colleagues and various audiences. In doing so, we end up settling for less than the total transformation of life itself but we can also discover enhanced value in actual accomplishments rather than lament the failure of unrealistic expectations.

THE STRUGGLE FOR UTOPIA

Book and jacket designed and electronically composed by Marta J. Huszar. The text is set in 10/13 New Baskerville; epigraphs 8/13 Syntax; footnote citations within the text 7/13 Frutiger Bold; footnotes 7/9 Syntax; and running heads 7/17 Frutiger Black. Printed on 60# Glatfelter Offset and bound in ICG Arrestox by Quebecor/Kingsport.